Portland

The Riches of a City

Produced in cooperation with the Portland Metropolitan Chamber of Commerce

Photo: Steve Terrill

Portland

The Riches of a City

By **K.C. Cowan**

Corporate profiles by **Gail Dundas** and **Ted Bryant**

Photography by **Steve Terrill** and **Larry Geddis**

Portland

The Riches of a City

Produced in cooperation with the Portland Metropolitan Chamber of Commerce
221 NW Second Avenue
Portland, Oregon 97209-3999
(503) 228-9411
Web site: www.pdxchamber.org

By K.C. Cowan
Corporate profiles by Gail Dundas and Ted Bryant
Featuring the photography of Steve Terrill and Larry Geddis

Community Communications, Inc.
Publishers: Ronald P. Beers and James E. Turner

Staff for *Portland: The Riches of a City*

Publisher's Sales Associates	Marlene Berg, John Hecker, Bill Kern, Arlaine Niclas
Executive Editor	James E. Turner
Managing Editor	Linda Moeller Pegram
Design Director	Camille Leonard
Designer	Scott Phillips
Photo Editors	Scott Phillips and Linda M. Pegram
Production Artist	Kim Smith
Production Manager	Cindy Lovett
Editorial Assistants	Robin Davies and Jarrod Stiff
Contract Manager	Katrina Williams
Sales Assistant	Annette R. Lozier
Proofreader	Wynona B. Hall
Accounting Services	Sara Ann Turner
Printing Production	Frank Rosenberg/GSAmerica

In Remembrance
Bill Kern
1935 - 1998
Friend, Colleague, and Sales Associate

CCI

Community Communications, Inc.
Montgomery, Alabama

James E. Turner, Chairman of the Board • Ronald P. Beers, President
Daniel S. Chambliss, Vice President

Photo: Steve Terrill

Contents

Photo: Steve Terrill

Photo: Larry Geddis

Photo: Larry Geddis

CHAPTER ONE
The Portland Advantage

Portland is a city of outstanding advantages, including its proximity to natural wonders like the Pacific Coast and the Columbia Gorge. Although it is a thriving urban center, Portland manages to retain a small-town charm. A look at the city's founding sheds light on its early growth and reflects on the economic forces that have shaped Portland's past as well as those that now direct its future.

CHAPTER TWO
Heart of the City

Portland's heart is its downtown. The year 1998 marked the 25th anniversary of the Portland Downtown Plan, a plan which rescued the core of the city back in the 1970s, when so many urban centers were falling into decay. Portlanders refused to accept that fate, and because of their vision, the downtown area now radiates excitement, day or night! Explore Pioneer Courthouse Square, known as the city's "living room," Old Town and the Saturday Market, the Park Blocks and Tom McCall Waterfront Park, plus shopping, business development, and more.

CHAPTER THREE
What's To Do?

Tourism has become a mainstay of Portland's economy. With an abundance of exciting things to see and do, it's no wonder Portland draws so many visitors every year. The jewels in Portland's crown of attractions sparkle—the Oregon Zoo and Rose Gardens; the Japanese Garden; the Grotto; the Oregon History Center; one of Portland's beautiful state parks inside the city limits; OMSI; and, of course, the festival that brings the whole city together in a joyful celebration of her favorite flower—the Rose Festival.

CHAPTER FOUR
Teaching for the Future

The future of a city rests with its children, and education is the key. While Portland's school system has had to cope with cutbacks, the city's teachers are creative and dedicated to bringing out the best in their young charges. Portland's higher education opportunities abound; some of them, like Portland State University, are located right in the heart of the city. For adults who want to expand their knowledge, but prefer to stay in Portland, both Oregon State University (based in Corvallis) and the University of Oregon (based in Eugene) offer classes in continuing education.

CHAPTER FIVE
Big-City Style, Small-Town Charm

One of the real strengths of Portland is the variety of its neighborhoods. From Laurelhurst to Multnomah Village, each has a distinct flavor and personality. Find out what makes these and other neighborhoods unique. Portlanders' love of their neighborhoods translates into active care and community concern. When challenges arise, the neighborhood associations pitch in and work to keep the neighborhoods connected to city hall and local government.

CHAPTER SIX
Preserving the Land

When the economy is hot, a city grows quickly. But with that growth comes inevitable growing pains. One of the things of which Portlanders are most proud is the region's lack of sprawl, a common dilemma for other large metropolitan areas. Portland's Urban Growth Boundary developed out of the community's concern for its future. Portland continues to work toward a balance between increasing density and maintaining green space.

CHAPTER SEVEN
Vital Services

From state-of-the-art technology, to trauma centers, to managed care programs, Portland leads the nation in providing excellent quality health care at low rates. Portland is also the center for medical research in the state of Oregon, with Oregon Health Sciences University (OHSU) directing the way. Three major health care providers call the Portland area home and are linked in some way to most of the 17-plus hospitals serving the metro area. And for Portlanders with a penchant for the nontraditional—the city has one of only two naturopathic colleges in the nation.

CHAPTER EIGHT
The Lively Arts

The arts have never been livelier in Portland! From touring shows to local theater companies, Portlanders have a plethora of possibilities from which to choose. Visit the Portland Center for the Performing Arts, the Art School, and the revitalized Portland Art Museum, as well as the popular Museum After Hours program. The Oregon Symphony is stronger than ever, and Maestro James DePreist remains a beloved figure in the arts community. The love of the arts begins early, with Portland's award-winning Youth Philharmonic. For the visual arts, visit the ever-popular First Thursday programs and explore the local art galleries downtown.

CHAPTER NINE
Getting from Here to There

How we get there matters! With expectations of an additional half-million people in the coming 20 years, transportation plays a vital role in shaping the Portland area's economy. From the light rail story to bike lanes, take a look at how folks travel in Portland and what their options may be in the future. Discover what makes Portland such a great city for pedestrians, too.

CHAPTER TEN
Brews, Books, and Lattes: The Passions of Portlanders

Portland has one of the more literate societies in the nation. Maybe it's all that misty weather keeping people indoors to read, but there's no doubt about it; Portlanders love their books and bookstores. Along with books, Portlanders love brews and lattes. Take the time to linger over a steaming "cup o' joe" while reading about the history and phenomenal growth of the microbrew industry.

Photo: Larry Geddis

Photo: Larry Geddis

Photo: Steve Terrill

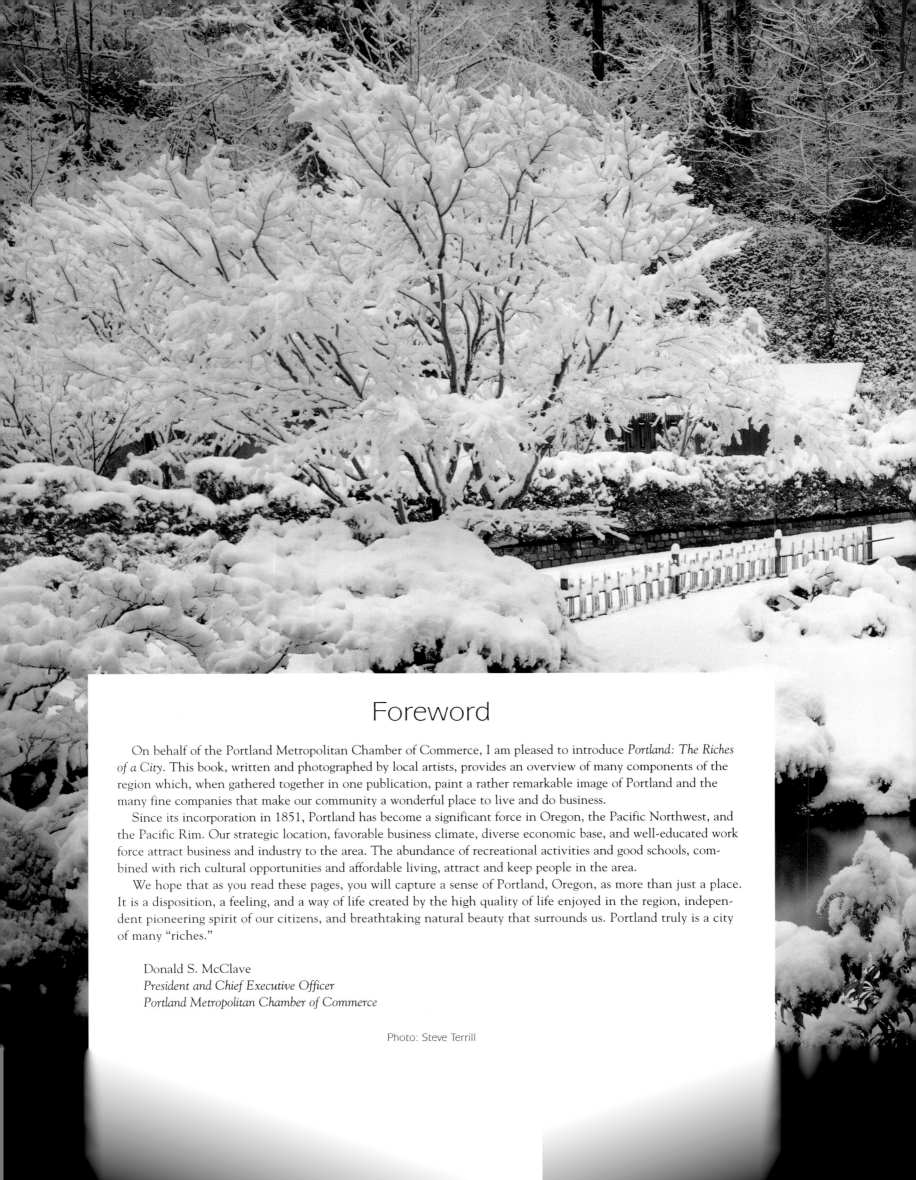

Foreword

On behalf of the Portland Metropolitan Chamber of Commerce, I am pleased to introduce *Portland: The Riches of a City*. This book, written and photographed by local artists, provides an overview of many components of the region which, when gathered together in one publication, paint a rather remarkable image of Portland and the many fine companies that make our community a wonderful place to live and do business.

Since its incorporation in 1851, Portland has become a significant force in Oregon, the Pacific Northwest, and the Pacific Rim. Our strategic location, favorable business climate, diverse economic base, and well-educated work force attract business and industry to the area. The abundance of recreational activities and good schools, combined with rich cultural opportunities and affordable living, attract and keep people in the area.

We hope that as you read these pages, you will capture a sense of Portland, Oregon, as more than just a place. It is a disposition, a feeling, and a way of life created by the high quality of life enjoyed in the region, independent pioneering spirit of our citizens, and breathtaking natural beauty that surrounds us. Portland truly is a city of many "riches."

Donald S. McClave
President and Chief Executive Officer
Portland Metropolitan Chamber of Commerce

Photo: Steve Terrill

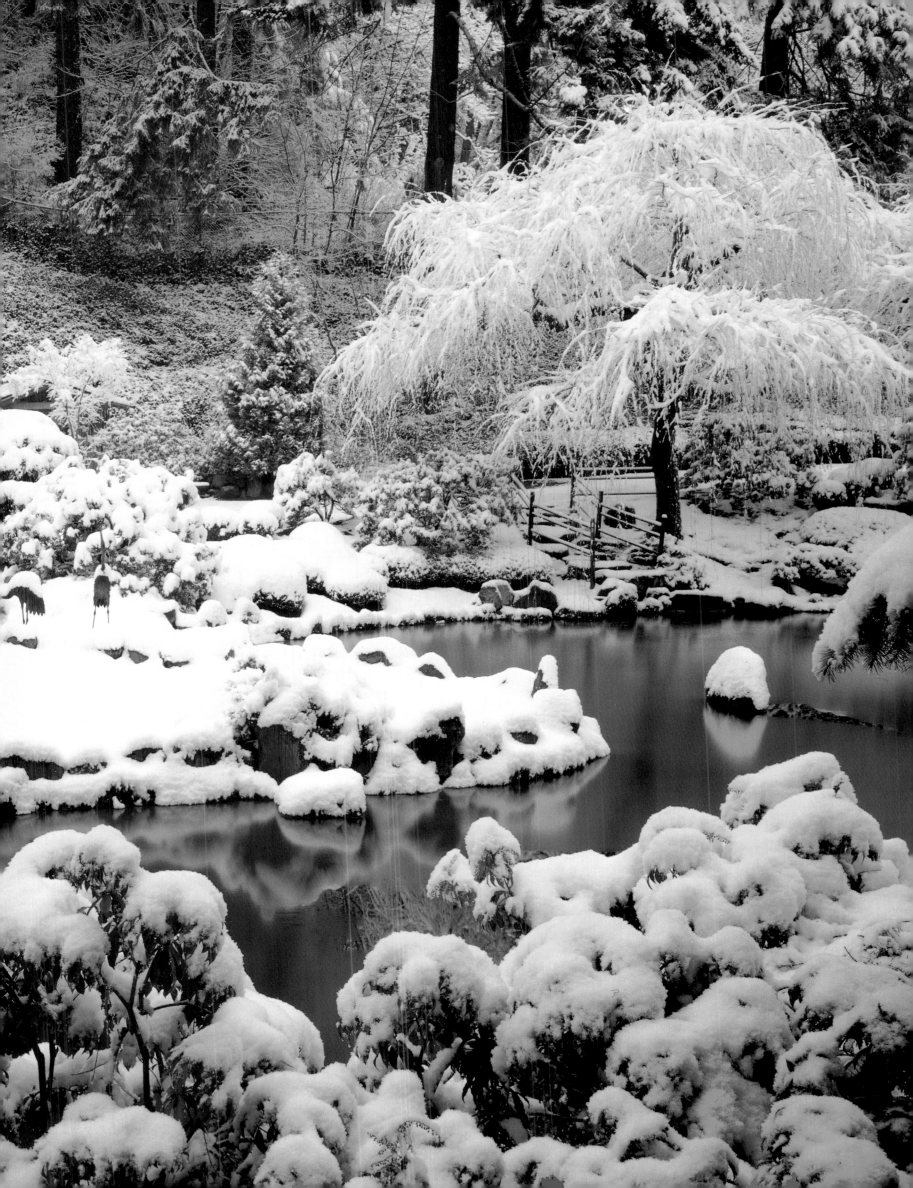

Preface

Being asked to write about the city I love was a great honor and challenge. How to do justice to Portland and cover every aspect I'd like to in just 20,000 words? However, I was eager to try to capture in these few words the many, many wonderful qualities that make Portland was it is.

As I interviewed Portlanders for the book, I found myself caught up in their enthusiasm for the city. Each person I talked to was so eager to share what he or she found remarkable, positive, and exciting about Portland, it was impossible not to feel the same way. I thank them all for making me fall in love with my hometown all over again.

Special thanks go to Carole Gutierrez at the Portland Metropolitan Chamber of Commerce and my editor, Linda Pegram. I am also deeply appreciative to the many, many people who gave me interviews. Without their willingness to sit down and talk with me and share what they know, this book would not have been possible. Special thanks go to Patrick O'Neill of the *Oregonian* and Ken Strobeck of Regence BlueCross and BlueShield, for their help with the chapter on health care, and to Mary McDermott who proofread every chapter for typos before I sent it to my editor!

Even a native Portlander can become blasé about the city, but writing this book taught me that we should never take it for granted. Those who came before us and worked so hard to make it the thriving, livable city it is today must be remembered for their efforts. The greatest honor we can pay them is to work as hard to make sure Portland continues to be a place where all people can live and work and achieve. We have been handed a great gift and must cherish it.

This book is dedicated to my mother, who always wanted me to be a writer.

K.C. Cowan

Photo: Steve Terrill

Part I

The Riches of a City

Photo: Steve Terrill

1

The Portland Advantage

"Good Citizens Are the Riches of a City."

Engraved on the Skidmore Fountain in Old Town

◗

Photos: Steve Terrill

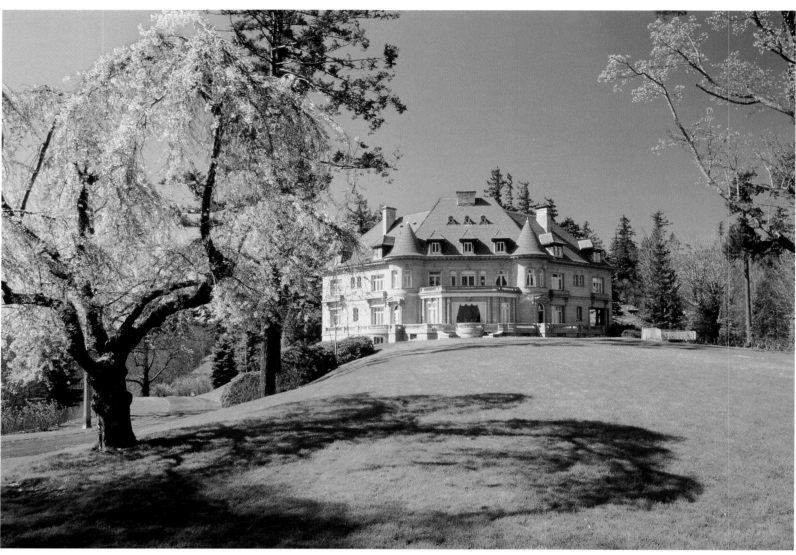

The Pittock Mansion, built in 1914, was almost torn down until the City stepped in and bought it in the 1960s. Now, it's one of Portland's most popular tourist attractions.
Photo: Larry Geddis.

Portland, Oregon—the City of Roses. Or is it the River City? Or Bridgetown, Puddle City, Rip City, Stumptown, the City of Homes, or even, as government vehicles proudly proclaim, the City That Works? Throughout its history, Portland has had many conflicting and unusual nicknames. But the first people to settle on these shores of the Willamette simply called it "The Clearing."

Native Americans used a site on the west bank of the Willamette River as a resting place while traveling between Fort Vancouver and Willamette Falls. It might have remained little more than a wide spot on the bank had not a sea captain discovered that the location was ideal for river trade. In 1840 Captain John H. Couch realized that while the Willamette River becomes too shallow upriver of The Clearing, any vessel that could make it up the Columbia River could also get as far as The Clearing on the Willamette. A strategic seaport was soon born.

Every Portland schoolchild is familiar with how the city was named: a toss of a copper coin between two Yankees whose names still grace Portland streets. Asa Lovejoy and Francis Pettygrove were the first to develop their claim of 640 acres on the riverbank into a township. In 1844, they built a log cabin store on what is today the southeast downtown corner of SW Naito Parkway and Washington Street. The following year they laid out a grid of 16 blocks and debated the name of their new home. Lovejoy, a native of Massachusetts, favored "Boston." Pettygrove, from Maine, preferred "Portland." An arbitrary toss of the coin may have decided the name, but it seems very little about Portland has been arbitrary since.

The city was laid out in 200-by-200-foot blocks, not because it was too tiring to walk longer blocks, but because someone with a canny sense of real estate realized that corner properties were more desirable. The shorter blocks simply enabled more of the valuable corner real estate to be sold. It may have been an economic decision, but it resulted in making Portland the pedestrian-friendly town it is today.

The west side of town was developed first, simply because the east side was somewhat swampy. It was easier to clear and build on the west side, although the early settlers who left the low stumps of the trees sitting in the newly formed roads gave

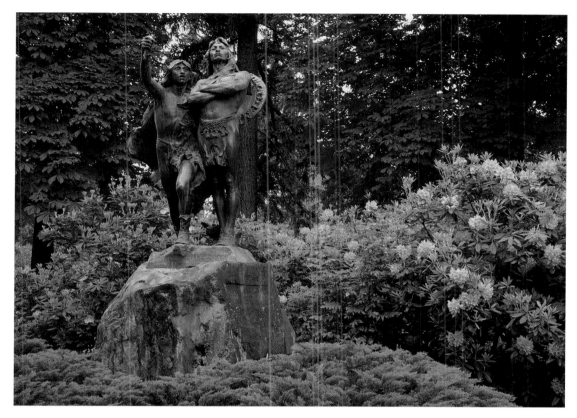

Portland remembers its original people with this beautiful bronze statue in Washington Park.
Photo: Larry Geddis.

The St. Johns Bridge, with its beautiful Gothic architecture, was the longest rope-strand suspension bridge in the world at the time it was built in 1931.
Photo: Larry Geddis.

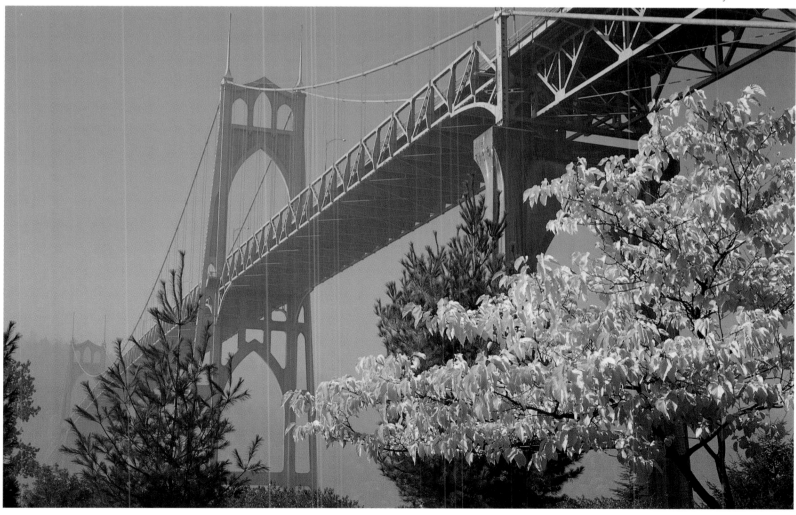

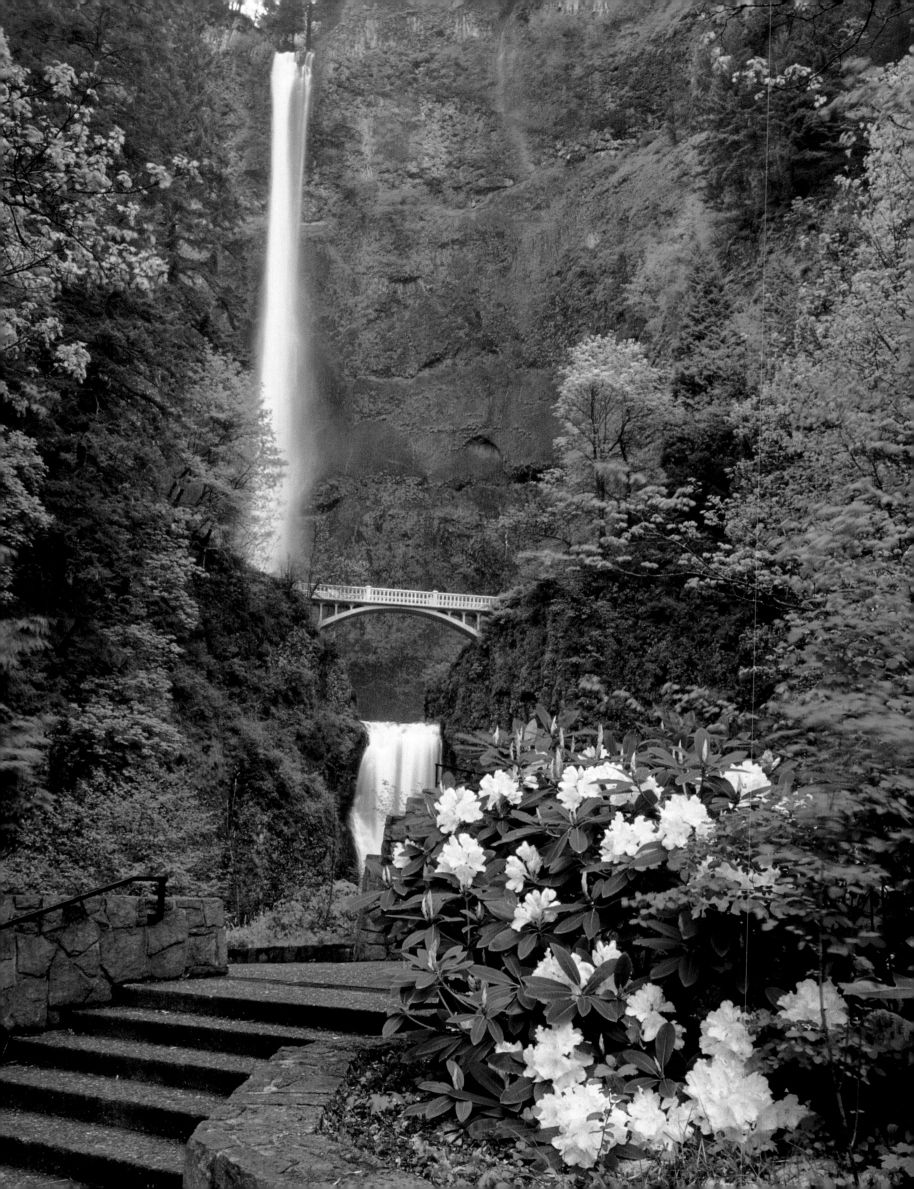

Portland her first nickname: "Stumptown." It was meant to be derogatory, but Portlanders, no doubt, were proud of the fact that the stumps were at least painted white so people wouldn't plow into them at night.

Today, a thriving city center rises along both sides of the Willamette and the Columbia. To say Portlanders love their rivers would be a vast understatement. The Columbia and Willamette Rivers provide a living for some, a playground for others, and a home to the many houseboats that you find clustered near the bridges. Groundbreaking environmental laws were passed in the 1960s to clean up the rivers, and the waterways are among the cleanest and clearest in the nation. Rain or shine, night or day, you can see a procession of small pleasure craft as well as mighty ships and barges gliding up and down the Willamette and Columbia. From the Rose Festival fleet that docks at the waterfront every June, to the festive, lighted "Christmas Ships," to sports enthusiasts enjoying a cool river on a hot summer day, Portland is enriched in innumerable ways by having two "rivers running through it."

Because it is a city divided by a river, Portland is by necessity also a city connected by bridges. Ten in all span the Willamette, from the graceful St. Johns suspension bridge, which was the prototype of San Francisco's famous Golden Gate Bridge, to the small Sellwood Bridge, which crosses the river near the west-side waterfront.

When you want to get out of town, you don't have to drive far to enjoy the scenic beauty of the Oregon landscape. Portland is an urban center in an agrarian state that truly has retained its rural sensibilities. A mere 20-minute drive west

takes you right into the heart of some of the most fertile land in the world. Here you'll find the thriving nursery stock industry and agricultural products such as hazelnuts, berry crops, and Christmas trees. A close proximity to processing, abundant rainfall, and a long growing season make this region's farming a $500-million economy in sales alone.

Continue west another hour or so and the Pacific Ocean invites you to dip a toe in the pounding surf. If you head south from downtown, in about 45 minutes you'll be in the heart of the state's vineyards, where you're welcome to stop and sample some of the many award-winning wines. To the east of Portland, the skiing, resort, and wilderness areas of Mt. Hood are little more than an hour's drive away, offering rivers, streams, and lakes to admire while hiking, fishing, or hunting. Or head up the beautiful Columbia Gorge to see Multnomah Falls and catch some world-class wind surfing!

Visitors to Portland remark on how "green" the city is. Everywhere you look, you see trees. There are 150,000 on the streets of Portland alone, adding to the livability and lessening the "big-city" feel. Portland has more than 10,000 acres of parks. The smallest is the 24-inch Mill Ends Park, and the largest is 5,000-acre Forest Park, the largest urban wilderness within any American city. In the whole metropolitan area, there are more than 37,000 acres of parks.

Newcomers also regularly comment on how clean Portland is. You never have to walk far to put your trash in a receptacle, and recycling is simply a way of life. Oregon was the first state to pass a "bottle bill" requiring a deposit on beverage containers. Highways are "adopted" by businesses, church

Opposite page
Beautiful Multnomah Falls, in the Columbia River Gorge, is the number one free attraction in the Portland area, with more than 2.5 million visitors. It's also the second highest waterfall in the country.
Photo: Larry Geddis.

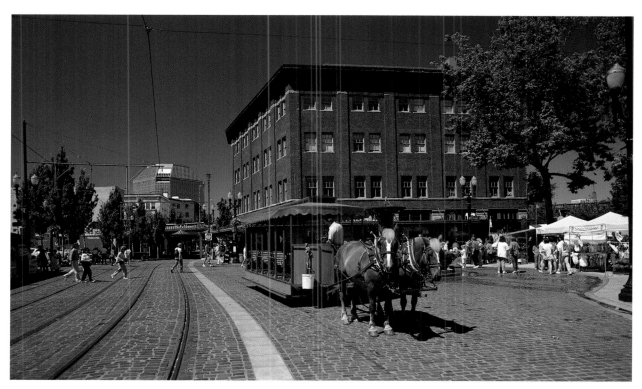

Portland keeps a touch of the old along with the new, as shown by this horse-drawn trolley through the historic Old Town District.
Photo: Steve Terrill.

groups, and individuals who pick up litter, and SOLV (Stop Oregon Litter and Vandalism) organizes thousands of people twice a year to keep our beaches clean.

Portland is blessed with moderate temperatures and an ideal, if not always sunny, climate. The average temperature is 33 degrees in January and 79 degrees in July. Snowfall is rare and doesn't stick around for long. While old-timers still talk about the famous Columbus Day storm, violent storms and extremes of nature are unusual in Portland.

While often thought of as a rainy city, Portland's average precipitation is 37 to 40 inches, less than Atlanta, Houston, or its northern neighbor Seattle. Still, the myth prevails that it

Portland is a major transportation hub for air, ship, and train travel. Here, a Southern Pacific Railway excursion train steams into town.
Photo: Steve Terrill.

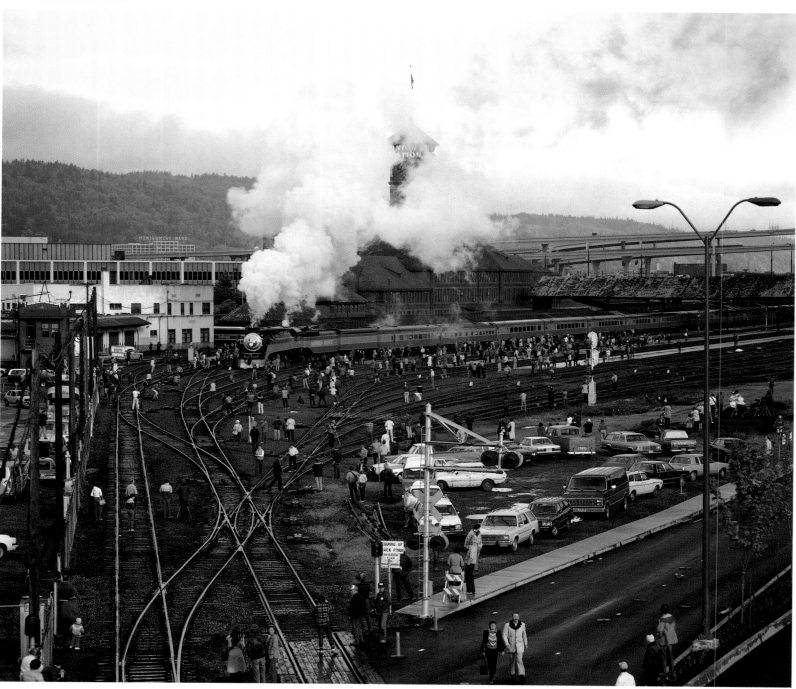

rains here all the time. Native and long-time transplanted Portlanders are apt to look oddly at strangers who ask, "What do you do when it rains?" The answer, of course, is nothing other than life as usual. The world doesn't stop when the rain falls, despite an 1852 editorial by a local newspaper, the *Oregonian*, which encouraged women to "stay home in rainy weather" so as not to shock the gentlemen of the city by delicately lifting a skirt to avoid puddles. If taken seriously, women would have been homebound some 150 days of the year!

Portland has seen waves of immigrants throughout her history. Initial immigrants came from New England and New York, bringing with them a strong puritan streak and vigorous work ethic. During the gold rush of the 1850s, 300,000 settlers sought their fortunes in California. But 30,000 of them turned right and came to Oregon. It brought diversity to Portland, and laws designed to keep immigrants of different races out of Portland failed to do so. Oregon's "melting pot" was well entrenched by the late 1800s.

The latest influx of settlers to Portland has come from the neighboring state of California. From 1990 to 1996, Oregon had a 12.7 percent population growth, placing it ninth among the top ten fastest growing states in the nation. In-migration to the state is twice the national growth. Nearly half of those moving to the state in 1995-96 came from California. But of the 221,395 new people who moved to Oregon between 1990 and 1996, more than 42,000 of them came from outside the United States. Our melting pot continues.

And a robust economy brings them here. Oregon has moved from an economy dominated by traditional forest products to manufacturing, high tech, services, and tourism. The economy is growing at an especially fast clip in the Portland area. Of the top 25 private sector employers in the state, the top 7 have their headquarters located in the metropolitan area. The largest employers are Oregon Health Sciences University, Providence Health System, and Fred Meyer, Inc. The neighboring city of Beaverton is home to world-renowned sportswear giant NIKE, Inc. In all, five *Fortune* 500 corporations claim Portland as their home: Willamette Industries, Thrifty Payless Holdings, PacifiCorp, Fred Meyer, and NIKE, Inc. And why not? After all, *Forbes* magazine named Portland one of the nation's top five cities for nurturing businesses.

Exports are a major economic force, with the Port of Portland bringing more than $500 million in direct earnings

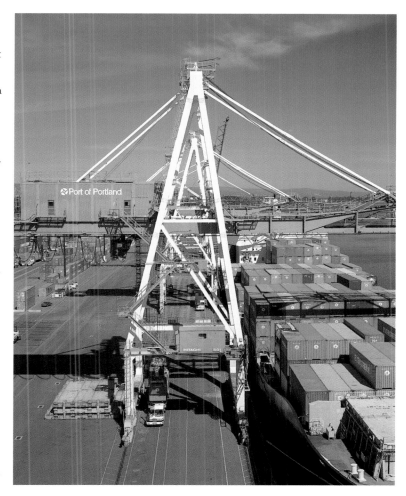

As a world-class exporting center, the Port of Portland brings an economic impact of more than $500 million to the metro area.
Photo: Steve Terrill.

to Portland metropolitan area residents. The Port of Portland is ranked as the largest wheat exporting port in the U.S. and largest volume auto handling port in the nation. It's no wonder that the Port plays a significant role in advancing Portland's trade and transportation position on the West Coast. The Port is also home to one of the largest floating dry docks in the Western Hemisphere, able to handle ships the size of three football fields in length, providing high-paying, family-wage jobs.

Adding to Portland's stature as a key hub on the Pacific Rim, Portland International Airport (PDX) continues to make gains in international service. Nearly 13 million travelers moved through PDX in 1997, more than double the number using the airport in just six years. Air cargo volumes expanded for 15 years in a row, with 12 all-cargo carriers serving Portland now. PDX is now Delta Air Lines' largest U.S. West Coast/Asian gateway, handling more passengers than even Los Angeles. In 1999, PDX will complete the Terminal Access Project, the largest and most complex construction project in the airport's history. When complete, it will add more than 2,000 parking spaces to the parking garage, roadway lanes in front of the terminal, and space inside the ticket lobby and baggage claim areas. Little wonder *World Trade*

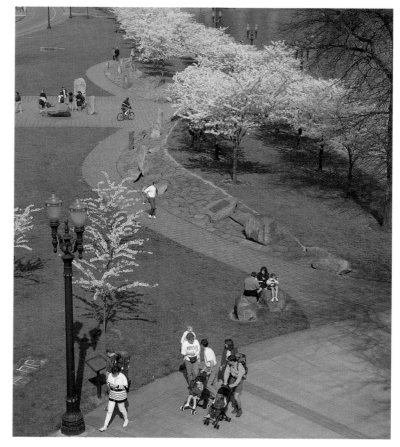

One of the newest Portland attractions, the Japanese American Historical Plaza features a sculpture garden and cherry trees. It is dedicated to the Japanese Americans held in detention camps in Oregon during World War II.
Photo: Larry Geddis.

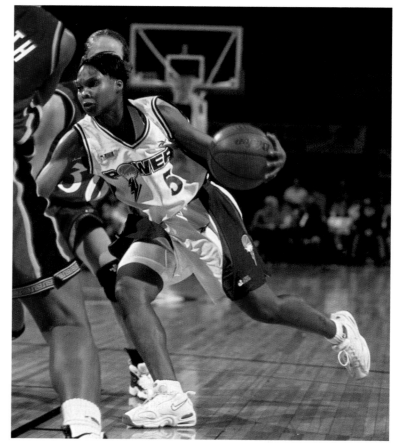

Portland is one of eight lucky cities to have one of the new American Basketball League women's teams. The Portland Power attracts large crowds to see the action.
Photo: Portland Power.

magazine named Portland one of America's 10 best cities for international companies.

Oregon's high-tech industry, with more than 1,000 companies employing about 54,000 people, is strong and diverse, producing a variety of software, semiconductors, computer instruments, and more. Most of the high-tech companies, with familiar names like Tektronix, Intel, Hewlett-Packard, Fujitsu, Epson, Sequent, and Mentor Graphics are located in the Portland area. Growth shows no sign of slowing down, either, with the high-tech industry expected to add another 28,000 jobs (with a median salary of $43,000) by the year 2000.

It isn't just large business that is doing well in Portland, either. In 1997, for the third straight year in a row, *Entrepreneur* magazine named the Portland-Vancouver metropolitan area the best region in the nation for small businesses and entrepreneurs. The magazine credited the friendly atmosphere, the diversified economy, and Oregon Venture, a program that attracts venture capitalists to learn about emerging companies in the state.

Tourism is an estimated $4.5-billion industry for the state, and Portland certainly attracts its share of those dollars. Visitors spent $1.7 billion in Portland in 1996—an 8-percent increase over the previous year. The tourism payroll alone is nearly $400 million. The Oregon Zoo, with its world-famous elephant breeding program, has the highest attendance of any paid tourist attraction in the state.

Sports fans have plenty of teams to cheer in Portland. "Rip City" is the cry heard around town when the Trail Blazers, one of the most successful franchises in the NBA, are inevitably headed toward the playoffs. The 21,000-seat Rose Garden arena is the Blazers' new $262-million showcase, as well as sometime home to the Portland Winter Hawks, Portland's hockey team in the Western Hockey League.

Other spectator sports to relish include the Portland Pride for indoor soccer; the arena football team, the Forest Dragons; and the Portland Rockies, which has one of the highest attendance records for minor league professional baseball. Women have not been left out, either. Portland nabbed one of the eight new women's

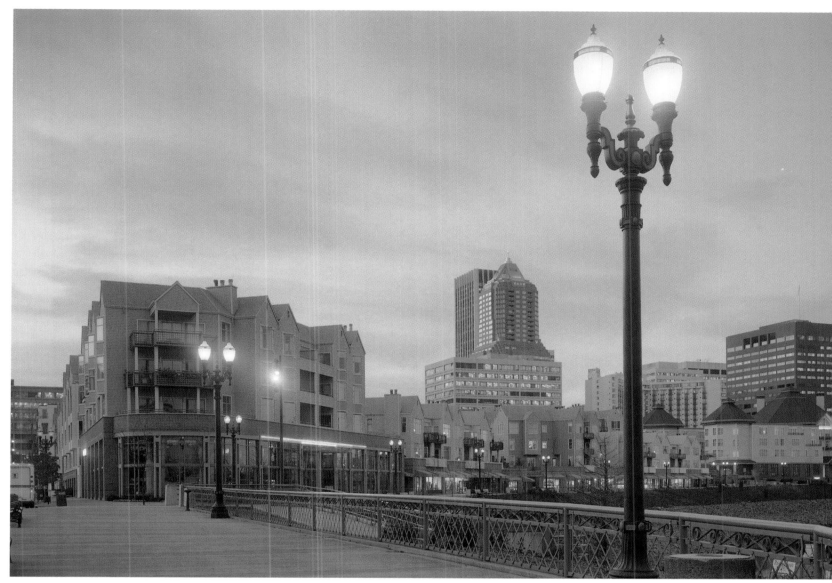

Portlanders love their waterfront! The RiverPlace Promenade is a popular place to jog, or take a leisurely stroll.
Photo: Steve Terrill.

American Basketball League teams—the Portland Power. From October through April, Portland Meadows offers live horse racing, and from May through September, the Multnomah Greyhound Park goes to the dogs with greyhound races every 15 minutes.

For golf enthusiasts, the lush turf of Portland's greens is attracting national attention. Recent golfing events include the Fred Meyer Challenge and the PING-Cellular One LPGA Golf Tournament. Portland certainly has a warm spot in the heart of golfing star Tiger Woods. It was at the Waverly Country Club that Tiger won his third straight U.S. Junior Golf Championship in 1993. In 1996 he completed another "three peat" when he captured his third straight U.S. Amateur Championship at the Pumpkin Ridge course. And local sports shoe and clothing manufacturer NIKE has added Tiger Woods to its illustrious roster of sponsored athletes.

Certainly, many Portlanders enjoy the excitement and discipline of participating in sports and sport activities, yet

gardening remains the number one recreational activity of residents of the Rose City. Portland is divided into five sections: northwest, southwest, southeast, northeast, and north. These distinct neighborhoods, each with its own style and personality, keep the city from feeling too crowded or homogenized. In 1906 Portland was known as the City of Homes because nearly half of the houses were owned rather than rented (still the case today!). And since a large garden was considered a prerequisite for each home, at one time Portland spread out over a larger area than either Seattle, San Francisco, or Los Angeles, even though its population was far less! Today, there are more than 20 garden clubs serving to beautify the city.

Nationally, Portland is one of the hot spots for home prices, with costs rising faster than inflation. While home costs rose an average of 5 percent in 1997 across the nation, in Portland the cost of a home rose 8.4 percent, with a median sales price of $151,100. While that is a hefty hike in the price of a home, Portland is still the second most economical city of the 10 metropolitan areas on the West Coast in which to buy a home. Moving vans are a familiar sight in town, as the metro area continues to be a key city for inbound moves.

At the same time, the number of low-income and subsidized small apartments and hotel rooms downtown continues to shrink. The city has set a goal to build more affordable, low-income housing units downtown, and reverse the trend that has resulted in a loss of more than 1,000 low-income housing units over the past two decades. Plans include innovative strategies designed to create a dynamic mix of housing to bring the number of affordable apartments and rooms back to the 1978 level of over 5,000.

Although Portland cannot escape the national trend of crime, serious crime in Portland dropped more than 10 percent in 1996. The overall rate of reported serious crime dropped from 113 per 1,000 residents in 1995 to 101 crimes per 1,000 the following year. Police credit local citizens for the recent drop in serious crime. Portlanders are more willing to get involved with police to help prevent crime, and Neighborhood Watch groups have increased across the city. Community policing, which emphasizes maintaining a visible presence in local neighborhoods, has also been a factor in crime reduction.

No wonder, then, that in a 1996 poll residents responded that they have more confidence in local government, feel good about their neighborhoods, and feel safe walking in their own neighborhoods. The Portland Multnomah Progress Board, established in 1993, continues to monitor our progress in such benchmark areas as reducing poverty, improving education, decreasing crime, and improving government service.

Portland is known as the City of Roses, but flowers of all kinds brighten downtown and the waterfront.
Photo: Steve Terrill.

The Sellwood neighborhood, while long since "absorbed" by Portland, retains much of the small-town feel it had once as an independent community.
Photo: Steve Terrill.

Good strides have been made in many areas, including improving education and reducing domestic violence.

Yet, with all this growth in the economy, exciting recreational opportunities, and positive outlook, Portland remains surprisingly laid-back. We're pretty relaxed and casual. After all, this is the state where Governor John Kitzhaber wore blue jeans to his own inauguration. As Jim Crotty, editor of *Monk* magazine, explained, "When we tell people in Seattle we're doing a story on their city, they respond, 'Great! When will it be on the newsstands?' When we tell Portlanders we're profiling their city, they ask us why anyone would want to do that."

Utne Reader may have named Portland the second most progressive city in the United States (next to Utica, New York) for its livability and creative approaches to solving urban problems, but it doesn't turn our heads.

Portland still manages to retain a small-town atmosphere amid all the opportunities and amenities of a big city. We like it that way. The pace around Portland is pleasant, not frantic, with a quasi-European feel, which is probably why so many people use the word "friendly" to describe it. It's a place where, if you are standing on a street corner puzzling over a map, someone is bound to stop and ask if they can help you find something.

Monk magazine put it this way: "...Portland has the highest percentage of people you'd want to call your friends. In other words, Portland is filled with real people, who are there for you.... In most American cities the locals are either so isolated in their car and work worlds, or so completely ruled by the fashions and currents of mass media, they've lost what it means to be authentically human. But in Portland, Oregon, you have a phenomenon that is almost revolutionary—intelligent, creative people who actually care about one another."

As the inscription on the Skidmore Fountain proclaims, our citizens truly are the riches of Portland. ◢

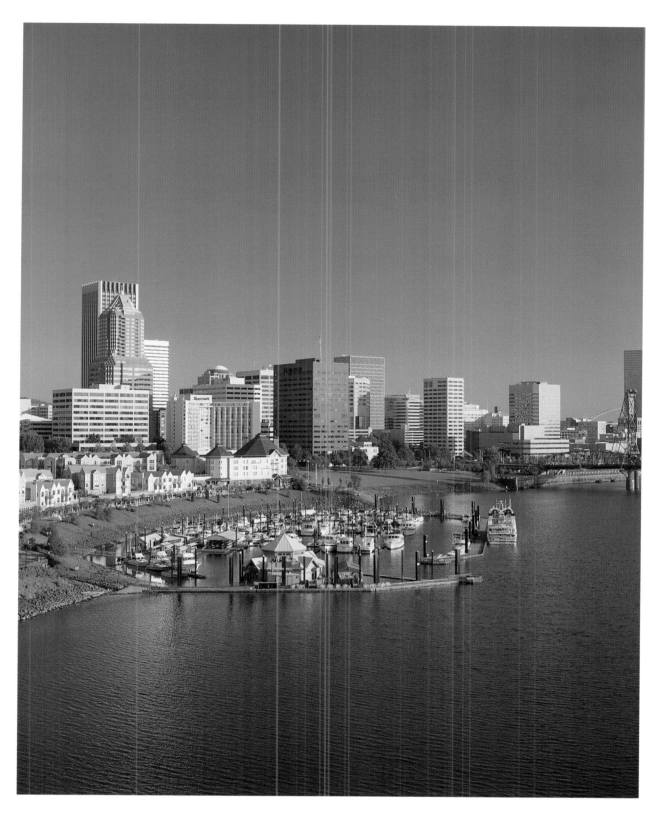

Left
**Portland's Downtown Plan
has given the city skyline
variety and color and
preserved access to the
waterfront for business
and pleasure.**
Photo: Steve Terrill.

Following page
**You don't have to drive far
from downtown to enjoy the
splendors of nature. Mt.
Hood reflects into Lost Lake
on a beautiful autumn day.**
Photo: Larry Geddis.

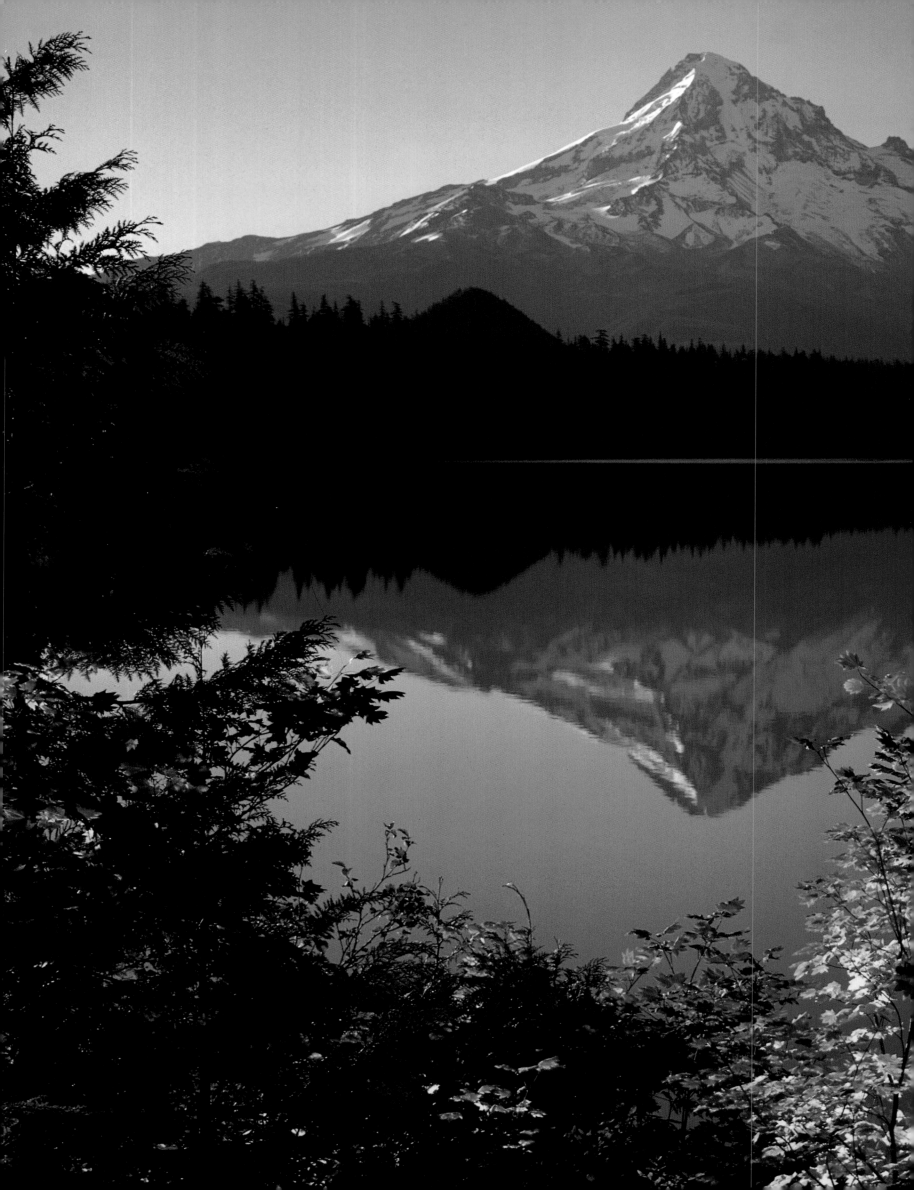

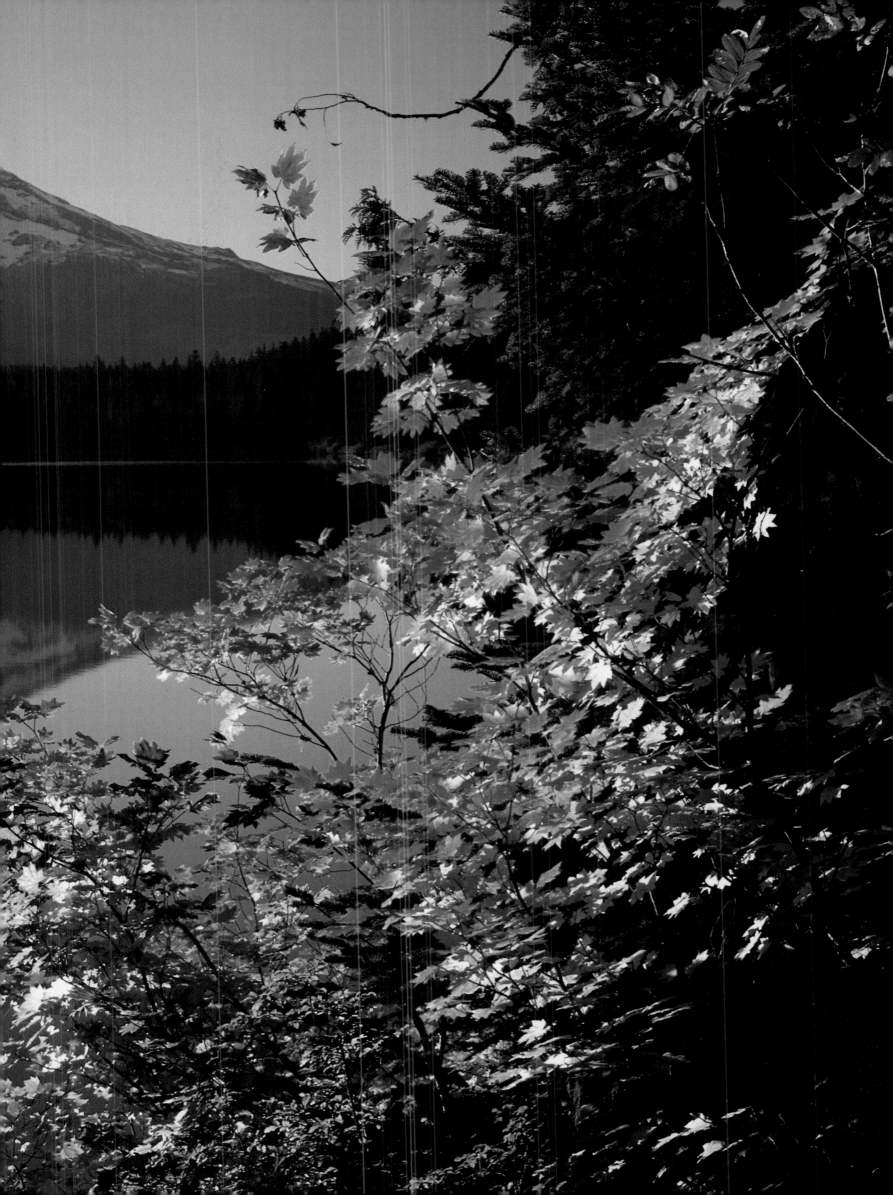

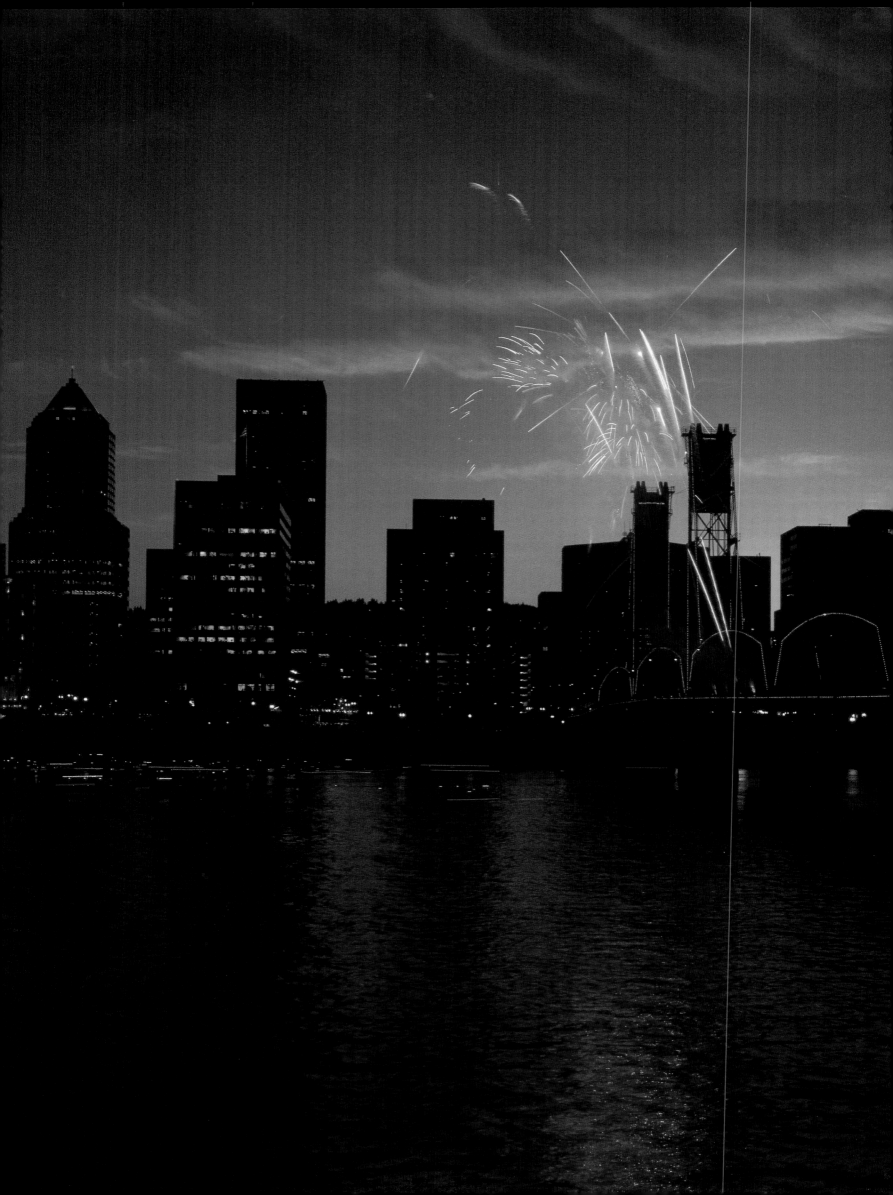

<div style="text-align: center;">

2

Heart of a City

"When people visit Portland, what they take away with them is that it's clean and safe and friendly and fun and exciting."

Ruth Scott, president and CEO,
Association for Portland Progress

◢

Photo: Larry Geddis

Opposite page: Steve Terrill

</div>

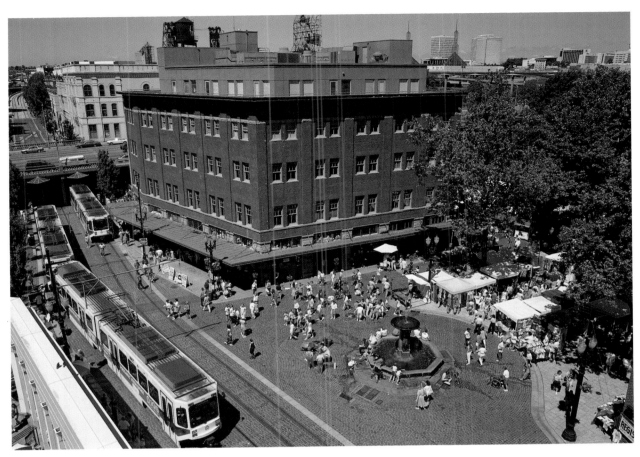

With all the parks, shops, restaurants, galleries, and gleaming office buildings, downtown is the crowning jewel of Portland. It's hard to believe it nearly suffered the same fate of urban decay and desertion as many big-city urban centers in the 1970s. And if not for the vision of Portland's citizens and civic and government leaders, downtown might well have seen business and retail flee to the suburbs. Instead, 1972 was a turning point for downtown Portland.

Portland in the late 1960s was not particularly inviting. Buses crisscrossed the city from all directions, impeding automobile traffic. Auto exhaust was so bad, the city regularly violated clean air standards for carbon monoxide. And most critical, businesses were moving out and fewer people were coming downtown to shop or dine during the day or evening.

But Portlanders refused to say die. A group was formed to find a way to revitalize downtown. The Portland Improvement Corporation was the genesis of the Downtown Plan. Today, The PIC has become the Association for Portland Progress, and everywhere you look you can see the results of its work to put that Plan into action.

It took the buses off many streets and put them on two core streets to create the Transit Mall. In order to help people get around downtown easily, Fareless Square was created so business people and shoppers alike could hop a bus for a few blocks at no cost.

The Plan sought to strengthen the existing concentration of theaters, restaurants, and hotels along Broadway. Today, the Arlene Schnitzer Concert Hall, movie theaters, and numerous hotels make this section of town lively day and night, even on weekends. All this helps enhance Portland's reputation as a "24-hour city."

Downtown, which was initially cut off from enjoying its own waterfront when the original seawall was built in 1929, and then further separated from the river when a highway was built parallel to the Willamette, reclaimed its roots by tearing up the Harbor Drive highway and putting in Tom McCall Waterfront Park. Only today can we truly appreciate what a radical step this was in the 1970s, when automobiles ruled. The waterfront is now a green belt that stretches for blocks, from its southern end at the RiverPlace marina development of hotel, condominiums, athletic club, shops, and restaurants, clear down to the north with the McCormick Pier development. The newest addition to Waterfront Park is the Japanese American Historical Plaza, which honors Japanese-Americans who were sent to internment camps during World War II.

On nearly any day, Waterfront Park is filled with joggers, bicyclists, roller bladers, businesspeople taking a stroll, or families and children enjoying the Salmon Street Springs fountain. The Park is also in regular use most weekends for events

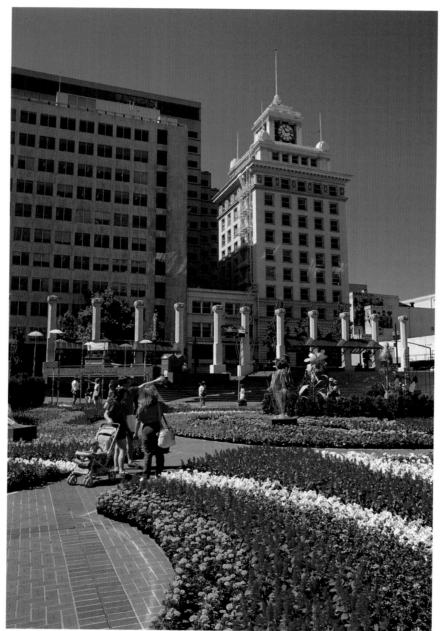

Each year, the Festival of Flowers takes over Pioneer Courthouse Square to the delight of the public. Later, hundreds will line up to buy these flowers to plant in their own gardens.
Photo: Larry Geddis.

Portland was named the number one bicycle city by *Bicycling* magazine in 1995. Bike paths are a priority for the city.
Photo: Steve Terrill.

such as festivals, concerts, or runs like the Race for the Cure.

The center of attention for Portland, however, has to be Pioneer Courthouse Square. Right smack dab in the middle of downtown and bordered on three sides by the Transit Mall and light rail tracks, this piece of real estate has always been important to the city. It was the site of the first real schoolhouse in Portland, a big, white New England building complete with cupola and bell. Then in 1891, the seven-story Queen Anne-style Portland Hotel rose on the site, just across from the Pioneer Courthouse. With its gracious design, portico, courtyard, and iron railings, it was the Grand Dame of downtown for decades. In 1951 it was razed to the ground and turned into a parking lot, a fate which the 1869 Courthouse just narrowly escaped.

For years there was talk of turning this wasteland of real estate into some sort of "public square"—a European-style plaza that would attract shoppers and business people during the day. Downtown businesses, however, also feared such a place would attract transients, and indecision nearly caused the plan to die in 1981.

To the rescue came City Commissioners Mike Lindberg and Charles Jordan. They rallied citizens and created the Friends of Pioneer Courthouse Square. The group raised $1.6 million with the novel idea of selling bricks inscribed with patrons' names. It seemed everyone wanted to buy a brick for themselves or as a gift, and the square was soon literally paved with names!

On April 6, 1984, Pioneer Courthouse Square, designed by late architect and visionary Will Martin, was officially opened as balloons filled the sky and thousands cheered. In the years since, it has truly become Portland's living room, where you're likely to find a business-suited man or woman sitting next to a multi-pierced street kid, as both enjoy an outdoor lunch, concert, or the weather machine's animated forecast each noon. As a nice touch to the city's heritage, the wrought iron gates and fencing on the Sixth Avenue side were taken from the Portland Hotel's entrance.

What would a downtown be without places to shop? Major downtown retail staples Nordstrom and Meier & Frank are a stone's throw from Pioneer Square, and just two blocks away is the newest shopping haven to grace downtown—Pioneer Place. Encompassing two city blocks, it includes not only Saks Fifth Avenue and a food court, but also four levels of shops in a skylight-topped pavilion. Portland's retail market is one of the strongest in the nation, with vacancy rates as low as 4.5 percent. Not only is there ample shopping in the immediate core of downtown Portland, but a quick bus or trolley ride can also quickly take you to two other great shopping areas, the nearby Lloyd District or the Nob Hill neighborhood in northwest Portland.

In Nob Hill, NW 21st and 23rd Streets transport you to a world reminiscent of a quaint European neighborhood. On any sunny day you'll see crowded tables at the many sidewalk cafés as visitors and residents alike enjoy a cup of coffee under a shady tree. Crowds come to shop at the trendy boutiques, fresh flower vendors, and bakeries, and peruse the art galleries and dusty antique and used book stores.

The Lloyd District has recently seen a major renaissance with commercial, retail, and residential renovation. The well-established Memorial Coliseum, Lloyd Center shopping mall, and nearby Lloyd Cinemas, as well as the Oregon Convention Center and Rose Quarter entertainment complex give people plenty of reasons to take the Metropolitan Area Express (MAX) or a reproduction Council Crest trolley across the river.

While Portland builds for the future, it has not erased the past. Part of the Downtown Plan was to encourage rehabilitation of historic buildings, which is why today, you can see the new Mark O. Hatfield Federal Courthouse, a towering architectural delight to the eyes, sitting two blocks from a restored three-story cast iron building dated 1893. Building height restrictions guarantee that Portland will not become a valley of concrete canyons where the sun never shines on the streets.

Nowhere is the dedication to preserving the past more evident than in one of Portland's several historic districts, including Chinatown, Old Town, Skidmore, Yamhill, and the Pearl District. You can almost feel yourself going back in time as you walk past beautifully renovated buildings. Portlanders know that a diverse downtown with many architectural styles helps create a unique urban environment.

The arts are also very important to a city, and they're given a boost in Portland, as well as every other town in the state by a unique law. Oregon passed one of the first laws requiring one percent of the cost of all new or remodeled state buildings be used to purchase or commission works of art. Examples abound as you walk through Portland, but the finest is

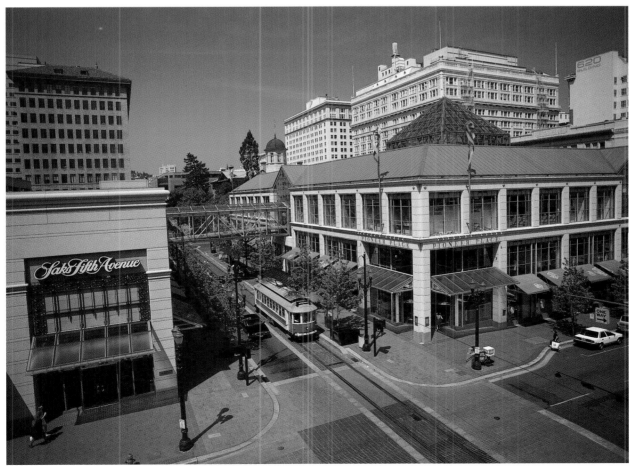

Take one of Portland's vintage trolleys from Pioneer Courthouse Square across the river to the Lloyd District. They're exact replicas of the city's original trolley system.
Photo: Steve Terrill.

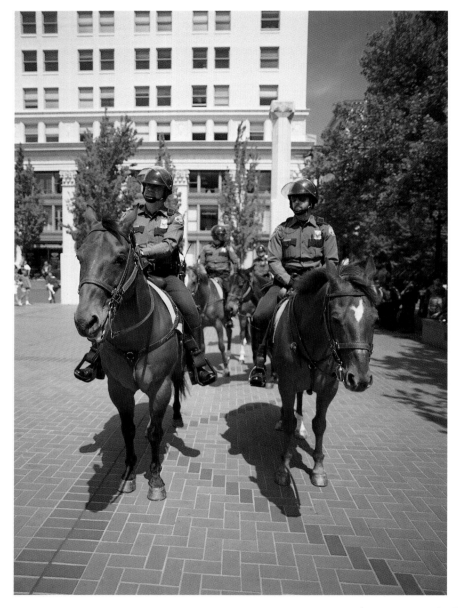

The popular Portland Mounted Patrol is a way for police to have a presence in downtown Portland that is both unique and accessible to the public.
Photo: Steve Terrill.

Opposite page
With 17 bridges, it's no wonder Portland is sometimes called the City of Bridges. The Hawthorne Bridge, which gained national recognition for its design in 1910, is also the world's oldest lift bridge.
Photo: Steve Terrill.

Got a question? Ask a Green Guide. These friendly folks walk the downtown core to give directions or advice to visitors and locals alike.
Photo: Steve Terrill.

Portlandia, a three-story tall hammered-copper statue based on "Lady Commerce" in the city seal. This statue, the largest of its kind next to the *Statue of Liberty*, has been loved by Portlanders since it first sailed up the Willamette River on a barge in 1985 to claim her spot on the postmodern Portland Building overlooking the Transit Mall.

If Portland was a near-terminal city in the late 1960s…a gray, dirty, even boring town…today it is hailed for its diversity of stores, architecture, streetscape, restaurants, cultural events, and vibrancy. Even the buildings are colorful, from brick red to the turquoise blue of the Portland Building.

Credit for the turnaround must be shared by the organizations willing to work to ensure that the greater downtown area remains a good place to visit, shop, and do business. One of these is the Association for Portland Progress, which brings together 90 civic leaders whose goal is to keep the Downtown Plan on track.

A key component is APP's "Clean & Safe" program. Created in 1988, Clean & Safe designated a 212-block section of downtown for special attention. It's funded by a business license fee on downtown property managers, and pays for everything from sidewalk cleaning and graffiti removal to the Portland Guides—green-jacketed, friendly faces who patrol downtown seven days a week. The Guides, the "Downtown Ambassadors," keep an eye out for criminal activity, offer humane assistance to the city's less fortunate individuals, and assist visitors who may need directions. Downtown Clean & Safe is one big reason why so many people feel safe to walk around downtown Portland both day and night.

Credit also goes to the Portland Metropolitan Chamber of Commerce. In 1972 the Chamber coordinated a study of how to maintain a vital downtown and implement an air quality strategy. The report stresses the importance of supporting housing, retail, entertainment, and dining in the city's core, because if "these are adversely affected we have lost downtown except as a governmental and financial center."

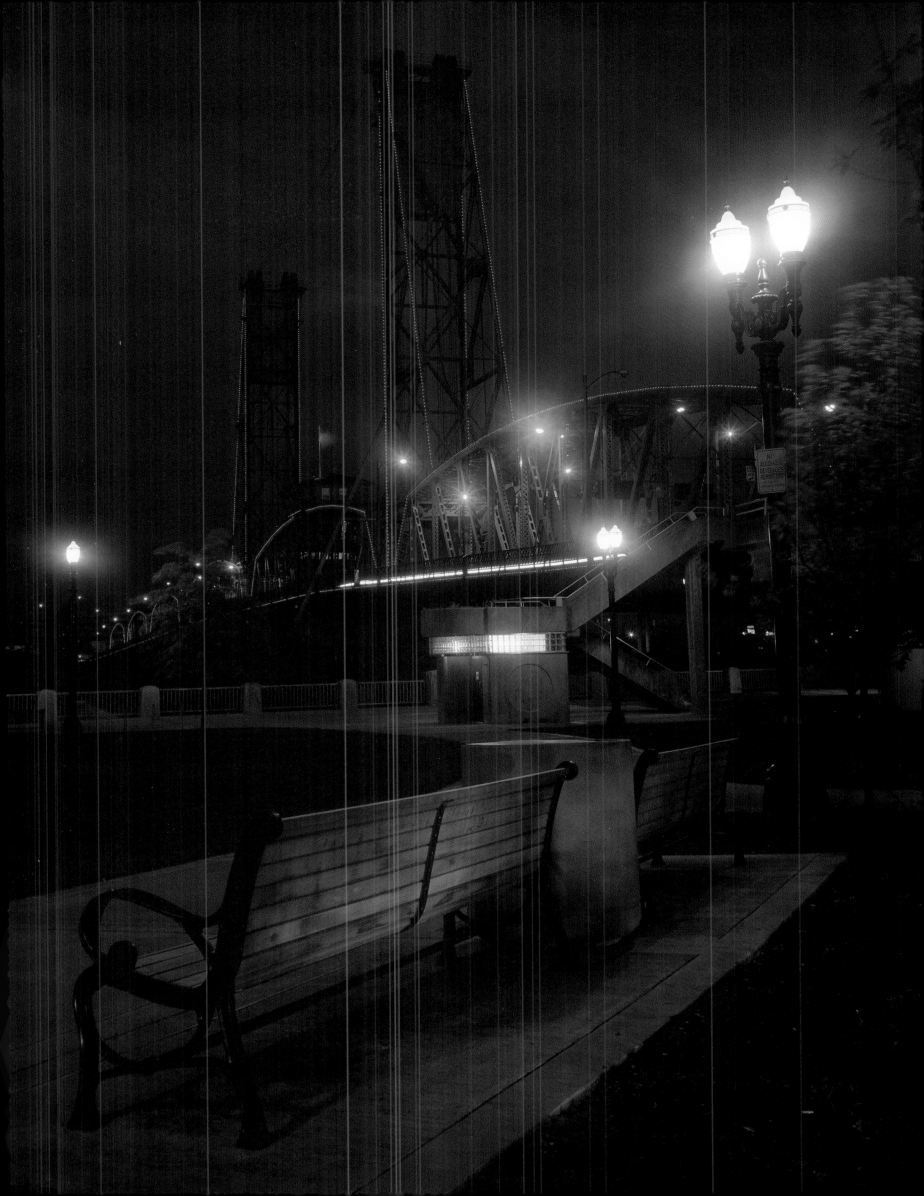

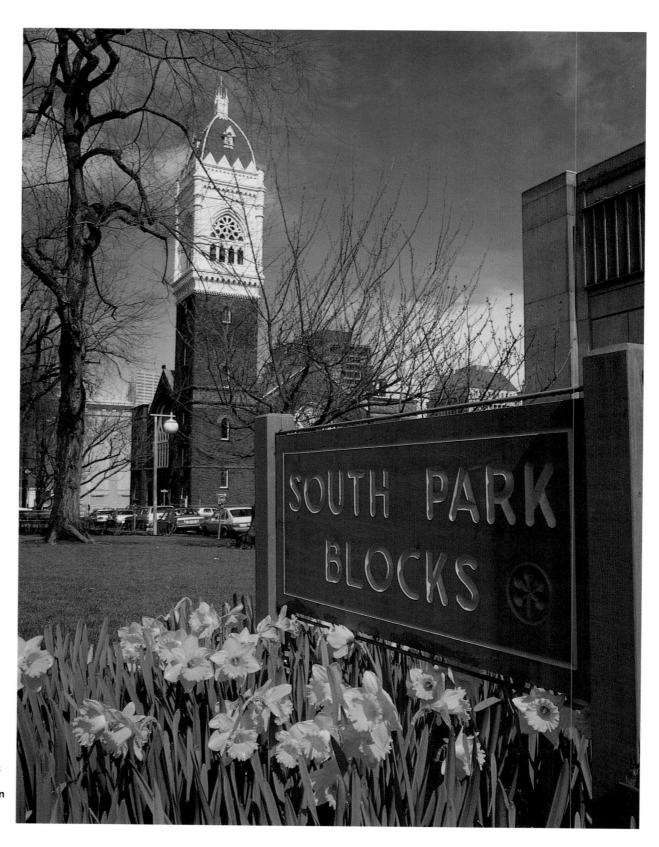

Portland's South Park Blocks offer an oasis of green along with colorful blossoms right in the heart of the city.
Photo: Steve Terrill.

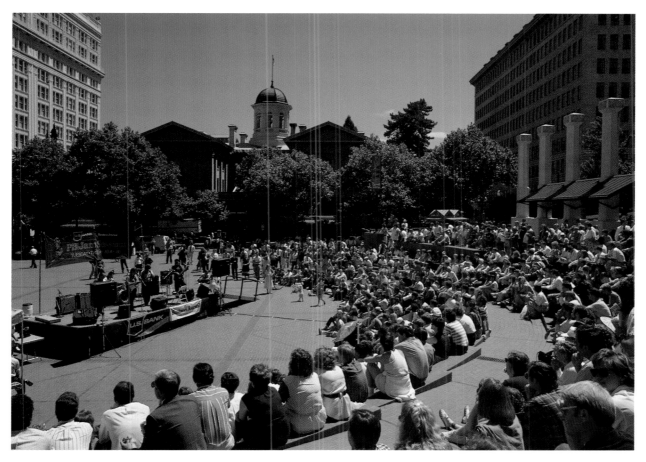

Known as Portland's "living room," Pioneer Courthouse Square packs them in for the many free noontime concerts, like this Peanut Butter & Jam.
Photo: Larry Geddis.

Fortunately, thanks to the work of concerned groups like the Chamber, that didn't happen.

New York has its Central Park; Portland has its Park Blocks. Created in 1852, and nicknamed the "Boulevard," the park was a gathering place for early traders and townspeople. Had not eight blocks mistakenly ended up in private hands in 1871, this stretch of green would run for 25 blocks. Instead, it starts along Park Avenue from the Portland State University campus and extends 12 blocks to SW Salmon Street. Then, after a brief interruption, the park continues as the North Park Blocks from West Burnside to NW Glisan. A cool oasis in the city's center, giant, 100-year-old elm trees offer shade to those resting on park benches, and roses and other flowers fill garden beds and surround sculpture along the way.

The South Park Blocks also border the upper end of the downtown cultural district. Within a few blocks of each other are the Portland Art Museum and the Portland Center for the Performing Arts, which includes the Arlene Schnitzer Concert Hall—a beautifully restored vaudeville and movie palace. Concerts, dance performances, and lectures keep people coming downtown year-round. In addition, the Oregon History Center opens out onto the South Park Blocks. This treasure trove of history is the oldest statewide cultural institution in the state. Not only are there permanent and changing exhibits that offer a glimpse into the lives of Oregon's

pioneers, but visitors can also access the regional research library, which houses thousands of rare books, manuscripts, maps, and literally millions of photographs.

A healthy downtown attracts a lot of visitors, and it needs to be able to provide ample accommodations. Portland has seen a boom in new hotels in recent years, but you might not notice them immediately. That's because some of our newest hotels are renovated old hotels, such as the Hotel Vintage Plaza, Multnomah Hotel Embassy Suites, and the Governor Hotel. They offer the charm and personal attention of small European hotels, with all the modern conveniences today's travelers demand.

With an average occupancy rate of 78 percent, the highest since the 1970s, there's still room for growth. Seven new hotels are slated for the central business district and Lloyd districts between 1998 and the year 2000, bringing the total number of rooms close to 1,500. This news should please visiting executives who have had to stay in airport hotels and commute downtown when hotels in central Portland were at capacity.

Commercial real estate in the greater downtown area is a hot market, unless you're looking to rent space. Portland office buildings are so popular that the total office vacancy fell to 6.9 percent, and experts say downtown rents can soon expect to hit $25 or more per square foot. The surrounding

area, meanwhile, is ranked number six among the nation's top suburban office markets.

Downtown can be as desirable a place as any in the world, but if you can't get there conveniently, or find parking, you're out of luck. The APP realized that, and in 1983 created Smart Park. It provides inexpensive, short-term parking near such popular sites as the Civic Auditorium, Civic Stadium, Memorial Coliseum, Portland Repertory Theatre, and the Old Town Arena. The six garages are owned by the City of Portland but managed by APP. They're profitable, at capacity, and expanding to ensure that shoppers, visitors, and workers have easy access to downtown.

The vitality of downtown Portland has attracted well-deserved national attention. In 1997, the International Downtown Association and the National Main Street Program both visited to learn what makes the Rose City so special. And they are only 2 of an average of 12 cities a month that want a presentation or tour. Dozens more request information. Ruth Scott, president and CEO of the Association for Portland Progress, says Portland's reputation is "we can do no wrong."

But what makes Portland's revival so amazing? Many cities have developed "plans" to keep their downtown regions vital. Yet, none have succeeded so well as Portland. Scott believes it's because Portland's Downtown Plan was created and implemented with a unique spirit of public and private partnership. It involved people of all walks of life. It established real policies, like having retail on the ground level, mandatory setbacks, and building design requirements. These policies, backed by the spirit of Portlanders determined to save their city, drove the plan that has made Portland the functional, thriving city it is today. ◪

Salmon Street Springs, in Waterfront Park, is probably Portland's most accessible fountain. The changing water patterns delight young and old and offer cool entertainment on hot summer days.
Photo: Larry Geddis.

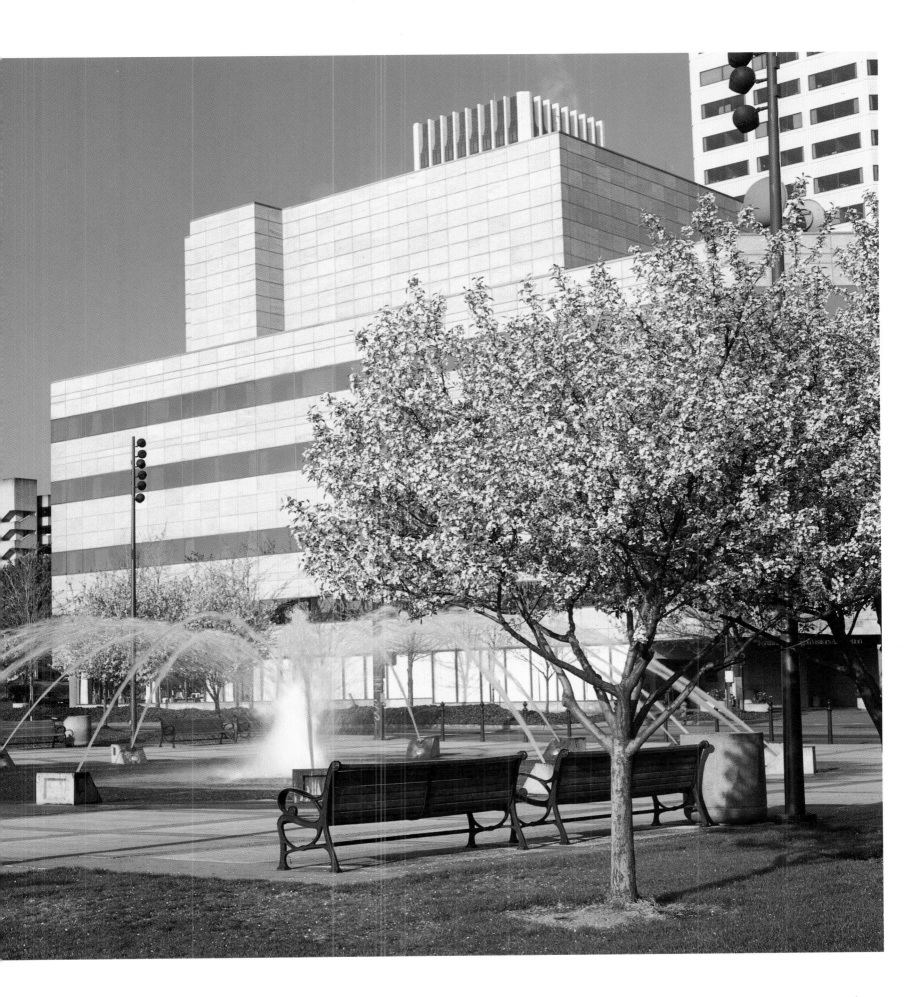

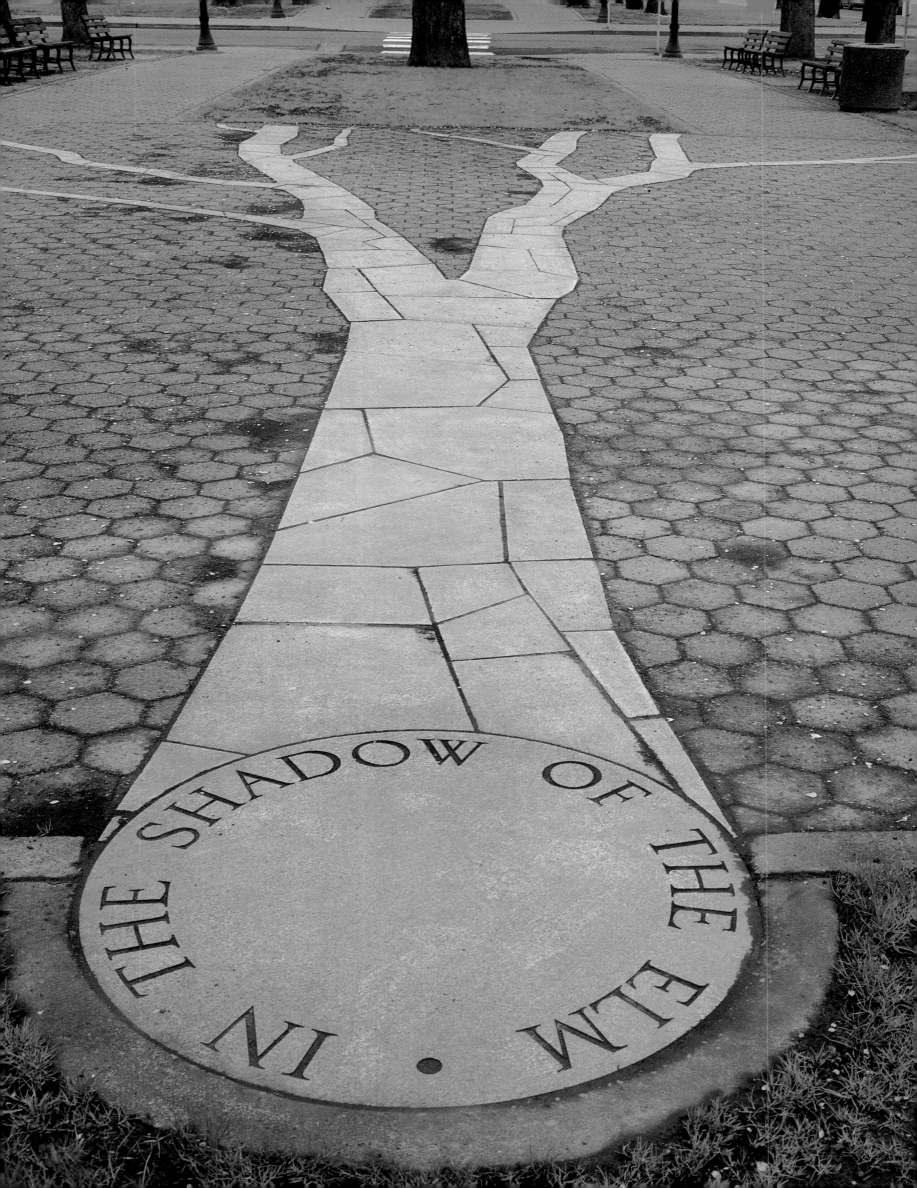

Any sunny day draws crowds to Waterfront Park— to walk along the seawall, or cruise up and down the Willamette River.
Photo: Larry Geddis.

Opposite page
Public art abounds in Portland, like this mosaic on the campus of Portland State University entitled *In the Shadow of the Elm*, by artist Paul Sutinen.
Photo: Larry Geddis.

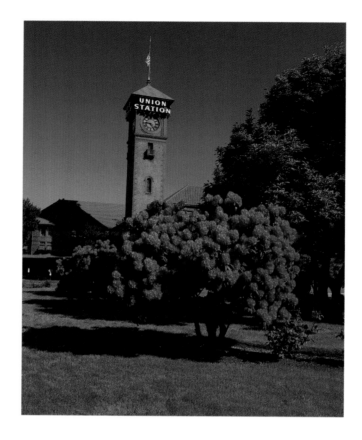

Portland's cool and wet spring weather is just the right climate for growing rhododendrons, like these by historic Union Station.
Photo: Larry Geddis.

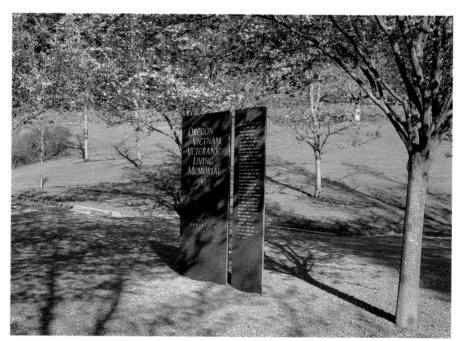

Oregon's Vietnam Veterans Living Memorial, in the West Hills, offers a quiet place to reflect on the losses suffered by the state.
Photo: Larry Geddis.

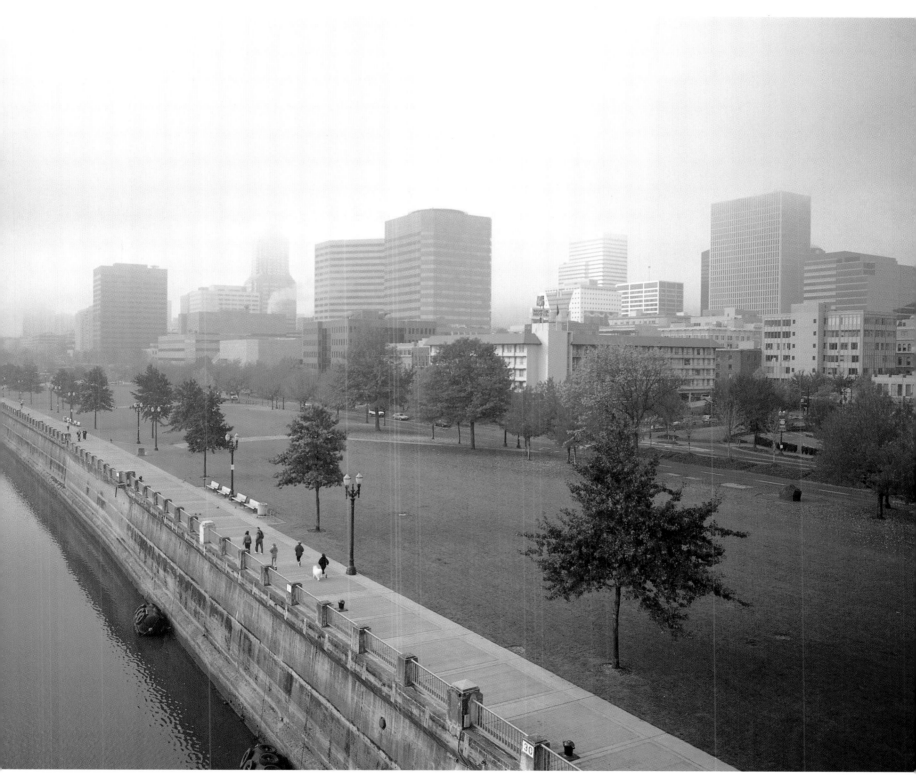

**Misty weather and fall
colors combine to create a
quiet ambience along the
city's waterfront.**
Photo: Steve Terrill.

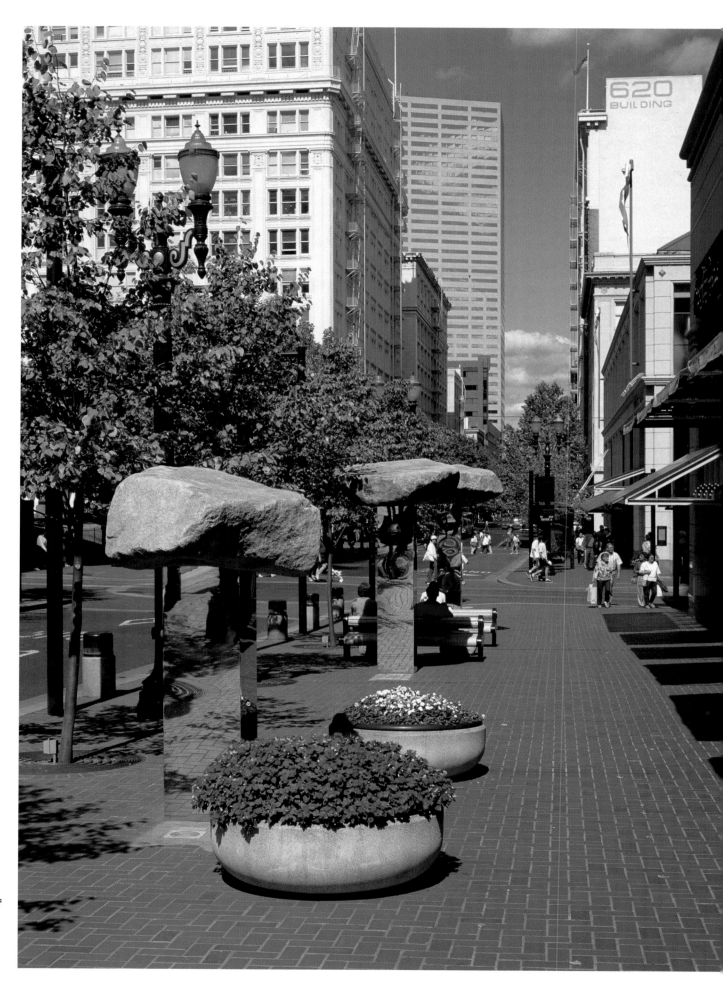

Soaring Stones is the title of this sculpture in downtown Portland—one of many examples of public art for all to enjoy.
Photo: Larry Geddis.

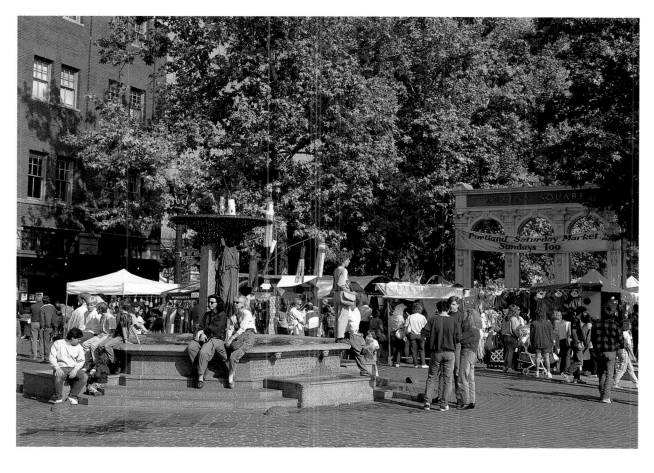

Rain or shine, from May to December, the Saturday Market offers beautiful handcrafted art in a festive outdoor atmosphere.
Photo: Larry Geddis.

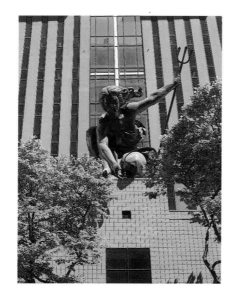

The second largest hammered copper statue in the country, next to the *Statue of Liberty*, *Portlandia* gazes serenely down on the passers-by.
Photo: Larry Geddis.

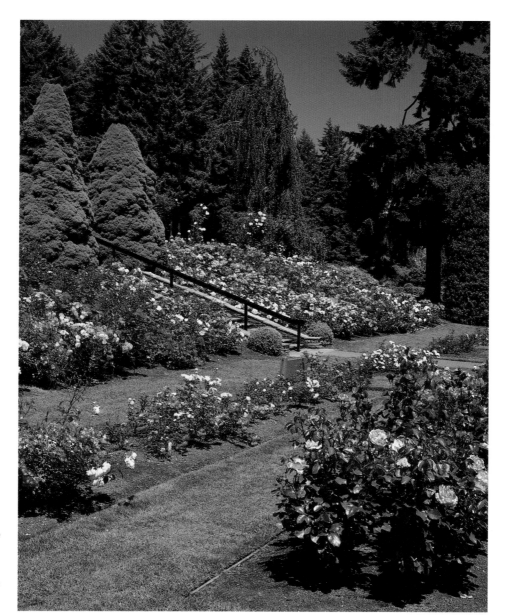

Opposite page
Majestic Mt. Hood is the crowning touch to the view of a beautiful and thriving downtown.
Photo: Larry Geddis.

With more than 7,000 roses, the International Rose Test Garden in Washington Park delights the thousands who come each year to enjoy the beautiful blossoms.
Photo: Larry Geddis.

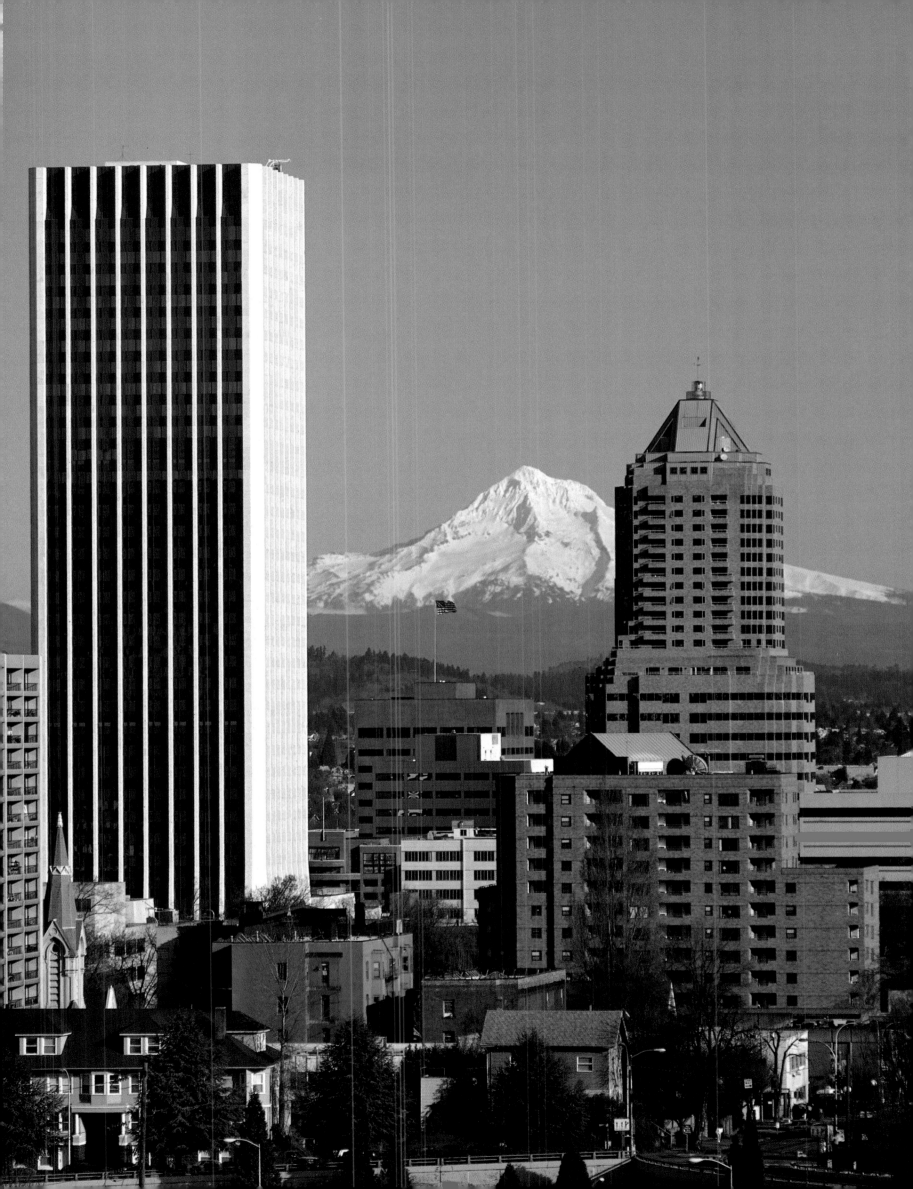

3

What's To Do?

"Portland is not a mass-produced destination."

Joe D'Alessandro, Portland Oregon Visitors Association

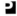

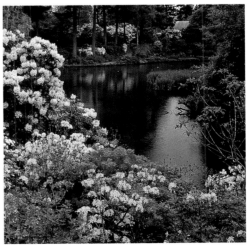

Photos: Larry Geddis

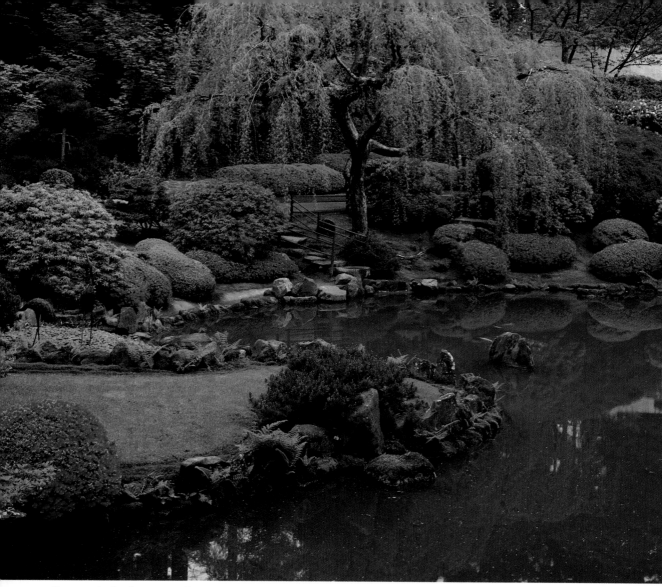

Contemplative beauty and the chance to enjoy the splendors of an authentic Japanese garden await visitors in this 5.5-acre oasis.
Photo: Larry Geddis.

Opposite page
One of the most outstanding views of Oregon's best known mountain, Mt. Hood, comes from Washington Park, high in the West Hills of Portland.
Photo: Steve Terrill.

The Grotto. Visitors to this 62-acre Catholic sanctuary can wander through gardens or wooded areas and admire a marble replica of Michelangelo's famous *Pieta* sculpture.
Photo: Steve Terrill.

Portland is popping up more and more on people's radar screens as a desirable place to visit. That's not so amazing. But what is amazing is that it's not for any one particular reason. It's not that we have a huge theme park, or a strip of casinos, or the beach right here. But what makes Portland a destination city is that what we do have works so well together. And much of it is within a central area that's pedestrian friendly, attractive, and accessible.

Although still best known, perhaps, for its annual Rose Festival, Portland has become a destination city for year-round activities and entertainment. From beautiful, tranquil gardens to Saturday Market's hustle and bustle, you're sure to find something to your liking.

You could spend several days alone just visiting all the gardens Portland has to offer. Throughout the city, there are 10,000 acres of parks ranging from natural, wild settings, to meticulously manicured gardens of perfect blossoms. The largest park is Forest Park, and it is, quite literally, a forest. In fact, at 5,000 acres, it is the largest urban forested municipal park in the nation. Enjoy the 70 miles of hiking and nature trails. Most likely you'll only see people walking their dogs on the paths, but keep an eye out for wildlife; you may be rewarded with a glimpse of coyote, deer or elk. During the late summer there have even been sightings of black bears foraging for berries.

Overlooking Portland is the pride of the city, Washington Park. This scenic urban preserve actually contains three parks,

including the International Rose Test Garden, the Rose Garden Children's Park, and the Japanese Gardens. The International Rose Test Garden, founded in 1917, is usually the first place a Portlander takes any visitor. Not only does the terraced garden provide a stunning view of the city, but it also offers more than 7,000 rose bushes of 519 varieties to enjoy. From old-fashioned fragrant blossoms to tiny miniature roses, and every hue imaginable, the International Rose Test Garden is the oldest continuously operating test garden in the country, and a definite must for any visitor even when the roses aren't at their peak bloom.

Just near the International Rose Test Garden is a special area for disabled children. The Rose Garden's Children's Park offers an interactive play spot for youngsters with all ranges of physical abilities to enjoy.

It's just a short walk from the roses to a seemingly other world. The Japanese Garden was acclaimed in 1988 as the most beautiful and authentic Japanese garden outside of Japan by no less than the Japanese ambassador to the United States himself. It is actually five traditional Japanese gardens spread over five and one-half acres. With a view of Portland below and Mt. Hood to the east, there is no more perfect place to spend some contemplative hours enjoying the quiet beauty.

There are few places in the country as green and lush in early spring as Portland. And the most colorful place in spring is the Crystal Springs Rhododendron Garden in southeast

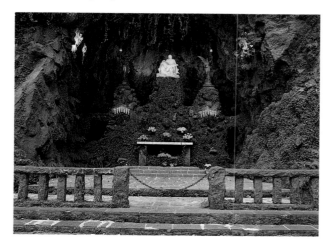

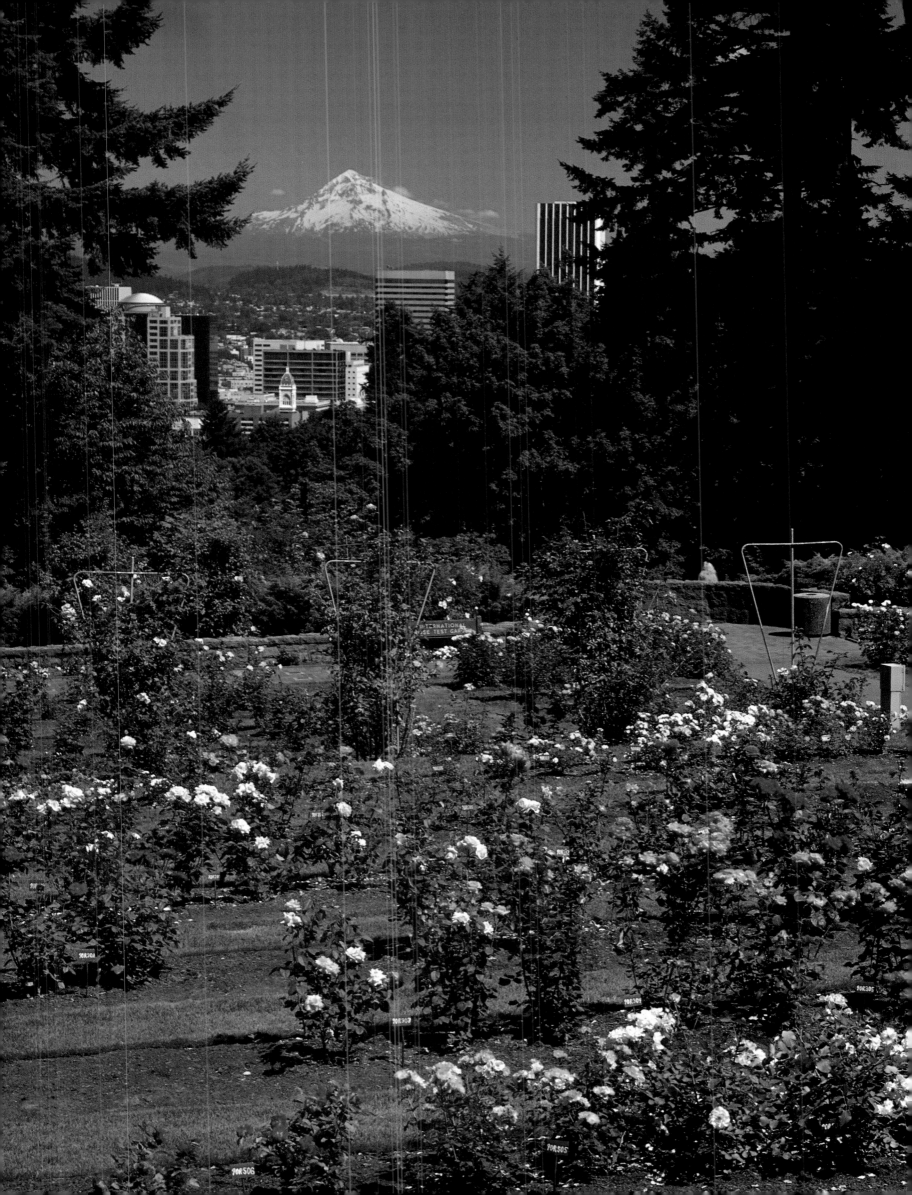

Portland. From March through June, the garden is ablaze with color—more than 2,000 native and hybrid rhododendrons and azaleas. The spring-fed lake, with its families of ducks, geese, and swans, makes this a wonderful park to take the whole family.

Looking for even more variety? Try the 14-acre Leach Botanical Garden, also in southeast Portland. It was started by amateur botanist Lilla Leach and her husband, John, in the early 1930s. Today, it holds more than 1,500 species of wildflowers, shrubs, native irises, and ferns. The Leaches' 1930s home is often rented for weddings.

When people look for a place to visit, they want something different— something that isn't like their own hometown. Portland offers just that type of atmosphere. It's the culture of our community that people enjoy...a culture that's relaxed, yet cosmopolitan; exciting, but not harried; classy, and at the same time handcrafted.

Joe D'Alessandro, president and CEO of the Portland Oregon Visitors Association, believes that's the future of tourism. To offer visitors not just the same stores in the same malls they can find anywhere, but to give them a chance to find the unique character of a city. And Portland has that in abundance. How many cities have so many different and graceful bridges crossing a river? Portland also offers eight major fountains, from the Elk Fountain of the 1900s on SW Main Street, to the Salmon Street Springs, with 185 jets that are programmed to change with the city's pace and mood. And only in Portland will you find "Benson Bubblers." Lumber baron and civic leader Simon Benson donated 20 of these bronze water fountains in order to offer his workers something cold to drink that was nonalcoholic.

Aside from these smaller gems, Portland has many large attractions to offer tourists. The number one gated attraction in the entire state is the Oregon Zoo. The zoo is world-renowned for its Asian elephant breeding program (when Packy was born in 1962, the birth made headlines around the world!), but this 109-year-old, 61-acre zoo also has the largest chimpanzee exhibit in the nation. Visitors can walk through an African rain forest (and experience rainstorms every hour), learn about the flora and fauna indigenous to the Northwest

The Oregon Zoo has more visitors than any other gated attraction in the state.
Photo: Larry Geddis.

in the Cascade exhibit, and see an underwater view of polar bears and penguins in their specially landscaped habitats. Don't forget the 35-minute train ride on the Zoo Railway that winds its way through the dense forests to the neighboring International Rose Test Garden.

While you're in the neighborhood, the Pittock Mansion is worth a visit. Built in 1914, it was the family home of Henry Pittock, the founder of Portland's daily newspaper, the *Oregonian*. It came within a hair's breadth of being torn down until citizens convinced the city to buy and restore it. Now, the 46-acre estate is the best spot to gain a view of Portland, the river, and the surrounding mountains. Regular tours are offered of the 22 antique-filled rooms, or just wander around by yourself and enjoy the splendor.

Portland isn't known for its earthquakes, but that doesn't mean you can't experience one, if you want to. You just have to head over to another popular Portland attraction—Oregon Museum of Science & Industry (OMSI)—and visit the earthquake room to feel one that registers 5.5 on the Richter scale. Situated on the east side of the Willamette River, the OMSI

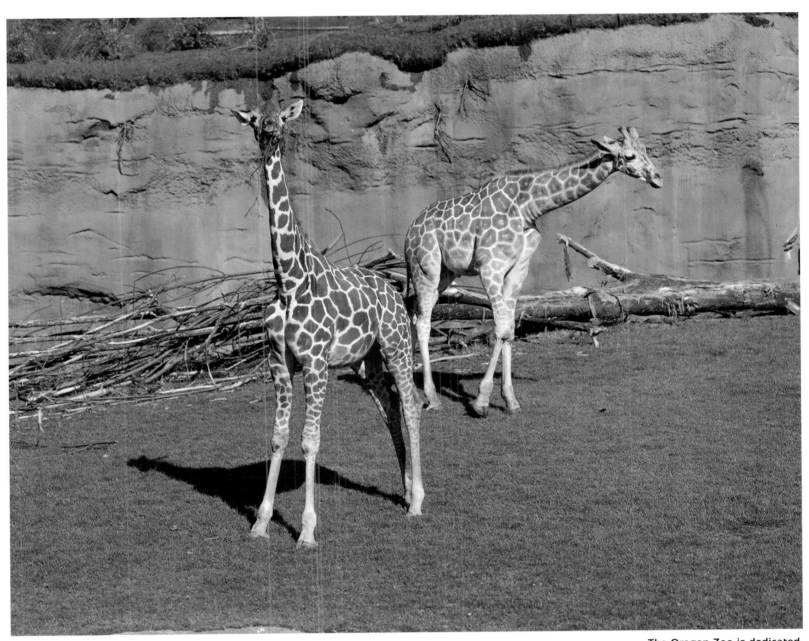

**The Oregon Zoo is dedicated
to the breeding of threatened
and endangered animals.
Best known for its elephant
breeding program, it has also
brought many new giraffes
into the world.**
Photo: Larry Geddis.

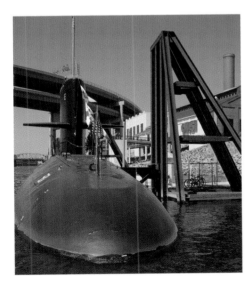

**Climb aboard the USS
Blueback, a Navy submarine
now docked by the Oregon
Museum of Science and
Industry (OMSI).**
Photo: Larry Geddis.

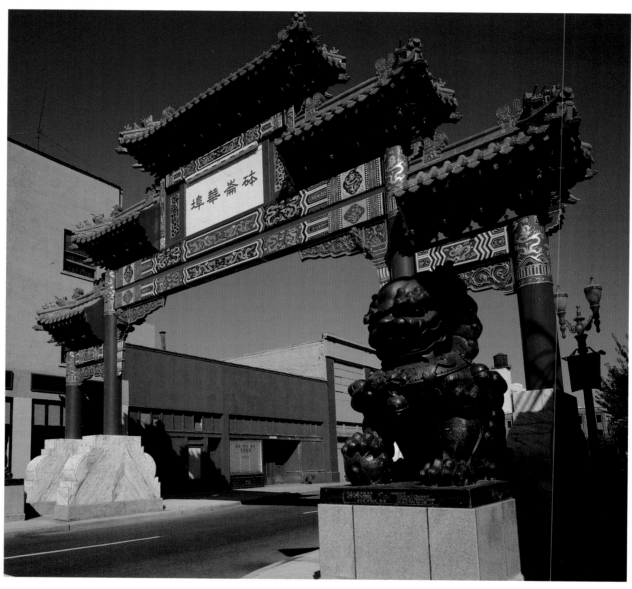

A gift from Portland's Chinese sister city of Kaohsiung, this ceremonial gate heralds the entrance to Portland's Chinatown District.
Photo: Steve Terrill.

is considered one of the finest science centers in the nation. It has hands-on exhibits, nationally acclaimed touring shows, and an intimate view of the stars in the cosmic Murdock Sky Theater. You can also experience the world's most advanced film projection system in the OMNIMAX® Theater, where images surround you on a five-story domed screen.

One of the most visited attractions in Portland is a little off the beaten path, but very worth the trip. The Grotto: National Sanctuary of Our Sorrowful Mother is both a shrine to the mother of Jesus and a beautiful wooded garden. Visitors of all faiths enjoy the serenity of the Grotto, from the marble replica of Michelangelo's famous *Pieta*, to the sweeping panoramic view of the Columbia River Valley, Cascade Mountains, and Mt. St. Helens from high atop the bluff above the garden. There's even an elevator to take you there!

Portland has museums aplenty for every taste, age, and interest. Start at the Portland Art Museum, located in the South Park Blocks. The Museum has an impressive collection

of Northwest Coast Indian art, prehistoric Chinese artifacts, and European and American art, but there's always something new and exciting to see. In fact, Portland was recently the only West Coast stop for the Imperial Tombs of China exhibit, which brought art admirers out in record numbers.

Advertising surrounds us every day, but only in Portland will you find a museum dedicated to it. The American Advertising Museum has more than 200,000 original print ads, along with a collection of vintage neon signs. Let yourself be taken back in time by watching some of America's favorite television commercials. Don't worry; no one will mind if you sing along with the jingles!

Strictly for the young, or, at least, the young-at-heart, the Children's Museum offers hands-on experience for the more than 90,000 visitors who arrive yearly. Located just south of downtown, exhibits are geared toward helping children ages one to ten role play, develop motor skills, and read in a way that enables them to learn while having fun.

Portland has a strong history as a port city, so it's only natural that there's a museum dedicated to that part of its past. The Oregon Maritime Center and Museum preserves the history of ship life with models, photos, and navigational instruments. Then, walk across Tom McCall Waterfront Park and visit the museum's largest artifact: the steam-powered Sternwheeler *Portland*. You can take excursions up the Willamette on both the *Portland* and other tour boats.

No museum list would be complete without the World Forestry Center. It features permanent and changing exhibits on the forests of the Pacific Northwest and around the globe. Experience the world's rain forests, travel back 200 million years in time with the petrified wood exhibit, Forests of Stone, and learn what makes Oregon's own old-growth forests so special.

Portland has many traditions. One of them is the Portland Saturday Market. This is the largest continuously operating open-air market for handcrafted goods in the United States, open from March through Christmas. Located in Old Town, just a short hop on a MAX light rail train in Fareless Square, this market, which starts under the Burnside Bridge and spills out toward the New Market Theater, offers more than 250 craft booths with everything from hand-thrown pottery to hand-knit sweaters. In fact, everything for sale is handcrafted. Don't eat lunch first or you'll miss out on the opportunity to sample some stir-fry veggies over noodles, giant burritos, or an elephant ear—with your choice of sugar and cinnamon, or strawberry jam! And bring your camera so you can take home memories of the musicians, jugglers, clowns, and other entertainers who regularly appear. By the way, don't let the name fool you. The fun continues on Sundays, too.

Not far from the market is another shining example of why, as the state tourism office is proud to say, "things look different here." The 24-hour Church of Elvis was established as a coin-operated shrine to the King that also offers tongue-in-cheek marriage counseling, weddings, confessions, catechism, and sermons. An "art experience" at its best, the Church of Elvis could make a convert out of you!

Chinatown was a well-established section of Portland, but really came into its own when Portland's sister city of Kaohsiung and the People's Republic of China presented the city with an elaborate ceremonial gate to mark the entrance to this neighborhood. Added to the special Oriental lampposts and traditional red facades, this is a fun and colorful section of town through which to stroll. Some of the best Chinese restaurants are in this section of town, but if you enjoy cooking your own, no problem. Grocery stores specializing in every exotic ingredient can also be found.

With all these things to see and do and sample, it's no wonder tourism is a $1.7-billion enterprise in the city that

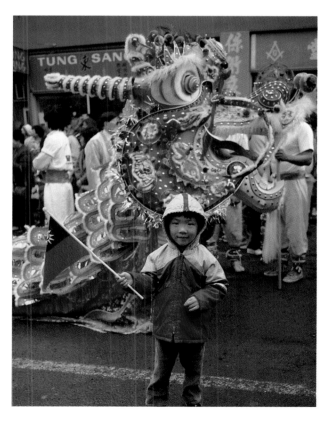

Portland's Chinese community brings culture and entertainment to the city with events such as the traditional Chinese Dragon Dance.
Photo: Steve Terrill.

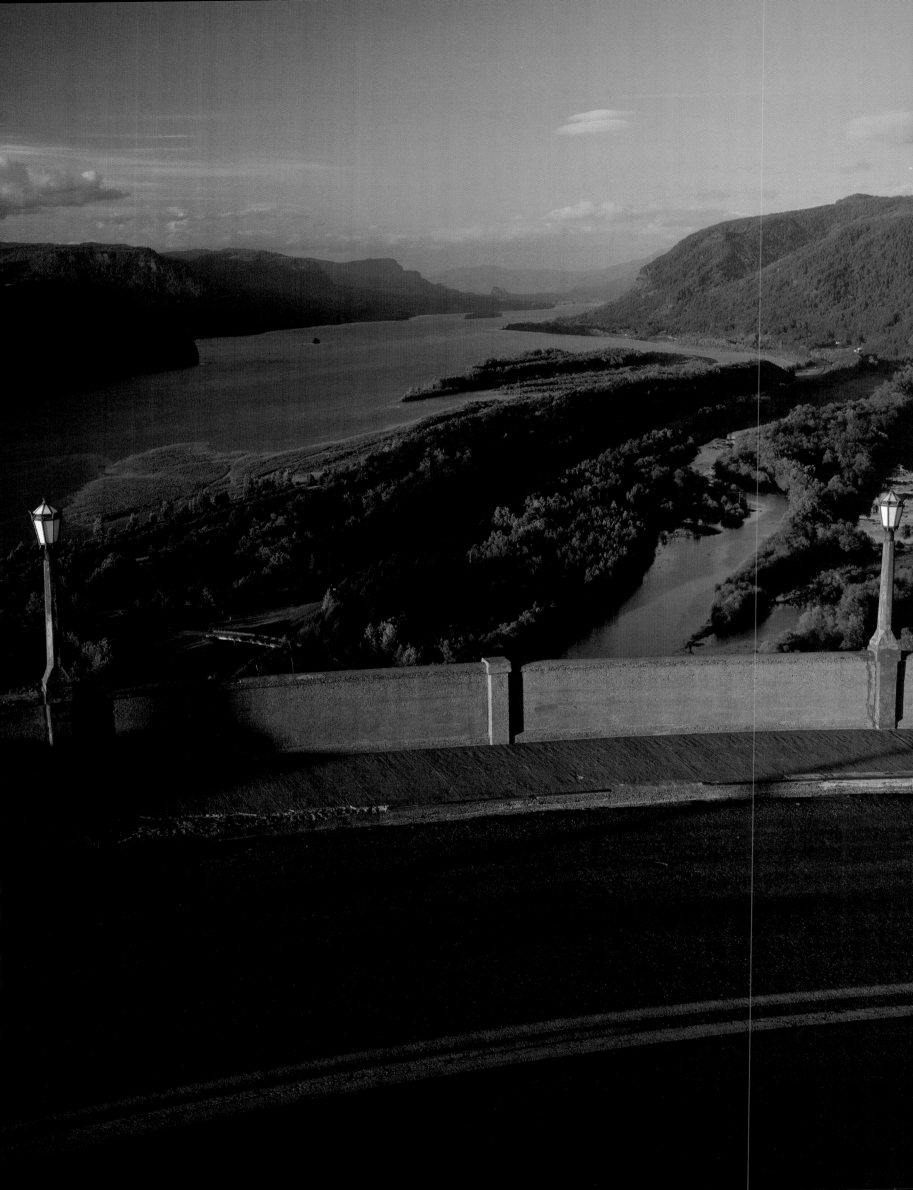

generates a payroll of $387 million. For many, their first visit to Portland is business-related, and the Oregon Convention Center has certainly played a part in bringing people to the Rose City.

The Convention Center, with its unusual twin-towers design, sits on the east side of the Willamette River, looking back toward downtown. This state-of-the-art facility has surpassed all attendance, job creation, annual sales, and annual tax contributions projections and will only continue to do so. Because it's located right by the light rail train tracks, attendees can easily hop a train from their hotel to meetings, then catch a ride back downtown for shopping or dining. Visitors rave about the unique character of the Convention Center and how functional it is. By all accounts, it has been a phenomenal success for helping to showcase the city.

With all these great attractions, it's a wonder we even need to market the city to trade show and convention planners. Joe D'Alessandro says Portland really sells itself, but the key is to get people to come here in the first place! We still have to compete with Seattle and San Francisco and the image that they have more to offer. But as the number of tourists continues to rise, it's clear that the word is getting out. ◢

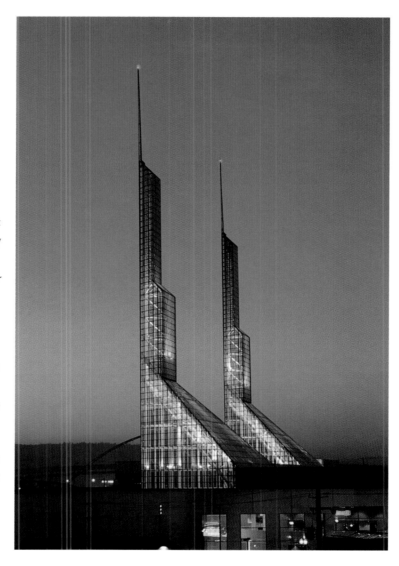

The Oregon Convention Center, with its distinctive twin peaks, attracts more than half-a-million conventioneers annually, adding millions to Oregon's tourism business.
Photo: Steve Terrill.

Opposite page
The Columbia Scenic Gorge is worth a visit to admire the 60-mile scenic stretch between Portland and Biggs. Along the Historic Columbia River Highway, you'll see Florentine viaducts, cut by Italian stonecutters.
Photo: Steve Terrill.

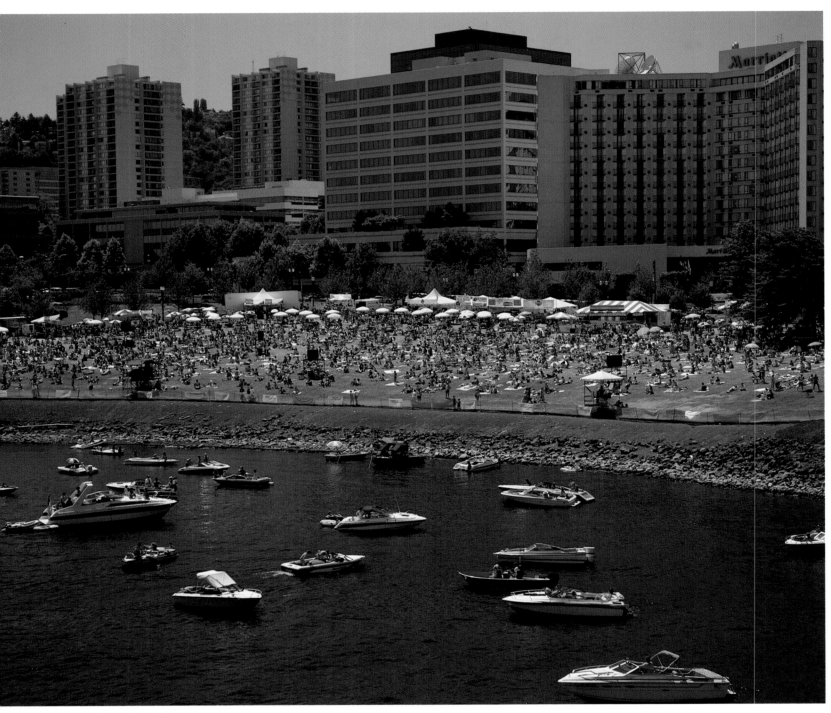

Portland's Waterfront Blues Festival, held each July, is the second largest such festival in the U.S. and attracts as many as 100,000 blues fans to hear both local and international blues artists.
Photo: Steve Terrill.

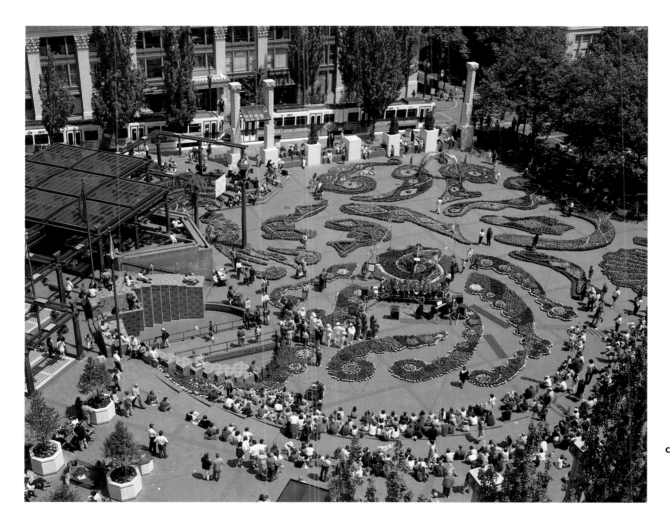

**The Festival of Flowers
covers the usual brick floor
of Pioneer Courthouse
Square with the beauty
of spring.**
Photo: Larry Geddis.

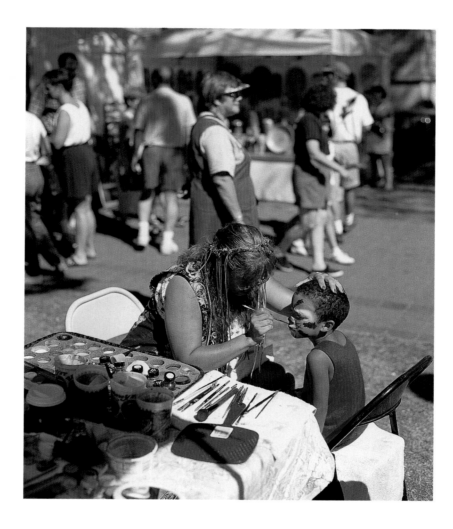

Art to go! A child gets his face painted at Art in the Pearl, an art festival held in the Pearl District.
Photo: Larry Geddis.

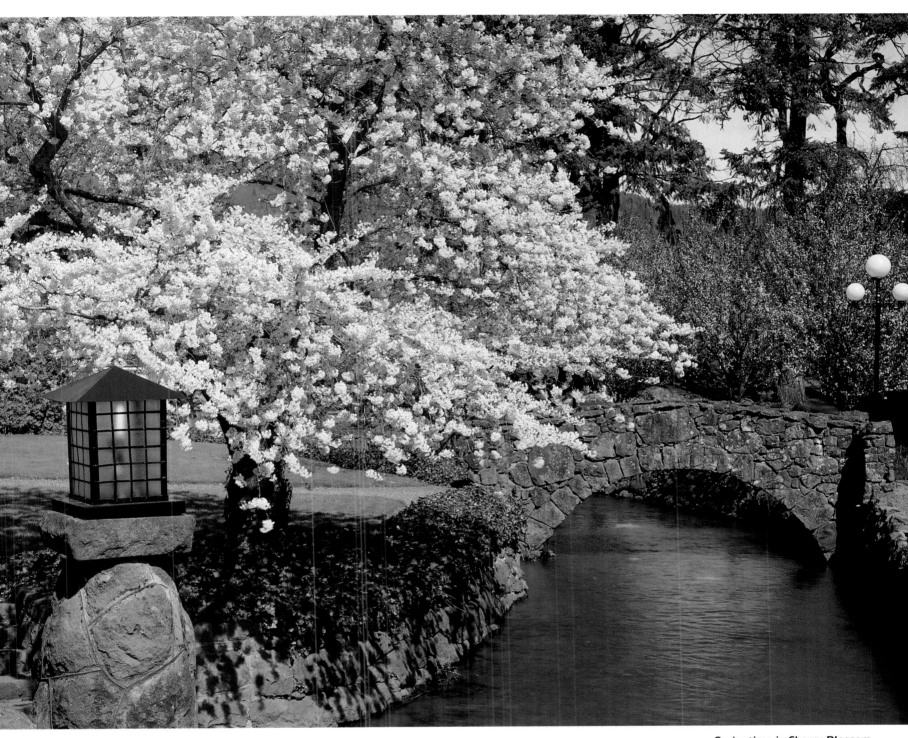

Springtime is Cherry Blossom time in the Columbia River Scenic Gorge. These bloom near Phelps Creek, not far from the historic Columbia Gorge Hotel.
Photo: Steve Terrill.

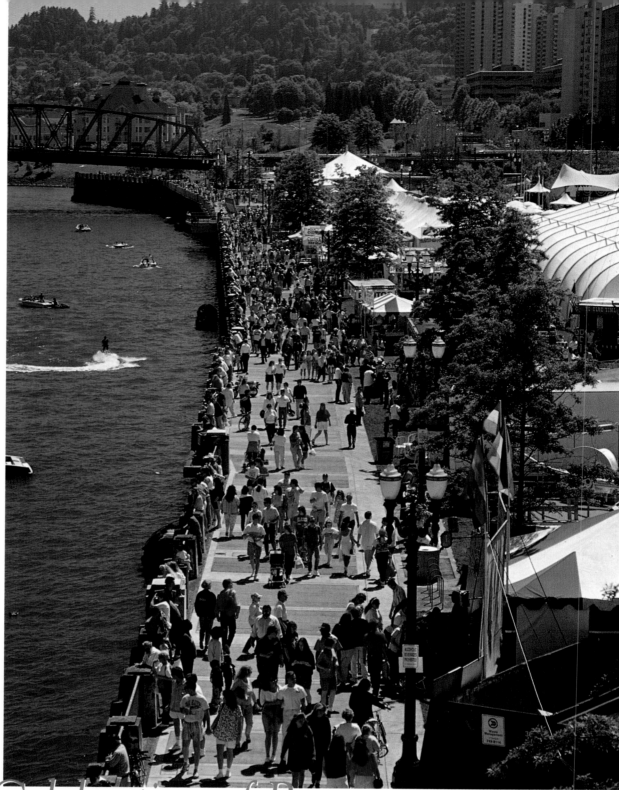

Waterfront Park, once a freeway, was reclaimed as a park in the 1970s and now hosts major events such as the **Rose Festival Fun Center.** Photo: Steve Terrill.

The Celebration of Roses

There is hardly a month that passes without some festival taking place in the Portland area. From *Cinco de Mayo* to the Zoolights festival, it's clear Portlanders love any excuse to party.

The largest celebration, however, not only brings together the entire city, but also merits national attention every year—the Portland Rose Festival. This month-long celebration includes so many activities, there is literally something going on every daylight hour. It's the Portlanders' chance to show off their city and take pride in everything that makes her special.

It all began in 1889 as a simple rose show by the Portland Rose Society. In 1904, the Society began holding a fiesta, and the first rose parade was held June 10th. The actual Festival began in 1907. Bit by bit, it grew until there are now some 80 events. You can see hot-air balloon races and an open-air

juried art show. At the Willamette River seawall, the Rose Festival Fleet gives you an opportunity to tour any one of several visiting cutters, destroyers, frigates, and patrol boats from American and Canadian fleets. Or catch the Dragon Boat Races, featuring authentic dragon boats from Portland's sister city in Taiwan. And there's plenty of music to enjoy, with band competitions and concerts. The rose show is still part of the Festival, too, but it's no longer just a simple event. It is one of the largest and longest running rose shows in the country, with more than 75 silver trophies awarded to the best gardeners in town.

During Rose Festival, Portland is no longer Portland. It becomes the "Realm of Rosaria," complete with its own queen and court of princesses. Fourteen high schools in the

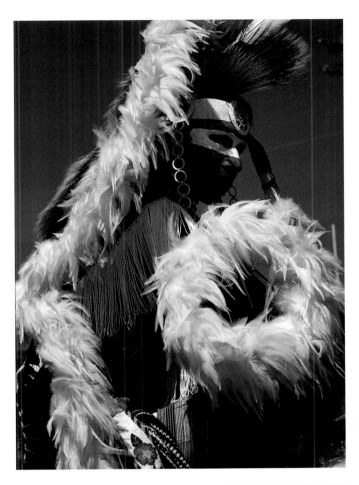

An American Indian woman in traditional dress dances for the Delta Park Pow-Wow, an annual event during the Rose Festival.
Photo: Steve Terrill.

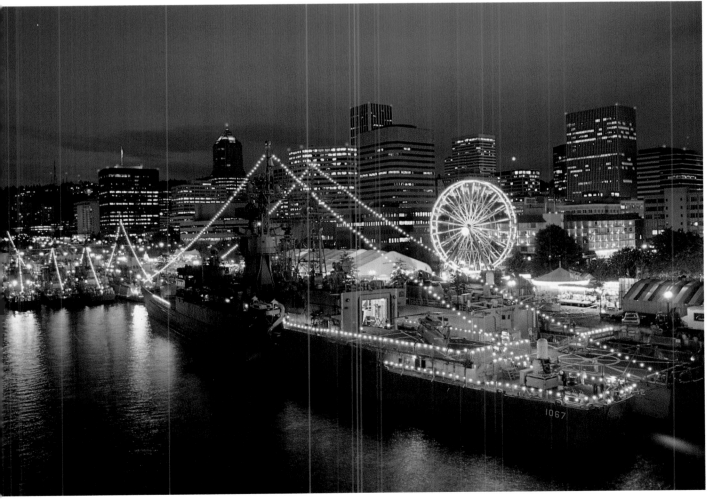

The fleet's in! Portland is a popular port for Navy and Coast Guard vessels during the Rose Festival. Many ships offer tours to the public.
Photo: Steve Terrill.

city nominate a princess from each senior class, one of whom will be chosen as the Rose Festival Queen. Opening night festivities include the crowning of the Queen along with a fireworks display.

The Queen represents Portland for an entire year, and one of her duties is to "knight" city notables. The Royal Rosarians, instantly identifiable by their white suits, capes, and straw hats, assist the Queen as she ceremoniously proclaims nominees "Knight" or "Dame" of the Realm.

What would a festival be without a parade? The Rose Festival has three of them: the Junior Parade, the Starlight Parade, and the Grand Floral Parade. The Junior Parade brings more than 10,000 youngsters out to dance, march, twirl, and pedal through Portland's Hollywood District. The Starlight Parade is the illuminated nighttime delight that brings out more than 250,000 people to clap and cheer the bands, floats, and other entries.

But the grandest of them all is the Grand Floral Parade, a 4.2-mile spectacular event with up to 25 flower-bedecked floats, marching bands from around the world, and equestrian units. Every float must be decorated using only natural materials. If you look closely, you'll see a giant bobcat whose fur is made up of different colored grasses, and whose red nose is really thousands of tiny dyed seeds! Of course, on every float you'll also see an abundance of beautiful roses. This parade is the crowning event of the Portland Rose Festival, so it's no wonder some people stake out their territory along the parade route with lawn chairs and blankets several days in advance. More than a half-million people will watch the parade go by, and curbside seating is at a premium; so don't be late! ◢

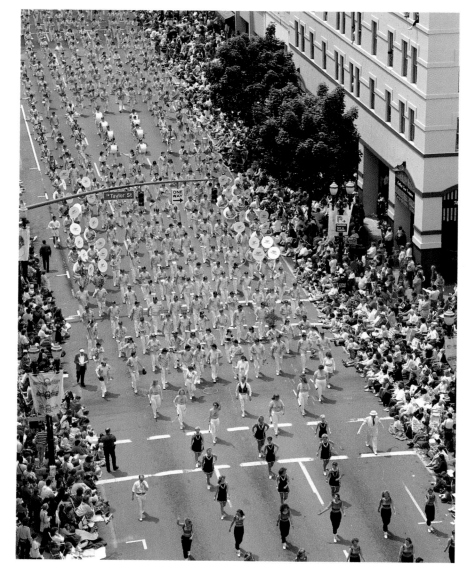

Bands come from across the country and even across the world to march and play in the highlight of the Rose Festival, the Grand Floral Parade.
Photo: Larry Geddis.

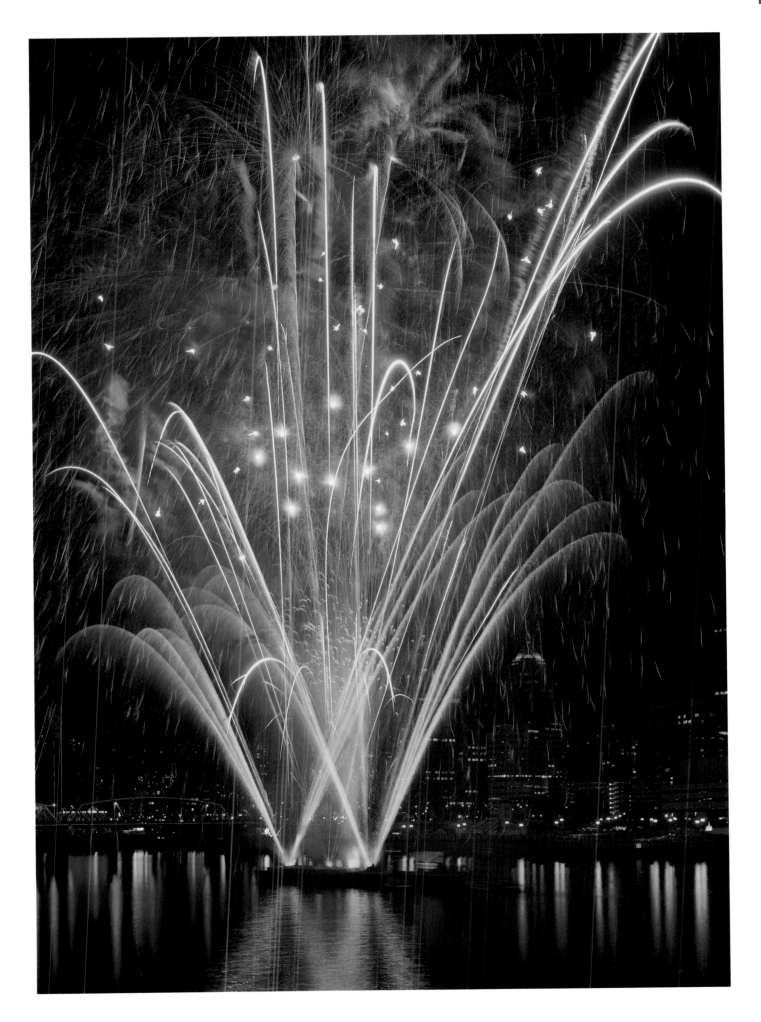

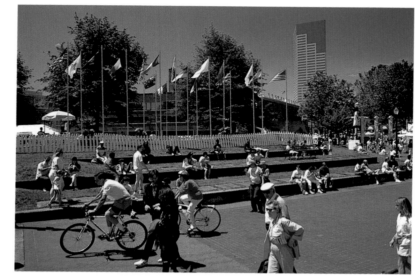

The Rose Festival Fun Center brings carnival rides, games, and food to Portland's Tom McCall Waterfront Park each June.
Photo: Steve Terrill.

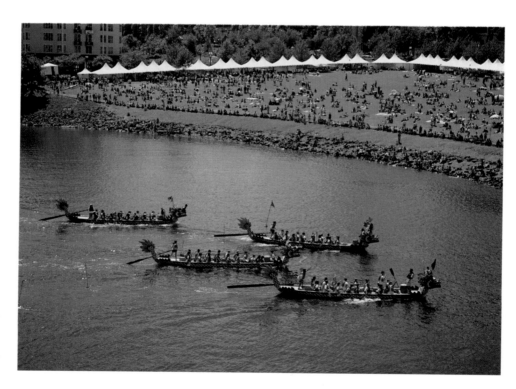

Modern muscle power and ancient Chinese tradition combine at the annual Rose Festival Dragon Boat Races on the Willamette River, a favorite Rose Festival event.
Photo: Larry Geddis.

The Rose Festival is the preeminent event in Portland—a time when the whole city becomes involved in the activities.
Photo: Steve Terrill.

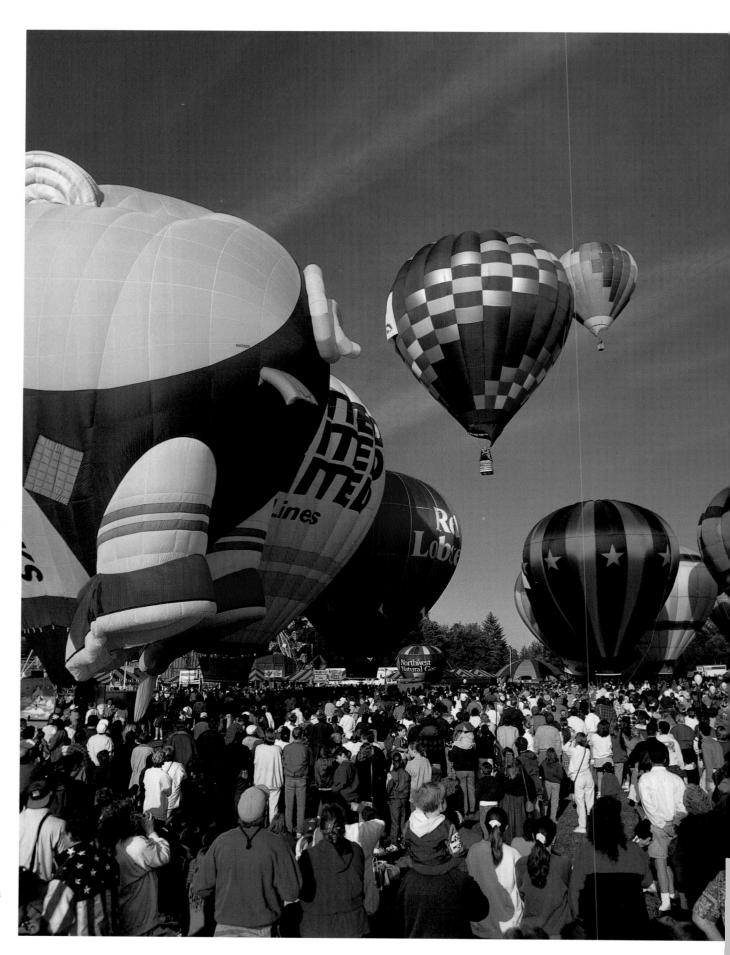

The hot-air balloon races
are one of the newer events
adding to the fun of
the Rose Festival.
Photo: Larry Geddis.

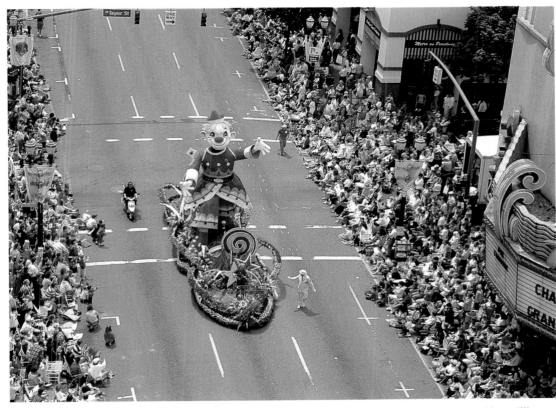

More than half-a-million people line the streets of Portland for the Rose Festival's Grand Floral Parade, which features floats covered with gorgeous fresh blossoms.
Photo: Larry Geddis.

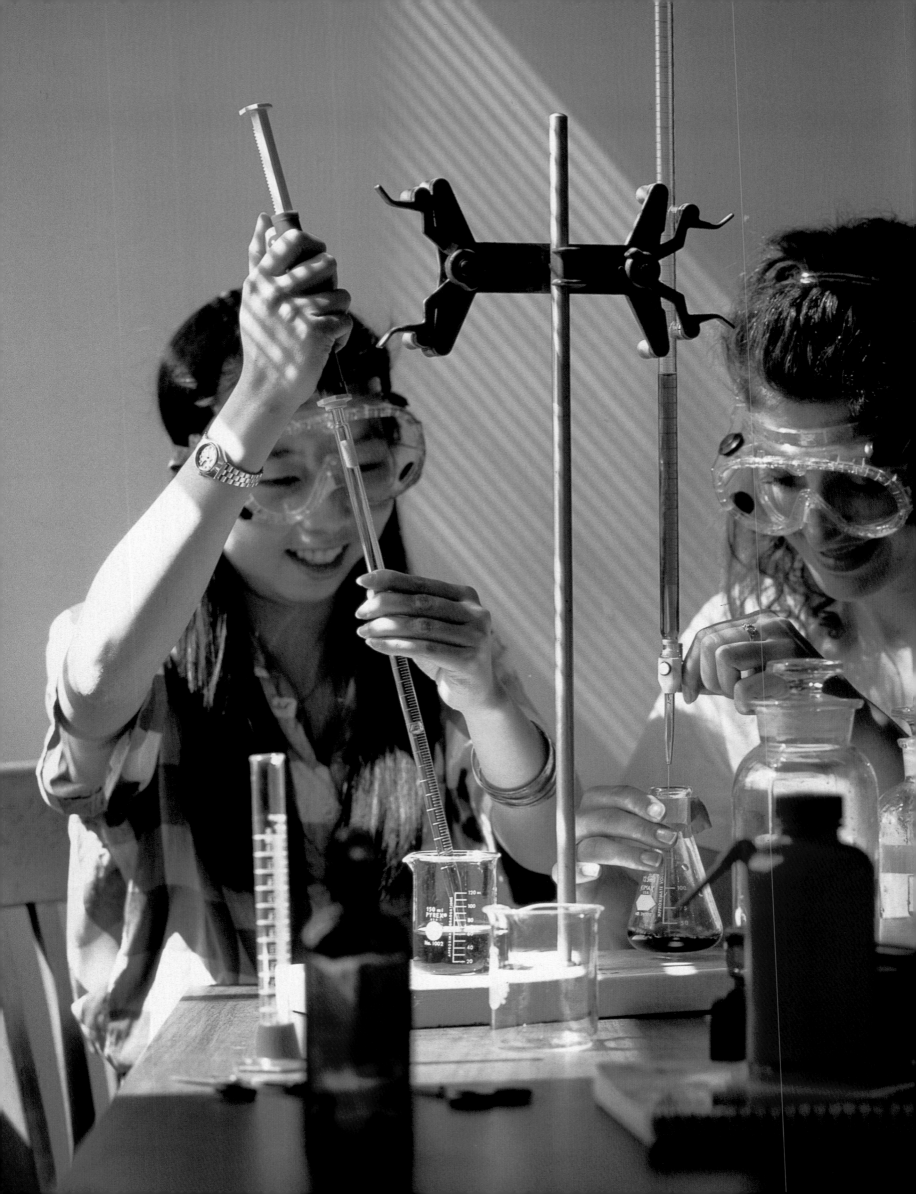

4

Teaching for the Future

"All children achieve—
no exceptions—no excuses."

Motto of Portland Public Schools

◗

Photos: © C. Bruce Forster/Viewfinders

Portland Public Schools (PPS) has been called "the last big-city school district in the country" and it's a title well-deserved. Unlike many school districts in similar sized cities, Portland is primarily a middle-class district, yet diverse. Its enrollment is 68 percent white, 15 percent African-American, 8 percent Asian, nearly 6 percent Hispanic, and 2 percent Native American. The largest school district in the Pacific Northwest, PPS teaches 58,000 students in 622 elementary schools, 17 middle schools, and 10 high schools or alternative programs with an annual budget of about $316 million.

Most parents in Portland don't feel a need to send their children to private schools, because they know they will get a good education in PPS. Having children succeed, says Lew Frederick, PPS spokesman, "is not just a slogan; it's a key element of the district's success."

The test scores bear this out. Seventeen of the top twenty schools in the state were in the Portland district. Four of those schools were in low-income neighborhoods.

Portland high school students rank number one in the nation in both SATs and ACTs, and are 32 points above the national average. Even in math test scores, which across the country have been slipping, PPS is 20 points above the national average—the only city in the nation to achieve that merit.

Look beyond the impressive test scores, however, and you'll see a school district that is willing to experiment, forges partnerships with business, and seeks to "raise the bar" even more to make sure its students succeed.

Gone are the days when students could get a family wage job in Oregon with only a high school diploma. Today's students need a complex set of skills, including computer literacy and work experience, to succeed. To that end, all Portland Public Schools are on the Internet. Oregon is a pioneer in the area of "school-to-work" programs, with some 5,000 of the state's high school juniors and seniors gaining valuable work experience. Roosevelt High, for example, requires all students to take part in its work study program. Students are linked first to an academic area and then to a specific business in which to shadow and eventually intern. In this way, they discover practical applications for their classes, such as how algebra is applied in veterinary science.

The business community realizes that if it wants an educated workforce in the future, it must step up to the plate and help Portland's schools. That used to mean donating some books or paint to a school. Today, it means much more. Businesses are looking at what they can do to fill in the funding gaps. Paragon Cable gave the Portland Public Schools a $250,000 grant to create a distance learning network at three high schools. Athletic footwear and clothing company NIKE has given nearly a half-million dollars in direct cash and in-kind contributions.

Wacker Siltronic Corporation has built a million-dollar "clean room" in the basement of Benson High to train students to work on electronic circuitry and crystals. Still other companies, like Hanna-Andersson clothing company, allow

These children are dressed for a Thanksgiving pageant, but it's Portland parents who are grateful for a strong urban school system.
Photo: Wendy Reif.

**Plenty of hands-on activities
for children make learning fun.**
Photo: © C. Bruce Forster/
Viewfinders.

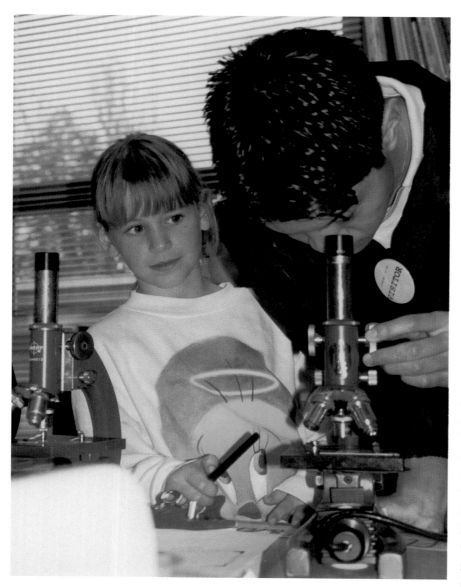

Portland schools have high academic standards in all areas, including science.
Photo: Wendy Reif.

Not all learning takes place in the classroom!
Photo: Wendy Reif.

their employees to contribute directly to a given school.

In Portland, folks don't just sit back and wait for the politicians to come up with the answers. The Portland Schools Foundation, whose motto is Schools Matter, seeks to raise awareness of the importance of quality education, and find funding alternatives in the face of cutbacks. They have formed foundations for each of Portland's schools, allowing anyone to contribute directly to a single school. But one-third of each individual contribution must go into a general fund for all schools. In this way, the foundation helps to achieve equity among different socioeconomic neighborhoods.

Portland Public Schools also offers students the chance to attend schools outside their own neighborhoods and work on specific talents through an incredibly diverse magnet schools program. There is an International Studies/International Baccalaureate program at Lincoln High School. Students can attend the performing and visual arts program or the biotech magnet program at Jefferson High. Cleveland High offers a magnet program in business management and marketing, and Benson High has a magnet for professional/technical studies.

There's been much talk lately about charter schools, where parents, teachers, and administrators of a school get their own charter to design a program of education that best meets the needs of the students. Such a program is virtually in place in Portland. Some schools have opted for year-round classes; others have decided on a language immersion program; others have focused on building a family cooperative school where parents spend a few hours a week in the classroom. At one school all the children learn American Sign Language.

Despite all these choices and high test scores, it still wasn't good enough for PPS. New Certificate for Initial Mastery (CIM) standards for 10th graders were implemented in 1998. Students are being tested to determine if they meet these new higher standards in English language arts, mathematics, science, social studies, second language, and the arts.

Portland is planning to go even further than CIM. Educators have opted for PASS—Proficiency-based Admission Standards System. PASS evolved from the collaboration between PPS and the Higher Education system to design a program in high school that makes a successful college student. The standard is no longer just GPA, and it goes beyond SAT scores. It's what students know and what they can prove they can do. For example, in the past, two years of German with passing grades would get you into college. After the year 2002, students will not only have to take the classes and pass, but also must prove they can actually "sprechen Sie Deutsch." The same goes for science, math, history, and the language arts.

Of course, not all students are geared towards the typical academic pace of Portland schools. There are alternatives, primarily the Metropolitan Learning Center. An alternative school K-12, it stresses a noncompetitive atmosphere with no letter grades. There's more flexibility in the schedule, and the program offers students the chance to do some off-campus learning. So a student might spend some of the day at MLC and part of it at another high school, or community college.

There's also the Vocational College High School. This is for students who have not been successful in traditional high school programs. Here learning is self-paced, ungraded, and tailored to a student's own needs. One can earn a GED, regular high school diploma, or certificates of competency in certain vocations, including child care, food service, graphic design, marketing, and office systems.

Oregon does not have a long tradition of private education, with the exception of parochial or church-affiliated schools. There are 6 private high schools and 24 private grade schools. Parents can choose from Montessori-type schools, to those that immerse a child in a language, as do the French American or German American schools.

Oregon does not accredit private schools. They merely have to be registered. Of course, many private schools have accreditation through the National Association of Independent Schools. In Portland, parents have a wide range from which to choose. Schools range from being very urban with small outdoor areas, like the 800-student Central Catholic High on SE Stark, to the large campus of Catlin Gabel in the West Hills, a school known for its vibrant performing arts and writing programs. Another large private school is Oregon Episcopal School, which serves more than 700 students in prekindergarten through grade 12 with a strong college preparatory program. Usually, smaller class size is

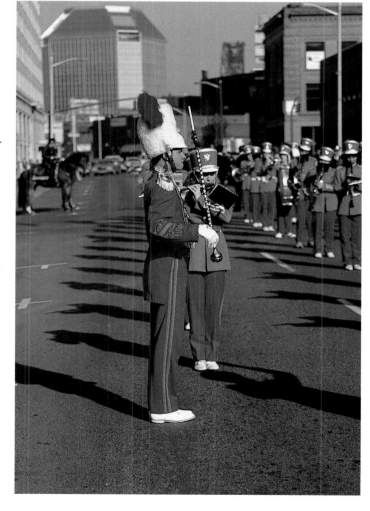

Portland schools offer outlets for students with musical abilities, like these members of the Madison High School Band.
Photo: Steve Terrill.

the big draw for private education, with an average of 14 to 22 students per class.

Home schooling is also popular for a small segment of the population. Oregon has some of the more liberal laws around regarding home schooling, which makes it easy for parents to teach their own children. More children are being home schooled every year in the state. Statistics are difficult to verify, but in Multnomah County, some 1,300 children are registered as being home schooled.

Opportunities for students abound after school as well. The Saturday Academy is a nonprofit educational enrichment program for students in grades 4 through 12. It's open to all students who are interested, with tuition fees ranging from $35 to $235. Students may take classes in everything from photography and musical/math to biotechnology/genetics and microcomputer programming. For motivated students, there are plenty of ways to expand both skills and knowledge.

HIGHER EDUCATION

Portland has plenty to offer in the way of higher education. There's Portland State University, located right in the heart of the city since 1952, and serving nearly 15,000 students. PSU is the state's major urban grant university, and its motto, *Doctrina urbi serviat* (Let knowledge serve the city), is its guide in designing programs to bring the university into the 21st century. PSU sees itself as an integral part of the city's growth and development. Plans are underway for a 134,000-square-foot Urban Center and University Plaza, with a public square to connect the University to downtown Portland.

PSU has strong liberal arts and sciences programs in addition to engineering, computer science, and international business, and is known for its high-tech research programs. PSU offers 61 bachelor's and 56 master's degrees, as well as doctoral degrees in seven areas: education, electrical and computer engineering, environmental sciences and resources, public administration and policy, social work and social research, systems science and urban studies, and planning.

The University of Portland, established in 1901, is the state's only private Catholic university. It's ranked by *US News & World Report* as first among all Catholic universities in the west for academics and price. It offers some 1,500 courses, 55 majors, and 17 graduate degrees in its college of arts and sciences, plus the schools of business administration, education, engineering, and nursing.

Located on a bluff overlooking the Willamette River and Portland, U of P strives to provide a balanced liberal arts education by placing teaching, faith, and service at the forefront of its mission.

Portland Community College—with a campus in southwest Portland and branches in north Portland and Washington County—is the largest institute of higher education in the state, serving more than 898,000 residents in a five-county area in addition to its three main campuses. PCC offers lower division college transfer courses, two-year associate degrees, and professional/technical career training.

In addition, more than 54,000 people annually continue their education at 200 locations. PCC's Steps to Success program helped 2,219 welfare recipients get off assistance and move into the workplace in 1996, and its Student Success Nursing program gives minorities the skills to master the tough nursing curriculum.

Another community college in the metro area is Mt. Hood Community College in Gresham. Students can earn an associate of applied science degree in professional and technical programs, one-year certificates, associate of arts/Oregon transfer degree, or an associate degree in general studies. Students planning to continue on with a four-year baccalaureate degree can often put many of their requirements behind them first at MHCC.

Reed College, founded in 1909, is known for its liberal philosophy and rigorous academic standards—it is often referred to as a "grind school." Reed has produced 31 Rhodes scholars, a record which only one other school in the nation shares. Reed is ranked second in America for the percentage of students who go on to earn doctorates in the social sciences,

One of the most academically challenging private colleges in the state, Reed College is known for producing many Rhodes Scholars.
Photo: Steve Terrill.

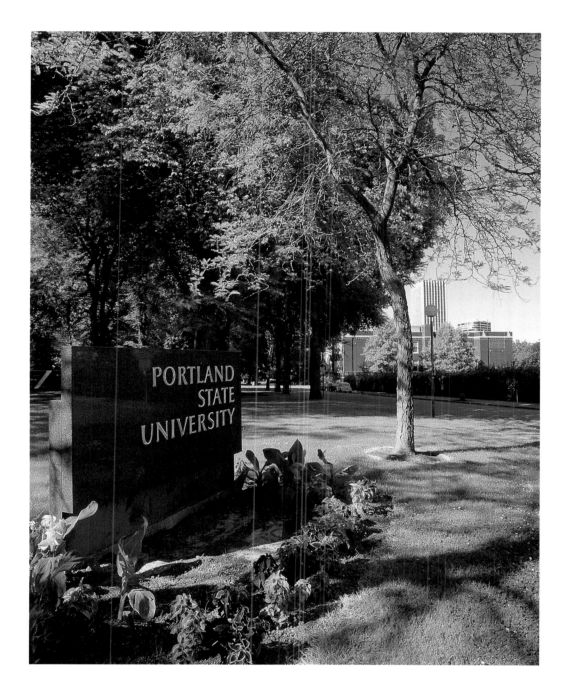

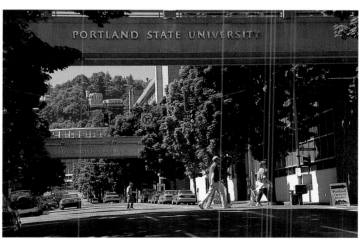

Left and above
Nearly 15,000 students attend Portland State. The University offers 61 bachelor's and 56 master's degrees in the humanities, sciences, social sciences, and professions. PSU also offers doctoral degrees in 8 areas.
Photos: Steve Terrill.

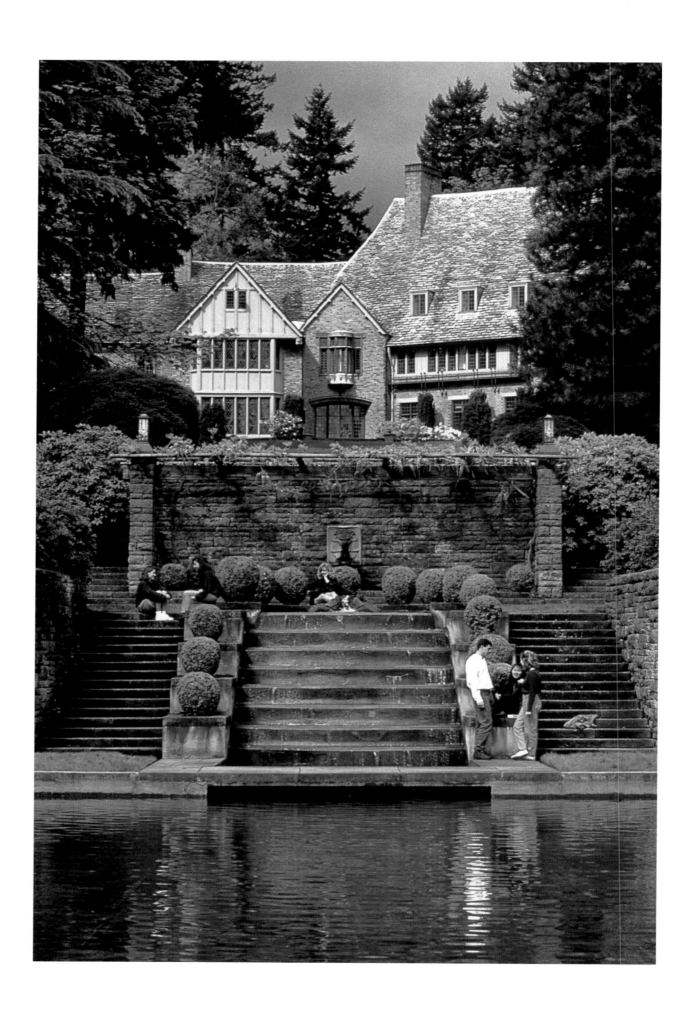

third for the percentage of future Ph.D.s in the sciences and humanities.

All of the college's 1,130 students are considered honor students and must write a senior thesis in their major field. The annual parade in which the seniors march across campus with their theses, burn their notes, and break open the champagne is almost a larger celebration than graduation! With one faculty member for every 11 Reed students, the college offers unparalleled access to teachers and a level of interaction rarely seen at the undergraduate level.

Reed has five academic divisions: arts; history and social sciences; literature and languages; mathematics and natural sciences; philosophy, religion, and psychology. Reed offers bachelor's degrees in 22 department majors and 12 interdisciplinary areas.

Concordia University, founded in 1905, is a private, four-year college in northeast Portland and is affiliated with the Lutheran Church. With an enrollment of 1,000, Concordia has a close-knit community of students and maintains an enviable 18-to-1 student/faculty ratio. Professors go beyond the classroom to help students find practical applications for their majors. Concordia offers bachelor's degrees in business administration, education, health and social sciences, liberal arts, theological studies, and environmental remediation. Master's degrees include master of arts in teaching, master of education in curriculum, and instruction or administration. Concordia is known for its quality programs.

Lewis and Clark College was founded in 1867 as Albany Collegiate Institute. In 1942, it changed its name to Lewis and Clark College and moved to the 130-acre former Lloyd Frank estate in Portland's southwest hills. In 1965, the Northwestern School of Law was merged with Lewis and Clark and is fully accredited by the American Bar Association.

Lewis and Clark students can tap into the collections of 11 Oregon colleges and universities through a computer system that is one of only two in the country. More than 45 percent of students participate in overseas studies—that's more than 20 times the average of any other college. Lewis and Clark offers 27 majors, 20 minors, and 14 master's degrees in four areas.

Warner Pacific College, a traditional liberal arts and science school, sits on a 15-acre campus in southeast Portland. The small campus allows students to get to know each other in a studious and faith-driven setting that emphasizes living by Biblical principles and practical preparation for a productive life.

Marylhurst University, established in 1893 by the Sisters of the Holy Names of Jesus and Mary, offers degrees in several areas, including the arts, art therapy, communications, humanities, human studies, music, and science among others. It is a private institution that serves a typically older college

Opposite page and left
Once a private estate, Lewis and Clark College covers 130 acres in the forested hills of southwest Portland.
Photos: Lewis and Clark College.

Marylhurst University is a cultural oasis for the larger community as well as a sanctuary of learning for its students. Here a visitor ponders modern art in an exhibition at the university's Art Gym, a well-known gallery featuring artists of note.
Photo: Marylhurst University.

population—from 30 to 45 years of age. About 1,600 students attend classes at Marylhurst each term.

Marylhurst University is the northwest leader in on-line distance learning, with more than 760 courses available on-line. An accredited liberal arts college, Marylhurst offers both 13 undergraduate degrees, and master's degrees in four areas, but also nondegree programs to a diverse student body who seek to improve their professional careers or enrich their personal lives.

A little farther out of town, but still within easy reach of Portland, is George Fox College in Newberg. Another Christian-based school where classes are small and personal, George Fox has repeatedly been voted one of America's best colleges by *U.S. News & World Report*, and is second in academic reputation among regional liberal arts colleges in the west. The college offers 34 majors and 40 minors ranging from natural science to fine arts and language. It also has a degree completion program especially designed for adults.

Portland also offers technical schools such as the Oregon Graduate Institute of Science and Technology, Oregon Institute of Technology, and ITT Technical Institute. There are two seminaries in the Portland area: Multnomah Bible College and Western Seminary. For business schools, students can choose from the Western Business College, the Business Computer Training Institute, and Heald College, which offers both a school of business and a school of technology.

Interested in the field of health care? You might want to take a look at Apollo College. Nationally accredited, and licensed by the Oregon State Department of Education, Apollo provides training for careers as a medical office manager, dental and medical assistant, pharmacy technician, and more.

For the artistically minded, the Pacific Northwest College of Art, established in 1912, offers a B.F.A. to approximately 260 students, half of whom are attracted to the school from out-of-state. Another 1,800 adults each year take classes for continuing education.

Portland is also a branch campus for out-of-state universities. Cascade College is a four-year Christian Liberal Arts branch of Oklahoma Christian University of Science and Arts. It offers six bachelor degree programs. The University of Phoenix recently opened a Portland campus. But don't send your 18-year-old high school graduate here! U of Phoenix specializes in real-world undergraduate and graduate professional degree programs designed for working adults.

Because Portland is the largest population center in the state, University of Oregon (based in Eugene) and Oregon State University (based in Corvallis) also offer graduate and continuing education classes in Portland. With offices right downtown, it's just another example of how learning opportunities abound in Portland. ◪

A student at Concordia University in northeast Portland enjoys a quiet place to study.
Photo: Concordia University.

Students gather in the atrium of the Cooley Science Center on the Oregon Graduate Institute campus near Beaverton. The building contains state-of-the-art research laboratories and is home to three of OGI's six academic departments: Environmental Science and Engineering, Management in Science and Technology, and Biochemistry and Molecular Biology.
Photo: Oregon Graduate Institute.

Opposite page
The tree-lined Park Blocks form the center of the Portland State University campus, which is located on the southern edge of downtown Portland.
Photo: Portland State University.

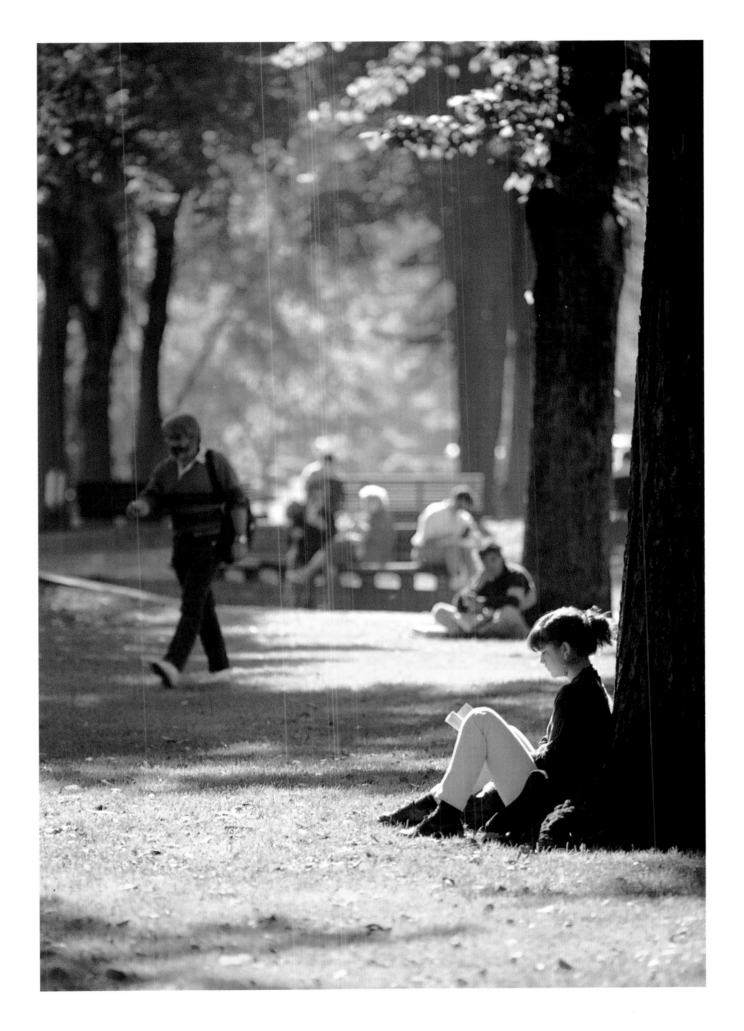

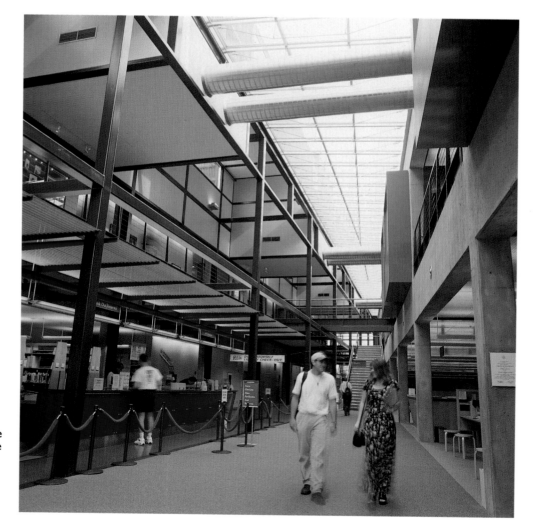

**Even in the center of a
bustling city, nature beckons
from forested havens
like this one.**
Photo: Larry Geddis.

6

Preserving the Land

"As long as we have a good economy and a good quality of life, people will want to come here. So we have to manage growth, and you start with vision."

John Kitzhaber, Oregon Governor

Photos: Larry Geddis

Autumn colors blaze in Laurelhurst Park, one of the hundreds of neighborhood parks in the city.
Photo: Larry Geddis.

Opposite page
Portland has earned the reputation of being a green city, with more than 37,000 acres of park land, and more being planned.
Photo: Larry Geddis.

This wetlands area in Blue Lake Park was created in a land trade after a wetlands area elsewhere was allowed to be developed.
Photo: Steve Terrill.

A hot economy in a beautiful setting attracts new people and industry. The big question is, where do we put all these people? For the Portland region, roughly 755 more people sit down to join us at dinner every day than were with us at breakfast. Why? After the recovery of the 1980s recession, more people are staying for jobs rather than seeking economic opportunities beyond the state. Plus, we're still having babies and living longer. All this means more people looking for housing and that piece of livability for which Portland is famous. But is it getting harder to find?

Designing a blueprint to fit the half-million people expected to be in the metro area in the next 20 years is the job of Metro, the nation's only elected regional government. Metro, made up of an executive director, seven-member council, and staff, manages the growth of our region. In that way, it is unique to other government agencies. Most city or county governments don't have the luxury of planning ahead—of looking beyond the immediate crisis at hand. Metro's whole purpose is to deal with the future—to figure out where we as a metropolitan region are headed. Yet, Metro doesn't have the power to implement zoning, codes, or any of the other usual means to control exactly who builds where.

It has some guidelines, however, primarily in the form of the Urban Growth Boundary. This tool is the main reason for

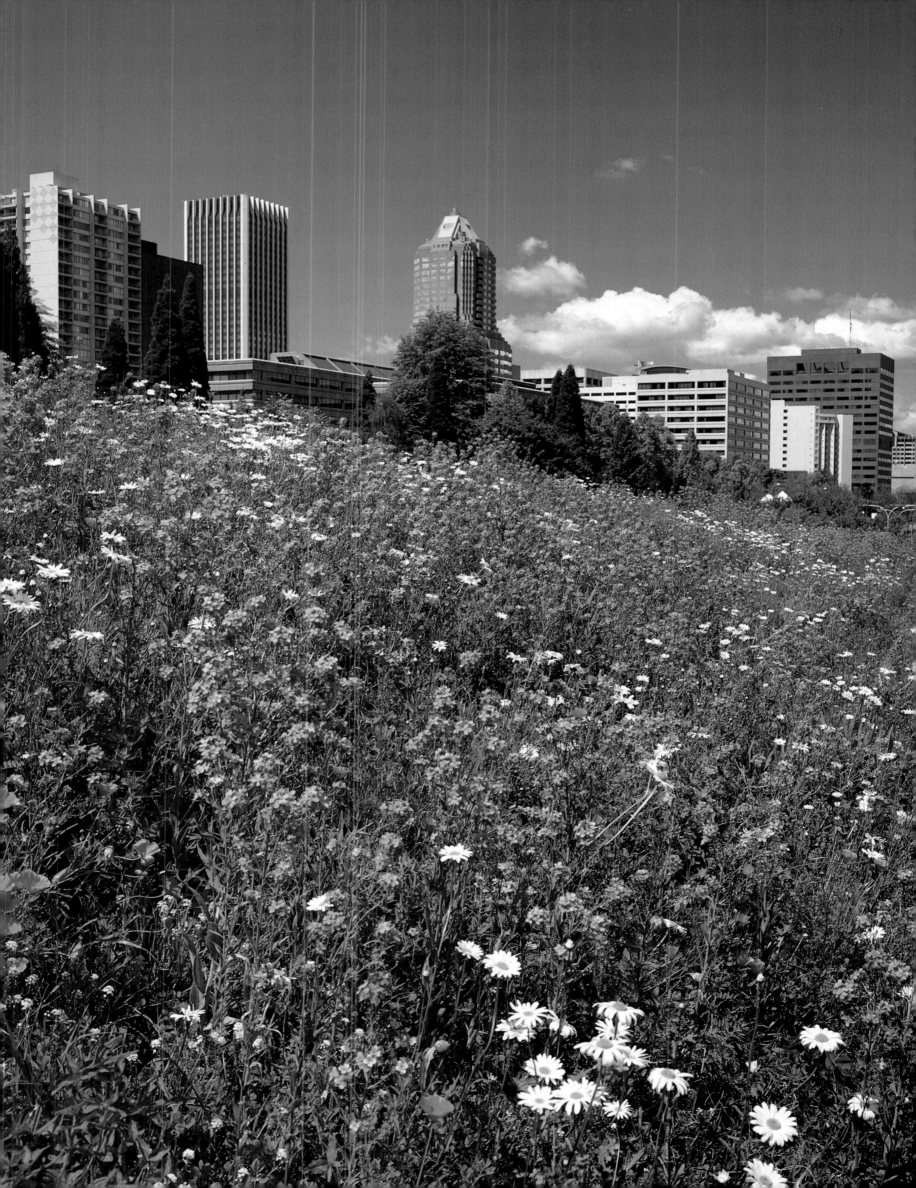

**Elowah Falls in John Yeon
State Park plunges 289 feet.**
Photo: Larry Geddis.

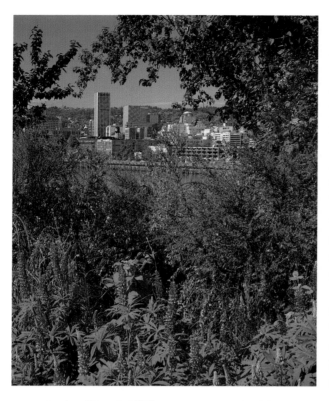

**Gardening is the number one
hobby of Portlanders, which
is why flowers seem to be
just about everywhere.**
Photo: Steve Terrill.

**Rafters maneuver through
the gates at Carter Falls
during the annual upper
Clackamas River White
Water Festival in Oregon's
Mt. Hood National Forest.**
Photo: Larry Geddis.

the livability of Portland. It has kept a tight control on development outside the Boundary, in order to avoid sprawl. It has forced us to make careful decisions on land use. And while Phoenix, Arizona, nearly doubled its urbanized areas in the past 20 years, Portland's has remained nearly unchanged. Which is why you can still see orchards, vineyards, crops, and nursery stock just 20 minutes from downtown Portland.

Metro governs 232,000 acres (364 square miles) within the Boundary, including 24 cities and portions of 3 counties, Clackamas, Washington, and Multnomah. Metro works with local jurisdictions to develop population predictions and how each area will cope with the growth. By restricting development outside the Boundary, we can protect our farmlands, forests, and access to natural resources. It's part of our heritage, this need to preserve the land, and it lingers still.

Not that our city would want to be completely unwelcome to growth. We've come a long way from the days of Governor Tom McCall when he advised people to come here and spend their money, but then go back home. We know we must grow, but we are determined to grow up, grow inward, and grow smart rather than just grow outward.

When Metro was created in 1979, one of its first jobs was to create the Urban Growth Boundary to help implement the new land-use laws. Great idea, but it had never been done before. So with a helicopter, officials flew over the region at night, looking over the land. Where there were lights they determined was urban area, where there was darkness—rural land. The lines were drawn and this primitive method of mapping was the genesis of creating the Boundary that has guided Portland's growth.

The original Boundary had to contain a 20-year land supply for future growth, with an anticipated population of 1.6 million people by the year 2000. What wasn't anticipated was the recession of the 1980s.

When the recession hit, people were leaving the state in droves, and Oregon actually had fewer people than when the Urban Growth Boundary was drawn. We built less, and used less of the precious land inside the Boundary. But the economy took off again in 1989, when the electronics industry in California needed some new territory in which to expand. Oregon has a plentiful supply of what this burgeoning industry needed: cheap land, cheap water, and cheap labor. By 1990, our population started to double annually. Instead of reaching a population of 1.6 million in the metro area by the year 2000, we hit the magic number in 1994.

Suddenly, the crunch was on and voices from all sides of the growth issue began crying out. Builders called for expanding the Boundary for new developments. Environmentalists called for preserving green space. Residents began to worry about longer commute lines and increasing traffic on neighborhood streets. New developments were crowding working farms. Housing prices increased, and first-time home buyers complained they were being shut out of the market. Downtown real estate owners feared expanding the Boundary would leave them with empty office space. And outlying towns began to get nervous that their own green spaces and park lands might be gobbled up. But it became clear that we no longer had a 20-year supply of buildable land within the Boundary. Expanding the Boundary became not just an issue to talk about, but one that had to be seriously considered.

Even then, the amount in question was far less than other metropolitan regions were adding. Minneapolis recently added 80,000 acres to its urban area, and Denver set aside more than 105,000 acres for future urban use. Metro was considering adding no more than 10,000 acres to the Boundary.

The very idea of tampering with something that has made the Portland region the envy of the nation was difficult, at best. Magazine articles raved about the rural landscape so close to downtown. Planners used Portland as an example of how to avoid sprawl. But clearly, the lines that once seemed so generous were beginning to strain at the edges. One news magazine called Portland a paradise, if not entirely lost, then "slightly dimmed." And the *Sacramento Bee* asked if the "dream was dying" in Portland.

CAN WE HAVE IT ALL?

Many believe we can. A poll conducted for Metro showed we're willing to make some changes in order to protect farms and forests. Forty-six percent said the Boundary should be held in place, even if it means increasing density. Thirty-two percent called for a slight expansion of the boundary, coupled with smaller lots for new housing developments. Only thirteen percent called for a large increase in the Boundary.

Livability is what people want. Flexibility is what people are willing to give. The Boundary

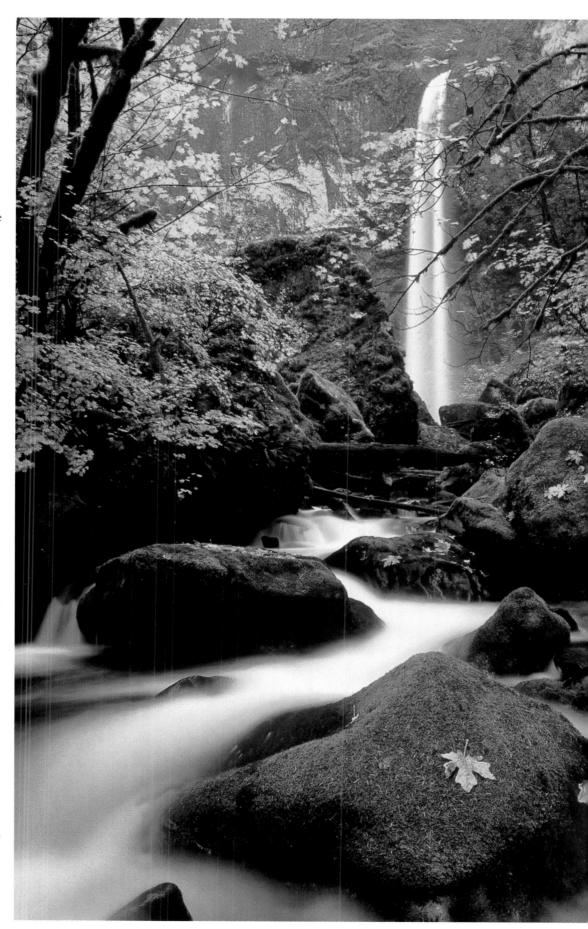

Wildlife within the city limits is a common sight, like these waterfowl in the Columbia Slough.
Photo: Steve Terrill.

was increased a mere 4,500 acres to accommodate the half-million more people expected to join us by the year 2017. In order to do that, density will have to increase within existing neighborhoods. Instead of large homes on 7,000-square-foot lots, neighborhoods are beginning to see lots of 5,000 square feet, and a mix of development such as townhouses and apartments.

But those who fear that density will erase Portland's famous "green" needn't worry. Our love of the land goes well beyond merely controlling development outside the Urban Growth Boundary. Voters approved a $135-million bond measure to let Metro acquire and protect open spaces, parks, and green-ways both inside and outside of the Boundary. These acquisitions will ensure Portlanders have access to nature for hiking, fishing, boating, and other recreational activities. But it also guarantees that sensitive wetlands and streams can remain wildlife habitats.

With more urban land being designated to accommodate our growing population, protecting and managing our natural resources for future generations has taken on greater urgency. Metro is charged with acquiring 6,000 acres of open spaces to preserve our "green" way of life.

Portland also realizes that preserving the land means controlling waste and garbage. Metro runs an aggressive recycling and waste reduction program and answers more than 105,000 calls each year about recycling opportunities. Nearly

45 percent of our trash is recycled; that's one of the highest rates in the nation. Setting out cans, bottles, plastics, yard debris, and newspapers isn't just a good idea—in Portland, it's a way of life.

Two permanent recycling collection facilities operate six days a week, year-round. There are large household hazardous waste collections, and even a program to recycle paint! Portland was also the first city in the nation to ban styrofoam take-out containers from restaurants and coffee shops, because they don't degrade in a landfill.

Portlanders have been well-educated on the importance of keeping some items out of landfills altogether. Why throw grass clippings in the trash when you can mix it with organic food matter and leaves and make mulch for your garden? Composting is king, and when Metro holds its annual compost bin sale, people line up hours in advance. Got a sofa or other item you can no longer use? No need to send it to the landfill. Portlanders can access a list of 250 companies that take everything from scrap metal to furniture. You're sure to find that your trash is another person's treasure.

Portlanders are also starting to realize that keeping that livability we have come to expect means searching for ways to do things differently. Can we improve transit to get more cars off the road? Can we reduce parking spaces to free up land for other uses? Can we design housing that doesn't require large

Opposite page
A girl tries her kite out in one of Portland's many designated green spaces. A funding measure passed by voters gives Metro more money to preserve spaces like this.
Photo: Steve Terrill.

The Urban Growth Boundary sets strict limits on development in order to preserve farmland and avoid urban sprawl.
Photo: Larry Geddis.

lots, yet still give people privacy? Can we encourage inclusive zoning to create more affordable housing?

The belt that surrounds the metro area may have been loosened just a notch, but Metro is determined that before new building takes place there will be a plan to protect parks and green spaces and at the same time provide adequate services such as sewers, schools, police, and fire protection.

Truly, no other state cares so passionately about land-use planning as does Oregon. No other city works so hard to maintain green spaces, use available land effectively, and preserve livability.

Since its beginning, Metro has looked ahead. It has raised citizen awareness of planning issues to a level rarely seen elsewhere in the country. We know what we want, but more importantly, we know what we don't want. We have a vision of the kind of state and city we want to live in, and we are committed to turning that vision into reality. We know we stand to lose too much if we don't. ◪

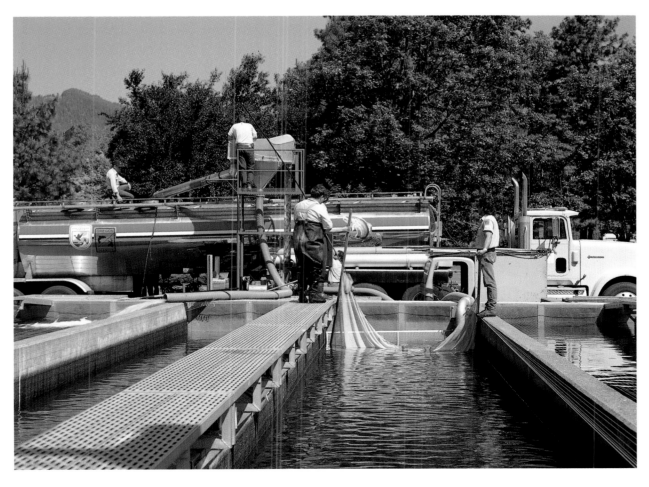

Trout are netted at the Bonneville Dam Hatchery. They'll test fishermen's skill in local lakes and streams.
Photo: Steve Terrill.

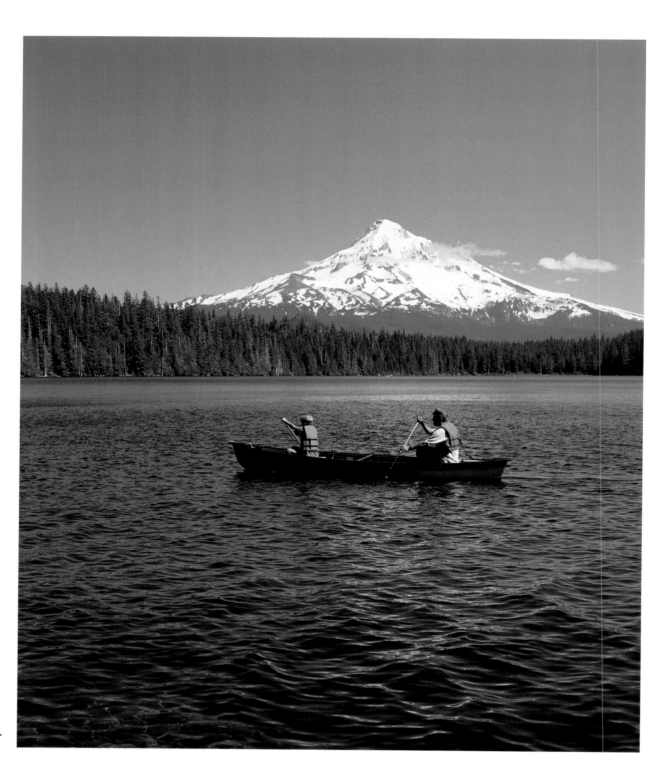

Canoeists on Lost Lake enjoy the natural beauty of Oregon.
Photo: Larry Geddis.

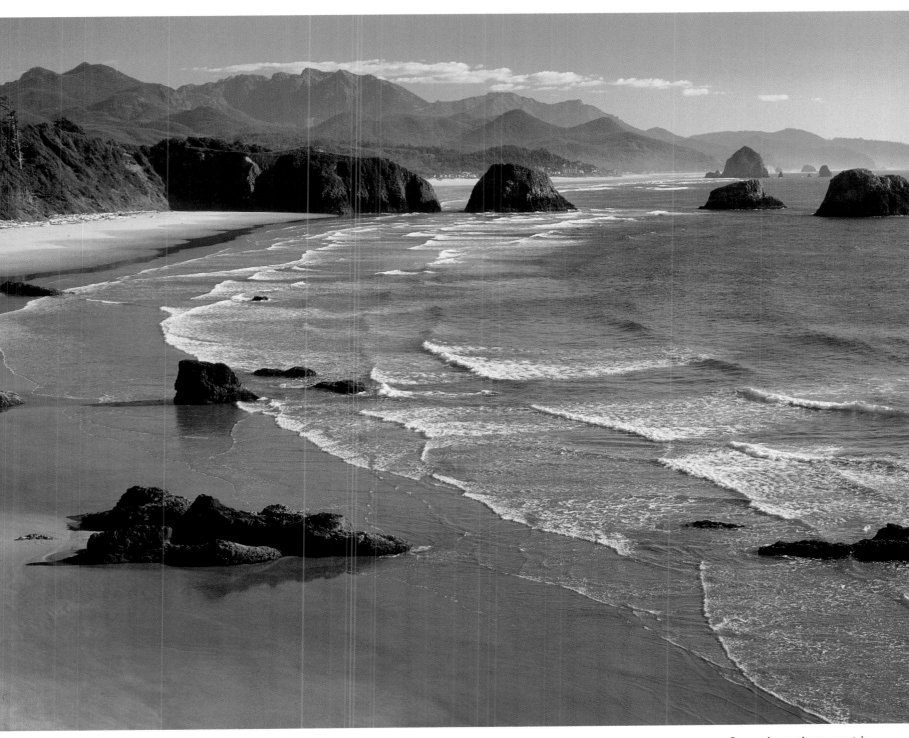

**Oregon's northern coast is
but an hour and a half from
metropolitan Portland.**
Photo: Larry Geddis.

Sailboats wait for a sunnier day to get out on the Willamette or Columbia— the two rivers that meet in Portland.
Photo: Steve Terrill.

Kelly Point Park, right at the confluence of the Willamette and Columbia Rivers, is a popular fishing spot.
Photo: Steve Terrill.

Swan Island, 20 minutes from downtown, is still owned mainly by farmers who grow everything from pumpkins to dahlias.
Photo: Larry Geddis.

Mt. Hood is rarely obscured by typical city haze thanks to clean air policies. Here, the majestic mountain provides a backdrop to golfers at the Persimmon Country Club Community.

Photo: Larry Geddis.

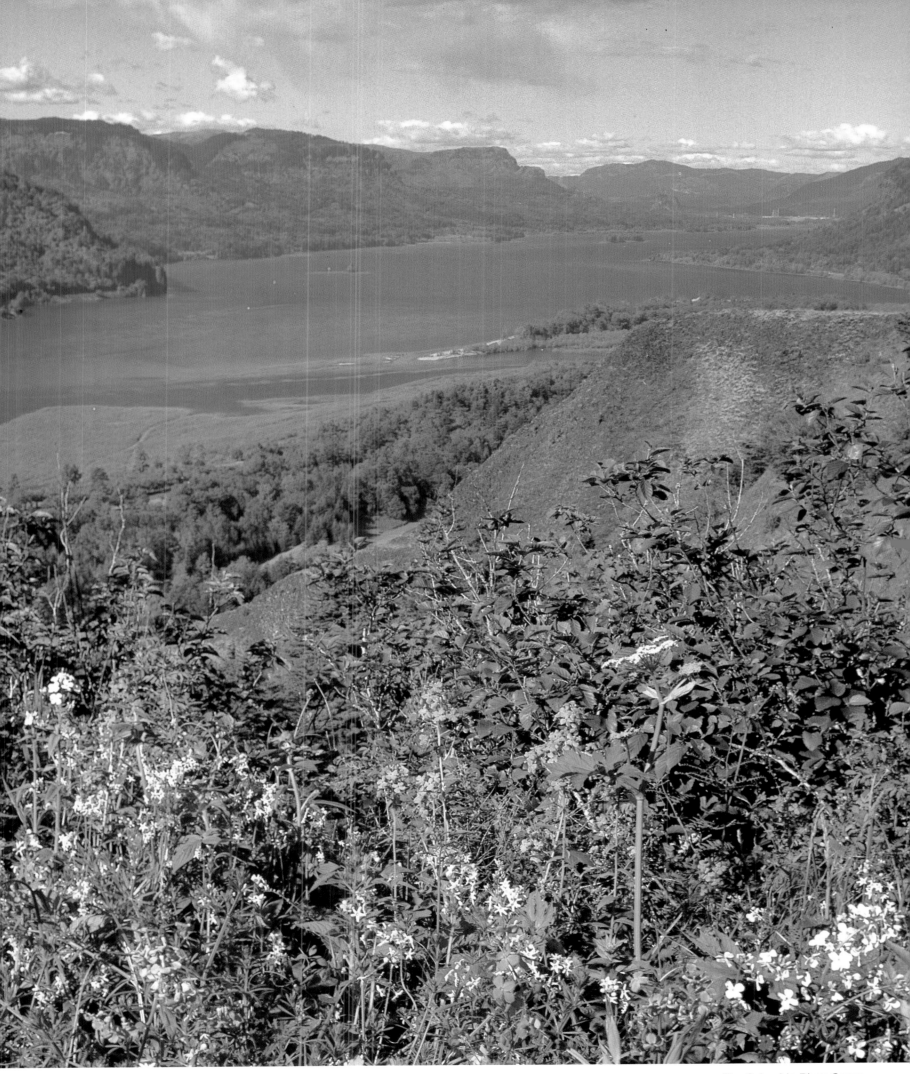

The Columbia River Gorge
National Scenic Area, as
seen from Crown Point,
is a photographer's
delight any season.
Photo: Larry Geddis.

7

Vital Services

"Portland, Oregon's healthcare market is already among the most efficient in the country."

Modern Healthcare magazine

P

Photos: Larry Geddis

Doernbecher Children's Hospital has been serving thousands of sick and injured kids from all over the Northwest for more than 70 years.
Photo: OHSU.

When experts look at the future of health care in America, many of them look at what's been accomplished in Portland. With one of the highest percentages of people in managed care programs in the nation, plus a system of hospitals whose work and cooperative spirit can only be described as "cutting edge," Portland leads the nation in providing excellent quality health care at low rates. In fact, Portland residents pay, on average, 20 percent less for health care than people in other cities. Credit goes to a combination of employers, insurers, and providers working together, plus the dominance of non-profit health plans and hospitals.

Portland has a long history of managed care, dating back to 1947, with the founding of Kaiser Permanente. Portland is what's called a "mature market" for managed care. It's been around for so long, there's been a wealth of experience in how it works. Roughly 50 percent of all Medicare beneficiaries are in managed care, as are Medicaid beneficiaries, and 43 percent of those covered by private insurance. That's the highest rate in the country.

In the Portland area alone, 65 percent of all residents are enrolled in a Health Maintenance Organization (HMO). That compares to a national average of only about 20 percent. In addition to HMOs, many are enrolled in Preferred Physicians Organizations (PPOs), another type of managed care program.

Kaiser Permanente's Health Resource Centers offer its members videos to check-out, health-related books and videos to borrow or purchase, health education hand-outs, access to health-related Internet sites, and referrals to Kaiser Permanente classes and community resources.
Photo: Kaiser Permanente.

Portland is a center for alternative or nontraditional medicine. Naturopathic physicians and acupuncturists are commonplace, and Portland is where you will find the national College of Naturopathic Medicine, one of the only two naturopathic colleges in the country. Portland also has the Oregon College of Oriental Medicine clinic and the East-West College of Healing Arts—Oregon's only American Massage Therapy Association-approved curriculum. In addition, Portland has a high number of chiropractic clinics, many of which are joining managed care networks. Another sign of the growing acceptance of alternative health care is that Providence Health Plan has started offering a new alternative-care rider that allows businesses to pay a little more in order to offer their workers insurance coverage for naturopathic physicians and acupuncturists.

There are three major delivery systems in the Portland market: Providence Health System, Kaiser Permanente, and Legacy Health System. Each claims a market share in the upper 20 percent range.

Four health plans dominate: Providence's Good Health Plan, Regence BlueCross BlueShield of Oregon, Regence HMO Oregon, PacifiCare of Oregon, and Kaiser. The other HMOs are HealthGuard Services/SelectCare, and Qual-Med Oregon. With more than 449,000 enrollees, Regence HMO-Oregon is the largest, with Kaiser close behind.

There are seventeen hospitals in the Portland metro area, most linked in some way to the three largest providers, and most nonprofit. Legacy, the primary delivery system for Regence HMO Oregon, owns four hospitals and has strategic partnership with Portland Adventist Medical Center; Providence has three hospitals and Kaiser, one.

Other hospitals in the urban area include Oregon Health Sciences University Hospital (OHSU), Eastmoreland General Hospital, Woodland Park Hospital, Willamette Park Hospital in Oregon City, and Tuality Community Hospital in Hillsboro. The newest is the Doernbecher Children's Hospital on "Pill Hill" by OHSU. This modern, freestanding facility was built to replace the cramped and outdated hospital. It offers the widest range of pediatric services available in the state and more than 30,000 children from Oregon and five surrounding states use Doernbecher's services each year.

Also on Pill Hill is the Portland Veterans Affairs Medical Center. This three-division medical center is a state-of-the-art facility providing care to more than 350,000 veterans in Oregon and southwest Washington. The 622-bed hospital has an affiliation with the Oregon Health Sciences University School of Medicine, and shares such medical resources as Magnetic Resonance Imaging, liver transplants, and radiation therapy. The VA Research Center boasts more than $9.5 million in laboratories and equipment for work in the areas of

Portlanders have a wide variety of hospitals from which to choose. Providence Health System alone operates three hospitals.

Photo: Steve Terrill.

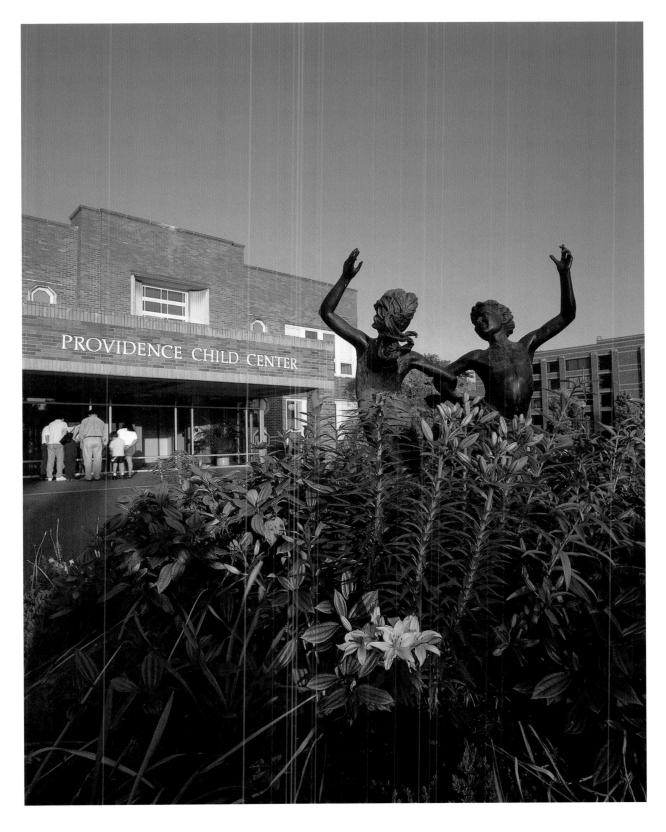

Providence Child Center is one of many health care facilities that has grown from the original hospital begun by the Sisters of Providence in 1875.
Photo: Steve Terrill.

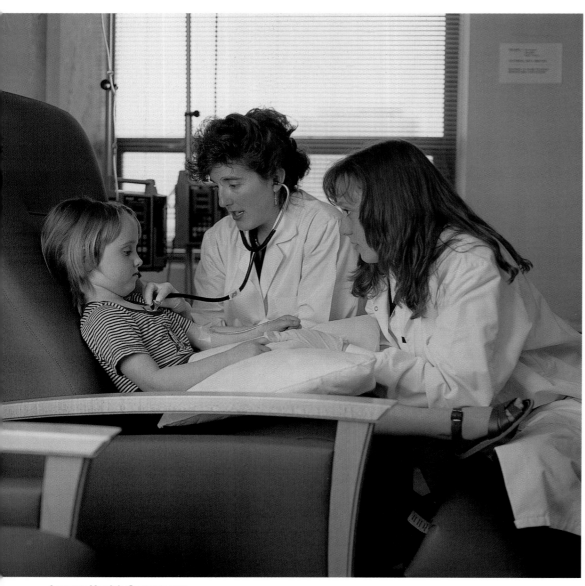

Legacy Health System provides a full range of health care services in the Portland metropolitan area. In addition to extensive services for women and seniors, Legacy Emanuel Children's Hospital provides complete children's services in a family-centered environment.
Photo: Legacy Health System.

multiple sclerosis, Alzheimer's, AIDS, stroke research, and more.

Over a 12-year period there was a steady drop in inpatient care, with an average of 38 days per 1,000 population. For people 65 and older, Portland's inpatient rate is half that of the national average, despite the fact that Portland is the state's referral center for health care, with patients coming to the city from across Oregon for care of advanced cancer, burns, transplants, and heart disease.

In managed care programs, health care systems focus on keeping patients out of the hospital. Whereas in the past hospitals dominated the health care system, today primary care is at the forefront. The emphasis on prevention, early detection, and health promotion creates more demand for primary care than hospitalization.

HMOs were once considered by some as "socialized medicine," but as they have extended their reach into the public and private sectors, the view of managed care has improved. Studies show that 47 percent of Portland area residents are very satisfied with the care they receive and feel that both the quality of services and access to them has improved. In addition, 63 percent of those surveyed think the trend towards managed care is a good thing.

For many people, choice has also improved. Those with large employer health plans can choose from two or three HMOs and a PPO. Mid-sized employers typically offer one or two HMOs and a PPO. Medicaid enrollees have up to eleven HMOs available to choose from. Employers generally cover 80 to 100 percent of their employees' premiums and 50 to 100 percent of dependents' premiums. Copayments and deductibles tend to be low, as is generally the case with managed care plans.

One advantage to large, managed health plans is the ability to get a broader view of a community's health. For example, a large health plan can identify a growing problem of premature births, whereas doctors in individual or small group practices may see few, if any, premature births a year. A large plan can therefore see a pattern developing, and respond accordingly.

Oregon is also one of the best states for consumer protection against abuses by health maintenance organizations. A report by Families USA Foundation, a privately funded, consumer watchdog organization, said Oregon ranked among the best in three key areas of consumer protection: access to appropriate specialty care; decisions to approve and deny care; and due process protections.

A FOCUS ON CARING

In Portland there is a strong tendency to see health care as a public responsibility. Major health care systems see their role as improving the overall health care of their community, not just patching wounds or healing disease. Most offer classes in everything from breast cancer recovery to lowering cholesterol. Adventist Health, for example, has its Healthvan, which travels to businesses, community events, and other public areas to provide health screenings and education on site.

Legacy Health System, winner of the prestigious Oregon Quality Award, is expanding its services in the area of pediatrics, remodeling its Children's Hospital, doubling the Pediatric Intensive Care Unit and rehabilitation rooms. On the other end of the age spectrum, Legacy also specializes in care for the elderly with St. Aidan's Place, an assisted living center for those with Alzheimer's and dementia. It reached full capacity within five months of opening, a sign of the growing need for this kind of service.

For those who travel from across the state to visit loved ones in Legacy hospitals, the Green Gables Guest House, located on the Good Samaritan campus, offers a supportive, low-cost home for cancer patients and their families.

Legacy's Visiting Nurse Association, established in 1902, sends nurses into an eight-county area in the Portland area to improve the health of the community through home health care, health education, and community wellness programs.

Legacy also recognizes the healing link between animals and humans. It has initiated a program where volunteers bring animals to visit hospital patients, providing affection and companionship.

Providence Health System continues the work started by the Sisters of Providence in 1875. Today, it has six hospitals—three of which are in the Portland area. The Providence Heart Institute is internationally renowned as a leader in cardiac care, research, and education, attracting cardiac specialists from around the globe for advanced training. The Earle A. Chiles Research Institute has developed pioneering new strategies for cardiac and cancer care.

As a nonprofit, Providence spends more than $30 million each year in outreach services to the community, from family medical clinics and adolescent treatment to

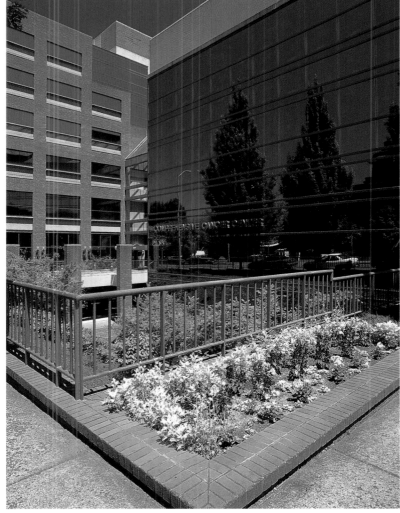

The Comprehensive Cancer Center located at Legacy Good Samaritan Hospital is one of the many facilities providing high-quality care to patients.
Photo: Steve Terrill.

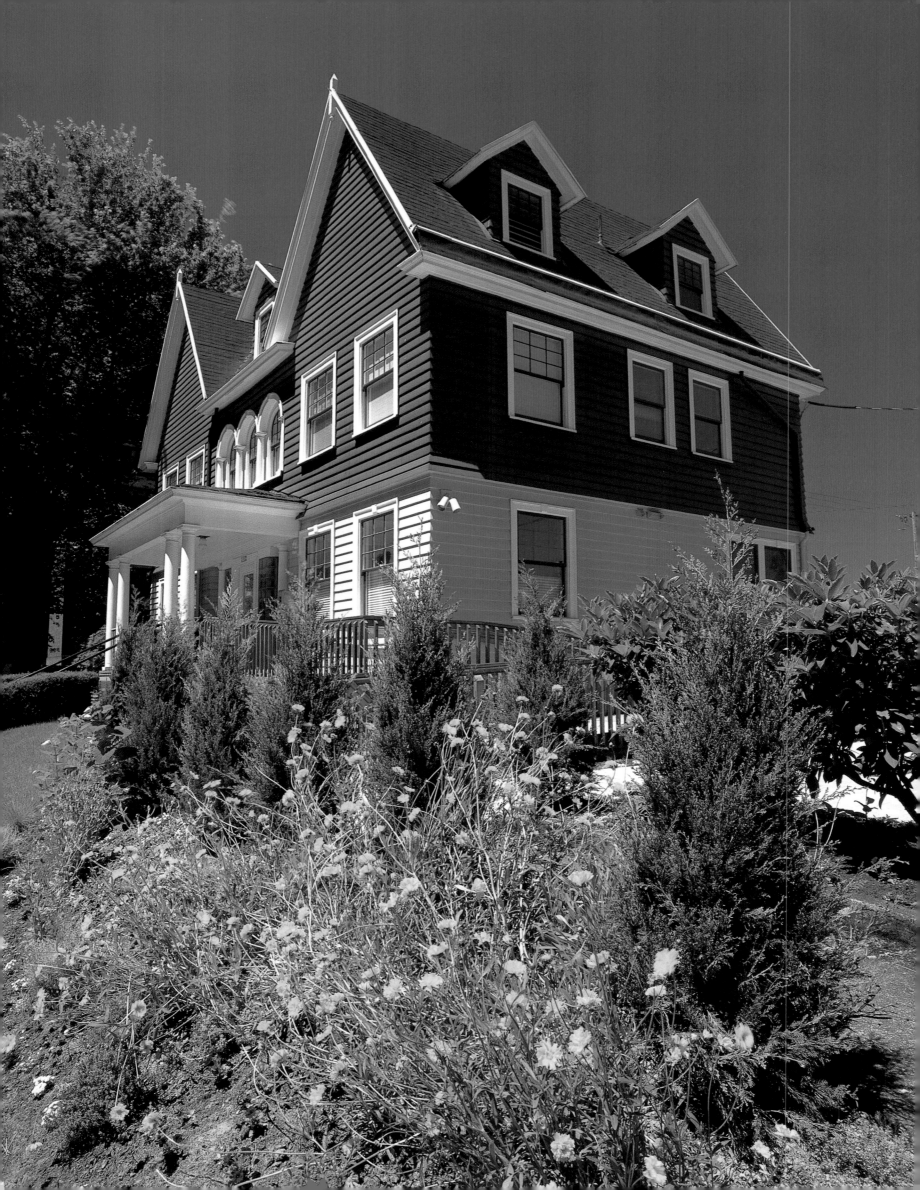

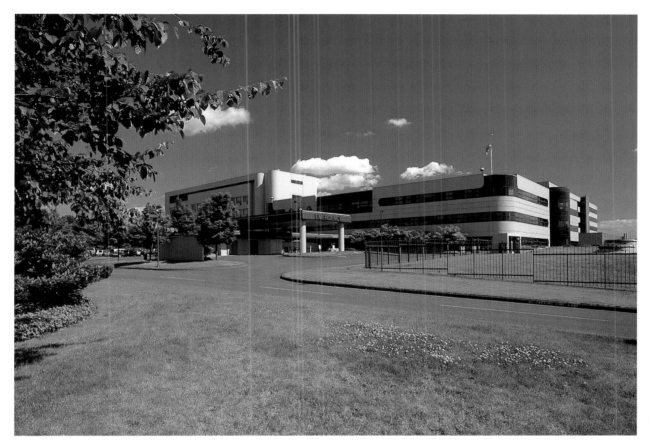

Legacy Emanuel Hospital & Health Center provides a comprehensive range of care with specialty services such as pediatrics through Legacy Emanuel Children's Hospital and trauma services through the Level 1 trauma center.
Photo: Steve Terrill.

adult day care and transportation. Providence also welcomes more babies into the world than any other health system in the state. Its special Women and Children's Program is devoted to improving the health of childbearing women and children from infancy to adolescence.

Kaiser Permanente's history in the Pacific Northwest goes back to the medical group established to serve workers and their families at Grand Coulee Dam and the Kaiser Shipyards during World War II. Enrollment was opened to the public in 1945, and the plan now serves more than 415,000 people.

Kaiser has one hospital, 19 outpatient medical offices, and 13 dental offices. With more than 168,000 members, it is the largest group practice dental program in the country. Its computerized medical records system is one of the best in the nation, allowing physicians immediate access to patient medical information.

The U.S. Public Health Service goal for the year 2000 is a mammogram rate of 60 percent to encourage breast cancer detection and prevention. At Kaiser, because members over 40 can self-refer for mammograms, the rate is already more than 76 percent.

Kaiser stresses medically proven health promotion programs aimed at changing unhealthy habits, such as smoking and overeating. Kaiser also sponsors a variety of community services and events in the areas of health, education, social services, and arts and culture.

Oregon Health Sciences University (OHSU) includes Doernbecher Children's Hospital and the University Hospital. It has one of the two Level 1 trauma centers in Portland and is the only hospital in Oregon that provides a comprehensive solid organ transplant program.

The state's only academic health center and the city's largest employer, in 1995 OHSU became the first academic health center in the country to change from a state agency to a public corporation. It is one of the few academic health centers in the United States not affiliated with a larger university.

OHSU is internationally known for pioneering nonsurgical treatments to open blocked blood vessels, shrink tumors, stop internal bleeding, and correct infertility. OHSU is nationally recognized for its neuroscience expertise, including programs in stroke, Parkinson's, and Alzheimer's diseases. *US News & World Report*'s nationwide surveys have placed eight of OHSU's specialties among the best in the nation.

Because of the lack of space to expand on southwest Portland's Pill Hill, OHSU has moved towards building primary care centers around the city. OHSU now runs six primary care centers that double as teaching centers with classrooms, conference rooms, and libraries. With 50 percent of graduating medical students choosing primary care specialties, OHSU believes it has developed new teaching models through these primary care centers.

Opposite page
Green Gables Guest House is one of the many specialized services Legacy Health System provides to patients who must travel to Portland for treatment.
Photo: Steve Terrill.

It seems to be paying off; in its comprehensive 1997 review of primary care graduate programs, *US News & World Report* ranked OHSU third in the nation.

As a public institution OHSU provides more charity care than any other health center in the state, delivering millions of dollars of uncompensated care each year.

COLLABORATIVE EFFORTS

Hospitals have become competitive, and as a result, there have been numerous consolidations and collaborations. Kaiser, for example, contracts out for services with Providence for some of its patients. Four hospitals share Aircare, a 24-hour inter-hospital flight service to transport critically ill patients throughout the state and the Northwest. And Oregon Health Sciences University has a joint bone-marrow transplant program with Legacy Health System.

Community health is such a concern that several large providers and insurers have formed the Oregon Health Systems in Collaboration (OHSIC). This public/private part-nership focuses on the tri-county area to look for solutions to problems such as low immunization rates.

CARING FOR THE NEEDY

Oregon is heading in the direction of universal coverage, and the Oregon Health Plan (OHP) was the first step. It was created in 1989 with the idea of providing basic health care services to more of the state's poor. As of June 1997 there were more than 102,000 enrollees in the Oregon Health Plan in the tri-county area. OHP has been very successful in bring-ing health care coverage to almost everyone below the federal poverty level, making small employer and individual health insurance more accessible, creating an insurance pool for "high risk" individuals, and providing more low-cost insur-ance options to very small businesses.

Before the Oregon Health Plan, nearly 18 percent of the state's population had no health insurance. By 1996, that number had fallen to 11 percent. And since those without insurance tend to put off regular doctor visits and then end up going to the emergency room later, providing basic health care has meant fewer uncompensated cases for hospitals.

With other states now looking to copy the Oregon Health Plan, it's clear that Oregon's innovation and willingness to try something different has put us once again a step ahead of the rest of the nation. ◼

The Adventist Health Medical Center has a long history in Portland. It began as a small sanatorium, dedicated to preventive health measures.
Photo: Steve Terrill.

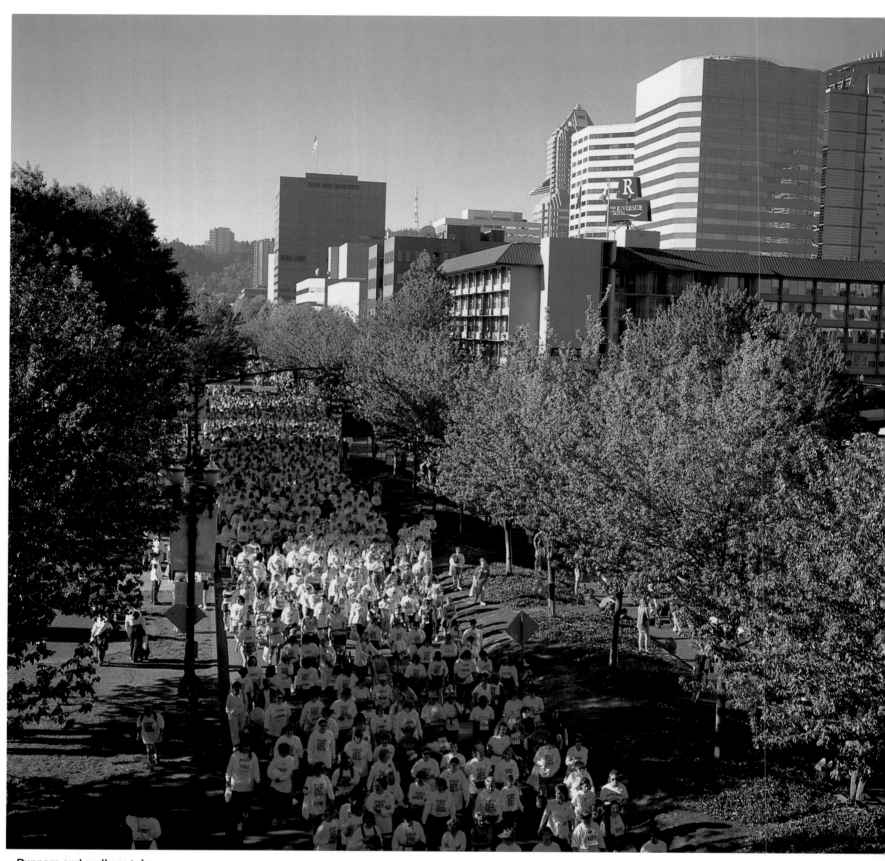

Runners and walkers take off for a good cause: Portland has the second largest turnout in the country for the annual Race for the Cure.
Photo: Larry Geddis.

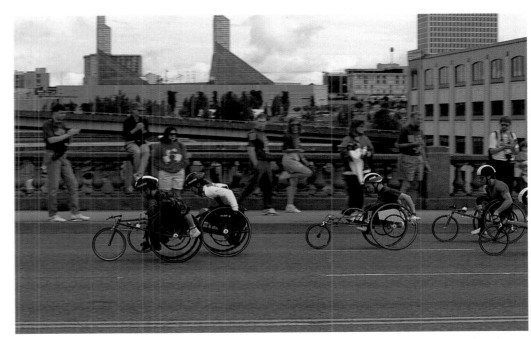

The Portland Marathon is one of several races that attracts athletes, both professional and amateur, of all abilities.
Photo: Steve Terrill.

There are always places to go for a run in Portland. You'll see the city's love of fitness almost everywhere you look.
Photo: Steve Terrill.

8

The Lively Arts

"There's a wonderful spirit for the arts in this community."

James Canfield, Artistic Director,
Oregon Ballet Theatre

Photo: Steve Terrill

Opposite page: Donna Zweig

Opposite page
The crown jewel in Portland's cultural district is the Portland Center for the Performing Arts on SW Broadway.
Photo: Larry Geddis.

The music of the Oregon Ballet Theatre's outdoor performance at Portland's Saturday Market proves irresistible to one young listener.
Photo: Steve Terrill.

What makes a city more than just a place to work or live? What makes a city a place that is truly inviting, creative, and exhilarating? Many would say the arts. From public art and galleries, to world-class orchestras, ballet and opera companies, and theater, Portland has much to offer in the world of the arts.

Almost since its beginnings, Portland has enjoyed theatrical performances of one sort or another. One of the first "respectable" theaters opened in 1888, when John Cordray opened an establishment that prohibited "liquor, peanuts, catcalls, or whistling." The following decades saw the growth of other stock theater companies and the beginnings of a symphony orchestra.

However, the success of the current arts world in Portland goes back only a little more than a decade, when the Portland Center for the Performing Arts was born in the heart of downtown.

In 1981, while Oregon was in the middle of a deep recession, Portlanders took a chance. Despite the troubled economy, voters approved a $19-million bond measure to build an arts center. It was a gamble, and yet, it showed the confidence Portlanders had in their city—the desire they had to make downtown someplace to go to even after five o'clock at night.

Building the theaters on Broadway Street was part of the plan to revitalize downtown and to create the 24-hour vibrancy that downtown supporters wanted. It has done all that, and more. It has brought good restaurants and a safe environment. It has brought a higher caliber of theater, music, and dance to our city, and allowed local artists to earn a living wage and stay in their hometown.

The Portland Center for the Performing Arts (PCPA) is comprised of four theaters: the Newmark Theatre, with 888 seats; the Dolores Winningstad Theatre, with 292 seats; the Arlene Schnitzer Concert Hall, a 2,776-seat restored vaudevillian hall; and the Portland Civic Auditorium, a 3,000-seat hall, originally built in 1917 and completely renovated in 1968. From local productions to touring shows, these four facilities offer a diversity of year-round entertainment for every taste.

Harriet Sherburne, director of the PCPA, says the main advantage to the PCPA is that it has allowed Portland to move up in the ranks of professionalism for both local and touring companies. One can't do sophisticated productions without a sophisticated space. When Portland was limited to the Civic Auditorium, it was workable for large events only. The 3,000-seat facility was fine for ballets or operas, but smaller theater companies couldn't hope to perform there. The only real, live theater being performed in Portland was community and storefront theater, often in cramped quarters and on hard seats.

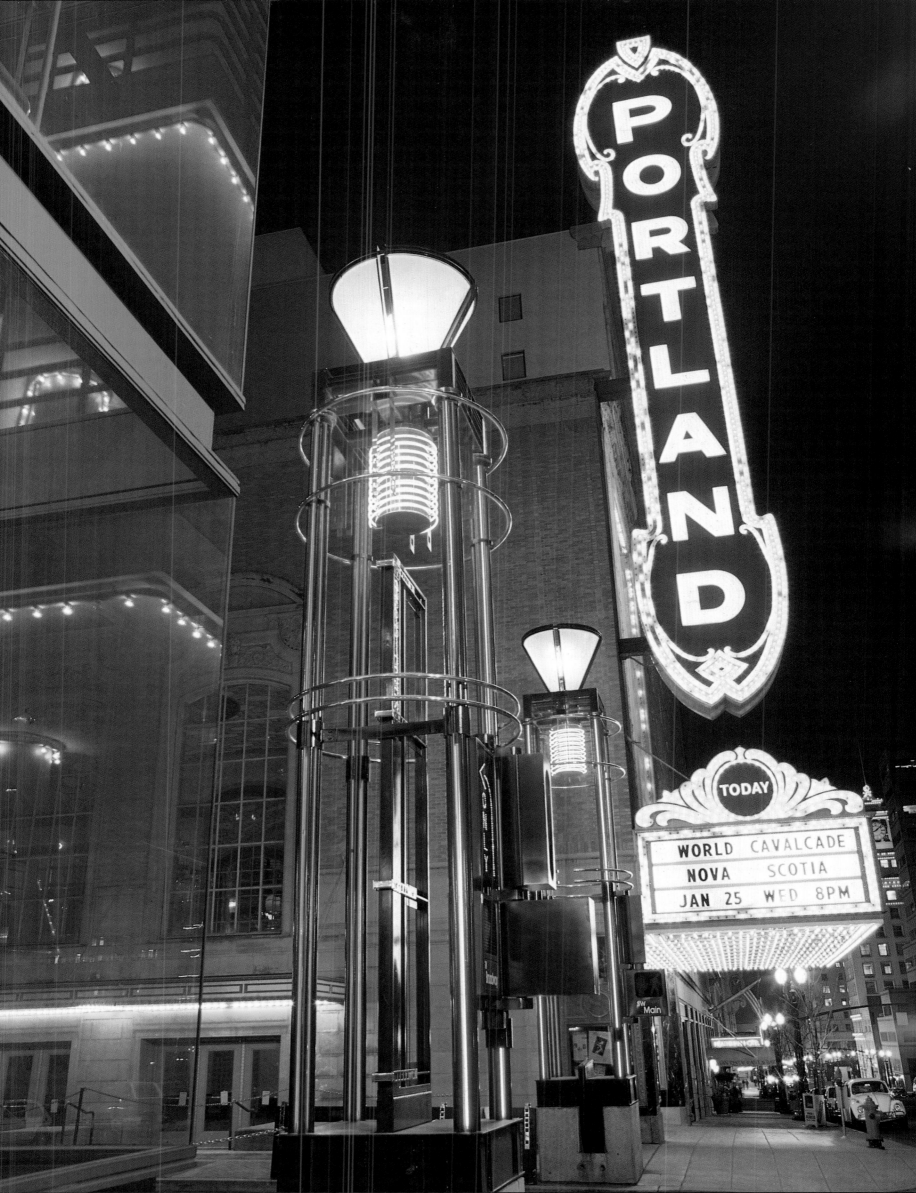

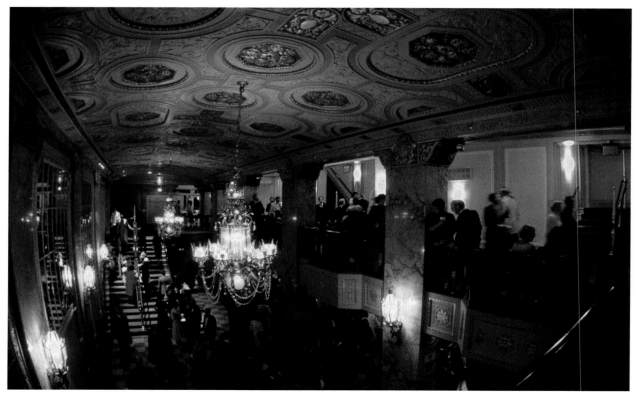

Once a vaudevillian hall, the beautifully restored Arlene Schnitzer Concert Hall is now home to the Oregon Symphony.
Photo: © C. Bruce Forster/ Viewfinders.

So when the PCPA was built, providing the Newmark and Winningstad Theaters, it was a chance for Portland to step up to a more professional level in its theater offerings for the city.

"There was the belief that there would be the talent to fill these halls," said Sherburne.

And there has been. In 1988, Portland Center Stage was recruited to be the resident company in the Newmark Theatre. The company performs five shows a year and is the major equity theater in town. Other tenants include the Jefferson Dancers, Oregon Ballet Theatre's American Choreographers Showcase, film premieres, the Portland Creative Conference, and other smaller concerts.

The Dolores Winningstad is an Elizabethan, or "black box" style theater, with an extremely flexible performing space. It has 292 seats, but the seating can be configured for a three-quarters, or "in-the-round," setting. Tygres Heart Shakespeare Company is the main tenant of the Winningstad, but Tears of Joy Puppet Theatre and other dance groups share the space.

Not all attempts to use the new space were successful. Even though unions agreed to allow volunteer ushers to save smaller companies money, the cost of working in the PCPA was staggering for some theater companies, and two of them hoping to make the jump from storefront to the PCPA folded.

Overall, Sherburne says it has been a success and given "top-notch" talent a showcase. She says there's been a maturation of the arts here that has allowed Portland to have many first-class arts organizations. The PCPA not only allows the arts community to thrive downtown, but the success also spills out into the neighboring areas. As people come to Portland to enjoy the arts, they then tend to support them in their neighboring towns of Gresham, Beaverton, and Forest Grove. As a result, there are expanded opportunities for artists, and these same talented men and women can not only live in their hometown, but they can also make a living in the arts.

That's certainly been the goal of the Oregon Ballet Theatre Company (OBT). Artistic Director James Canfield brags that no other arts organization in the city can make the claim of "growing" its talent right in the community. Thanks to a quality ballet school that nurtures 9- to 13-year-olds, OBT doesn't need to draw from New York for its dancers. The future talent pool for OBT is already at work in the dance studios seven hours a day.

"In two years," says Canfield, "those 13-year-olds will be coming into the company. And one advantage they have over outside talent is they already know the culture of both the company and the community."

Oregon Ballet Theatre is one of the arts success stories of Portland. It presents more than 100 performances each year both in its home at the Civic Auditorium, and also on tour. With an active repertoire of more than 50 works, OBT continually garners rave reviews for its creative and highly professional productions.

Like OBT, the Portland Opera also sets a high standard. Director Robert Bailey says Portland Opera is definitely in the same class as its "big sisters," San Francisco and Seattle. Yet, what sets Portland apart, he believes, is its integrated ensemble approach to opera.

"Great singing is important, yes," says Bailey. "But Portland Opera focuses just as much on the costuming, the sets, the makeup, and the staging. Every element is given balanced attention because people have such high expectations. And I often hear how surprised first-timers are when they see the caliber of talent here in Portland."

Portland Opera produces four operas and one operetta per season. It has not only performed standard Italian and German operas, but has also debuted several modern operas. Portland Opera was the second company in the country to try "super-text," where the translation of what the artists are singing is projected above the stage, not unlike subtitles in a foreign film. It was an immediate success and Bailey says it makes the opera more accessible.

Portland Opera also is a partner in bringing Broadway touring shows to Portland. Along with other booking and theatrical groups, it created the Best of Broadway Series. The series has a subscriber base of more than 2,000 who enjoy such impressive Broadway productions as *Phantom of the Opera*, *Les Misérables*, *Hello Dolly*, and many others.

That in itself is affirmation of how far Portland has come in supporting the arts. For years Broadway productions wouldn't include Portland in their tours, but the 1993 *Phantom of the Opera* was a major turning point. Portlanders bought out five full weeks at the Civic Auditorium for the first time ever. That sent a strong message to producers and agents that our market was ready to see and support Broadway talent.

Portlanders are not lacking when it comes to music opportunities. The city boasts the oldest symphony in the West. Founded as the Portland Symphony Society in 1896, it became a professional organization in 1911, and the Oregon Symphony now boasts a budget of $11 million. Conductor James DePreist says the audiences are enthusiastic and large.

"Our hall seats 2,700 people and we do triple performances of each concert, which few orchestras can boast of these days," says DePreist. "We have one of the highest subscriber bases in the country, and 54 percent of our annual budget is earned at the box office."

The Oregon Symphony has survived a couple of close calls with disaster, including a bankruptcy crisis in the early 1980s and a strike that almost brought the organization to its knees. DePreist calls them "growing pains" that resulted in a stronger, leaner organization. At the same time, the orchestra moved from the Civic Auditorium into the Arlene Schnitzer Concert Hall. This has given musicians a consistent rehearsal and performing space and full-time salaries. Now with six CDs under its belt, the orchestra has achieved major symphony status in the music world.

Under the artistic direction of James Canfield, Oregon Ballet Theatre is a classically based professional ballet company presenting endearing classics, including *Swan Lake*, and contemporary and world-premiere dance.
Photo: © J. David Straub/ Oregon Ballet Theatre.

Above, left
Portland's Opera Company mounts four opera productions a year, including classics like *Carmen*.
Photo: Portland Opera.

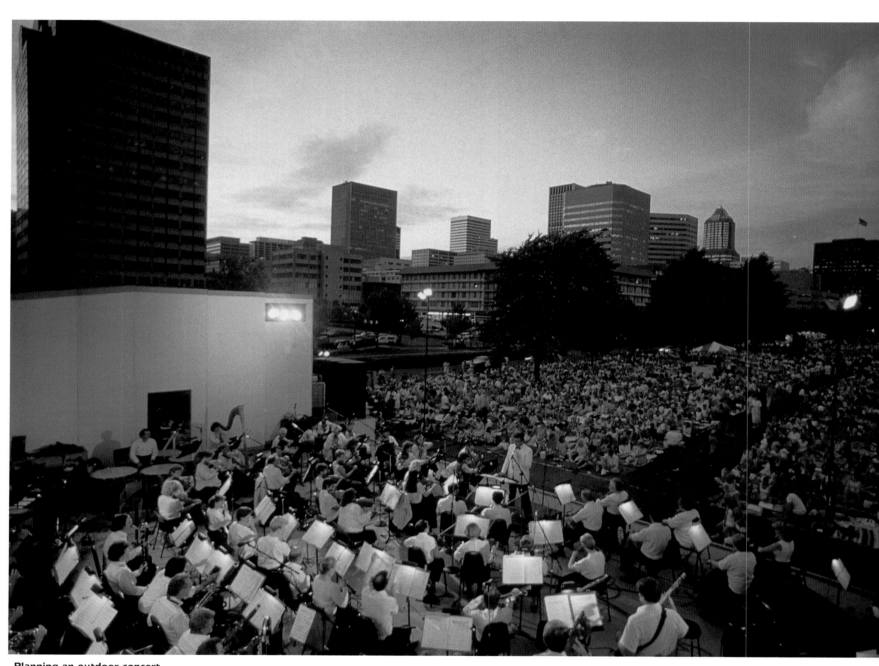

**Planning an outdoor concert
can be a little dicey in a city
known for its rain, but several
are performed each year!**
Photo: © C. Bruce Forster/
Viewfinders.

Portland Baroque Orchestra and Chamber Music Northwest offer music lovers even more variety. The Baroque Orchestra features some of the world's finest period instrument musicians performing classical music that dates back to the 1600s. The intimate performing space of both Trinity Cathedral in northwest Portland and St. Anne's Chapel at Marylhurst University brings the music and musicians closer to its audience. Chamber Music Northwest holds a five-week summer concert series. People often bring their picnics and spread out under the shade on the grounds of Reed College and Catlin Gable School to enjoy these chamber musicians.

Perhaps future professional musicians are already playing in the Portland Youth Philharmonic (PYP). The PYP, under the direction of Huw Edwards, is the oldest youth orchestra in the country, having been founded in 1924. More than 250 student musicians from 100 schools audition for highly coveted spots in three orchestras performing four concerts a year in the Arlene Schnitzer Concert Hall. In addition, the PYP members present free concerts at schools across the state, and the orchestra has toured in Europe and Asia.

Portlanders love their theater, too. Not only do Portland Center Stage and Tygres Heart Shakespeare Company have loyal followings, but Artists Repertory Theatre has also won enough support over the years to recently move from its space in the YWCA to a $1 million-plus home in the Reiersgaard Theatre in upper southwest downtown Portland. This daring company presents some of the city's most difficult shows and has been rewarded by dominating the Portland Drama Critics Circle awards in past years.

For those who can't get enough of those show-stopping numbers, The Musical Theatre Company runs an annual season of four Broadway musicals—from *The Mikado* to *My Fair Lady*. Shows especially for children are seen at the Oregon Children's Theatre Company and the Northwest Children's Theater and School. Triangle Productions, which showcases gay-oriented shows, and Stark Raving Theatre, which produces shows about as exciting as the name suggests, share space at the Theater! Theater! building on SE Belmont.

Sylvia's Class Act Dinner Theatre combines the best in Italian cooking and intimate dinner shows; Do Jump and Imago Theatre challenge their audiences with the unexpected in their very physical performances; and for added variety, there's Painted Maniac Productions, Bridge City Productions, the Eggplant Faerie Players; performance art by the Portland Institute for Contemporary Art; and the Miracle Theatre company featuring plays by Latino playwrights.

Nor are the visual arts ignored. One of the most popular places to be on the first Thursday of each month is near the numerous downtown art galleries as they stay open late to

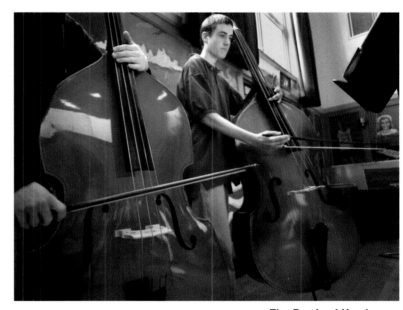

The Portland Youth Philharmonic spends many hours in rehearsal for its two concerts held each fall and spring for over 5,000 school-children in grades 3-8 at the historic Arlene Schnitzer Concert Hall. These concerts introduce children to classical music forms in a concert hall setting.
Photo: Portland Youth Philharmonic.

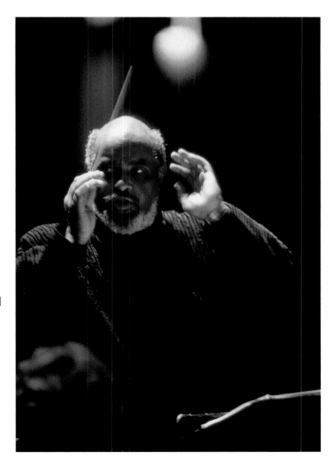

James DePreist, conductor of the Oregon Symphony, is one of the most recognized and beloved figures in Portland.
Photo: © C. Bruce Forster/ Viewfinders.

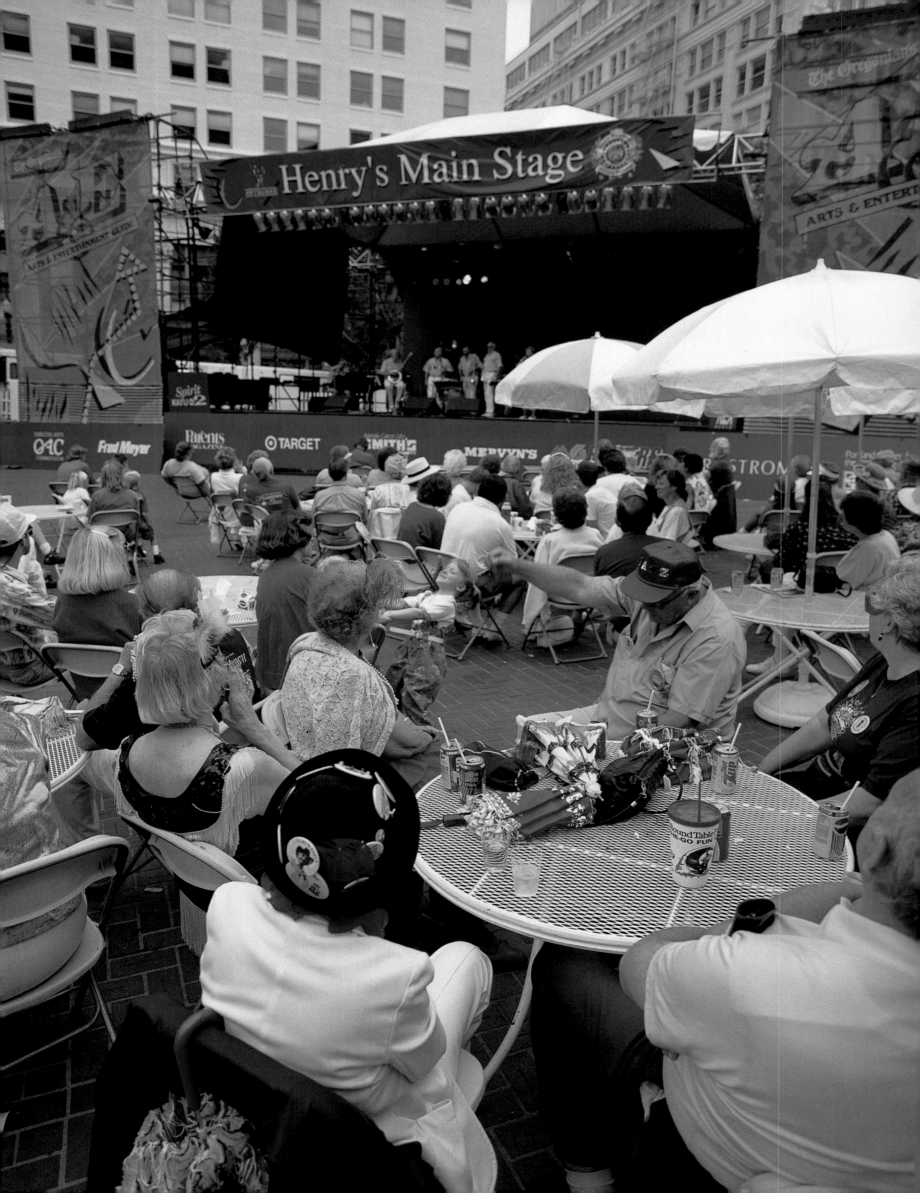

premiere their new shows. Started in 1986, First Thursday has strengthened awareness of and attendance at more than 50 local arts galleries. It has also increased purchases, as visitors to galleries realize they don't have to be wealthy to buy original art, but can often take something home for as little as 100 dollars.

Every Wednesday evening at the Portland Art Museum, from October through April, more than 500 men and women come to check out the art and each other at what has been dubbed Portland's biggest singles party. Museum After Hours features live music, food and drink, and a chance to mingle with other art lovers. It's the cheapest dating service in town.

Yet with all these opportunities for appreciating the arts, there is still cause for concern. The Regional Arts & Culture Council (RACC) says while Portland area arts groups earn approximately 68 percent of their budgets from ticket sales, versus a national average of 50 to 55 percent, and although corporate contributions have doubled between 1990 and 1995, Oregonians continue to lag well behind in individual contributions. State funding of arts programs places 54 among 56 states and territories.

"People assume that due to the current high quality of arts, that the arts are well, or at least adequately, funded. That's not the case," said Bud Lindstrand, the driving force behind the Northwest Business Committee for the Arts (NWBCA). "Many of the best arts organizations may be on the brink of failure."

And, in fact, he's right. In 1998, the Portland Repertory Theatre, which had been entertaining audiences since 1980 and was one of the city's finest equity theaters, closed. It simply couldn't overcome a massive debt, despite loyal audiences and fund-raising efforts.

NWBCA is a group of businesses throughout the four-county area whose goal is to promote adequate funding for the arts. Members encourage even small businesses to give more to the arts, and the group is advocating a small hotel/motel tax dedicated to the arts.

That makes sense to Portland Center for the Performing Arts Director Harriet Sherburne.

"The quality and quantity of the arts in Portland has made the city more of a destination," said Sherburne. "We've always been known for our exteriors—clean, green, and walkable. But the arts make up our interior environment, and that's starting to be reflected in the tourism and convention business."

Arts leaders in Portland agree; the city isn't known for its deep pockets when it comes to philanthropy towards the arts.

"People don't give to the arts at the same level they give, say, to educational institutions," says James DePreist. "We do things modestly here in Oregon."

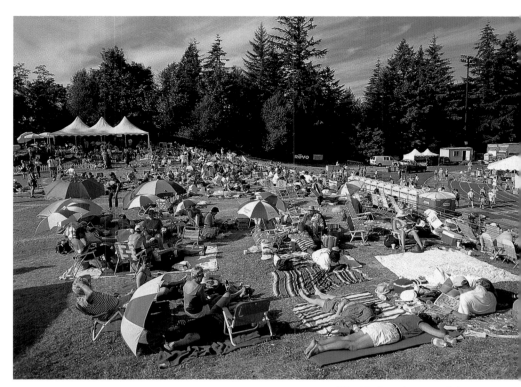

World-class jazz musicians appear each year at the Mt. Hood Festival of Jazz, held at Mt. Hood Community College.
Photo: Steve Terrill.

Opposite page
Summertime concerts in Pioneer Courthouse Square give downtown workers an entertaining way to spend a lunch hour.
Photo: Steve Terrill.

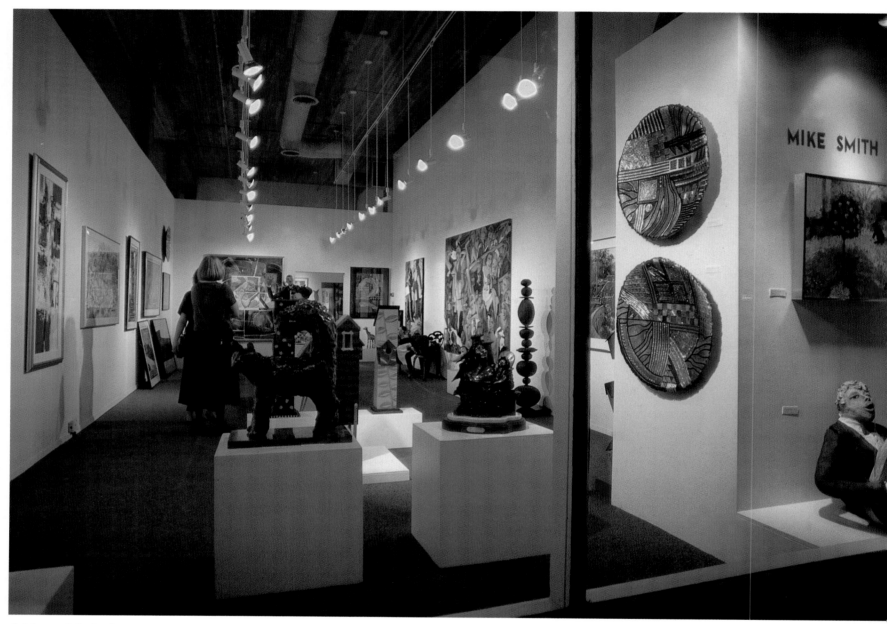

Art lovers take in the newest show on First Thursday, a monthly event when art galleries stay open late.
Photo: Steve Terrill.

Robert Bailey believes the arts are the core of vitality to the city and yet…"The city has not come into the full realization of what it takes to have a cultural community, or what the full benefits are."

And James Canfield believes you must show how you are benefiting the community and being socially responsible. Then the community will step up to the plate and support you. He feels outreach opportunities aimed at children will benefit arts organizations in the long run.

"I can be patient and wait for them to grow up," said Canfield. "I'm committed to this community and I'm in it for the long haul."

Bailey and DePreist would agree. The arts are so important to the fabric of the city, they both say they'll continue to "grow" their audiences and their support.

In the meantime, they'll enjoy giving the best in the arts to Portlanders. That's why Sherburne is optimistic about the future of the arts.

"We're on the cusp—we're at a magic moment," she says. "The economy, physical spaces, and intellectual talent have all come together." ◪

Top
Central to Portland's cultural district is the Art Museum, which sits in the South Park Blocks amid 100-year-old elm trees.
Photo: Steve Terrill.

Bottom
Art in the Pearl attracts artists and craft vendors from across the country for the open-air fair in the Pearl District.
Photo: Steve Terrill.

An annual event for many Portlanders, the Singing Christmas Tree kicks off the holiday season at the Portland Civic Auditorium.
Photo: Steve Terrill.

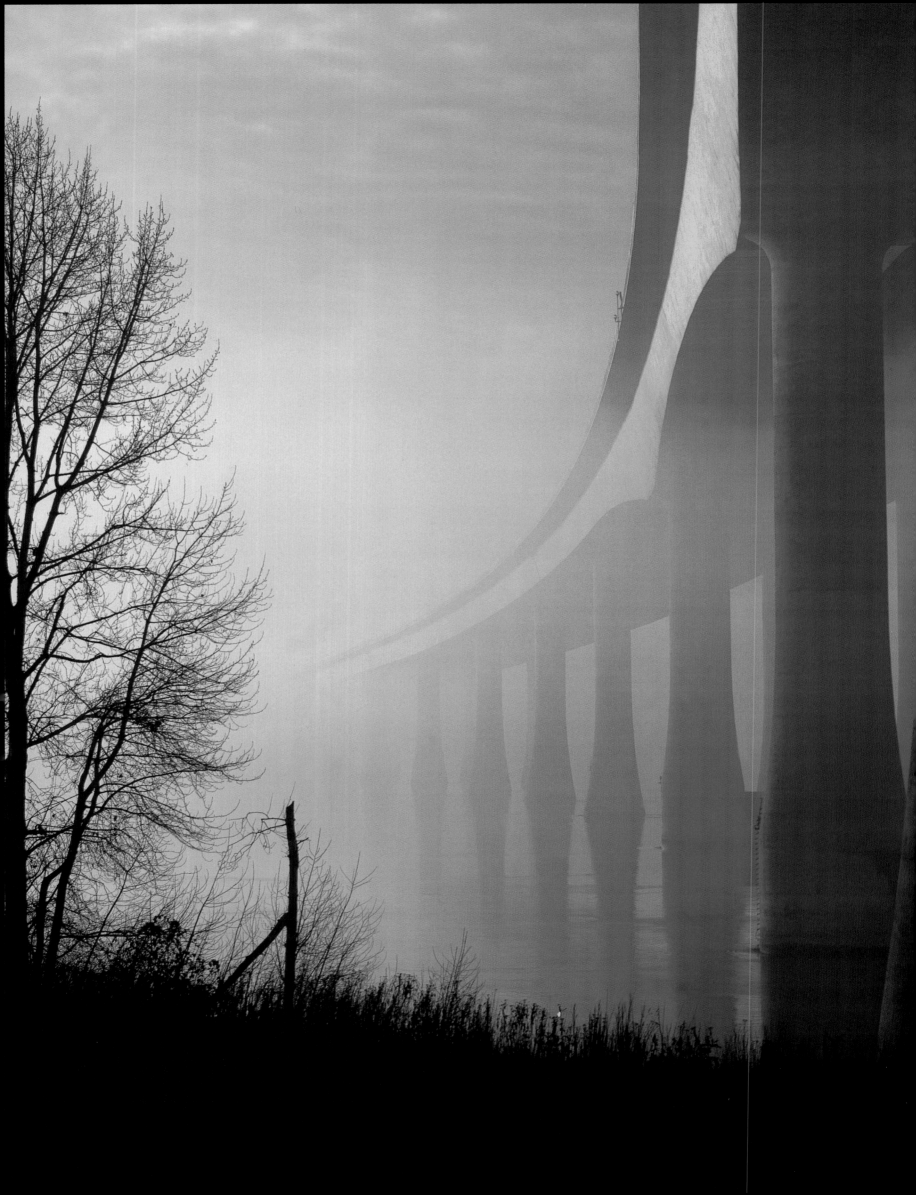

Getting from Here to There

"We are building a city for the 21st century. A livable city has safe neighborhoods, with connected streets, sidewalks, public transit, and bike lanes."

Charlie Hales, Portland City Commissioner

Photos: Steve Terrill

Opposite page
MAX, the Metropolitan Area Express, has proven to be a fast and popular way for commuters to travel to downtown Portland.
Photo: Steve Terrill.

In early spring of 1998, every politician worth his PR machine was at Pioneer Courthouse Square in downtown Portland ready to board a MAX light rail car for its first trip through the new three-mile-long tunnel beneath the West Hills. With both local and foreign news media in attendance, every representative from City Council, Metro, the County Commission, and Legislative District was eager to share in the glory of the latest expansion of light rail.

A far cry from when the first MAX train rolled through town in 1986, and many politicians and pundits predicted that Portland's light rail system would be a "white elephant on rails."

Instead, MAX turned out to be so popular, with ridership far exceeding expectations, that plans immediately began to expand the light rail transit. Today, it's just one more reason why other cities look to Portland as an example of "how to do it right."

Congestion is the number one issue of concern in local community surveys. As the metro region has grown, so has the number of cars on the roads, lengthening commute times. Officials all acknowledge that at our present growth rate, we cannot "build our way out of the problem" simply with more roads. Transit is the best option to solve the commuter crunch.

Fortunately, Portland already has such a strong transit system in place, it makes it easier to build on. Tri-Met, the transit system, has been growing ridership faster than auto trips. It also has higher per-capita ridership than other cities. These are trends that are unique to the country and there are several reasons for it.

G.B. Arrington, Director of Strategic Planning for Tri-Met, says Portland has long had a vision of how it wants to look and has chosen to manage growth and invest in transit to accomplish that vision. Mike Burton, Executive Director of the regional government, Metro, says Portland is unique in how it coordinates transportation issues with land use planning. Both agree cooperation among different cities, counties, and agencies is key to Portland's success with transit.

"You can't talk about Portland's success without saying 'we,'" says G.B. Arrington. "The community really gets the credit for making the decisions. Tri-Met just cuts across all groups in order to get a consensus."

Metro is the designated metro area planning organization for development of an overall transportation plan. Mike Burton says Metro must create a plan of long-range improvements to the region's transportation system, but do so in cooperation with all governments on a state, local, and regional level. A near Herculean effort, but a successful one.

"We plan—Tri-Met executes," says Burton. "But it is possible because we all agree on what we want in the first place."

The numbers speak for themselves. Tri-Met's light rail set a record ridership in 1997, with 9.7 million boardings—an increase of more than a million from the previous year.

Portland's airport serves national, international, and commuter airlines. The recent renovation of the terminal and parking structure will improve access.
Photo: Steve Terrill.

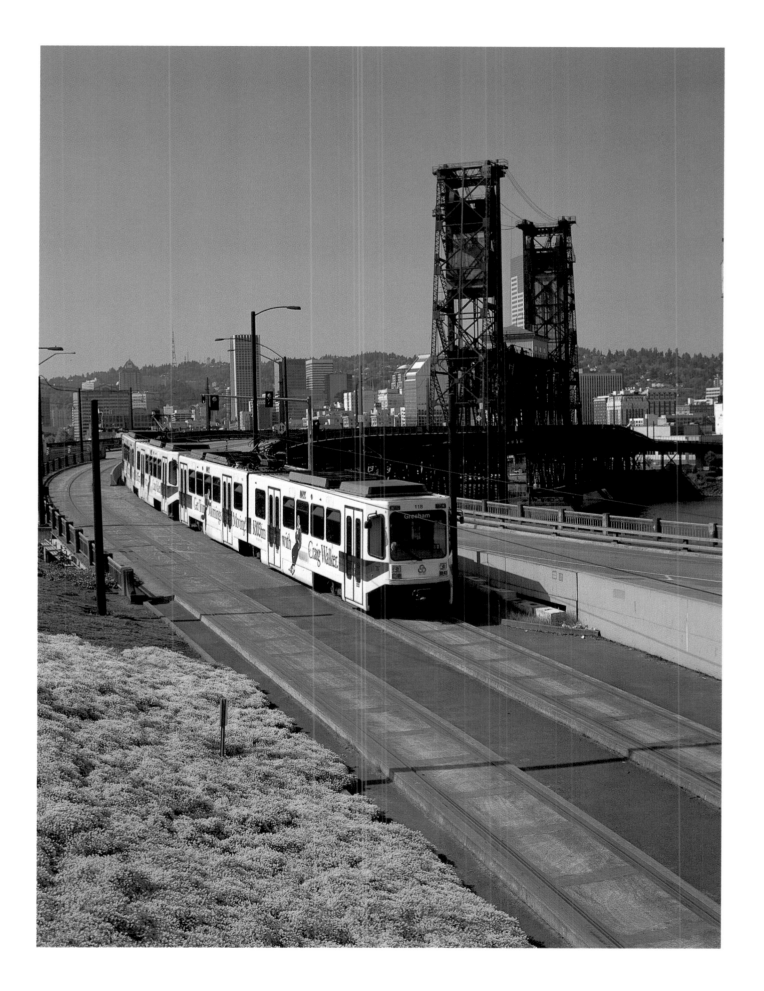

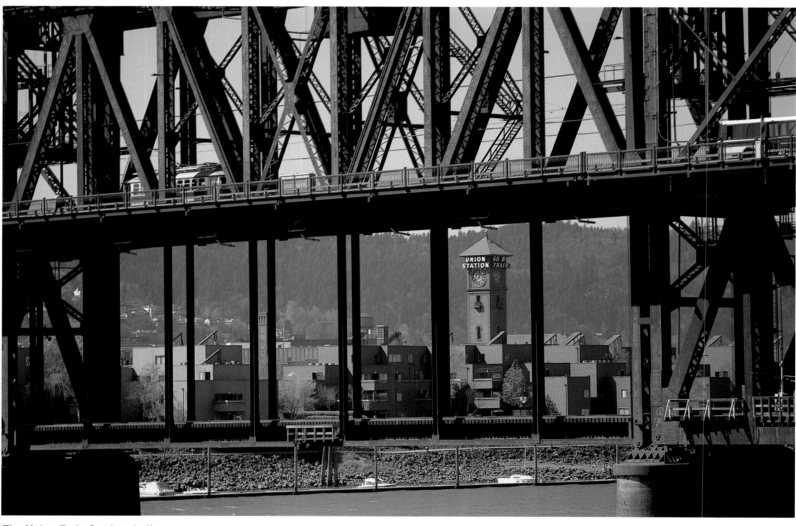

The Union Train Station, built in 1895, is on the National Register of Historic Places. Union Station is where Amtrak passengers arrive and depart.
Photo: Steve Terrill.

Regular buses also saw ridership increase by 3.6 percent with 57.1 million total boardings.

And why shouldn't transit be popular? Not only is it widely accessible, but downtown Portland's Fareless Square allows anyone the opportunity to hop a bus or MAX train and ride it for several blocks for free, an easy way to get around quickly. And in addition to the MAX trains, riders can take replicas of the original Council Crest trolley cars from downtown across the river to the Lloyd Center District. Step onto these beautifully crafted wooden trolley cars, complete with uniformed conductors, and you feel as if you've stepped back in time.

The newest light rail line runs from downtown 18 miles west. It adds 20 new stations and makes the total MAX light rail system 33 miles long from Gresham to Hillsboro. In order to encourage more people to get out of their cars and use transit, station stops are being developed as more than just a place to get on and off, but as an attraction in and of itself, with business, housing, and entertainment. More than $230 million's worth of development is expected along the Westside MAX stations, including 6,000 dwellings.

Officials are already planning the next expansion...the South/North line. This light rail line will run from Clackamas Town Center to Vancouver, Washington, and serve an estimated 40,000 riders a day.

Another proposal calls for a light rail line from the Gateway Transit Center to the Portland International Airport. Not only will this 5.5-mile extension provide an easy commute for some of the 15,000 employees at the airport, but by the year 2001, passengers will also be able to take light rail from Hillsboro right to the front door of the terminal for their flight. Or perhaps they'll travel from downtown Portland to a meeting at the Portland International Center, which will be equipped with a conference center, hotel, and retail.

The popularity of the Council Crest replica trolleys has also given city commissioners ideas. Portland once had streetcars running all through downtown. Now, City Commissioner Charlie Hales is the chief proponent of building a new European-style streetcar that will run from Portland State University in the SW Park Blocks to the popular northwest neighborhoods. This $42-million project may be up and running by 2002.

It's no wonder Washington Governor Gary Locke recently said he envied our light rail system and that Oregonians are "smarter about transportation" than Washingtonians.

Not everyone travels by bus or MAX. Many Portlanders ride their bikes on a regular basis, and the City has a Bicycle Master Plan to increase both ridership and safety over the next 20 years.

There are currently more than 150 miles of bicycle lanes, boulevards, and off-street paths for bikers. Eventually, there will be a 600-mile network of bikeways in the city. Cyclists can park at more than 1,400 publicly installed bike racks, or rent space at one of 190 bike lockers. And bikers can even load their bikes on the bus, since all Tri-Met and Washington State's C-Tran busses are equipped with bike racks.

The racks came as a result of the work of the Bicycle Transportation Alliance (BTA), a statewide organization with 1,300 members that works with the city and other levels of government to make communities a better place to bike. BTA believes when it comes to bike lanes, the more you build, the more bikers will get on the road.

"Bike lanes are like advertising," says BTA Policy Director Rex Burkholder. "And the bikers do come and use them."

While thousands use their bikes for their daily commute, it's also a recreational activity. Events like Bridge Pedal bring out nearly 10,000 bikers for a day of biking back and forth across the Willamette River on nine different bridges.

Portland even tried to encourage non-bikers to pedal more by placing bright yellow bicycles around the city for anyone to use. The idea was anyone could use the bike for a few blocks, or miles, then leave it out for someone else to ride. The Free Bike program was popular, although most of the bikes ultimately disappeared into "private" ownership. Supporters are not giving up, however, and say they will launch another Free Bike program.

Transportation also includes air travel, another major growth area for Portland, as it positions itself to be a major transportation hub and international trade center. Nearly 13 million passengers and more than a quarter million tons of cargo moved through Portland International Airport (PDX) in 1997, prompting a $200-million construction project—the largest renovation in the airport's 57-year history. By the time "PDX 2000" is finished, it will triple nearby parking, double roadway access in front of the terminal, and expand the terminal's ticket and baggage areas.

PDX is run by the Port of Portland, whose entire reason for existing is to help the city and

Portland is blessed with a river that runs right through the heart of the city. Barge traffic is a common sight on the Willamette.
Photo: Steve Terrill.

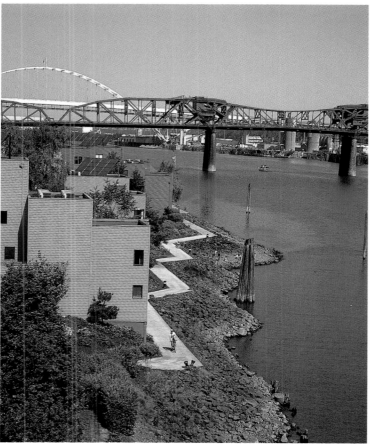

Walkers along the Willamette River at McCormick Pier in northwest Portland see a wide variety of river traffic.
Photo: Steve Terrill.

Portland has a good freeway system, which is one reason why the average commute to work is so short.
Photo: Steve Terrill.

state's economy compete in a world market. Transportation is at the very foundation of our region's economy—how cargo moves from place to place to support the marketplace.

An efficient and well-structured transportation system drives a sustainable economy. In Portland, we don't consume all the products we produce, so we must find markets for them and have a way to get them there.

"You can take any industry in the area, and the reason it works is that the transportation system allows people and goods to move to compete in a global marketplace," says Mike Thorne, Port Executive Director since 1991.

In addition, Portland is blessed with an excellent river system. If you look at the major metropolitan communities in the world, 80 to 90 percent are located on a river or waterway. Because of the Willamette and the Columbia, Portland has become an agricultural gateway to Asia, and is the largest wheat exporter in the nation and the second largest in the world.

But it isn't just wheat. Portland is the tenth largest metropolitan retail/wholesale trading center in the United States. Remarkable when you consider how much lower our population is compared to other cities.

Transportation is more than barges, airplanes, or railroad cars. More than 100 trucking companies have either their headquarters or distribution headquarters located in Portland. More evidence that we are a transportation hub.

So what's the economic impact of all of this on citizens? Transportation is a fundamental key to making business work. An efficient transportation system allows a company to receive manufacturing components on a "just-in-time" basis. This avoids the costs of warehouses and excess inventory. That keeps costs down for a business and, ultimately, for the consumer. The region's high-technology industry thrives with minimal inventory, in part due to the ability to get materials easily and just when they're needed.

Mike Thorne believes Portland has such a stellar reputation for transportation because we've historically kept ahead of our transportation needs financially. But today, there's less money available from the federal government and the state. Governor John Kitzhaber has made transportation a key issue for his administration. He seeks millions in new dollars to maintain and expand the state's transportation infrastructure.

What's at stake, many believe, is nothing less than the future of our economy. We'll suffer as a region if we don't adequately fund our transit, river, railroad, air, and road systems. ◪

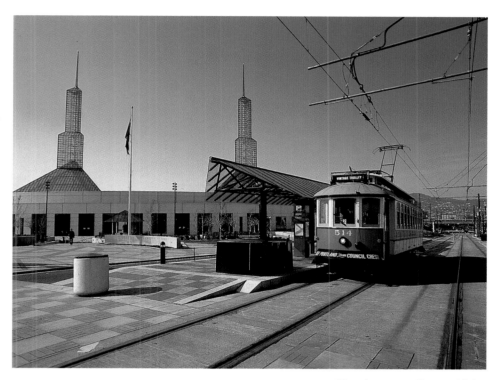

The vintage trolleys, which travel between the Lloyd District and downtown, are replicas of the original trolley cars that went up to Council Crest.
Photo: Steve Terrill.

Like any big city, Portland has a rush hour. That's why transportation and government leaders plan for future growth with commuter options like light rail.
Photo: Steve Terrill.

A major port, tons of cargo go in and out of Portland every year, from wheat to automobiles.
Photo: Steve Terrill.

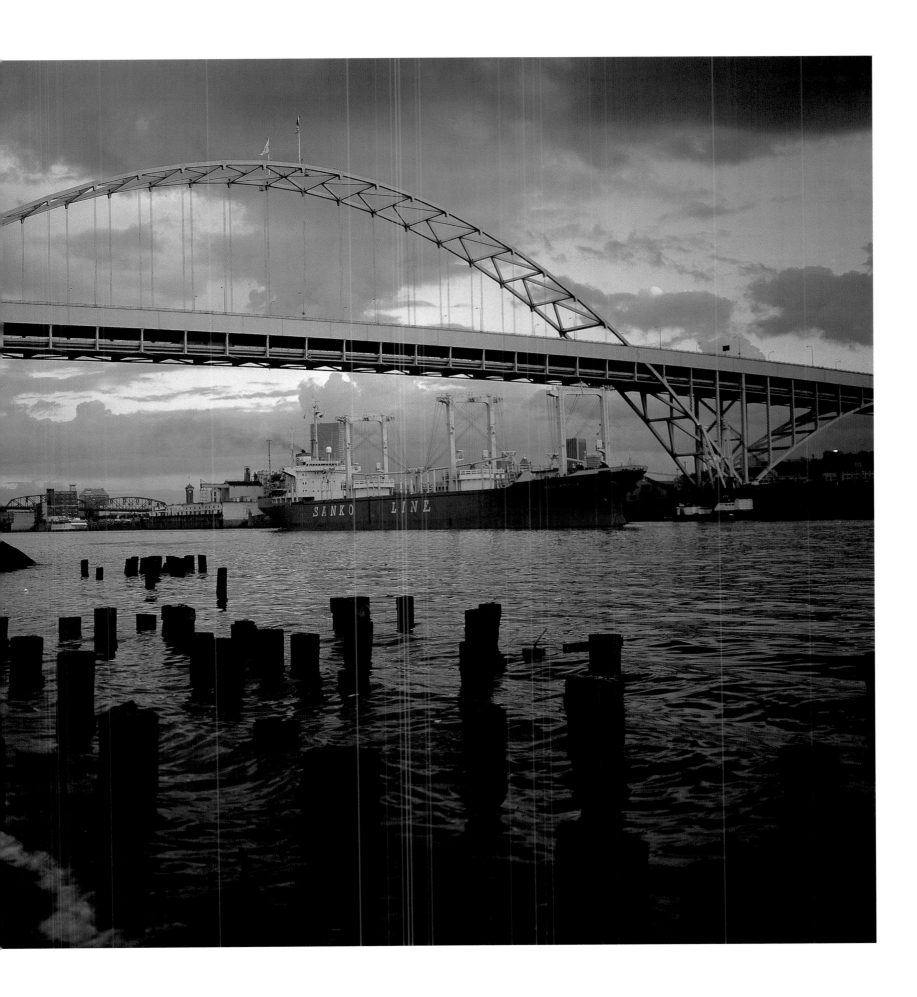

Brews, Books, & Lattes

The Passions of Portlanders

"Our mission is to improve everyone's sense of taste."

Stanley Selland, Marketing and Community
Relations of Coffee People, Inc.®

◢

Photo: Larry Geddis

Opposite page: Steve Terrill

One of the first drive-through coffee bars in Portland, Motor Moka lets you get your cappuccino to go!
Photo: Larry Geddis.

It's been said that if you can't ask for a specialty coffee drink without using at least three adjectives, you're not a real coffee lover and you're definitely not a true Oregonian. In Portland, you'll find more than coffee lovers. You'll find coffee fanatics who line up every morning for their double-tall-no-fat-light-foam latte like so many groupies waiting for tickets to their favorite band's concert. The lines literally stretch out the door.

There are no fewer than 160 retail coffee shops in the Portland area, and that's not counting the little latte stands you'll find in malls or on street corners downtown. The signs of our coffee habit are everywhere. There's a newspaper column, "Coffeehouse Kids," written by two teenagers dedicated to critiquing local coffeehouses; celebrity judges who decide who serves the best cup of coffee in the annual "Portland Cup;" and even some fast-food restaurants that offer cappuccinos ("You want fries with that?") to their customers.

The coffee market in Portland is very competitive and getting more so every day. But even though Starbucks® may outnumber the smaller coffee shops three to one, Coffee People Inc.® can still set up right across the street from a Starbucks® and still do a good business. That's how popular coffee is in the Northwest.

Does the weather play a part? Possibly. The cool, wet weather certainly strengthens the appeal and enjoyment of a hot beverage. Some also credit the high number of Scandinavians here, a culture famous for its love of strong, dark coffee. But Taylor Devine, president and CEO of Coffee People®, believes it's the atmosphere of the coffee shop itself that people enjoy, an atmosphere that is transferable from cool, wet Portland to hot, sunny Phoenix.

There is no typical coffee drinker. You'll see a Mercedes and a BMW at a Motor Moka coffee drive-in right behind a pick-up truck and a van. (Yes, there are actual drive-in coffee shops in Portland—just one more example of our desire to get our favorite drink quickly and conveniently.) Step into any coffee shop and you'll see teens enjoying a nonalcoholic place to hang out, Gen-Xers, Baby Boomers, and older adults all enjoying their favorite cup of brew.

Such diversity is the mission behind the Northwest coffee company Coffee People Inc.® Founded in 1983, this company

Foaming, hot, and fully "caffeineated," a Caffe Uno latte is ready to help start someone's day.
Photo: Steve Terrill.

A leisurely cup of coffee and the latest news entice a few Portlanders to put off other errands for now.
Photo: Steve Terrill.

seeks to unite "…a diverse group of people in an atmosphere of acceptance and respect where all can enjoy coffee's energy and naturalness."

Coffee really started to take off in Portland about 1987. A few years earlier, espresso shops were growing in California, in the Santa Cruz area. But when it spread to the Northwest, it took off with a popularity that surprised everyone. Overnight, it seemed, there were coffee shops offering drinks never before heard of, let alone tasted, in Portland—lattes, espressos, cappuccinos, and more.

Coffee houses have become the "community center" in many neighborhoods. It's where you see familiar faces, have a favorite spot to curl up with your latte and a newspaper, meet friends, and exchange gossip. In that way, today's coffee shops are not much different from the coffee houses in England in the 1600s. Coffee houses were the focus for the literati and intelligentsia of the town. Much business was conducted over cups of steaming brew, and even the famous Lloyd's of London started out as a coffee shop.

The connection between people who drink coffee and people who read has always been strong, and it continues today. Reading and the literary arts can be said to be the second passion of Portlanders.

There's an old story that describes a branch in the Oregon Trail. The route south to California was marked by a heap of gold quartz, while the one north by a sign lettered "To Oregon." Those who were greedy went south; those who could read came here.

We still love to read. In Portland, going to bookstores isn't an errand—it's a recreational activity. On rainy days, it's a grand place to spend a couple of hours pouring over a volume in solitary contemplation, or to meet friends in the bookstore café for a cup of coffee and a bite to eat.

Why is Portland such a town of book-lovers? Michael Powell, of Portland's famous Powell's Books, says there's no easy answer. He credits our school system, which he calls one of the best, the overall high level of education among adults, and a generally homogeneous population with little in the way of huge income disparities.

But he also says there's a kind of cultural belief that fuels the optimism that Portland is more literate than other places.

"There is a larger pool of people who read and think and worry about the issues of life. I can't prove it one way or another," says Powell. "But experientially, I can tell you we have an enormous, wide, diverse audience for books. And that's refreshing."

Powell's challenges that audience of readers by having a wide and diverse collection of books. One million-plus volumes. More than one-half million titles. This, when the average new bookstore has a mere 125,000 titles.

But all bookstores seem to do well. There are hundreds of bookstores in the Portland area—large chains as well as the smaller independent neighborhood bookstores. Portlanders support their libraries, too, continually voting to tax themselves for the sake of bettering their lending libraries.

Portlanders have no lack of literary opportunities. The Sunday *Oregonian* newspaper devotes a third-of-a-page to list book readings, book signings, and writing workshops. Local publishing houses are flourishing. SMART (Start Making A Reader Today), a program started by former Oregon Governor Neil Goldschmidt, brings hundreds of volunteers into community schools to help children with their reading skills. And Literary Arts Inc. is a statewide, nonprofit organization that supports books and the people who read, write, and publish them.

Literary Arts Inc. presents the Oregon Book Awards, which the *Oregonian* called "…the state's most significant literary event." Each year the jury reviews some 89 to 110 submissions and awards prizes in the categories of poetry, fiction, nonfiction, young readers, and drama, as well as giving special awards.

In its mission to support the written word, Literary Arts offers fellowships ranging from $500 to $2,000 that encourage writers and small publishers to stay in Oregon. It also created the Portland Arts and Lectures Series—a six-part series featuring well-known authors.

It may well be the largest bookstore in the world. Powell's world of books stocks more than a half-million new and used titles on its seemingly endless wooden shelves.
Photo: Steve Terrill.

Opposite page
If you don't want to take advantage of Portland's many bookstores, you can always find a library nearby.
Photo: Steve Terrill.

Julie Mancini is director of the Portland Arts and Lectures Series. She says when it began in 1984, a house of 300 or so could be expected. Today, more than 1,000 regularly attend, and occasionally, the 2,776-seat Arlene Schnitzer Concert Hall is sold out.

Portland Arts and Lectures was based on a successful similar lecture series in Washington State. But it wasn't easy to convince authors to stop here. They were going to Seattle and San Francisco, but Portland was overlooked. Now, the Rose City is a mandatory stop for many famous authors such as John Updike, Joyce Carol Oates, Margaret Atwood, Garrison Keillor, and Maya Angelou, to name just a few of the literary luminaries who have graced the stage of the series in recent years. They know they'll find an intelligent audience eager to hear more about the craft and art of writing.

Mancini puts it this way: "The city embraced having these writers come and talk. I never thought it would be a success of the magnitude it has."

Mancini says the true mark of how successful the Portland Arts and Lecture series is can be seen in two ways. First, the inability to find a given book in any bookstore the day after an author has come to talk about it, and secondly, the many other lecture series that have moved into the market.

There can be no doubt that Portland, and the state as a whole, have a very strong and connected writing and reading community. For Portlanders, reading is truly a lifelong activity.

And the third passion of Portlanders? Why, it's beer of course. Beer has been popular in the city since German brewer Henry Saxer settled in Portland and opened a brewery in 1852. He later sold his brewery to Henry Weinhard. Blitz-Weinhard Brewing Company is still a landmark in Portland's Old Town.

Aside from Prohibition, not much of interest happened in the world of beer until 1984, when Portland's first microbrewery, Bridgeport Brewing Company, was founded. The following year, Kurt and Rob Widmer established a German-style brewery and introduced Hefeweizen to Portlanders' vocabulary and taste buds.

Also in 1985, the Oregon Legislature passed a law allowing brewers to sell beer directly to the public, rather than just in kegs. Two brothers, Mike and Brian McMenamin, seized the opportunity to open the city's first tavern/brewery. Still in business, the Hillsdale Brewery and Public House was the start of a genuine love affair between Portlanders and a glass of foamy, hand-crafted beer. The McMenamins have gone on to dominate the microbrew scene, with an additional 34 brew pubs statewide, three combination movie theater/pubs, and brew-pubs/bed-and-breakfasts. The brothers' showpiece, the Crystal Ballroom, with its famous "floating dance floors," features live music six nights a week and is keeping ballroom dancing alive with its special Sunday dance series.

In all, there are more than 40 microbreweries and brew pubs in Portland, more than any other city in the country. No wonder we've earned the title "America's Microbrew Capital."

Like our love of coffee, it's hard to explain why Portlanders love a good glass of ale or lager. But the numbers speak for themselves. The Oregon microbrewery industry produced approximately 137 million pints of beer in 1996. And while nationwide, microbrewery sales are only 2 percent of all beer sold, Oregon's microbrewery sales account for nearly 10 percent of sales.

These beer-makers take their craft seriously. In 1992, brewers formed the Oregon Brewers Guild that supports the marketing and promotion of breweries. The Guild has its own "Quality and Integrity" logo to identify true Oregon beers. And they've even got their own Web page.

For the same reason vineyards do well in Oregon, hops also flourish in the state's mild climate. In fact, Oregon produces 19 percent of the nation's hops. And the great diversity of microbrews is no surprise when you learn that in the Willamette Valley alone, farmers grow more than 14 different hop varieties.

We don't like to brag, but we take beer seriously here. What more proof do you need than to know that beer brewing is part of the college curriculum at Oregon State University in Corvallis. The Department of Food Science and Technology features a fermentation science class that is helping establish Oregon as a prime location for hands-on beer studies.

Can't get to class? No problem. On-site do-it-yourself breweries let you brew and bottle your own lagers and ales. There are two of these "U-Brews" in the Portland region, letting beer enthusiasts create their own micro-microbrewery.

Want to sample every kind of microbrew around? The three-day Oregon Brewers Festival, the largest of its kind in North America, makes it easy. Held in July, it draws some 80,000 beer lovers to Tom McCall Waterfront Park to sample local, national, and international brews.

From the largest craft brewer in Portland, Widmer Brothers Brewing with 140,000 barrels per year, to Saxer, Oregon's only microbrewery dedicated exclusively to lagers, it's no wonder some people call Portland "Beervana—a beer lover's paradise." ◢

At the Portland Brewing Brewhouse Taproom and Grill, visitors can watch the brewery at work as it produces several beers and ales with its Bavarian brewery equipment.
Photo: Steve Terrill.

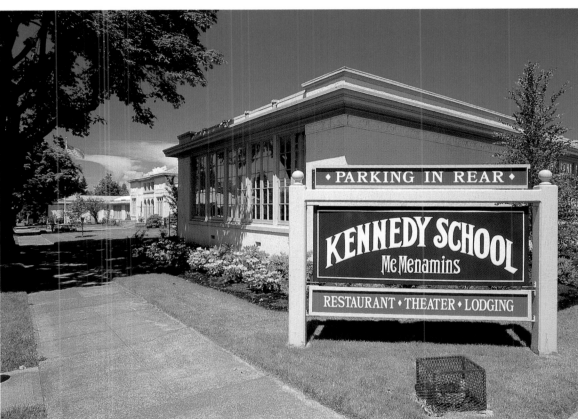

Above, right
Kennedy School, a brew-pub and restaurant, is just one of the projects of Portland's famous McMenamin brothers, who have revolutionized the industry.
Photo: Steve Terrill.

Above, left
Hops grown in the Willamette Valley give their distinctive flavor to many of Portland's microbrews.
Photo: Steve Terrill.

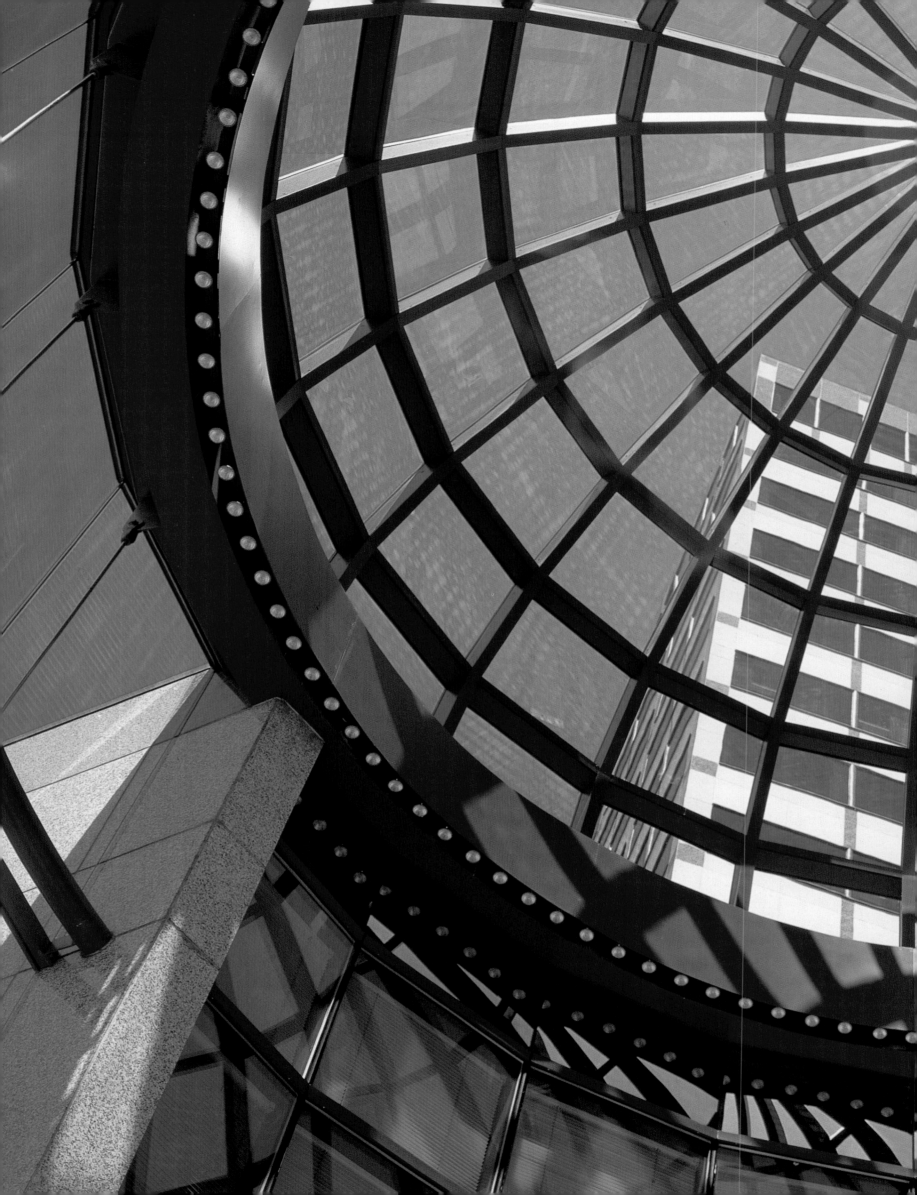

Part II
Portland's Enterprises

Photo: Larry Geddis

Transportation, Communication, & Energy

Photo: Steve Terrill

KATU

In a era of hostile takeovers and giant conglomerates, KATU stands apart from the crowd with especially familiar ties to the region it serves; Channel 2 is the only television station in Portland owned by a Pacific Northwest company. The station's switch was first thrown on March 15, 1962, in a structure that dated from the turn of the century, formerly occupied by the Crystal Laundry. There were 30 employees and the station broadcast just under 12 hours each day. Today,

A winning combination! Channel 2 News' Emmy Award-winning anchor team (from left to right), Meteorologist Jim Bosley, Anchor Steve Dunn, Anchor Julie Emry, and Sports Director Steve Arena. They deliver the most-watched newscasts in the Northwest.

with a staff of 180, the station is on the air 24 hours a day, every day of the year. It also maintains a fully staffed news bureau in Washington, D.C., along with satellite offices in Vancouver, Washington, and at the state capital in Salem.

KATU has witnessed many "firsts" in its nearly four decades. And all that experience has provided a special understanding of the region and the people who live here. The Power of 2 is more than a slogan; it is a fact demonstrated by the amount of local programming produced by KATU, more than any other Portland station. It is also reflected in program continuity. "AM Northwest" is in its 23rd year,

unprecedented tenure for a Portland television program. The Executive Producer of Local Programming, Frank Mungeam, calls it "More than a TV program. It is a positive part of the community and a vehicle for expressing our local pride. Viewers tell us they appreciate the positive and enthusiastic nature of the show."

Jim Bosley was the original host of "AM Northwest" and has been doing the program ever since. "The first guests were then-Mayor Neil Goldschmidt and his wife and kids," recalls Bosley. His enthusiasm remains high. "I just love the atmosphere and the audience. When people respond, when they get something out of it, that's when I feel best." Bosley's length of service has also been a factor in KATU's success as the market's news leader. He continues to present the weather forecast in the early evening newscast. "We've come a long way. Technology has been the big change. It's still a challenge but we're now more accurate than we've ever been."

Another program that demonstrates KATU's commitment to the community is "Town Hall," which has highlighted local issues of importance every Sunday evening in prime time for 22 years. This type of program is rare in the nation; continuing it for over two decades is virtually unheard of. The high level of viewer support confirms the community impact of both programs.

KATU Senior Vice President and General Manager Jim Boyer has introduced a groundbreaking approach to maintaining effective communication between viewers and the station. When a viewer calls KATU, instead of getting a switchboard operator, a customer service representative answers. "The object is to respond directly. If a viewer calls with a question, concern, or complaint, they need talk with only one person. That person will either have the answer or will get the answer and call back with it. We want to solve the problem and explain it personally to the viewer." The department provides regular reports about viewer concerns and interests, which often guide the station in its development of special programming.

"We are broadcasters but we are also active members of the community," emphasizes Boyer. "We have a sense of pride and community involvement which carries over not only in our programming but also to the things we do in the community." That commitment was dramatically demonstrated in 1997. Through telethons and other on-the-air campaigns, KATU

Another phase of the station's continuing education program is courses taught by university professors. These classes emphasize professional skills. KATU is open to flex time and job sharing. Employees are also encouraged to consider jobs in other departments if they see an opportunity for more job satisfaction. "We'll do just about anything," says Allen, "to keep a good employee." Looking to the future KATU awards two Thomas R. Dargan minority scholarships annually. Along with the $4,000 scholarships, the winners are guaranteed paid summer jobs with the station.

Weather Anchor Rhonda Shelby is chair of the committee which selects the recipients. The committee includes KATU employees and three members of the community. "We look for people who want to be in the Northwest. And we give them real jobs so they can discover what this business is all

helped raise over $7 million for a variety of charities. The $4.5 million collected for the Doernbecher Children's Hospital during the Children's Miracle Network Telethon was the most generated by any station in the nation. KATU also contributed broadcast time for public service announcements that amounted to $1.75 million. "We are committed to the community, and we wish to excel at contributing to the community," says KATU Vice President and Station Manager Jan Allen.

KATU is one of the few companies which pays employees to work in the community. Each KATU employee may take two paid days off annually for volunteer efforts. "They may do whatever is important in their lives," explains Allen. In-house training is also available to KATU employees. Several times a year, three-day seminars are conducted which deal with the culture and commitment of the Fisher Company. "We encourage employees to help make this a better place to work," according to Allen.

Experts on the skies! The Channel 2 News Weather Team (from left to right), Jim Bosley, Rhonda Shelby, Katy Brown, and Rob Marciano.

about. Our ultimate goal is to have them working in the company after college." Shelby attended college through a minority scholarship, so the Dargan program is "very close to my heart."

A "team approach" is basic in the KATU Sales Department's service to its clients. It is another important part of the Power of 2. "We have led the market in the key area of marketing services," says Department Manager Diane Gervais. "It ensures that our clients get results." KATU provides extensive market research to clients in dozens of categories, from shopping malls to hospitals. The Semiconductor Workforce Consortium hired KATU to promote careers in the semiconductor industry. The atypical client has a typical customer reaction. "The partners were very pleased with the campaign," declared Project Manager Marcia Fischer. "We found the KATU staff to be extraordinarily professional and creative."

The KATU sales department has considerable expertise in

Surrounded by dozens of TV monitors and thousands of buttons (from left to right), Director Anthony Brock and Technical Director Rich Dargan prepare for news time in the KATU Control Room. This is where the newscasts are produced and directed each day.

A live studio audience joins hosts Rebecca Webb and Jim Bosley each morning for "AM Northwest." Portland's only live, local, daily talk show has helped viewers start their day for more than 20 years.

helping local clients collect co-branding, or cooperative, financial support from national distributors. And the station is equipped to support clients in their overall marketing strategies, not just those involving television. "We have a team of marketing experts who are experienced not only in advertising but also have retail backgrounds," explains Gervais. "So our clients know we understand their business." A production department equipped with the latest state-of-the-art equipment provides clients with dramatic and sophisticated visual results.

KATU's news department sets the standard for television news coverage in Oregon. From 5:30 Monday morning through 11:30 Sunday night, the station broadcasts 28 hours of local news. More than a million viewers tune in during that

time to find out what's going on in their region and their neighborhood. For the last seven years viewers have chosen KATU's evening news programs as Portland's ratings leader, an extraordinary achievement in the sometimes mercurial world of television. News Director Gary Walker declares it is his determination "to be connected with the people in the community, to present news that is relevant to their lives, and to do it in an interesting way."

KATU's innovative neighborhood news line receives 15,000 to 20,000 phone calls a year from viewers who know of stories that have not traditionally been covered by television news. A staff of five collects those tips, which result in more than 2,500 stories a year. "If we find an interesting local story, we'll cover it," says Walker. And those stories help explain to residents of other neighborhoods what is going on in their city. The quality of KATU's coverage has been recognized with regional Emmy awards, Associated Press citations, and the prestigious national Edward R. Murrow Award from the Radio, Television News Directors Association.

And there have been other changes. News anchor and reporter Paul Linnman started as a film editor in 1968, a position, he smilingly points out, that no longer exists. "We're

Even though KATU Channel 2 is housed in a turn-of-the-century building, continuous renovations keep the station looking state-of-the-art.

microwave-equipped news vans, KATU has the ability to explain to viewers what is happening from multiple locations simultaneously.

KATU continually updates equipment and renovates its facilities, and that modernization has intensified as the station enters the age of digital and high definition broadcasting. All present analog broadcast equipment will be replaced during the next five to ten years. Ten to $20 million will be spent to design and construct a new digital television station in the same space. General Manager Boyer predicts, "The distribution system may change, but we're still going to be producing local programs and news. However, you may very well see it on your computer. It opens a lot of programming opportunities." Boyer concedes the transition will have profound technical effects on how his station functions. He emphasizes, however, that the basic standards of the station will not change.

The KATU philosophy, summed up in its mission statement, is concise and precise: "A place where we're better tomorrow than today. A place without barriers. A place where people choose to be accountable for their actions. A place that is responsive to viewers and clients. A place that leads and gives back to the community."

Concludes Boyer, "We believe in this community. We take pride not only in what we do but also where we do it. We define ourselves as *The* local station." ◪

Experience the Power of 2! Jet Ranger One and Jet Ranger Two cover the skies for Channel 2 News. KATU is the only Portland television station with a helipad on the roof.

looking at stories where people live and that impact them on a daily basis." Reflecting over three decades, Linnman adds, "The young people here are better prepared and may understand a bit more about the world than I did at their age. It seems to me we're better at communicating with our audience than we've ever been."

News specials have made an important contribution to such communication. Every year KATU focuses on issues of concern among viewers with one-hour specials. Many of them deal with issues faced by parents in the '90s. KATU is committed to continuing its response to such matters of community interest. KATU is the leader in covering high school sports in Oregon. For the tenth season "Friday Night Sports Extra" covers 15 to 20 high school football games each week. The 30 minutes of prep highlights features a studio audience. School pep bands add to the fun and excitement.

The Power of 2 includes the latest technical equipment to get the job done. It is the only station with a pair of news-gathering helicopters. With the helicopters, a satellite truck, and a fleet of

Let's take a look at the tote board! The Children's Miracle Network Telethon, a benefit for Doernbecher Children's Hospital, annually raises millions of dollars in just one weekend. In 1998, viewers helped KATU raise more than $5 million for local kids.

Workers raise a pole in Ashland, Oregon, in 1920. The company began in 1910, serving 7,000 customers in Oregon and Washington.

PacifiCorp established its reputation as a progressive electric utility from its very first days in business.

Known then simply as Pacific Power, the company was established in 1910 through the consolidation of several smaller power companies. The young company served some 7,000 customers in a variety of growing Northwest communities from Astoria, Oregon, to Yakima, Washington.

Pacific decided to stake its claim in the fledgling power industry by instituting a then unheard-of practice—providing electricity 24 hours a day. Back then, customers simply expected the lights to go off when the power operator went home for the night. By leading the industry rather than following it, Pacific began as it meant to go on.

Today, PacifiCorp is a multibillion-dollar, multinational, energy services company whose shares are traded on the New York Stock Exchange. From its humble beginnings, Portland, Oregon-based PacifiCorp has mushroomed both at home and abroad. The company's activities now span numerous U.S. states as it serves some 1.4 million retail electric customers and scores of wholesale power customers. The company that once ran the streetcar business in such rural communities as Astoria, Oregon, and Walla Walla, Washington, now provides the electricity for state-of-the-art light rail services in urban centers such as Portland and Salt Lake City.

Overseas, PacifiCorp is building its reputation as well. The company serves some 550,000 customers in the Australian state of Victoria and is involved through joint ventures, consulting agreements, and equity interests in numerous countries around the world.

Even more change is on the horizon for PacifiCorp because the electric utility business itself is changing. For decades, the industry has operated as a monopoly. Companies such as PacifiCorp have served franchised service areas and offered carefully regulated rates. But customers nationwide are demanding the right to choose who supplies their electricity. With that, the tightly controlled world of monopoly service territories and regulated rates is falling by the wayside. As the industry struggles to meet those new challenges, *Forbes* magazine describes PacifiCorp as one of the energy companies best-positioned to deal with deregulated electric markets and the competition that will bring. The Electricity Supply Association of Australia has cited PacifiCorp as demonstrating the "world's best practices" in its generation, transmission, and distribution operations.

PacifiCorp garners such honors due to the company's fundamental strengths as a progressive electric utility: its ability to deliver low-cost electricity, its skill in managing fuel and generating resources, its environmental stewardship, and its ability to energize the spirit of the communities it serves.

First and foremost, PacifiCorp is a low-cost provider of electricity to its wholesale and retail customers.

When the 1989 merger of Pacific Power and Utah Power formed PacifiCorp, the company gained much more than an expanded service area. It created an unparalleled transmission system that gave customers the advantage of diversity. Rainy Pacific Northwest winters and homes largely heated by electricity had always meant Pacific Power built its generating capacity to serve the peak winter needs of its customers. In summer, those same plants sat largely idle as customers opened their windows and enjoyed temperate weather. In contrast, Utah Power's mountain service area was mostly stressed during the intense heat of summer, as sweltering customers sought the relief of air-conditioning. For Utah Power, winter was the off season. With the merger of the two companies, each became able to take advantage of the other's idle season. The electric plants that heated Northwest's homes in the winter could now help cool Salt Lake City during the stifling heat of summer. Massive electric generating plants dotted throughout the rural landscapes of states such as Utah or Wyoming could now be called on when Portlanders cranked up the heat in response to bitter winter winds.

That seasonal diversity left PacifiCorp with excess power to sell. In addition, regulatory approval of the merger had required the newly formed company to make excess capacity on its vast transmission network available for sale to other utilities. The two factors combined to create a burgeoning new business in wholesale electric sales, which still stands as one of the company's greatest assets. PacifiCorp's high-voltage, open access transmission service today connects more than 50 electric entities and is one of the largest such systems in the U.S.

When coupled with the efficiency of seasonal diversity, the company's profitable wholesale business created a boon for PacifiCorp customers. The combined cost and operating efficiencies helped the utility emerge as one of the West's lowest-cost energy providers.

Yet running a successful electric utility involves more than poles, wires, and moving power from place to place. It involves careful management of power plants and fuel sources, encouraging customers to conserve energy when possible, environmental stewardship, and simply lending a helping hand to communities where the company does business.

PacifiCorp excels at helping its customers to become more competitive by reducing fuel costs through careful management and conservation. The company is also involved in transporting fuel, managing fuel contracts, and as owner/operators of coal mines. The subsidiary Interwest Mining Co. alone produces some 22 million tons of coal annually. PacifiCorp has also recently added natural gas sales to its energy portfolio through its acquisition of Houston-based TPC Inc.

But managing vast resources brings with it great responsibility. That is why PacifiCorp is a leader in environmental stewardship and actively explores the use of new energy resources. It is through these actions that PacifiCorp provides proof that companies can do well by doing good.

With more than 70 percent of its coal produced from surface mines, PacifiCorp has dedicated itself to careful site reclamation. The rewards range from honors by peers and regulators for outstanding work at the Centralia Mine in Washington State, to the breathtaking sight of wild horses grazing the restored grasslands near the Jim Bridger Coal Co. mine in Wyoming.

A worker secures an osprey nest near power lines along Oregon's Klamath River. PacifiCorp has installed hundreds of perch guards and nesting platforms on power poles to protect birds of prey.

Solar II in Daggett, California, is one of PacifiCorp's renewable energy projects. The 41.4-megawatt Wyoming Wind Energy Project won the first-ever Clean Energy Award from Renewable Northwest Project.

Operational excellence results in service reliability and is the product of skilled and dedicated employees.

Cooling water recycled from the Hunter and Huntington coal-fire electric plants is being used to irrigate alfalfa, barley, and other crops in central Utah. Ratepayers and shareholders benefit, too, as the company saves an estimated $8 million a year over traditional wastewater disposal costs at these two locations alone.

Similar approaches toward recycling of materials save money throughout the company while saving the earth's precious resources. Aluminum, copper, and steel are routinely recovered at all locations. Used oil from vehicles and from transformers is recycled, filtered, and put back to use. Scrap wood is recycled into pressed wall board. Fly ash, the residual product left after burning coal to produce electricity, is sold to companies which use it as a cement additive.

PacifiCorp bears the distinction of being the first utility in the nation to offer its customers zero-interest loans for installation of energy conservation measures. That commitment to both customers and conservation continues today in PacifiCorp's Energy FinAnswer program. The program helps businesses cut their energy consumption through measures such as energy management systems, high-efficiency heating and cooling technology, and improved lighting. Two landmark properties served by the program bear witness to its success. FinAnswer adjustments saved the owners of the Rose Garden Arena in Portland some 4 million kilowatt hours each year. The owners of Salt Lake City's famed Salt Palace are saving an even more startling 5.2 million kilowatt hours annually. The annual savings from those two buildings alone is enough electricity to serve some 900 homes.

Always seeking new ways to become more efficient and environmentally friendly, PacifiCorp has made significant strides in the use of renewable electric generation. Renewables are forms of electricity powered by the gifts of nature—water, sun, wind, and the earth's geothermal heat. Unlike fossil fuels such as petroleum, the earth naturally renews its supplies of each of these nonpolluting fuels.

Water-fueled electric generation, known as hydroelectric power, has been serving the Pacific Northwest for generations. PacifiCorp operates more than 1,000 megawatts of such generation. The Blundell geothermal plant in Blundell, Utah, has been serving PacifiCorp customers since the 1970s powered by heat released from natural fissures in the earth's surface. But where PacifiCorp stands a leader is in its use of the latest developments in solar and wind technology.

Though solar and wind technologies still cannot match the cost of more traditional fossil-fuel sources, the innovative projects of companies such as PacifiCorp are taking us ever closer to that point. PacifiCorp has invested about $1.3 million in Solar 2, the world's most advanced solar-fueled electricity generation facility. Located in the baking heat of California's Mojave Desert, the experimental facility uses molten salt technology to capture and store the energy of the sun. The project provides power for some 10,000 homes—even at night.

PacifiCorp's wind technology investment is even more promising. The company is 80 percent owner of the Wyoming wind energy project, a commercial-scale wind farm located between Laramie and Rawlins, Wyoming, on the gusty eastern slopes of the Rocky Mountains. The company is partnering in the project with the Eugene Water and Electric Board and the federal Bonneville Power Administration. The wind facility can provide electricity to as many as 24,000 customers.

Since 1993, PacifiCorp employees have joined hands with their local communities to better their corner of the world. In Salt Lake City, employee volunteers plant shade trees with the help of a PacifiCorp GreenCorp grant.

Utah's Huntington Canyon Power Plant exemplifies a commitment to a clean environment. The plant burns low-sulfur coal and removes most sulfur dioxide that remains after combustion with special devices called scrubbers.

Frederico Peña, then-U.S. Secretary of Energy, praised the project. "This project helps push wind energy into the mainstream, while contributing to a cleaner environment," said Peña.

A concern for the environment—and the communities it serves—shows up throughout PacifiCorp both at home and abroad.

Close to home, that concern is evident from neighborhood substations to huge, rural generation facilities. Landscaping emphasizes native plantings, creating greater harmony with natural surroundings, and reducing the need for artificial irrigation. To discourage birds of prey from landing on power poles and transmission towers, PacifiCorp has installed hundreds of nesting platforms for the safety of birds such as hawks and osprey. The efforts so impressed the National Fish and Wildlife Foundation, it presented PacifiCorp with a first-ever award for excellence in environmental protection.

The company is also a careful steward of natural environments for use by the general public. Since the first few picnic tables were placed beneath the trees at its Merwin hydro facility back in the 1930s, PacifiCorp has been offering the public abundant opportunities to enjoy the outdoors. Lands surrounding 53 of its electric generation facilities now offer a variety of wholesome activities, including fishing, boating, camping, and bird-watching.

The commitment to preserving and improving the natural environment is closely tied to PacifiCorp's dedication to the communities it serves. Thousands of employees volunteer hours each year speak to that commitment. Employee-initiated projects range from stream clean-up projects to planting butterfly gardens to creating innovative employee transportation plans to reduce energy consumption and vehicle emissions.

In recognition of its role as a global corporate citizen, PacifiCorp looks beyond its geographic boundaries for innovative environmental solutions. Because of its concerns about

the potentially harmful effects of global warming, PacifiCorp has joined with a handful of other utilities and environmental groups such as the Nature Conservancy in carbon dioxide mitigation projects in Central and South America. The company is also involved in many smaller projects at home in an effort to determine effective, yet cost-efficient, ways to deal with the political and scientific issues surrounding the global warming controversy.

Whether half a world away—or in your own back yard—PacifiCorp remains dedicated to progressive technologies and policies to better serve its customers. ◢

Wild mustangs live outside PacifiCorp's Jim Bridger thermal plant in Rock Springs, Wyoming. The company draws its 7,334.3-megawatt net capacity from 15 thermal electricity generating plants in five states.

PacifiCorp's boating, fishing, and camping facilities along Washingon's Lewis River are popular recreation sites. PacifiCorp maintains 53 such parks in seven states, most located near hydroelectric generating plants.

Natural gas, because of its clean-burning properties and its abundant supply, is often called "the fuel of today and tomorrow." PG&E Gas Transmission-Northwest provides enough natural gas, on a typical day, to heat 11 million homes. If that were converted to electricity, it would amount to about one-and-a-half times the amount of electricity used daily in Oregon, Washington, and Idaho.

In 1993 a pipeline parallel to and interconnected to the original system was opened. That increased PG&E GT-NW's capacity by about 60 percent. The system provides important flexibility to those it serves. A customer's firm service can be augmented through interruptible transportation. The system also allows a non-firm customer to use the pipeline when firm customers are not using all their allotment.

PG&E Gas Transmission-Northwest's headquarters building

The system has the capacity to transport more than 800 billion cubic feet of gas every year. That's a third of all the natural gas exported annually from Canada, making the company the largest U.S. transporter of Canadian natural gas.

The 612-mile system opened nearly four decades ago. The pipeline, which begins at the British Columbia-Idaho border, carries natural gas across the rich desert of central Oregon and the Siskiyou Mountains to the California border.

There are 37 delivery points along that route, including major interconnections with Williams (Northwest Pipeline Corporation) at Spokane, Washington, and Stanfield, Oregon, and with Tuscarora Gas Transmission Company near Malin, Oregon.

Through the use of parking, a customer may "store" gas in inventory for later withdrawal. Through lending, a client may "borrow" gas for a specific time.

Customers may also move gas into and out of their own "paper pools" to increase flexibility in the purchase and sale of gas. And they may market their reserved capacity to other shippers. There are occasions when such adaptability can be vital to the business interests of PG&E GT-NW clients.

More than 45 companies receive firm transportation under long-term contracts. Firm and interruptible delivery is also provided to more than 150 clients.

The experienced PG&E GT-NW coordinators know the pipeline system and the requirements and preferences of those they service. Customers know they can rely on these experts to manage their day-to-day and hour-by-hour gas flows.

PG&E GT-NW's dedication to training is reflected in an enviable safety record. The result is that the system's reliability and ratio of capacity utilization are among the best in the industry. The firm's electronic communication system, Pacific Trail,® is recognized in national surveys as one of the most user-friendly in the industry. It is another demonstration of PG&E GT-NW's dedication to innovation and to the development of technology that best serves its customers.

PG&E GT-NW has a firm commitment to the development of services which support its customers' abilities to respond to changes in their markets. The firm's rates and regulatory affairs team has been influential in shaping policies affecting the gas industry, including open access, unbundling, and the pricing of pipeline services.

PG&E GT-NW's constructive relationship with its primary regulator, the Federal Energy Regulatory Commission, has helped it pursue innovative approaches to customer service.

The U.S. Forest Service and other organizations have cited the firm for its efforts to protect wildlife habitat and air quality. During construction projects, workers receive comprehensive and continuing instruction in environmental sensitivity and its application to work practices. Native Americans have advised the company in how to conduct projects which may impact cultural sites. The PG&E GT-NW objective is to leave the land the same as it was, or better.

The firm's environmental commitment extends to the indoors as well. Its company-wide recycling program was built into its spectacular new headquarters building along the Willamette River in Portland. Recycled materials were used throughout the structure, and its shape and orientation toward the sun reduce air-conditioning demands. Chutes on each floor quickly and conveniently transport recyclables to a central collection site. As a result, the amount of useful office material recovered is much greater than that collected from garbage facilities. When an office space is vacant, sensors turn off the lights. Reflectors bounce sunlight from ceilings and lights are automatically dimmed.

It is estimated that as a result of the attention to conservation and efficiency, PG&E GT-NW's corporate headquarters building uses a third less energy than other structures its size. The downtown location also means employees may get there conveniently by mass transit. PG&E GT-NW pays a share of the fare to encourage such energy conservation.

The firm aims to be a responsible community citizen through its support of a broad range of civic and cultural programs. And many of PG&E GT-NW's approximately 250 employees volunteer in the places where they live.

The firm has demonstrated through experience and accomplishment that it is able to identify new markets, secure regulatory approvals, and allocate assets in a timely and effective fashion.

These attributes are reflected in PG&E GT-NW's strong earnings and enviable evaluations from rating agencies. Just as it did when it built the first high-tech pipeline in North America, the company looks to the future with continuing dedication to the advancement of technology in the interests of those it serves. ◢

NW NATURAL
Fired Up to Fuel Portland

Just weeks before Oregon officially became a state in 1859, two young men saw the future flickering beyond the candles and kerosene used to light Portland's streets and homes, and began Portland Gas Light Company. Today, it is NW Natural, and it has expanded its customer base from 49 in less than one mile to 458,000 in two states today.

NW Natural's service territory includes the Portland-

NW Natural, headquartered in the Old Town section of downtown Portland, Oregon, with seven district offices, serves more than 458,000 customers in northwest Oregon and southwest Washington.

Vancouver metropolitan area, the Willamette Valley, the northern Oregon coast, and the Columbia River Gorge. The area served by NW Natural is one of the fastest growing regions in the country. In the last seven years alone, NW Natural's distribution system has grown by more than 172,000 customers.

For 250,000 Portland households, keeping warm, cooking meals, washing and drying their clothes, and taking a hot bath is due to NW Natural's clean, efficient, and low-cost fuel.

Each day, 28,000 Portland businesses rely on natural gas for their operations. In downtown Portland alone, 7,700 businesses use natural gas.

NW Natural President and CEO Richard Reiten leads the company in its commitment to be the best local gas distribution company in the country.

The economic growth and development in the Portland metropolitan area and throughout Oregon has led to a higher demand for this highly efficient, low-cost energy source. To meet demand, NW Natural has expanded its distribution and transportation system.

Factors contributing to the expansion include newer applications for natural gas in the home, such as barbecues, and a 20 percent annual growth in sales of gas fireplaces, gas fireplace inserts, and log sets. With gas fireplaces in more than 70 percent of the new homes built in its service territory, NW Natural is in a prime position for continued growth.

Though the market is in place, NW Natural isn't just waiting for the business to roll in. Instead, it's focusing on customer service. As customer choice and competition come to more energy customers, NW Natural plans to be the energy provider of choice. To do that, it is committed to being fast, flexible, and responsive to customers' needs. The company is already known for its exceptionally high levels of service, which may explain why 85 percent of customers in its service area choose natural gas service.

A thriving Oregon economy, bolstered in part by growth of the high-tech industry, fosters this growing service territory. The region's economic growth, which began in Portland, now extends from Clark County, Washington, to Eugene, Oregon, along the I-5 corridor, which is the heart of NW Natural's service territory. Nationally, NW Natural is considered one of the country's fastest growing local distribution companies.

Utilities are often judged by their record of outages and amount of time required to fix those outages. NW Natural has an outstanding track record, with only once—in its 139 years of operation—experiencing a complete interruption of service during the devastating Portland flood of 1894. Learning from that experience, the company built its next

coal gasification plant (a production method now long out of use) above the high-water mark.

As competition increases and the energy industry changes, NW Natural plans to offer consumers a broader array of products and services. Richard Reiten, NW Natural president and CEO, emphasizes that while the company intends to grow, it has no intention of de-emphasizing its natural gas business. "Make no mistake: our core business is, and will continue to be, selling and transporting natural gas—our region's clean, efficient, preferred energy source," Reiten said.

While remaining an independent company, NW Natural seeks strategic alliances with other companies to provide additional energy services in response to customer needs. For example, in 1997 NW Natural entered into a marketing alliance with PacifiCorp, which allows the two companies to jointly market natural gas and electric commodities and related energy services throughout Oregon and Washington as opportunities become available. By joining forces, the company is better able to give customers in this region the very best in local, reliable competitive products and service.

"NW Natural has a commitment to remain an independent, local company with Northwest values and a Northwest heritage," says Reiten. "In an era of mergers and acquisitions in the energy industry, we feel it is important to reassure our customers that we're here to stay."

Where does NW Natural's gas come from? The company originally produced gas by carbonizing coal which was transported by barge from Vancouver Island in Canada. In 1913, the company built its third (and final) gas manufacturing plant, Gasco. The plant manufactured gas from oil, and the company sold several by-products from this process. Coal briquets, the principal by-product, were delivered to homes and businesses. In 1955, by-product revenues accounted for roughly one-third of gross company revenue.

The company switched to natural gas in 1936. Natural gas was piped into the company's distribution system though 1,500 miles of pipeline. The pipeline originated in the San Juan Basin in New Mexico and subsequently extended north to Tacoma, Seattle, and the Canadian border.

Today's economy mirrors that in place when NW Natural founders began the company. Continuing high levels of customer service and keeping plants above the high-water mark mean Portland customers can count on NW Natural to provide them with natural gas for at least another 139 years. ⌐

NW Natural works hard to be a good community member. Here an employee volunteer visits an elementary school and conducts an interactive presentation about the principles and safety aspects of natural gas.

NW Natural strives to provide excellent customer service in all aspects of its business: from the customer service representative who takes a customer's call, to the service technician who inspects the natural gas equipment in a customer's home.

Portland General Electric has a long history of connecting people, power, and possibilities. It started back in 1889—only 30 years after Oregon became a state—when PGE produced the nation's first long-distance transmission of direct current electricity.

The firm, called the Willamette Falls Electric Company in those days, transmitted power from a generator at Willamette Falls in Oregon City 14 miles downriver to streetlights in Portland. This was just PGE's first step in bringing to Oregonians the possibilities that electricity could provide.

Every year, hundreds of PGE employees pitch in at the SOLV beach clean-up.

EARLY GROWTH

PGE's predecessors also introduced the first electric trolley line on the West Coast. The trolley system, which PGE ran until 1946, changed Portland. It helped the city's boundaries grow. Residents could live further out in the "country" but still reach downtown quickly to work or shop.

As automobiles became popular, the trolley lines began to fade. But household electrical demand was on the rise. PGE not only sold electricity but also sold electrical appliances to help drive the demand. By 1938, electricity moved to the countryside. PGE provided power to 86 percent of the farms and rural homes in its service area—the national average was only 19 percent. Demand continued to grow and exploded following World War II.

TODAY'S SAFE, RELIABLE SERVICE

The System Control Center is the hub of PGE's distribution system.

Today, PGE serves nearly 1.5 million people over 3,170 square miles. This area includes 44 percent of Oregon's population and 60 percent of the state's economic base. These residents and business owners use over 17 billion kilowatt hours of electricity each year.

Customers no longer expect trolley rides or electrical appliances from PGE. Instead, they simply count on PGE for safe, reliable electrical service. They trust that when they flip a switch, the power is on. And, on those rare occasions when the power is out, because of harsh winter winds or ice, they know that PGE crews will have their power restored as quickly as possible.

"Our top priority is make sure our customers have dependable electrical service. That is what we're committed to, every day, just as we have been for more than 100 years," explains Peggy Fowler, PGE president.

To make that promise a reality, the staff at PGE's System Control Center is continuously monitoring and controlling the entire electrical grid, 24 hours a day, 365 days a year, to make sure the power is there when customers need it. PGE's line crews are vigilant about maintaining and repairing their substations and 24,114 miles of transmission and distribution wires. PGE also maintains a nationally recognized tree-trimming program that patrols along the entire distribution system to help prevent outages.

Volunteers help plant trees as part of the Friends of Trees' "Seed the Future" campaign, which helps restore Portland's "urban forest."

LOCAL COMMITMENT

PGE is a wholly owned subsidiary of Enron Corp., one of the world's largest integrated natural gas and electricity companies. PGE is also still very much an Oregon company, with a strong commitment to the local community. The nearly 3,000 employees who work for PGE care about the neighborhoods in which they live and the people they serve.

Ken Harrison, chairman of the board and chief executive officer, puts PGE philosophy this way: "We're more than the power company; we're also your neighbors. So we're deeply committed to supporting programs that improve the health, safety, and livability of Oregon."

PGE contributes money, expertise, and thousands of hours of employee volunteer time to helping improve local communities.

One example of PGE's commitment is their "One School at a Time" program, which links PGE employees with needs in their local schools. Employees can volunteer in the schools and also nominate schools for grants to help with anything from computer equipment to arts programs or even an area rug where primary students can gather for story time.

As a company deeply rooted in Oregon, PGE is also involved in helping the environment. They sponsor Friends of Trees' "Seed the Future" campaign. This campaign, which is aimed at restoring Portland's urban forest, will have helped plant more than 144,000 trees and seedlings by the year 2001.

PGE is also a major supporter of Stop Oregon Litter and Vandalism (SOLV), and PGE employees are regular volunteers in SOLV's projects—painting over graffiti, distributing litter bags at the PGE-SOLV Starlight Parade, and cleaning up illegal dump sites.

These are just a few highlights of PGE's commitments to the communities it serves, and its contributions as a good corporate citizen earned PGE the Mayor's Spirit of Portland award for continuing community involvement.

THE FUTURE

The electricity industry is changing rapidly as it moves from an era of regulated monopolies to a time of competition. And as the future brings changes and choices, customers can continue to count on PGE to deliver power, safely and reliably. And PGE will continue to be actively involved in supporting and improving local communities.

PGE equipment and methods have changed in a hundred years. PGE convictions have not. ◪

PGE linemen, pictured here with Mt. Hood in the background, work vigilantly to maintain and repair their substations and 24,114 miles of transmission and distribution wires.

The Pacific Northwest is renowned for its scenic treasures—the Cascade Mountain Range, rain forests, the panoramic Pacific Coastline, vast, arid desert, and the inspiring beauty of the Columbia River.

A BPA high-voltage transmission tower in eastern Oregon is part of the highway that distributes roughly half the electricity used in the Northwest.

Crown Point, a viewpoint on the Oregon side of the Columbia River. Bonneville Dam in the background is a vital part of the river flood control system.

The Columbia and its tributaries define the Pacific Northwest. As the river flows from deep in the Canadian Rockies to the Pacific Ocean, it is fed by rains and melting snows, ensuring the continuous cycle that supplies the lifeblood of the region.

All this natural splendor also provides one of the most reliable, low-cost power generating systems in the world. It began in the late 1930s during President Franklin D. Roosevelt's "New Deal" era. A growing need for inexpensive electric power in rural areas of the Pacific Northwest gave birth to one of the most ambitious public works projects in U.S. history, the Federal Columbia River Power System. The goal was to generate low-cost power for rural electrification and regional economic development by harnessing the tremendous hydropower potential of the Columbia River.

In 1937, President Roosevelt signed the Bonneville Project Act, declaring that "the facilities for the generation of electric energy...shall be operated for the benefit of the general public, and particularly of domestic and rural consumers." It also established the Bonneville Power Administration (BPA), a federal power marketing agency headquartered in Portland, Oregon.

BPA was designed to pay its own way without burdening U.S. taxpayers. And so, the U.S. Treasury "loaned" the money needed to construct hydroelectric projects and a massive transmission grid, requiring that the money be paid back with interest. BPA built and runs the transmission lines; the U.S.

Army Corps of Engineers and Bureau of Reclamation built and operate the dams. Within three decades, 29 nonpolluting hydroelectric generating facilities were built on the Columbia River system.

The result is a reliable, low-cost system which generates nearly half the electricity used in the Pacific Northwest. For over 60 years, the Corps, Reclamation, and BPA have worked together to manage the operation of this extensive hydroelectric system for the benefit of Pacific Northwest residents. While rural electrification was a primary purpose of the dams' federal power, the projects also provide flood control for public safety, irrigation for agricultural development, commercial waterways, and reservoirs for recreational use and sport fishing. There was no more dramatic demonstration of the public safety benefits of the system than in the winter of 1996. River system operations prevented an estimated $3 billion in flood damage in downtown Portland, while keeping the lights on.

In the 1980s, BPA pioneered use of energy conservation to avoid the high cost of building new power plants. From 1982-96, the agency invested $1.6 billion in energy efficiency, and saved enough energy to keep the lights on in Boise and Eugene. The agency continues to invest in renewable resources, such as wind and geothermal projects.

BPA is committed to responsible stewardship of the region's federal hydro system. The agency funds about 300 projects a year to restore and protect fish and wildlife affected by the hydropower system. The projects range from repairing spawning streams to researching fish diseases and controlling predators. BPA works with state and federal agencies and Northwest Indian tribes to manage the most comprehensive fish and wildlife protection effort in the world. It has invested $3 billion in fish and wildlife protection since 1980.

The 1992 National Energy Policy Act introduced deregulation of the electric utility industry. Federal regulators wanted high-voltage transmission facilities to be organized in regional nonprofit grids, acting as common carriers for power from all sources over long distances. In response, integrated electric

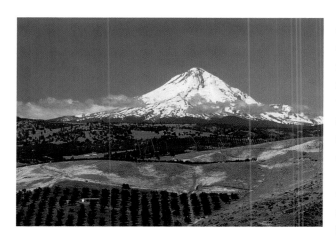

utilities had to split their operations into separate power generating and transmission businesses. Open access to transmission was the first step in setting the stage for consumer choice. Individual states will decide their own rules for how retail consumers will choose among competing power suppliers.

As a result of deregulation, BPA's nearly 15,000 miles of high-voltage transmission system is now managed by Transmission Business Line, located in Vancouver, WA. It is responsible for electricity distribution across approximately 300,000 square miles of service territory. From its Dittmer Control Center, it schedules and dispatches wholesale power marketed by BPA's Power Business Line and other electric power providers. BPA's power is generated by hydroelectric facilities and one nuclear plant. Construction began on several small renewable resources (wind and geothermal) in the late 1990s. The agency will also market the power from these projects when they are completed. Surplus power that is not used to serve the Pacific Northwest is sold into Canada and the Southwest markets.

In addition to selling environmentally friendly power, BPA also provides time-of-day pricing, energy management services packaged with power delivery, and custom billing for aggregated services. The agency's $2 billion in annual sales revenue pays the following:

- the U.S. Treasury debt,
- the bonds that financed construction of the Washington Public Power Supply System's WNP-2 nuclear generating plant located in Richland, WA,
- programs to offset damage to fish and wildlife from the federal hydro system,
- operation and maintenance of power and transmission facilities,
- and BPA's other public responsibilities.

In the late 1990s, BPA began installing a fiber-optics communications and control network to improve the reliability of its system operations. BPA has also established partnerships with several private telecommunications companies. In

exchange for investing in the projects, companies were given exclusive rights to market the excess capacity BPA did not need for system operations. Rural utilities located along BPA's fiber routes can work with the telecommunications companies to extend the available fiber into their communities. Having a high-quality telecommunications link to the world would remove a major obstacle to community and economic development.

BPA has adapted to a changing business environment by cutting its operating costs. From 1995 to 1998, the agency reduced its workforce by nearly 25 percent. In addition, it implemented new, more efficient business practices. Through these efforts, the agency was able to lower customer rates, while cutting projected costs by over $600 million. Still, BPA continues delivering clean, low-cost hydropower so vital to the region's economy and quality of life.

There are many good reasons why people choose to live and work in the Pacific Northwest. Regardless of whether you live here, or simply visit the region on business or pleasure, BPA will keep the lights on for you. ◢

Celilo Falls, an ancient Indian fishing site on the Oregon side of the Columbia River. Snow melt from Mr. Hood in the background is an important renewable source of the nonpolluting electricity distributed by BPA.

Grand Coulee Dam, largest dam on the Columbia River, produces as much electricity as six nuclear plants. It provides irrigation for half-a-million acres of farmland.

"America's business moves on the wheels of trucks that move by the skill of their drivers. We salute the truck drivers of America and thank you for including us on your run. We wish you fair weather, good roads, a fast trip, and a safe return."

That sentiment expresses the feelings of the Jubitz family about those they serve. That involvement in trucking began with Monroe Albin "Moe" Jubitz. After five years with Portland-based Wilhelm Trucking, he was convinced of the opportunities for a truck leasing operation in the Portland market. In 1952 he founded Fleet Leasing, Inc. It was the

Jubitz Truck Stop, I-5 at Exit 307 in Portland, offers full services for the professional truck driver. Since 1958, Jubitz has been one of the best known independent truck stops in America.

Caring for the needs of truck drivers nationwide and Northwest-based truck fleets of all sizes, Jubitz Tire & Retreading delivers fast, efficient service in first-quality new and Bandag retreaded tires to commercial customers throughout Oregon and Washington.

beginning of Jubitz Corporation, and the introduction of an idea whose time had come. Monroe Jubitz listened to truckers and responded to their needs. "Truckers really appreciate it when you sit down and listen to their concerns," observed Monroe Jubitz. "Their comments gave me the direction I needed to grow my business."

Six years later, in 1958, he moved his business to a site near the future Interstate 5, which, over the next 15 years, became one of the best known full-service facilities of its kind in the country. Today, the business built by Monroe Jubitz and his sons, Al and Fred, has become a small conglomerate of services to the trucking industry, organized into four divisions. The Jubitz Fleet Services Division operates, as its core business, a Pacific Pride card-lock fueling franchise. Fleet Services also provides drug and alcohol testing, highway use and fuel tax reporting, insurance services, safety consulting, and other safety compliance products which help the trans-

portation industry meet Department of Transportation requirements.

Jubitz Truck Stop, known locally as a great place to dine and dance, has become a nationally recognized 24-acre complex, with truck repairs services, motel, restaurant, lounge, convenience store, and "Club 307," which provides business services for truckers.

A third division, Jubitz Tire and Retreading, serves the local commercial trucking business with new tires as well as Bandag retreads manufactured by the company.

The Jubitz family introduced a fourth division, DAT Services, in 1978. Today, DAT Services is the North American leader in computerized matching of available freight and trucking equipment. DAT Services maintains TV advertising monitors in more than 1,000 major truck stops across the nation, and posts available loads and provides freight-matching information to transportation companies via phone, fax, PC, and satellite-fed desktop terminal. In addition, Jubitz Corporation is allied with other truck stop operators in SmartStop, Inc., a telecommunications company developing a voice, video, and data network in truck stops designed to connect drivers, truck stops, and fleets throughout the country. There are over 500 Jubitz employees in Oregon, California, Florida, Tennessee, Canada, and Belgium. These employees follow the philosophy that drove the company at its beginning nearly a half-century ago: listen to and respond to the customer.

Giving back to the community is another Jubitz family tradition. Jubitz Corporation budgets a percentage of its pretax

profits to contribute to community programs that benefit children, families, and the transportation industry. The company also supports programs that provide educational opportunities. Al and Fred Jubitz became copresidents and cochairmen when their father retired in 1996. They follow in his footsteps in contributions to the community. For three decades Monroe Jubitz, along with Al and Fred, has served in many capacities for organizations that support children's charities and educational institutions, as well as trucking industry trade associations.

Al and Fred Jubitz are dedicated to continuing their family's tradition of innovative business services. "It's the obligation of business to find better ways to serve the customer. Our goal is to make Jubitz the very best home away from home for the truckers who move America's freight," declares Fred Jubitz. "We must also remember our sense of place in the business and civic community. Equally, we strive to make Portland, Oregon, an even better place to live and raise a family." Al Jubitz adds, "Truckers have a difficult job. By constantly listening to them and responding to their needs, we have become successful. We help them make their businesses successful and create an atmosphere that enables other hardworking truckers to shape future success." And he emphasizes: "As a company we help our customers and our community prepare for the challenges of the future. By providing good jobs in a safe workplace, we make Portland and the Northwest a better community. Long-haul trucks bring us the things we need to maintain our quality of life. Our job at

Jubitz Corporation is to help them get their goods to market more efficiently."

Back in the 1960s, when Jubitz was primarily a truck leasing company, one of their trucks was the first transcontinental "sleeper" Freightliner built. Monroe Jubitz bought it for $3,500, which, as he puts it, "was a pretty steep price back in the 1960s." Today Freightliner #1 is on display in the Smithsonian Institution's Museum of American History in Washington, D.C. Monroe Jubitz observes wryly, "Can't think of a better place to garage it." It is a testament to vision and dedication. When he graduated from Yale at the end of the Depression, recalls the founder of Jubitz Corporation, "My one goal in life was to find a job. Any job." He believed there were opportunities in the trucking business. He was right. ◪

In it for the long haul. Jubitz Corporation Cochairmen and Copresidents Fred Jubitz (left) and Al Jubitz (right) continue a family tradition focused on services and products designed for the professional trucker. Their father, Monroe A. "Moe" Jubitz, founded Jubitz Corporation in 1952.

Via in-truck stop monitors, phone, fax, software, and satellite-fed desktop terminal, DAT Services provides freight matching and information services to the ever-changing North American transportation industry.

KXL RADIO

L isteners regularly choose KXL as their radio station of record from The Dalles to Lincoln City and from Longview, Washington, to Corvallis.

KXL's news staff is the largest in the area, and in an era where loyalty is limited in the broadcast business, many KXL reporters and anchors have been at the 750 spot on the dial

KXL moved to its new state-of-the-art broadcast studio in southwest Portland in April 1996.

for well over a decade. They know their business, but more importantly, they know their community. Listeners know they can trust the news brought to them by KXL. The news staff's expertise has been recognized by their professional colleagues with both national and state awards for excellence in news coverage, including the 1998 AP award for "Best News Station" in the state of Oregon.

Advertisers as well as listeners are loyal to KXL. KXL was Document Solutions' first experience with radio advertising.

Document Solutions' president, Tom McNamara, said, "The response we received from KXL will easily amount to over six figures in sales for us! We are now a firm believer in radio."

KXL was an early member of the radio community. It went on the air in 1926, when only about 280,000 people lived in Portland. That was the year Philadelphia hosted the World's Fair, Marilyn Monroe was born, Congress created the Army Air Corps, Gertrude Ederle became the first woman to swim the English Channel, and everyone was humming "I Found a Million-Dollar Baby in the Five-and-Ten Cent Store."

A KXL news reporter hunts down the hot stories for Portland listeners.

The man who has been responsible for the emphasis on local people and local issues is Les Smith, who has owned the station since 1955.

"Radio is a local medium," declares Smith. "It's where people go to find out what's happening in their community. KXL communicates to the Portland community, and that's what we intend to continue doing."

When they are not providing information about floods, ice storms, or elections, most of the reporters are involved in their neighborhoods. So are the other KXL employees. Their activities range from coaching little league teams, to volunteering with the Salvation Army , Cancer Society, and the Oregon Symphony.

KXL's community contributions are many and varied. The station sponsors an annual Career Fair, bringing together potential employees and employers.

The Alpensrose Easter Egg Hunt is an annual fun event sponsored by KXL. The Rose Festival Airshow has been another crowd pleaser. So has the Oregon Symphony Pops Series. The station has collected funds to support alcohol and drug rehabilitation. KXL has also helped rehabilitate homes of low-income elderly and assisted in collecting food for the hungry. Each year the station broadcasts nearly a million dollars' worth of public service announcements without charge.

Ken Madden of Madden Industrial Craftsmen, Inc. says, "Your station has proven to be a great boost to our sales efforts. A new customer who heard our ad on KXL could amount to over a million dollars in sales!"

General Manager Tim McNamara sums up KXL's philosophy: "Our programming is centered on the issues that affect this area and those who live here. We are associated with events which bring tens of thousands of people together, but we also help smaller communities with events which are important to them. Our aim is to be a contributing part of the community." ◢

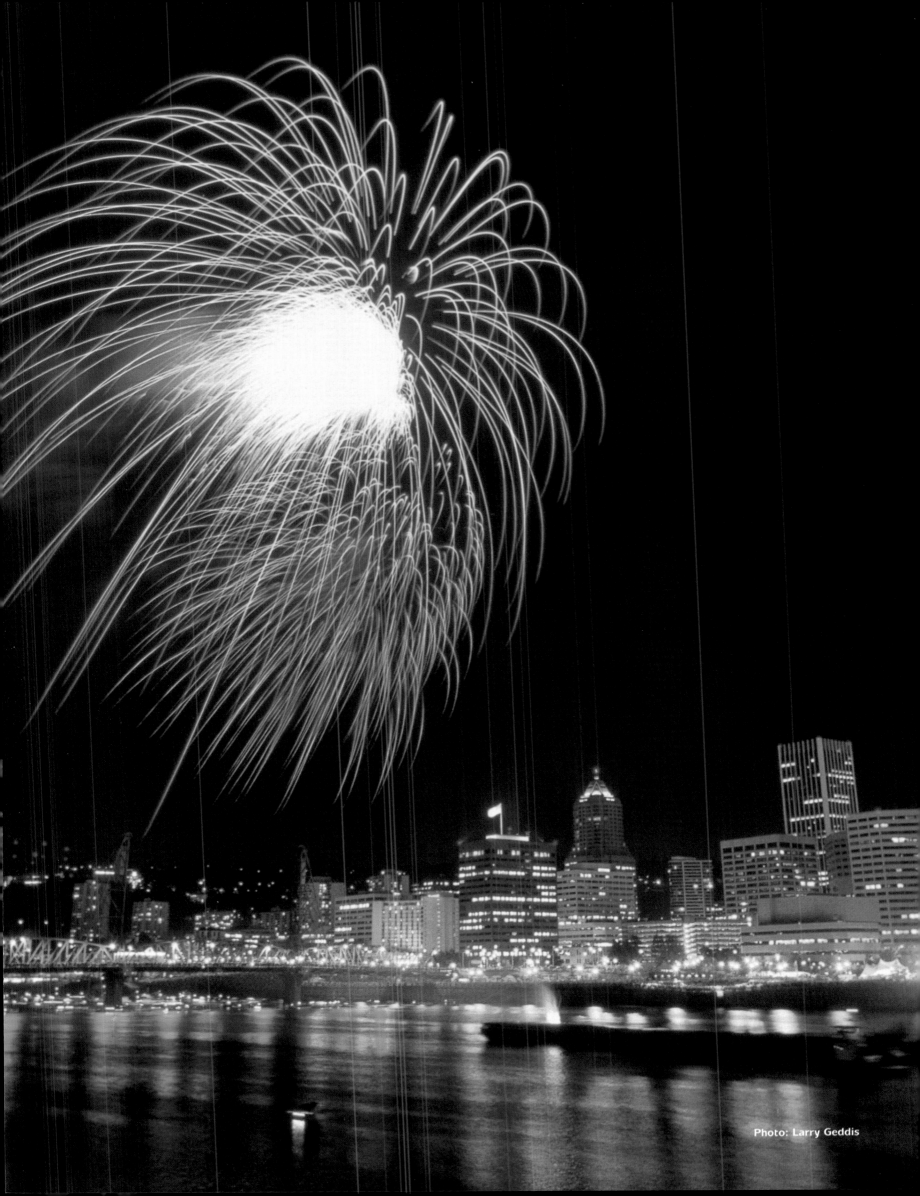

Photo: Larry Geddis

Manufacturing
& Distribution

Photo: Steve Terrill

Trees, trees . . . everywhere you look, Portland's streets are lined with trees. And for good reason. Portland is at the center of one of the best tree-growing regions in the world.

Weyerhaeuser manages its forestlands on a sustainable basis.

Little wonder then that the world's largest tree-growing company, Weyerhaeuser, has a major presence in the Portland area.

Weyerhaeuser owns and operates six different Portland area businesses, employing more than 400 people, for a combined annual payroll of $17.5 million.

In addition, the six businesses spend about $31.7 million per year on goods and services. And they pay about $650,000 per year in taxes.

Forest management is based on sound, current science.

While the businesses vary—from tree-growing to paper recycling—all share Weyerhaeuser's corporate vision: to be the best forest products company in the world.

TIMBERLANDS

All the Portland businesses are dependent on the wood and fiber that come from trees. Weyerhaeuser is committed to maintaining a healthy balance between the demand for forest products and the need to protect the environment. As the world's largest private manager of merchantable softwood timber, Weyerhaeuser takes its care of forestlands very seriously. More than 2,500 employees and contractors manage the company's 2.1 million acres of forestland in Oregon and Washington on a sustainable basis.

SUSTAINABLE FORESTRY

From its beginning, Weyerhaeuser has pioneered responsible forestry practices. Nine years after the company was founded at the turn of the century, Weyerhaeuser helped create the Western Forestry and Conservation Center. In 1936, Weyerhaeuser initiated its tree-growing program. In 1941, the company dedicated the nation's first tree farm, launching an American Tree Farm system that now covers nearly 90 million acres in all 50 states. And in 1966, Weyerhaeuser inaugurated its High Yield Forestry program to improve the quality and volume of wood growing in its working forests.

Sustainable forestry has always been part of the Weyerhaeuser philosophy. When company founder Frederick Weyerhaeuser made an early timber purchase far from major U.S. markets, he said, "This is not for us, nor for our children, but for our grandchildren."

Weyerhaeuser bases its forest practices on sound, current science. The company's forestry research organization is recognized around the world for its leadership in silvicultural and environmental sciences. Ongoing research has helped forest managers identify key Weyerhaeuser Forestry Resource Strategies. These strategies address . . .

- Water quality and fish habitat
- Wildlife habitat
- Soil productivity
- Forest products
- Cultural, historic, and aesthetic values

WATERSHED ANALYSIS

Today, the centerpiece of Weyerhaeuser's forestry initiatives in the Northwest is its watershed analysis program. With watershed analysis, Weyerhaeuser scientists gather data about streamsides, fish habitat, and the potential for landslides and sedimentation. Once sensitive conditions are identified, Weyerhaeuser partners with adjacent landowners, regulatory agencies, and others to prepare a customized plan for each watershed.

These customized plans include protections for sensitive areas, such as leaving additional trees near fish-bearing streams, enhancing stream channels, creating pools, replacing culverts that block fish passage, installing fish ladders, improving (or retiring) forest roads, and avoiding forest activities on steep slopes.

Watershed analysis is required by law in the state of Washington, and Weyerhaeuser voluntarily extended this process to its Oregon forests. Within the next decade, the company plans to analyze every watershed on its Northwest forestlands where it has significant ownership.

ENVIRONMENTAL PARTNERSHIPS

Watershed analysis is just one example of an environmental partnership. There are countless others.

Nationally, Weyerhaeuser joined with the American Forest & Paper Association (AF&PA) to develop the Sustainable

Forestry Initiative.™ This Initiative promotes sustainable, environmentally sound forest practices among large and small landowners, loggers, state and private foresters, conservation groups, and universities. Compliance with the Initiative's guidelines is mandatory to maintain membership in the AF&PA, whose members produce 90 percent of the paper and 60 percent of the lumber made in America today.

Regionally, Weyerhaeuser partnered with the Washington State Department of Transportation and the Rocky Mountain Elk Foundation to develop a Forest Learning Center at Mount St. Helens. Multimedia shows and displays recreate the forest environment around Mount St. Helens before, during, and after the May 1980 eruption. Visitors who walk the forest trail can see the difference between devastated areas that are growing back naturally—and will take 500 years to recover—and devastated areas that have been reforested and will be ready for harvest in 50 years. Weyerhaeuser spent seven years and $66 million to reforest its Mount St. Helens acreage with more than 18 million hand-planted seedlings!

In Portland, Weyerhaeuser has partnered for years with SOLV (Stop Oregon Litter and Vandalism) to clean up illegally dumped refuse along public greenways. Hundreds of Weyerhaeuser employees gave up their Saturdays to clean up the Oaks Bottom Wildlife Refuge and the Sauvie Island Wildlife Sanctuary, recovering everything from an old washing machine to a full case of beer.

Around the state, Weyerhaeuser also teamed with Oregon Trout on a "Salmon Watch" program that gives middle and high school students the opportunity to discuss salmon survival issues and view salmon spawning in the wild.

Today, the centerpiece of Weyerhaeuser's forestry initiatives in the Northwest is watershed analysis.

Watershed analysis ensures that sensitive areas within Weyerhaeuser's forestlands are protected.

WINNING RECOGNITION

As a result of these kinds of environmental efforts, Weyerhaeuser is winning recognition as a conscientious corporate citizen. Weyerhaeuser has consistently ranked number one

Forbes magazine ranks Weyerhaeuser number one in responsibility to the community and the environment.

in *Fortune* magazine's annual "Corporate Reputation Survey," in the category of responsibility to the community and environment among forest industry companies.

Closer to home, the Oregon Department of Fish and Wildlife and the Oregon Department of Forestry awarded Weyerhaeuser the "1997 Fish and Wildlife Steward Award for Forest Lands" in the industrial landowner category for improving animal habitat in the Coos Bay area. Weyerhaeuser also earned a "Commendation for Fish and Wildlife Stewardship" for the Springfield operation's watershed and habitat enhancement efforts.

As one of the world's largest forest products companies, Weyerhaeuser knows that the world is watching. Weyerhaeuser holds itself to extremely high standards. Consequently, the company was pleased to receive the 1997 American Business Ethics Award in the category of public companies.

Weyerhaeuser's vision is to be the best forest products company in the world.

LENDING A HAND

Citizens expect corporations to do more than simply provide jobs and operate responsibly. They also expect corporate citizens to "give back" to the community.

Weyerhaeuser does that wholeheartedly. In Portland, the Weyerhaeuser Company Foundation focuses its philanthropy on helping young people—contributing to United Way's youth programs, to Kids Can (to short-circuit child abuse), and to House of Umoja (for at-risk youngsters). One Weyerhaeuser-supported program for children is being considered as a model for other communities: a program that teaches Head Start teachers how to better integrate science activities into their preschool curriculum.

The Weyerhaeuser Company Foundation also focuses on recycling. To encourage recycling at the Oregon Zoo, Weyerhaeuser has contributed to construction of recycling stations throughout the site. Cans, juice cartons, and zoo maps are collected, removing tons of debris from the landfill. Weyerhaeuser has also distributed $80,000 to schools and school districts throughout the state to recognize and reward innovative approaches to school recycling.

REWARDING EMPLOYEES

Weyerhaeuser knows that, without outstanding employees, none of the achievements described here would be possible. It is Weyerhaeuser employees who deliver superior customer service, who enthusiastically support their communities, and who genuinely care for our precious natural resources.

That's one reason why, in 1996, Weyerhaeuser launched a Performance Share Plan for all employees. This program tangibly recognizes the importance of employees by rewarding them with company stock when their hard work results in improved financial performance.

On the threshold of the 21st century, Weyerhaeuser is poised to achieve its vision of being the best forest products company in the world. At Weyerhaeuser—and here in Tree City, U.S.A.—the future truly is growing.

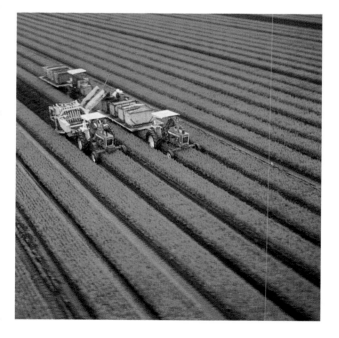

PORTLAND AREA OPERATIONS

Aurora Forest Nursery - Weyerhaeuser's Forest Nursery covers about 200 acres in Aurora and employs 14 people full-time and 130 seasonal contractors. The nursery produces 25 million bareroot tree seedlings annually, half of which are purchased by other timber companies, land owners, and the general public. Weyerhaeuser has planted 2.5 billion seedlings nationwide in the past half century.

Building Materials Customer Service Center - Located off Allen Boulevard in Beaverton, the Customer Service Center is a wholesale distributor of lumber and building materials. Its 40

employees sell to lumber dealers, home centers, retail stores, industrial shops, and manufactured housing companies throughout Oregon, Washington, and the Pacific Rim. The Portland Customer Service Center—one of 48 such centers in the United States and Canada—sells about $40 million in building supplies each year.

Northwest Hardwoods - Part of Weyerhaeuser's Hardwood Lumber division, the Portland office of Northwest Hardwoods is the national sales center for hardwood manufacturing facilities in Oregon, Washington, Wisconsin, Pennsylvania, Michigan, Oklahoma, and Arkansas. The office's 35 employees handle sales, marketing, credit and accounting, and general administrative functions from offices on Greenburg Road. Each year Northwest Hardwoods' facilities manufacture nearly 350 million board feet of premium hardwood.

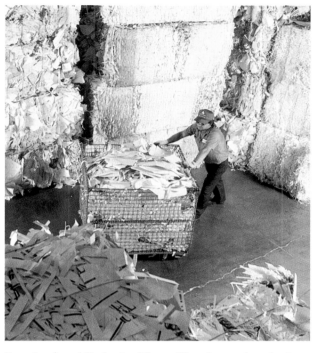

Weyerhaeuser is one of the top three paper recycling companies in the world.

Containerboard Packaging Plant - Weyerhaeuser's packaging plant in east Portland is part of a nationwide network of company box plants. In fact, Weyerhaeuser is the largest manufacturer of corrugated packaging in the country. More than 180 employees at the Portland plant produce over 100 million boxes annually for a wide variety of uses, including farm products, manufactured goods, and moving and storage.

Recycling Center - The Recycling Center on Western Avenue in Beaverton employs about 75 people who help ensure that Weyerhaeuser's paper mills have a steady supply of recycled fiber. Employees collect and sort waste paper of all kinds . . . about 90,000 tons of paper per year, sorted into 50 different grades. Since its first recycling facility opened in 1974, Weyerhaeuser has become one of the top three paper recycling companies in the world, operating 26 facilities in North America.

Quality Sort Center - Another recycling facility, the Quality Sort Center, is located in northwest Portland. There, about 50 employees collect and ship high quality used newspapers and magazines for de-inking and remanufacture at NORPAC, Weyerhaeuser's joint-venture newsprint operation in Longview, Wash. Some 213,000 tons are recycled each year—an amount equal to all of the daily newspapers published in Oregon, Washington, and Idaho! ◢

Portland's athletic inhabitants train among tree-lined streets in the shadow of snowcapped mountains with the not-so-distant surf keeping time with the pounding of their adidas-encased feet. With adidas America's corporate headquarters located in Beaverton, it's simply natural.

The adidas Store, at 5020 N.E. Martin Luther King Jr. Boulevard, is located just five minutes from downtown Portland. Photo: Stephen Cridland.

The adidas Store is the first of its kind in the United States. Photo: Stephen Cridland.

The adidas mission has changed little since founder Adi Dassler began making sports shoes in the 1920s. Dassler's desire was to make the best sport shoes in the world. Today, adidas has expanded its goal to being the best sports brand in the world. adidas accomplishes this goal by following in Dassler's footsteps and continually designing shoes which are geared towards satisfying each athlete's needs. Recent examples of athlete-oriented innovations are the Torsion® System, which increases flexibility, and Feet You Wear™, which provides added agility and stability without hindering performance. Focusing more on function and less on fashion, adidas strives to provide athletes with shoes and apparel that can make a tangible difference in their performance. Meeting athlete needs is what makes adidas the best. adidas America has continued to build on this history.

In February of 1993, adidas AG acquired Sports, Inc., a U.S.-based sports marketing company founded by former Nike executives Rob Strasser and Peter Moore. Sports Inc. has been working in conjunction with adidas USA on the design, development, and marketing of the adidas Equipment line. adidas Equipment helped rejuvenate and reposition the adidas brand in the U.S. by creating an exclusive line focused on fulfilling the functional needs of the athlete and by utilizing the best materials and athlete input in the tradition of Adi Dassler. After the successful creation and launch of adidas Equipment, adidas AG combined adidas USA and Sports Inc. to form adidas America.

adidas AG's objective for adidas America was to bolster the connection between adidas AG's operations in America and Europe, and to revitalize the company's U.S. business. Strasser was appointed president and CEO of adidas America, and Moore became the creative director. After Strasser's unexpected death in October of 1993, Moore filled both positions. In 1955, Steve Wynne was selected as the new president and CEO, and Moore became worldwide creative director for adidas AG.

Despite changes in management at adidas America, Rob Strasser's original mission and philosophy remain. adidas America is committed to producing the highest quality shoes and apparel in the world. To accomplish this goal, Strasser created a working environment that promotes cooperation and encourages creativity. At adidas America, titles and positions are unimportant. Employees at all levels are free to approach each other with ideas and suggestions. Strasser eschewed the typical corporate world of suits and subordination for a more open, comfortable environment.

In 1994, adidas leapt from eighth to third in the U.S. Footwear Industry Rankings. Since then, unwilling to be content with 1994 success, the company has made huge developments in both footwear and apparel. Moore said of 1994, "This past year was definitely a successful one for adidas, but in no way are we satisfied. We have created tremendous momentum for the brand, but now we'll have to work twice as hard to keep the ball rolling." In 1998, it is clear that adidas has reasserted itself as one of the highest quality, most

popular brands of shoes and apparel in the U.S. In an effort to offer adidas quality to a variety of customers, adidas America currently produces footwear and apparel for Adventure, Alternative, Basketball, Cleated (baseball and football), Kids, Running, Soccer, Training, Tennis, Originals, Walking, and Women's Workout.

A 1994 article in *Sporting Goods Dealer* summarized the successful re-entry of adidas into the American market. David Sparrow writes, "It is the 1990s and two footwear superpowers with different philosophies share a common goal: world supremacy. But while every move Nike and Reebok make is aimed squarely at the other, their global ambitions, especially in Germany, have awakened a sleeping giant named adidas, whose greatest resource is its rich history and former global dominance. adidas threatens to challenge and mystify both of these footwear superpowers for years to come."

True to its history, and the objective of adidas founder Adi Dassler, adidas America is committed to producing the best sports footwear and apparel in the world. Wynne elaborates on this mission: "The reason this brand stands today is because Adi Dassler stood for quality and performance. And as long as athletes continue to push the physical limits of competition, adidas will be there."

So every time Oregonians put on their adidas shoes they can be confident that this hometown brand is enhancing their athletic performance. After all, it is the company's mission: To be the best sports brand in the world. ◪

Available at the store is the newest adidas footwear and apparel. Photo: Stephen Cridland.

Throughout the store there are many fixtures containing adidas performance merchandise. Photo: Stephen Cridland.

NIKE

And so it began. . . with a waffle iron. Photo: NIKE.

Its trademark logo swoosh is seen on some of the greatest professional athletes in the world, as well as some of the most intense weekend warriors. It took just a little over two decades for NIKE to become the premier footwear and apparel company in the business, with annual revenues in the billions. It is so clearly the leader in the fast growing world of sports, that it's hard to remember when there wasn't a NIKE.

The history of NIKE reads like a recipe for achieving the American Dream. University of Oregon track coach Bill Bowerman and student Phil Knight first met in 1957. Both shared a passion for running and sports in general. While Knight went on to get an MBA at Stanford, Bowerman, still coaching at U of O, fiddled around with ideas to create better running shoes. This included pouring rubber into a waffle iron to create a shoe outsole that was durable, lightweight, and gave great traction.

After receiving his MBA, Phil Knight took a world tour. In Japan, he contacted the Onitsuka Tiger company, which made athletic shoes. He convinced them that there were tremendous marketing opportunities in the United States. When asked who he represented, Knight boldly made up a name: Blue Ribbon Sports. It was to be the first step in the creation of NIKE.

With a $500 investment each and a mere handshake, Knight and Bowerman went into business. Their first shoe, the Tiger Marathon, was the first to use a quick-drying, lightweight nylon instead of leather. In 1972, having broken from Tiger, the company was renamed NIKE, after the Greek goddess of victory. The Waffle Flat Racer, with the waffle sole design Bowerman had tinkered with earlier, premiered at the Olympic Trials in Eugene, Oregon, in 1972. Since then, NIKE has become the leader in refining sports technology, continuing to give athletes the competitive edge.

The first 25 years of growth for the company took NIKE from a small firm that received its first shipment of shoes at Phil Knight's parents' house, to a large and mature company employing tens of thousands. As it has grown, so has its community involvement in terms of money and people.

NIKE knows the product it makes will stand for itself. But the overall mission of the company, that sports equals empowerment, is a message that is just now gaining real strength and understanding. NIKE wants to be known as the brand that empowers people, not just through sports, but through its investment in the community.

If NIKE has been quiet about its involvement with the community in the past, it can be credited to following the example of its leader. Phil Knight can be rather quiet and reclusive in his manner and perspective. And while Phil's donation of $25 million for the University of Oregon library received a lot of press, he has always been involved in the community in a myriad of thoughtful and caring ways.

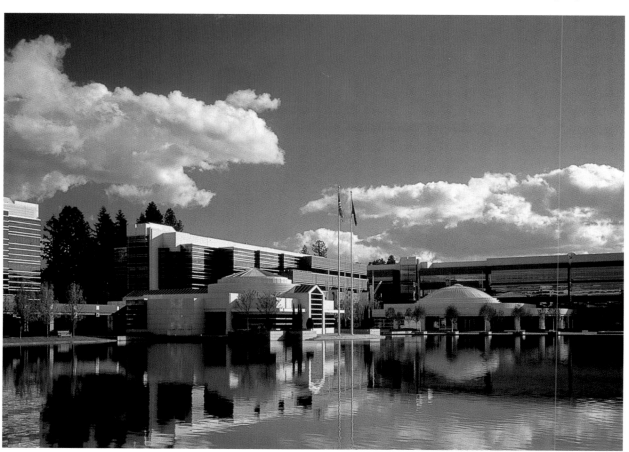

Heart and "sole" of NIKE, where over 2,000 employees Just Do It. Photo: Jeff Goldberg.

NIKE receives 50,000 sponsor requests a year from around the world. But how do you donate and keep a focus on your core belief—that sports make people stronger and better—that sports are positive for youth?

NIKE has decided to limit its charitable contributions to three key areas: youth sports and mentoring, education, and enterprise programs that lead to self-sufficiency.

P.L.A.Y. CORPS is an example. Launched in April of 1996 in Portland, this program identifies and trains college students to coach in city and town youth leagues. The CORPS provides opportunities for students to use their love for sports to contribute to the athletic and personal development of kids in underserved communities. This extremely successful program is now being expanded nationwide, and has added a component to encourage kids to become teachers.

NIKE's program to put computers into Head Start centers is an example of the company's dedication to education. In partnership with the National Head Start Association, NIKE lauched Start Line, an educational outreach program designed to provide computers, software, and staff training in Head Start centers up and down the West Coast. Kids, parents, staff, and Head Start teachers will have access to the computers and software programs. Each center will track the development of the youngsters to judge the success of the program.

In enterprise programs, NIKE provides grants to underserved groups. By linking up with the Urban League, NIKE gets high school kids in a landscape program that pays them for doing landscaping for senior citizens in north and northeast Portland four days a week, and requires them to hear speakers on entrepreneurial issues on the fifth. On a larger level, NIKE runs a Diversity Retailer Loan program, providing start-up money to minorities and women who wish to get into the retail business. The program targets those who have a difficult time qualifying for a loan. And on an international level, NIKE has a similar loan program for women in Vietnam and Indonesia who want to start their own company.

Clearly, NIKE has a huge commitment to the state of Oregon. It is, after all, a home-grown program by a home-

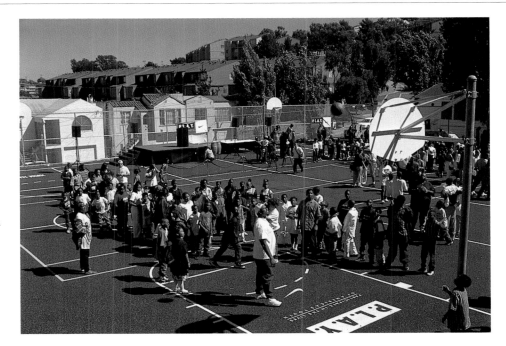

Where kids play.
Photo: Otto Greule Jr.

town boy. But if Phil Knight sets the tone with a dedication to community involvement, that example is followed by countless employees.

The rank and file of NIKE are also big volunteers, coaching kids, tutoring youngsters in the SMART (Start Making A Reader Today) program, and in many other areas. In fact, to encourage its employees to volunteer and contribute, NIKE makes matching grants to the organizations. NIKE matches dollar for dollar work or contributions to a charity, and if it's a program that works with youth, the match is two-to-one. For tutoring a child the payoff is even greater—ten dollars for every dollar's worth of work. This, plus the annual community giving campaign, has led to more than a million dollars invested in the Portland area.

NIKE doesn't simply hand over cash and think its job is done. The company tries to limit its involvement to three to five years. During that time, the recipient program is encouraged to make other connections in the corporate world to partner with. In this way, NIKE helps create a sustainable program environment that will continue long after NIKE has moved on to other worthy causes. In this way, the program will no longer be completely dependent on one company for support, and it encourages other corporations to become involved in the community. Like ripples in a pond, the effects continue to grow.

As for the future? Well, as NIKE itself likes to say: "There is no finish line." ◪

Business training session
at the Women's Union
for loan borrowers.
Photo: NIKE.

**Mark A. Suwyn,
L-P's chairman and CEO.**

Louisiana-Pacific Corporation is a longtime forest products company that is turning the traditional forest products company approach inside out. L-P is now working from the customer back to the mill, creating products the customer needs and desires, rather than the traditional wood products industry approach of creating the products it wants to make.

Headquartered in Portland, this major manufacturer of building materials and industrial wood products operates throughout the United States, in Canada, and in Ireland. Its sales exceed $2 billion annually.

Becoming the premier building products supplier is the company's goal. To achieve that goal, L-P is holding fast to its position as a strong player in basic construction products, while also placing increased emphasis on high value, engineered products that make L-P's customers' lives easier.

L-P innovated its strategy because the industry has changed. The era of plentiful resources, large diameter old growth timber, and demand that once frequently outstripped supply is gone.

L-P has seen significant changes in both itself and in the building materials business. Like most wood products companies, L-P's business historically began with its key resource: the trees. The resource base, or the type of trees abundantly available, drove what type of mill to build, and what type of equipment to install. Then, the focus would shift to running the mill operations as efficiently and effectively as possible.

L-P's strategy—to use its marketing expertise, technology, and sophisticated R&D and manufacturing—is to listen to the end user. L-P defines the products the customers really need. Then, it develops and manufactures those products.

Sounds like the simple, straightforward solution. But it has only recently become the mind-set for forest products companies, companies that enjoyed an over-abundant resource for years, and were staffed with people expert in accessing and processing the resource but not in marketing the resulting product. Today, the skill-set needed is obviously different. And L-P reorganized specifically to build in this capability.

The company has recognized that the era of engineered building products has dawned. With fewer very large trees available for wide lumber or plywood, engineered products have become an increasing part of the forest products indus-

try. Oriented strand board, medium density fiberboard, and particleboard are more and more the products of choice for trim, furniture, siding, structural, and nonstructural panels. These products, too, are more cost-effective, and their properties can be tailored by L-P plants to fit specific needs.

There are also more builders capable of evaluating new products that can help them build better housing for lower cost. Certain sophisticated manufactured home building companies can integrate improved products in the homes they build. L-P is working with both of these groups to provide suitable products in support of their needs.

Large retail chains—the building products superstores—are revolutionizing the route to market for L-P's products. These retailers present a range of new products to markets of both do-it-yourselfers and contractors through point-of-purchase displays, videos, and a trained sales staff. This group of customers is now of far greater importance to L-P, since their products are intended for far more than just the largest of builders and contracting companies.

L-P's innovation in developing new, affordable, environmentally sound products for homebuilders, remodelers, commercial builders, and furniture and cabinet manufacturers means less reliance on scarce large timber. Most of these new

L-P wildlife biologist researches a salamander as one indicator of the condition of stream habitat on L-P lands. Photo: Bruce Forster.

recycle newspapers.

Another environmentally friendly product from L-P is TechShield™ radiant barrier products, which provide energy efficient structural panels. The reflective layer on these standard plywood or OSB construction panels keeps attics cooler and reduces air-conditioning loads. It's particularly attractive in sunny, warm climates.

Beyond its products, L-P has a deep commitment to environmental excellence. Its new Environmental Management System (EMS) recognizes that every job in the company carries with it environmental responsibility. The goal is to ensure that environmental compliance is an integral part of each employee's job, not just an add-on program.

Celebrating 25 years as part of the Portland community, Louisiana-Pacific is committed to playing an active and vital role in the life of this great city. As America approaches a new millennium, L-P—in partnership with its community—has rededicated itself to ensure that the superb quality of life that characterizes the Portland area be preserved for future generations.

Portland's contemporary portrait is a rich and diverse tapestry that involves each and every member of its community. At the new Louisiana-Pacific, they are "doing it better" because the Portland community deserves the very best. ◢

Educating young people about modern forest management and factors that affect tree growth. Photo: Bruce Forster.

products are made from plentiful, noncontroversial tree species grown specifically for commercial use. Some of L-P's building products use recycled paper as a fiber source.

L-P's product list includes oriented strand board structural panels, SmartStart™ siding, TechShield™ radiant barrier panels, laminated veneer lumber, medium density fiberboard, particleboard, hardboard, lumber, Cocoon™ cellulose insulation, and Southern pine plywood.

L-P's focus from a technical standpoint is to operate plants efficiently and cost-effectively, build in better day-in and day-out consistency in products, create innovative products to stimulate market growth and better profits, and be good stewards of the environment.

One example of L-P's awareness of the environment in developing new products is the Cocoon™ cellulose insulation made from recycled newspaper. A better insulator than fiberglass, with better sound deadening properties, Cocoon is also more fire retardant. It is not associated with the health concerns that have dogged fiberglass. And it's another way to

L-P's Cocoon™ insulation is made from 100 percent recycled newspaper and has better insulating properties than competing insulation. Photo: Bruce Forster.

EFTC Northwest Operations, with facilities in Newberg, Oregon, and Moses Lake, Washington, provides high-mix electronics manufacturing services to large original equipment manufacturers (OEM).

EFTC Northwest offers world-class equipment, facilities, and ISO 9002-certified processes which are customer focused and innovative. EFTC can consistently provide the highest quality product because each team throughout its Northwest Operations is committed to quality, on-time delivery, and the overall joint success of its partner companies and EFTC.

EFTC Northwest, formerly Current Electronics, is part of EFTC Corporation. EFTC Corporation quietly leads the nation in high-mix electronics manufacturing services. Established in 1981, EFTC has grown to 2,000 employees. It has greatly increased sales, as well the number of customers it serves and the technological capabilities it offers. Customers are in the communications, avionics, instrumentation, and computer peripherals industries. EFTC occupies over 800,000 square feet in ten facilities across nine states, with headquarters in Denver, Colorado.

Manufacturers are usually in search of a company that can produce one or more products that don't require their own dedicated line. If a product can be split into relatively small batch sizes, it qualifies for high-mix production.

What makes high mix a special category? Traditional contract manufacturing companies often prefer the ease of setting up a line once and popping off a product. It costs less in time, expertise, and attention, because once the line is set up and running, it virtually runs itself.

High-mix manufacturing, on the other hand, needs significant expertise and staff dedicated to manufacturing quality products. EFTC recognized this market niche was underserved and positioned itself to earn the business of companies in search of high-mix manufacturing. Today, it is the undisputed industry leader.

Its position drives it to adopt new technologies as quickly as customers' needs change. The company's current equipment supports automated surface mount assembly (Fuji), automation through-hole insertions of radial, axial, and inte-

IPC-certified trainer LuLu Carl guides Magdaleno Tijerina and Myanah Nguyen in the art of soldering components to a printed circuit board.

Program Manager Bonnie Dundas-Flegal and Engineer Mark Okazaki review customer's PCB and assembly requirements.

grated circuits (Universal), In-Circuit testing (HP 3075 series II), and conformal coating. EFTC's highly skilled employees are proficient in the hand assembly of circuit cards, box builds, customer cabling, and functional testing. Plus, EFTC has the capability to work with various technologies, including BGA, Flex circuits, double-sided complex circuit boards, and more.

In its 70,000-square-foot Newberg facility, the company is positioned to be the premier electronics contract manufacturing facility in the Northwest. In fact, says Jim Davis, EFTC's VP and General Manager for its Northwest Operations, "This facility is EFTC's showcase manufacturing facility."

Asynchronous Process Manufacturing (APM™) was innovated by EFTC as part of its corporate realignment to exclusively serve the needs of OEMs with high-mix requirements. APM™ enables EFTC to take what has traditionally been considered an oxymoron in the industry—high speed in a high-mix environment—and transform it into a competitive advantage.

High speed is critical to EFTC's competitiveness, and the ability to perform at a high rate of speed with accuracy depends on well-trained, well-rewarded staff. At EFTC, a strong team environment is fostered. Most teams are formed by function, working together on all products that go through their area. Team members interact with each other while working and while on break.

In addition, EFTC believes the right culture is of prime importance to employee morale. Information is freely, widely, and consistently shared about the corporation, facility, upcoming goals, and progress toward established goals.

Recognizing the value front-line employees can bring to improving processes, employee input is encouraged in two

ways. These are the Continuous Improvement Program (CIP) and the Corrective Action Request (CAR). The CIP is designed to find better ways of addressing issues. A cross-functional team is formed and has six months to research an issue and recommend a solution. CIPs have resulted in positive changes in many processes at EFTC.

Employees are recognized and rewarded when EFTC is successful, through incentives and awards, which are tied to team goals.

Another program that makes a difference in employee morale and retention is the 100-week journey of progress. All direct labor employees are eligible for this attendance award. At the end of 100 weeks, all employees who have not had any unscheduled absences are entered into a drawing for $25,000. In addition, quarterly attendance awards are offered for perfect attendance.

EFTC also offers flexible schedules to help employees balance their personal and work lives.

Employee training is critical for EFTC Northwest, and it supports that need by providing significant resources for employee training and continuing education. Two full-time IPC certified manufacturing trainers provide classes to help employees improve their skills, a resource employees take advantage of regularly. A full-time professional development training specialist is also on staff, coordinating all training and development within the organization, including professional and management development.

A $2,500 subsidy per year in education assistance to all full-time employees is offered with the company paying 100 percent of all tuition, lab, and registration fees, and 50 percent of the cost of books if the employee earns a passing grade. EFTC pays for employees to improve their computer skills by attending various software classes on company time. And the company offers an internship program through its engineering department to provide students with workplace experience.

Employees are encouraged to advance within the organization if they wish.

Recognizing the value of a strong community, EFTC Northwest contributes to many local (Yamhill County) programs, as well as several regional and national programs. The company has given to dozens of organizations, including Northwest Medical Teams International, DARE, Newberg High School, United Way, and the March of Dimes.

The company also encourages volunteerism in the community, usually sending several employees during working hours to help out with two events put on by Yamhill County high schools. During the holiday season, employees adopt families and bring in food for families in need. ◪

EFTC Northwest Operations recently completed construction of its new world-class facility in Newberg, Oregon.

Dat Vo monitors a high-speed Fuji line, which automatically places surface mount technology components on printed circuit boards.

The Oregon Cutting Systems Division of Blount, Inc. operates three plants—one in Canada, another in Brazil, and a third in the United States. Here, at an investment casting facility in the Portland, Oregon, plant, technicians produce drive-sprocket rims for chainsaws.

Oregon Cutting Systems is the flagship division of the Outdoor Products Group of Blount, Inc. Blount is a diverse international industrial—and consumer—products company operating 15 manufacturing facilities in North and South America. And Oregon Cutting Systems is an Oregon success story of the most genuine kind.

The story begins in the fall of 1946, when logger/inventor Joseph Buford Cox was chopping firewood. He paused for a moment to examine the curious activity in a tree stump. A timber beetle larva, the size of a man's forefinger, was easily chewing its way through sound timber, going both across and with the wood grain.

Joe was an experienced operator of the gas-powered saws used in those days, but the cutting chain was a problem. It required a lot of filing and maintenance time. "I spent several months looking for nature's answer to the problem," Joe recalled. "I found it in the larva of the timber beetle."

Joe knew if he could duplicate the larva's alternating C-shaped jaws in steel, it could revolutionize the saw chain industry. So he went to work in the basement shop of his home in Portland and developed the first Cox chipper chain prototype, which was produced and sold in November 1947. The basic design of Joe's original chain is still widely used today and represents one of the biggest influences in the history of timber harvesting.

In 1947, the Oregon Saw Chain Manufacturing Corporation was founded with four employees and one product. Today, known as the Oregon Cutting Systems Division of Blount, Inc., the same company is part of a corporation with 5,000 employees and thousands of products ranging from a single cutting chain link to the 72,000-seat New Orleans Super Dome.

The Outdoor Products Group manufactures and markets saw chain, bars, sprockets, and maintenance accessories for

The Oregon Cutting Systems Division of Blount, Inc. maintains its headquarters in Portland, Oregon. More than 1,000 Oregonians are employed in the administrative and manufacturing facility.

chain saws, industrial cutting products, riding mowers, and yard and garden tools. The group sells to over 50 original equipment manufacturers and to end users through a strong, diverse distributor and dealer network, as well as through home centers and hardware stores in more than 130 countries.

From the original cutting chain guard links that created fewer chain saw accidents, causing a number of companies to mandate the use of the new chain, to high-performance cutting chain for timber-harvesting machines, Oregon Cutting Systems has been on the cutting edge of new product development.

And Oregon Cutting Systems intends to continue making positive contributions to the world's forest industry with innovative products. At the same time, the company encourages sound environmental practices to meet the ever-growing needs for clean air, water, wildlife habitat, and wood products.

James S. Osterman, president of the Outdoor Products Group of Blount, Inc., and head of the company's Milwaukie Oregon Cutting Systems Division, won the Governor's award for lifetime achievement in international business in 1997. The award is sponsored by the Pacific Northwest International Trade Association and is presented annually to

recognize the importance of international business to the state's economy.

Oregon Cutting Systems Division partners in the awards program include the District Export Council, Oregon Department of Agriculture, Oregon Economic Development Department, Pacific Northwest International Trade Association, Port of Portland, Portland Chamber of Commerce, Small Business International Trade Program, and the World Trade Center Portland.

Within the industry, Oregon saw chain is one of the most respected and recognized brand names in the world. In its 50-year history, the company has experienced phenomenal growth. Its high-quality saw chains, guide bars, and accessories are sold in more than 130 countries, and 65 percent of the company's business is done outside the United States.

A global view allows Oregon Cutting Systems to expand markets with innovative new products. "We study local requirements around the world and manufacture products that are tailored to their needs," says company president, Osterman. In addition to its manufacturing facility in Portland, the company has plants in Canada and Brazil.

European headquarters are in Belgium; Oregon Cutting Systems maintains sales offices in Germany, Sweden, France, the United Kingdom, Japan, and Russia. ◗

Highly specialized concrete-cutting saws are produced and sold worldwide by the Industrial Cutting Systems operation of Blount, Inc. The group is part of the Oregon Cutting Systems Division. The saws are driven hydraulically or by gasoline-powered engines and are designed for many unique cutting applications.

Gen. Charles (Chuck) Yeager (USAF, Ret.) is a spokesman for Oregon-brand products. The general is a longtime user of the company's cutting chain, guide bars, and maintenance accessories.

ander into Rodgers Instrument Corporation showroom, eyes closed, and listen to warm strains of heavenly music that transport you to the great cathedrals of the world. Now, with open eyes, see that same beauty in the exterior of the organs

This Rodgers Model 960 is similar to the one in New York's Carnegie Hall and Portland's Schnitzer Concert Hall.

themselves, the room filled corner to corner with organs of every size, the sumptuous handcrafted wood, each grain coaxed lovingly to a warm glow by one or more Rodgers associates.

Rodgers uses only the finest wood for its state-of-the-art organs, making Oregon—with its plentiful wood supply—an ideal location. The company buys raw, rough-cut oak, walnut, maple, rosewood, and other types of wood and completely processes it, to veneer lay-up, finishing it into the kind of beauty sought for churches, concert halls, and living rooms.

These all-wood instruments are created by Rodgers artisans, highly skilled people who take great pride in what they do. These Rodgers associates know that their instruments will be with church congregations, musical organizations, and families for one or more lifetimes. Each organ has a multigeneration life expectancy, and Rodgers is committed to providing parts to keep them healthy. Special features include four-point leveling, advanced catalyzed finish, a removable back for easy servicing, and reliable, low-voltage lighting for organ controls and music racks.

For many on the job at Rodgers, their career is also their avocation. The same hands that carefully craft these organs find themselves on the keyboards after hours, coaxing the

**Right:
Rodgers manufacturing facility and administrative offices**

harmony out of them and taking pride in the role they've played in making the experience divine. A quartet of Rodgers employees have even composed a winning musical composition.

The American Guild of Organists has exacting standards for building organs, and Rodgers strives to exceed them. Every element of Rodgers organs is built to construction quality—console, bench, even pedalboards. The durability and strength of an organ's construction is one of the critical elements to consider when purchasing an organ—and that includes its ease of maintenance. Rodgers organs are equipped with a self-diagnostic system that oftentimes allows the organ to function until a Rodgers technician can repair it. Also, they're designed so that parts are readily accessible and boards are easy to replace, keeping service time—and cost—to a minimum.

All Rodgers classic organs are entirely built in Oregon, and are crafted using Shoda routers, arguably the most precise guide routers available.

Well before the words "environmentally aware" became buzzwords here in Oregon or in the national consciousness, Rodgers was sensitive to treating its environment well. The company's reliance on wood for its finely hewn musical instruments is environmentally sensitive; wood is a natural, renewable resource. Rodgers also recovers the water-based materials it uses to treat and finish the wood.

Longtime craftspeople are the heart of Rodgers. Four Rodgers associates smile from an advertisement for the company. These are four of the artisans you'll find at Rodgers. Together they have 104 years of experience. Even the youngest of the four has 26 years of service with the company. They stay. Why? Because they get to do challenging work and are valued players on the Rodgers team. To these talented people, working at Rodgers is more than just a job; it's a way of life. And for them, hearing the music is equally as intense as creating where it comes from. ◢

NABISCO

An Oreo cookie tastes as good in Boise as it does in Honolulu, Seattle, or Fairbanks.

That's because of the quality standards practiced by the Nabisco bakery of Portland. It is probably the most technologically advanced facility of its kind in the Pacific Northwest. But the objective is not just volume. It is quality. And while the automated system is essential, people still play a vital role in the success of the nearly 500,000-square-foot production facility.

Plant manager Art Morton says, "You can put all the machinery, all the technology in place you want, but people are the most valuable part of the operation."

That philosophy became fact with installation of a Foxboro distributed control system. It put user-friendly advanced technology at the fingertips of Nabisco workers. Employees who once dumped 50-pound bags of ingredients into mixers have become process managers integrated into a single seamless system. That means all employees are involved in every process.

A trio of changes was essential to success. Basic was the determination to increase the skills and expand the knowledge of those who do the job. Employees welcomed the challenge. Surveys demonstrated they wanted to make significant contributions to the bakery. Their desire was directly related to the firm's second major change, the improvement of product quality and consistency.

Variables are a frustrating part of baking. Eliminating such inconsistencies and maintaining quality required updating the plant's equipment. That was the third goal. All were essential to the facility's ability to compete.

And the change was not gradual. All the improvements were initiated simultaneously. It was a baking revolution. Don Enstrom, engineering manager, called the changes "a jump through three generations of technology."

The equipment renovation involved installation of a distributed control system called the Foxboro I/A. At all key processing points computer terminals put advanced technology at the fingertips of employees. Operators retrieve information about their own area and any other process in the plant.

Departments in the Nabisco plant are both supplier and customer. Each is obligated to deliver the highest quality product to the next department. Each may reject a product it considers below its standards.

The nearest Nabisco plants to the Portland facility are in Chicago and southern California. There are many retail stores in between. To stock those shelves, 600,000 pounds of dough is mixed daily.

Nabisco Inc.'s Portland, Oregon, bakery

Oreo cookies, perhaps the bakery's most popular product, are produced in 16- and 20-ounce bags; as many as 100,000 cases a day are dispatched to markets throughout the West. The plant also bakes Chips Ahoy!, Premium Crackers, Cheese Nips, Better Cheddars, Wheat Thins, Vegetable Thins, and Ritz Air Crisps. The annual volume amounts to 100 million pounds.

Employee computer training has been essential to the success of the Nabisco plant, but the education process has paid other dividends. Manager Art Morton emphasizes: "The bakery has seen major equipment improvement. Through education employees play a central role. That training also influenced the quality of employee contributions to their families and to the community. My determination is that expanded employee education and equipment upgrades are continuous Nabisco commitments." ⏎

The Franz family first began baking bread while Theodore Roosevelt was president. It was 1906 and horse-drawn wagons delivered the fresh-baked bread. The bakery's operations have matured along with the city that has been its home.

Each addition to the United States Bakery family of operations brought new products and brands to its customers. It now offers the widest selection available in the Northwest.

Today, Franz, as part of United States Bakery, serves more than 9 million customers in Oregon, Alaska, Washington, Idaho, Montana, and California.

Franz became the largest family-owned bakery in the Pacific Northwest through the purchase of William's Bakery in Eugene, Smith Cookie Company (Archway) in McMinnville, and two Washington bakeries, Snyder's in Spokane and Gai's Northwest Bakeries in Seattle. The addition of Gai's provided a base from which to serve a radius of 200 miles around Seattle and doubled the U.S. Bakery market. In Portland and the other communities, local bakeries continue to operate under their original names.

President Bob Albers says incorporating the experience and skill of each acquisition has strengthened U.S. Bakery. "That's important," he adds, "because the biggest thing facing us is the constant battle to stay ahead of our competition."

New technologies are vital to that goal. "If you lag two, three, or four years behind in technology, you get into trouble," declares Albers.

The "home" bakery in Portland with the spinning bread loaf on top is an example. The facility sprawls over five city blocks and houses state-of-the-art systems that allow precise bak-

"The Loaf Spins On" — Franz Bakery, founded in 1906 by the Franz family.

ing at high speeds. Products baked in Portland are shipped throughout the U.S. Bakery system, supplying customers from Canada to California. To make those deliveries, USB drivers roll up 400,000 miles each week.

The company's distribution system is the best in the Pacific Northwest says Albers. There are more than 700 routes. Its biggest competitor has only half that number. Although it covers a large territory, the system is highly efficient because all the bakeries are within a few hours driving time of one another. "That," stresses Albers, "is a big advantage for us."

Even so, in the interests of efficiency, each bakery and every phase of operations is reviewed monthly. It is part of the company's commitment to reducing expenses. And the company's decentralized operation is a continuing demonstration of that dedication. A compact corporate staff in Portland is yet another example of U.S. Bakery's cost-conscious approach.

Each week the 3,000 employees produce 7 million pounds of quality baked goods, everything from white bread to cakes and French bread to potato rolls and donuts. Grade school youngsters may watch the process year-round. In fact, Franz is one of the few bakeries that still conducts school tours. And Franz supports the community in other ways. Each year it donates $500,000 worth of bread products to Portland charitable organizations.

Though the company is privately held, some key employees are also shareholders. All, says Albers, want to see the company remain privately held.

"We can sit down as a small group and consider options thoroughly. We are always listening to our customers about new products. We have the flexibility to act quickly, the freedom to reinvest in the business. So we operate with our hearts as well as our heads." ◢

GREAT WESTERN CHEMICAL CO.

Great Western Chemical Company is the largest independently owned full-line chemical distributor in the United States. The firm serves markets from the Pacific Ocean to the Atlantic and from Montana to Texas.

Customers from as far away as China, South America, Russia, and Mexico are familiar with the Great Western name. The company, headquartered in Portland, maintains distribution sites in Canada and plans for future global expansion.

W.C. McCall founded the company in 1956. The McCalls were well known for their service stations and home heating business.

Great Western's initial focus was to deliver chemical supplies to laundry companies and to firms involved in plating, compounding, painting, and coating. Today, Great Western provides chemical supplies to companies which process French fried potatoes, manufacture auto bumpers, fabricate circuit boards and semiconductor wafers, process petroleum, produce notebook paper, and dig for precious metals.

Great Western is determined never to compromise safety or environmental protection for profit. Health safety and environmental considerations are a priority in company planning. All new facilities are designed and built to meet or surpass all environmental requirements. The pace of the firm's construction schedule and its renovation of aging facilities is unprecedented in the industry.

Surpassing customer expectations is Great Western's goal. The firm takes pride in providing immediate response to customers' needs and to anticipate changes in those requirements. The Production Manager of Tillamook County Creamery Associate, Dale Baumgartner, declares, "Any time we have a problem, all I have to do is call a Great Western Chemical representative and he will be here."

Often, Great Western delivers to customers on an as-needed basis. For some firms that means shipments twice a day. In addition to the distribution of commodity and specialty items, Great Western designs a Total Inventory Management

Services (TIMS) program to meet a customer's unique requirements.

The Plant Manager of Umpqua Dairy Products in Roseburg, Oregon, Tom Rise, calls Great Western, "Not only our supplier, but our partner."

Great Western is committed to the betterment of the communities it serves and to those who live there, including its

Great Western Chemical Company distribution center, Portland, Oregon

employees. The company mission statement promises that the firm "must be a place where employees can excel and achieve professional and personal growth." The tenure of those who are responsible for daily field operations reflects that commitment. Many have been with the firm for a decade. Of those who commenced careers as truck drivers or warehouse workers and are now managers, several have been on the job over 20 years.

Great Western customers can be confident they will receive quality products, competitively priced, delivered on time, and accurately invoiced.

As company President and CEO Don Aultman puts it: "We're not satisfied being a chemical supplier. Great Western Chemical Company is built on a philosophy of value-added service. Today's marketplace, characterized by the supply-chain management theory of measurable value, offers Great Western the greatest opportunity for growth and customer satisfaction in our 40-year history. Our goal is to take our culture of quantifiable value-added service to a leadership position in all the key markets we serve." ◪

**Left to right:
Robert H. McCall, vice chairman of the board;
Don Aultman,
president and CEO;
W.C. McCall, chairman**

CASCADE GENERAL, INC.

Where a port exists, there are bound to be ships. Hardworking ships require regular maintenance and repairs. Fortunately, for ships within reach of Portland, Cascade General—one of the largest and most complete ship repair facilities in the world—is here.

Cascade General has serviced nearly every type of vessel that sails the oceans of the world, including oil tankers, cargo ships, cruise ships, and military support vessels. It has done so with a 2,000-strong, highly skilled workforce that understands the intricacies and priorities involved in this type of work: timing, scheduling, tight controls, and timed-to-the-second coordination.

Ship repair is a long tradition for any self-respecting port city, and Portland is no different. Yet the industry's very existence was threatened in the face of a business climate that closed more than 40 shipyards between 1984 and 1994, putting close to 100,000 people out of work.

Cascade General didn't escape the cutbacks. But today, with a unique agreement in place with the trade unions

Cascade General boasts the largest floating dry dock in the Americas at its Dry Dock 4, with a lift capacity of 87,000 long tons and overall length of 982 feet. Along with two other dry docks, the shipyard features 17 Whirley cranes and more than 7,000 feet of deep water repair berths. Cascade General's mammoth site also includes:

- huge craft shops,
- fully loaded machine shops complete with overhead cranes,
- full-service pipe and sheet metal shops,
- large surface preparation and coating facility,
- electrical and electronic repair facility capable of fiber-optic cable installation,
- structural fabrication shop that can create steel structures to any size,
- special barge for in-water rudder removal, and
- ballast water treatment facility.

With a Voyage Repair Division that completes ship repair away from the yard, Cascade General is ready for anything. And just about anything has come its way!

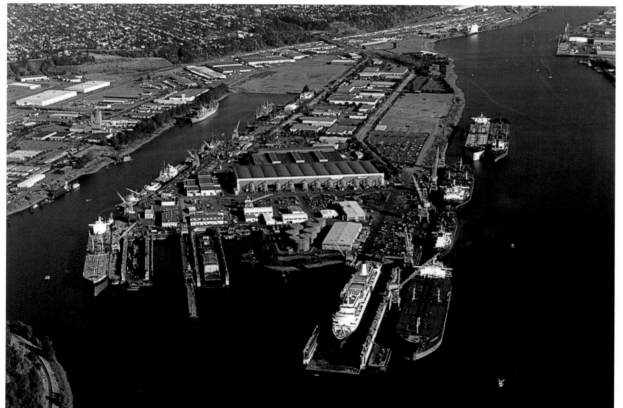

When the *Star Princess* ran aground near Juneau, Alaska, sustaining extensive damage, it was the ship repair specialists at Cascade General who removed and replaced more than 210 tons of damaged steel and repaired the starboard intermediate shaft, tail shaft, and propeller. Cascade General saved the owner millions of dollars by cold straightening the intermediate shaft in its machine shop—a unique service most shipyards don't provide in-house. Repairs were completed around the clock, astounding the customer when it was finished within 21 days. Both the builder and crew of the *Star Princess* had said it couldn't be done in less than two months.

The salvage ship *Glomar Explorer* benefited, too, from Cascade General's skill. After 20 years in lay-up, it came to Cascade General. After 135 days of round-the-clock work, it was born again as a state-of-the-art, deep-water drill ship. This incredibly quick conversion was made more amazing by the fact that it was completed 15 days ahead of schedule, a schedule with specified work having virtually doubled since the initial planning. ◢

that allows the company to bid competitively, and reward and keep the highest skilled employees and teach others, the company thrives. Its prime location is a 96-acre yard on the Willamette River—the best environment for ship repair. It's a fresh-water channel dredged to 40 feet, and offers a salt-free environment in a mild climate and a sheltered location.

COLUMBIA SPORTSWEAR COMPANY

Oregon's positive reputation for its green beauty and raging waterways is lauded around the world, while its rainy weather, which creates the stunning scenery, is lamented. The true Oregonian, though, knows the key to enjoying Oregon's stunning scenery and outdoor sporting opportunities year-round is wearing the right clothes, and the designer and manufacturer of the right clothes is right here in Portland: Columbia Sportswear Company®.

Gert Boyle, who, along with her son Tim Boyle, runs the company, is somewhat of a legend in Oregon. Her likeness is recognized internationally, since she stars in many of the company's advertisements. Her likeness can even be found on greeting cards. The story of her role in the company is the stuff of which business legends are made.

Her parents started the company after they escaped Nazi Germany, naming it after the river that runs through Oregon. Gert's husband, Neal, joined the family business and ultimately took its helm. Then, Neal's fatal heart attack in 1970 left the Columbia Sportswear without a president, leaving Gert Boyle to run or sell the company—and she had no business background. She chose to run it with her son, and today it is one of the world's largest outerwear manufacturers and the leading seller of skiwear in America.

Careful design and development are what make Columbia's products different and best-sellers. With input from sales representatives and key customers, the product is well-refined before it ever hits the retail floor. Then it's backed with a limited lifetime warranty against manufacturing defects, ensuring its customers are always receiving the highest quality products and service.

This customer emphasis really began with a fishing vest. In 1960, while fishing, Neal Boyle came up with the idea to make a vest with pockets that provided easy access to all of his fishing gear. His fishing buddies were Columbia's first focus group, and Gert was operating the sewing machine. This highly successful fishing vest taught the owners of

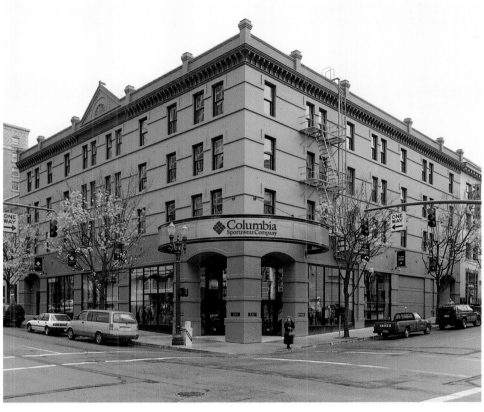

Columbia's flagship retail store, located in downtown Portland, Oregon

Columbia Sportswear two very valuable lessons: If it's not out there, design it, and if it's designed by and for real outdoorspeople, those people will buy it.

These basic principles guide Columbia through the creation of innovative and highly popular designs, one of which is its famous Interchange System™. The first Interchange jackets were designed for hunting, featuring a weatherproof outershell and an insulating inner jacket that could be worn together or separately, so each garment was really three or four garments in one. With the popularity of this product, a ski parka was likewise designed, called the Bugaboo™. It is arguably the best selling ski jacket ever.

At Columbia, excellence in manufacturing means more than just making a great product; it means creating products in safe, ethical working conditions and in an environmentally responsible manner. All of the factories with which Columbia contracts in the United States and overseas comply with local labor laws, and the company works hard to ensure that the jobs it creates offer meaningful benefits and a positive effect on the local economy. And the local economy, to Columbia, could be anywhere in the world. With products available through more than 10,000 retailers in over 30 countries, from Argentina to New Zealand to Korea. The company employs more than 1,100 people all over the world. ◨

Columbia Sportswear's award-winning advertising

In October 1995, the Century Class introduced a whole new class of technology for the trucking industry, including driver air bags and crash resistance that meets European standards.

Oregon's pioneering spirit is reflected in the shiny exteriors of the trucks produced by Freightliner Corporation out of its Portland manufacturing operation and in the company's motto: The company that does things right.

When Leland James, founder of Consolidated Freightways, saw the need for a lighter, stronger, and more economical truck, and was unable to find a manufacturer willing to tackle his revolutionary truck design, he set out to build it himself.

The first truck to bear the Freightliner nameplate appeared in 1942. Their aluminum components, used for the first time, meant the early Freightliners carried 2,000 pounds more payload than any other truck on the road, with more resilience to stress and resistance to corrosion.

In 1950, the Hyster Company became the first private carrier to purchase a Freightliner truck, and a trucking legend was born. "Hyster No. 1" logged more than 4 million miles before being retired, restored, and donated to the Smithsonian Museum of History and Technology.

These breakthroughs were followed by innovative designs like the all-aluminum cab, the aluminum integrated sleeper, and the first 90-degree tilt cab.

In 1981, Freightliner's commitment to technological leadership took a giant step forward when the company became partners in the North American truck market with Mercedes-Benz A.G., the world's foremost automotive engineering company and leading builder of heavy-duty diesel trucks.

For Freightliner, the '90s have brought about the most aggressive new product development in the history of the industry, from its popular "SleeperCabs" to its Business Class, its highly acclaimed entry into short-haul and mid-range applications such as pickup and delivery, refuse collection, and fire and rescue trucks.

In 1995, Freightliner introduced the Century Class, easily the most revolutionary new truck family since the days of Leland James. New from the rails up and the roof down, the Century Class pushed the envelope in virtually every performance category, including vehicle reliability, low maintenance, safety, visibility, aerodynamics and fuel efficiency, driver ergonomic and comfort factors, customer engineering, and the application of computer intelligence in a truck.

Vehicle export received Freightliner's serious attention in 1991. Working with Mercedes-Benz and its worldwide distribution network, Freightliner entered markets in Mexico and several Central and South American countries, in the Philippines, Australia, and the Middle East. Although Freightliner was the last truck manufacturer to enter the export arena, it came out leading truck exports by the end of 1992, and exporting to some 23 countries by 1995.

With the support of its 300 highly qualified North American truck dealers, Freightliner has also taken the lead in applying new tools, systems, and services for its customers' greater success. Its SpecPro® NG software, for example, helps to assure that all truck buyers specify the optimum vehicle configuration for their needs. The PartsPro® electronic parts catalog simplifies dealer identification and ordering of required parts. And ServicePro®, Freightliner's newest and most revolutionary software package, puts instant expert diagnostic assistance, vehicle history, relevant service bulletins, and warranty information at the fingertips of the service advisor and mechanic.

All of this is supported through aggressively expanded and modernized truck manufacturing facilities in Portland, Mt. Holly, North Carolina, Cleveland, North Carolina, St. Thomas, Ontario, and Gaffney, South Carolina.

Freightliner's commitment to invest in its customers pays off: it has gained in sales or share of market or both every year but one for the past 18 years. It assumed North American market leadership in 1992 on the basis of some 36,000 new truck sales. In 1997, Freightliner built 86,000 trucks and achieved an unprecedented 29.4 percent market share of Class 8 sales. ◢

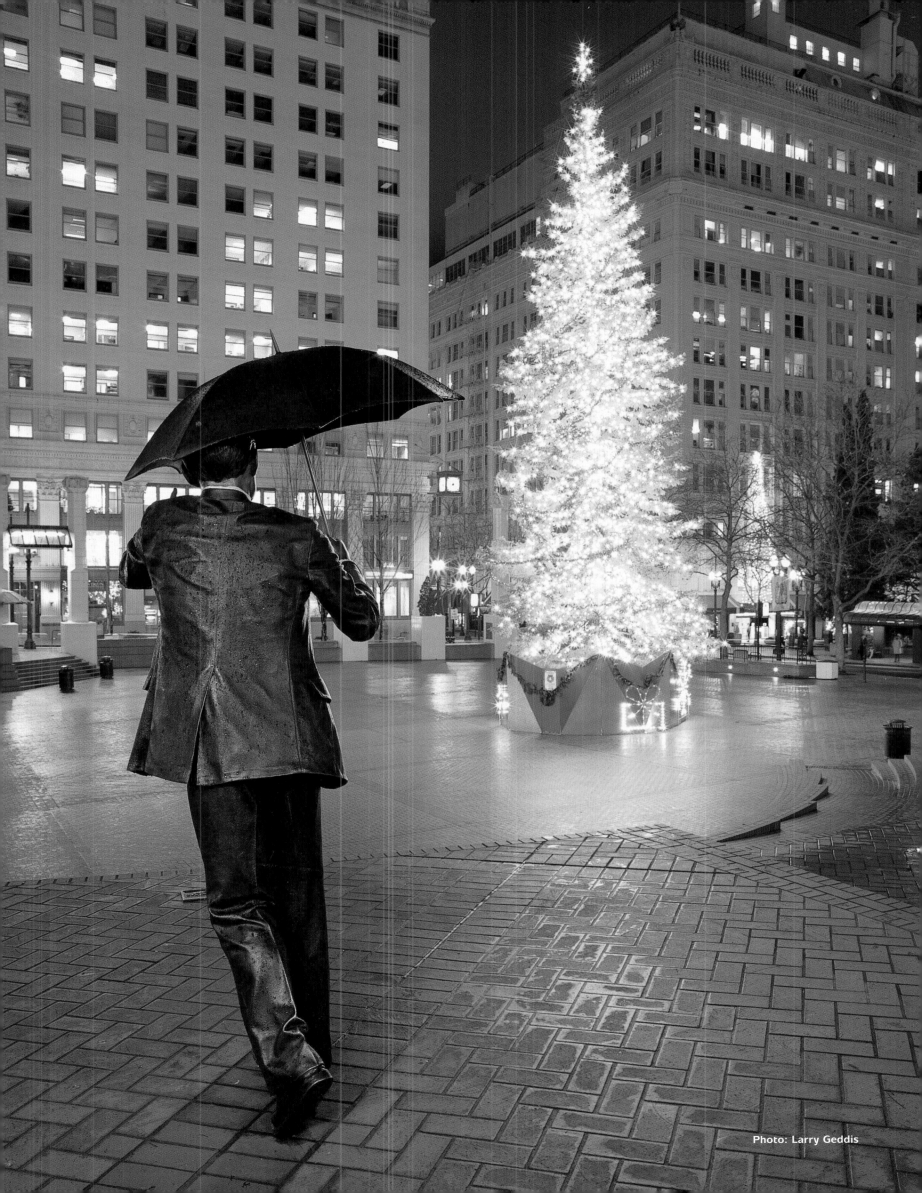

Photo: Larry Geddis

13

High Technology

Photo: First Light

An emerging market for ADC Kentrox is telemedicine. Providence Health Plans has built a network using ADC Kentrox multiservice access concentrators to consolidate communications for data and claims processing for its Oregon and Washington health plans. ADC Kentrox products ensure Providence can meet future communications growth and network requirements.

ADC Kentrox has expanded its office and manufacturing facility twice in the last five years. The most recent addition, completed in June 1998, added 80,000 square feet to the company's site on Northwest Science Park Drive in Portland, Oregon.

If you have ever sent and received E-mail, participated in a teleconference, or logged on to the Internet, chances are you have taken advantage of ADC Kentrox's network access technology. ADC Kentrox is the world's leading provider of high-speed network access equipment.

ADC Kentrox is constantly working to meet the insatiable demand for more instant information. The company provides a variety of comprehensive products which allow intelligent management of network access. Now, using the Web network, managers can diagnose, troubleshoot, and repair their networks. This innovation provides flexibility that allows network managers to do their jobs from any desktop, laptop, net station, or wherever a Web browser will work. Anywhere in the world.

ADC Kentrox President Lonnie Martin believes that the Internet is changing the way companies do business. "Businesses are using voice, data, and video technology to connect networks that may span several continents. Kentrox helps them get where they need to go." ADC Kentrox has been doing that since its founding in 1967 as a pioneer in Oregon's high-technology industry. During the past three decades, the firm has achieved an impressive number of technological firsts and a reputation as an industry innovator and leader. The company has demonstrated that ability again by developing an information technology system that resolved the so-called "year 2000" issues that confront other companies.

ADC Kentrox is recognized as a leader in reliability, performance, and quality. And the company is known for its prompt, expert customer and service support. Northwest Colorado Board of Cooperative Educational Services

selected ADC Kentrox multiservice access concentrators to build a state-of-the-art distance learning network. "We have found ADC Kentrox products to be the best available to meet our projects needs, and they back them up with the highest levels of service and support."

Recognition of ADC Kentrox product quality is reflected in the firm's increasing revenues of over 500 percent during the last five years. To accommodate the economic growth, ADC Kentrox has added an 81,000-square-foot structure to its 107,000-square-foot plant. In 2003, a new headquarters and manufacturing campus will be developed on other property in the Sunset Corridor. Nearly 200 more employees will be hired by the turn of the century, increasing the work force to 600. ADC Kentrox has a direct sales channel with more than 25 offices in 10 countries.

During his eight years with ADC Kentrox, a principal engineer, Gary Hanson, has seen his company grow and his opportunities expand. "I have worked on many design projects and found that this is a company where I can take on as much responsibility as I can handle. And I have always been treated with respect here." He adds that the acquisition of Kentrox by ADC Telecommunications in 1989 has contributed to company stability and his confidence of job security.

ADC Kentrox employees share in the growth of the company through profit sharing, retirement savings programs, education reimbursement, and training programs. There are also bonuses and other financial incentives. Employees participate in defining their jobs and they are encouraged to be innovative. Employee teams are involved in evaluating current sys-

tems and developing new products. All employees have the opportunity to suggest improvements in customer relations. Quarterly, a team reviews business processes and makes recommendations for improvements. President Martin emphasizes, "Employees are our key asset. Quality products begin with quality employees. We work hard to create an organization where employees can be involved and share in our success." Those involved appreciate that management commitment. In a recent employee survey, returned by 99 percent of the employees, 87 percent declared themselves satisfied with their job and with their workplace. And the firm has been on *Oregon Business* magazine's "Best Companies To Work for in Oregon" each year of the survey.

ADC Kentrox employees care about their community. The ADC Kentrox Employee Association is a major contributor to the "Toys for Tots" program, which collects toys for needy children during the holidays. And employees participate in annual food drives for the local food bank. During Christmas in April, employees repair homes for low-income, elderly, and disabled homeowners. Additionally, an employee committee spearheads the company's United Way campaign. ADC Kentrox supports this employee effort by matching contributions.

ADC Kentrox believes it has an obligation to support community and cultural events that enhance the community environment. Each year the firm contributes approximately one-half percent of operating profits to charity, with an emphasis on the arts, science, and education. Portland Art

Museum and the Oregon Symphony have benefited from ADC Kentrox contributions. The company also supports the Oregon Zoo, Special Olympics, Doernbecher Children's Hospital, and Oregon Public Broadcasting. ADC Kentrox has been a consistent supporter of Oregon Museum of Science and Industry and Oregon Graduate Institute. The company provides a program to help public school teachers improve their computer network management skills, with engineers conducting training workshops to help teachers keep up with technical developments. The company recently donated equipment for a computer lab at Beaumont Middle School, which will be used for student and teacher training throughout the Portland Public School District.

ADC Kentrox has come a long way. President Lonnie Martin says, "When we opened our doors, Oregon's high-tech players could be counted on one hand. Now there are dozens of companies. We're proud to have been a leader in building an industry which has become so important in our community." ▐

ADC Kentrox is the world leader in high-speed network access equipment that helps businesses build data, video, and voice networks, and connect to the Internet.

ADC Kentrox has a reputation for high-quality products and superior customer service. The company's state-of-the-art manufacturing facility ensures all products meet the Year 2000 issues, and around-the-clock technical and service support guarantees total customer satisfaction.

Mentor Graphics' headquarters sits on a 90-acre campus in Wilsonville, Oregon. The state-of-the-art facility includes six acres of wetlands and ponds; wooded hiking and running trails; soccer and softball fields; a nationally recognized Child Development Center for employees' children; and a commons building that houses a cafeteria, gym, credit union, and espresso bar.

Walden C. Rhines, president and chief executive officer of Mentor Graphics, is recognized as one of the industry's leading technologists.

The high-technology industry is brutally competitive, particularly the demanding market for electronic design software and services. Talented people with innovative ideas have driven the creation of countless technology companies. Most, like shooting stars, dramatically make their presence known, then quickly fade away.

The enduring vitality of a company can only be measured over time. From among a host of promising companies, a mere handful will show the ongoing ability to evolve, adapt, and grow stronger in the face of continuous changes in technology, the industry, and the market.

Mentor Graphics is such a company. In 1981, nine people with folding chairs, card tables, a blackboard, and an idea created Mentor Graphics. Most came from successful careers at Tektronix, the source of many of the Portland technology companies that today comprise Oregon's "Silicon Forest."

The vision these nine shared at that time was called computer-aided engineering, or "CAE." The advent of powerful microprocessors—the "brain" of any computer—led to the creation of a new type of desktop computer: the "workstation." With workstations, engineers for the first time had individual access to computing power that was previously locked away in the "glass houses" of mainframe computers. With the appropriate software installed on these workstations, engineers could automate the design of increasingly complex semiconductors and electronic systems. In fact, such automa-

tion was essential if the electronics industry was to continue to advance: it was no longer possible to create such sophisticated designs using conventional techniques.

CAE was an idea whose time had most emphatically come. Mentor Graphics, as well as two primary competitors, recognized the opportunity and were determined to provide the specialized design software for engineering workstations. So enormous were the opportunities, the original concept of CAE soon proved too limited, and was redefined as electronic design automation (EDA).

It was a time of intense competition and 18-hour days. Yet even in its formative years, Mentor Graphics emphasized the importance of its individual employees and collective culture. An early employee benefit was a rather primitive shower, soon followed by a modest exercise room, so employees could run off or lift away some of the stress. Company get-togethers were scheduled every Friday—or for whenever anyone could find a reason.

The idea, the talent, the hard work, and, yes, the fun paid off. Three years after its founding, Mentor Graphics' initial public offering was one of the most successful of the 1980s. Today, a remarkable 17 years after those first folding chairs, Mentor Graphics is the only one of the original EDA companies remaining. Its 2,500 employees, not only in Wilsonville, Oregon, but in 63 service and support locations, 7 R&D facilities, and 10 design centers throughout the world remain the

strength and focus of Mentor Graphics, which reported revenues of $461 million over the last 12 months.

A great deal has changed in those 17 years. The very nature of electronic system design is massively more complicated than ever before, placing new demands on both Mentor Graphics and its customers, among them the world's largest telecommunications, automotive, consumer electronics, computer, semiconductor, and aerospace companies. The market's never-ending appetite for electronic products that are lightweight, portable, and inexpensive—and yet ever more powerful and multifunctional—forces systems designers to include more and more circuitry on less and less silicon "real estate." The result is electronic design at the submicron level, a confoundingly miniaturized world of transistors, circuits, analog and digital signals, and hardware and software components. To make its customers successful, Mentor Graphics has had to respond to submicron design with new technologies, products, and consulting services that forge genuine long-term partnerships between EDA suppliers and electronics manufacturers.

Mentor Graphics has changed physically as well. Simple showers and a small weight room bear little resemblance to today's Wilsonville headquarters. On an environmentally conscious campus located in a thriving wetland, great blue herons, hooded mergansers, and kingfishers go about their daily routines with little apparent interest in electronic design automation. Wooded walking trails invite a random jog or picnic lunch. A soccer field and a baseball diamond create the eastern campus border. A commons building provides complete cafeteria services, a gymnasium, weight room, sauna, spa, meeting rooms, and a credit union office.

More fundamentally, though, there is much about Mentor Graphics that has not changed at all. The company has always enthusiastically viewed educational and community support as a core value. Since its founding, Mentor Graphics has initiated programs such as the K-12 Volunteer Grant Program, K-12 School-to-Work Program, and adoption gift benefits. The same culture that helped make Mentor Graphics one of the quintessential entrepreneurial models of the 1980s is alive and well in 1998. The focus is on the work, and the emphasis is on the fun and the excitement of individual and collective challenge and achievement.

For five consecutive years, *Working Mother* magazine's "Best 100 Companies to Work For" list has included Mentor Graphics. The company has consistently been an industry leader in providing a superior working environment and benefits package for its employees throughout the world. Mentor Graphics operates its nationally recognized Child Development Center at its corporate headquarters, focusing on the developmental needs of children in an environment that is family centered. In San Jose, Mentor Graphics has opened its Early Learning Center (ELC) at the Orchard School District's K-8 school site. The ELC is open to the children of both Mentor Graphics and school district employees.

The following fundamental values remain unchanged for Mentor Graphics. They reflect the company's determination to be successful, both as a business enterprise and as a member of its local, national, and international communities:

- Be a fierce and relentless competitor.
- Maintain the highest ethical business standards.
- Pursue excellence in everything we do.
- Act boldly and decisively.
- Challenge our people.
- Be a social and economic asset to the community.

Those values served Mentor Graphics well in the early 1980s, and they continue to define the spirit of Mentor Graphics as the next century approaches. The challenges to come will be driven by change every bit as profound as that of the past 17 years. But with a unique ability to balance the demands of the industry with the needs of the individual, Mentor Graphics is well positioned to meet those challenges. ◿

Mentor Graphics' Child Development Center (CDC) is a nationally recognized full-time early childhood and family support program for employees' children, ages six weeks through kindergarten.

Children at the Child Development Center are part of a strong school community that supports the family. Children and parents have the comfort of knowing that one another is nearby. The overarching philosophy of the CDC is to provide a program for young children that fosters the development of emotionally healthy children and stimulates children's natural interest in learning.

Rodgers Instrument Corporation is a high-technology company in disguise. Though located where the Silicon Forest rises along the Sunset Highway corridor, and recognized for creating and using breakthrough technology in digital sound, its product has little to do with personal computers. Instead, Rodgers' products grace cathedrals, homes, and music halls.

an authentic pipe organ, with none of the challenges. It's the melodic beauty of the pipe organ without the complexity or cost of pipes. The beauty of PDI is that it goes beyond accurate depiction of a pipe organ; it is also dynamic and musically responsive.

With close to 2,000 combination electronic/pipe organs

Rodgers' world headquarters is located in Oregon's growing Silicon Forest.

Rodgers builds classical and contemporary organs.

Like many of its neighbors, the company's roots are in high technology. Rodgers was formed when two Tektronix employees, Fred Tinker and Rodgers Jenkins, convinced Tektronix President Howard Vollum to financially support their non-standard high-tech dream in 1958. They founded Rodgers, and developed the world's first successful solid-state transistorized classical organ, the first electronic instrument to truly challenge the performance of the traditional pipe organ. That was only the beginning of "firsts" for this company. Next came computer capture combination action, the first musically successful combination pipe/electronic organ and microprocessor-controlled, serial-keyed organs.

Listening to an organ, nonmusicians might not realize the complexity of the instrument, the necessity for perfect tune, rich, natural harmonic structures, and limitless sound possibilities. Authentic pipe organs create a sound as indescribable as the perfect autumn day in Oregon. But pipe organs bring with them their own challenges.

Recognizing this, Rodgers developed the revolutionary Parallel Digital Imaging®, known as PDI™. This patented digital sampling technology brings forth the rich, warm sound of

This Rodgers Model 960 is similar to the one in New York's Carnegie Hall and Portland's Schnitzer Concert Hall.

sold—more than any other company—and uncountable electronic organs installed throughout the United States, Rodgers is well-recognized as one of the largest and most respected organ manufacturers in the world, the foremost builder of pipe/electronic combination organs and a leader in technical innovations. A member of the Roland Group, Rodgers benefits from the expertise of more than 300 engineers on both sides of the Pacific Ocean. Roland invests heavily in sound technology research and development and, as a $500-million company, can conduct ongoing exploration and experimentation.

Rodgers has also been recognized for its innovation and business growth, earning several awards, including the "E" award for export excellence from the president of the United States, the Governor of Oregon's "Marketing Firm of the Year Award," and the Portland area's "Top 10 Growth Companies" award.

Most importantly, of course, are the company's customers. Rodgers customers include the masters of music, outstanding concert organists, and major symphonies. In the Pacific Northwest, both the Oregon Symphony and the Seattle Symphony use Rodgers organs. Elsewhere, the Philadelphia Symphony, Chicago Symphony, and Los Angeles Philharmonic also rely on Rodgers' instruments. Rodgers' organs are in concert halls from Portland's Schnitzer Concert Hall to New York's Carnegie Hall.

While Rodgers Instrument Corporation is known as a classic organ manufacturer, its design, engineering, and technological sophistication is equal to that of its high-tech neighbors. ◙

omputer People Inc. (CPI) has served the Portland area as a leading provider of high-tech consulting services since 1988. Since the office started in Portland, it has worked and grown to serve the information technology (IT) needs of companies in Oregon and the surrounding area. CPI provides large and small companies with a variety of skilled consultants with expertise in a wide number of computer platforms and languages. Since 1988, CPI has had the opportunity to grow and thrive in a very competitive marketplace, partly due to the quality of the relationships built between CPI and its clients and consultants.

One of the main reasons for this success is the people. CPI Portland has a team of account managers who work one-on-one with clients to assess needs, fill requirements, and provide a quality service program that is second to none. The branch's recruiting staff has the resources and experience behind it to find qualified consultants not just in the United States, but around the world. The Area Technical Management (ATM) group is one of the best in the business in not only solving consultant issues, but also in providing unique and innovative training and career growth programs. Finally, the exceptional administrative staff works with every other area to allow all parts of the business to run smoothly.

As an internationally based company, CPI is proud of the broad range of technical skills and experience levels of its professional staff. For many years, CPI was a resource for companies which only had mainframe programmer/analyst needs. Today, clients can count on CPI to provide them with consultants who work on a wide range of platforms and environments, from large mainframe systems to single PCs.

One benefit that consultants and clients all enjoy is CPI's commitment to training and continuing education. One of

the goals of CPI Portland is to ensure consultant success by empowering employees to achieve their personal best. In order to achieve this goal, CPI Portland offers in-house computer-based training, technical classroom instruction, periodic presentations on topical subjects, interpersonal skills training, and more to its professional staff. In addition, tuition reimbursement is made available to all employees who want to continue their education.

Proud of its tradition of Portland community service, CPI encourages its staff to give something back to the city. CPI Portland and its staff support and are involved in a broad range of charitable and philanthropic activities and causes.

As the pace of technological change continues to increase, Computer People in Portland will continue to change and improve to keep up with it. The staff at CPI Portland also recognizes that, beyond the technology, if it were not for the collaborative efforts between itself and its clients and consultants, it could not be as successful as it is today. ∎

The management team for the Portland branch of Computer People Inc.: (standing, left to right) Holly Redfern, Lead Recruiter; Jim Lawrence, Area Technical Manager; (seated, left to right) Rand Zoborowski, Branch Manager; and Debbie McCoy, Lead Account Manager

The Portland branch of CPI has been serving the Portland/Salem/southwest Washington area for 14 years, providing a full range of business solutions to local *Fortune* 500 companies.

14

Business
&
Finance

Photo: Larry Geddis

PORTLAND METROPOLITAN CHAMBER OF COMMERCE

The Portland Metropolitan Chamber of Commerce, with some 2,000 members, is the largest business organization in the region. It draws its strength and success from its members—companies with vision, determination, and a healthy dose of

Oregon Economic Development Department, and the Portland Development Commission, to attract new industry to the area. At the same time it supports state and local efforts to nourish and expand manufacturing projects through the use of tax incentives and other tools.

The Chamber also plays a key role in creating demand for Portland and Oregon products around the world. Beginning as early as 1906, the Portland Chamber facilitated trade partnerships with Japan and other Asian countries, laying the foundation for today's thriving international trade.

Small businesses are the lifeblood of the Chamber, with nearly 85 percent of its member firms qualifying for that classification. As a result, the Chamber actively looks for associations and programs which nurture small businesses. Because people do business with people they know, the Chamber is a primary resource for its members in building business contacts and networks. With some 50 special events every year and more than a dozen committees and task forces, members have a wide variety of channels to use for building contacts and growing their businesses.

For more than a century the Portland Chamber has worked for an efficient transportation system. Early Chamber leaders built a world-class port city with deep shipping channels on the Columbia and

Tom McCall Waterfront Park, once a freeway through downtown Portland, hosts numerous community festivals throughout the summer. Photo: Steve Terrill.

independence, which have been the hallmarks of Oregonians since the early pioneers.

From its earliest days as the Portland Board of Trade and its incorporation in 1890, the Portland Chamber has played an integral role in shaping Portland and the region. Whether it was building bridges and roads, creating a world-class port, or attracting settlers to the region, the Chamber and its members have been working with one ultimate goal—building a prosperous Portland.

Within its mission of promoting business prosperity, the Chamber focuses on diversifying and strengthening the region's economy, improving transportation, and providing for the common good.

The Chamber has long held that family wage jobs are the foundation for a strong and diverse economy. Throughout its history, the Chamber has fought to promote a business climate which would encourage job growth and economic development. By fostering working partnerships with local officials, the Portland Chamber is able to help craft public policy so that decisions are fair for all and do not have unintended results which could damage business.

In its continued efforts to diversify the region's economy, the Chamber works with others, such as the Port of Portland,

The Port of Portland's world-class marine facilities process goods from all over the world. Photo: Steve Terrill.

Willamette Rivers, public docks, and a flourishing shipping industry. Their Portland had paved roads and bridges connecting the east and west banks of the Willamette. An extensive trolley system brought residents to the heart of the city. Portland became a transportation hub.

Following their lead, today's Chamber is a key player in developing and implementing a regional transportation plan designed to respond to the pressures of a growing population. The Chamber is working with civic and government leaders to identify transportation priorities and seek funding solutions to improve the transportation infrastructure. Key components include an efficient transit system with adequate buses and light rail lines, better roads and highways, and expanded port facilities to handle today's deepwater ships and air cargo.

Portland is a good place to live and do business due in large part to the early partnerships developed between local governments and the business community. Working together for the common good, the Chamber has created an attractive business climate and community complete with excellent schools, beautiful parks and green spaces, well-funded and equipped libraries, and the other components that make Portland a vibrant metropolis.

Education is the key to providing a knowledgeable workforce and future employment gains for the region. From its earliest beginnings, the Portland Chamber has helped lead the effort to provide an outstanding public education system. Those efforts paid off because Portland has one of the best urban school districts in the nation.

While the Chamber's early efforts concentrated on bricks and mortar for Portland schools, today's issues are more complex. With recent changes in Oregon's tax structure, adequate school funding has become a real concern. Coupled with an ambitious state-mandated educational reform, public school districts are looking toward the state legislature for funding solutions.

The Portland Chamber has advocated a long-term statewide solution which will provide stable funding and supported a statewide ballot measure allocating a portion of the state's lottery dollars to public schools. It is also working with local school districts and others to find solutions for K-12 funding.

Since the passage of sweeping property tax reforms, Oregon's colleges and universities have worked to eliminate duplication in program offerings and have developed other cost cutting strategies to ensure a continued high quality education for its students. Despite best efforts, higher education continues to need additional funding. And, like K-12, the State System of Higher Education needs help in solving its funding problems and looks to the Chamber's leadership in its search for solutions.

A high-quality, well-educated workforce makes the Portland metropolitan area desirable for businesses and families alike, and the Portland Chamber will continue to work for the best possible education for all from preschool through college.

Early pioneers had a vision for Portland—a world-class port city rich with natural resources, populated by well-educated people working in a wide range of industries. So successful were those early visionaries that the Portland metropolitan area has become one of the fastest growing regions in the country. That is why the Chamber is deeply involved in Metro's Region 2040 plan—a long-term strategy for regional growth management. Without growth management, Portland would be destined to become like so many other cities—managed by growth rather than managing its growth.

The vision and dedication of the Portland Chamber's leadership has served the region well. The men and women who belong to the Portland Chamber today function in the same spirit as its founders. They seek to be an integral part of the community, providing thoughtful leadership and committed to building a prosperous Portland. ◪

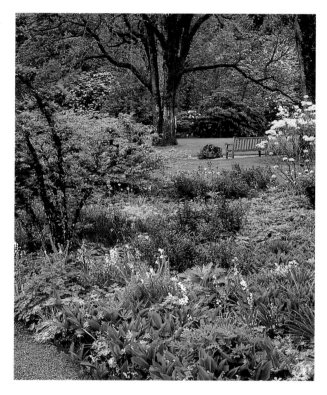

**The Portland area boasts of thousands of acres of parks, from the world's smallest park to the nation's largest urban park.
Photo: Larry Geddis.**

**Pioneer Place, downtown Portland's newest shopping center, is easily accessible to all.
Photo: Larry Geddis.**

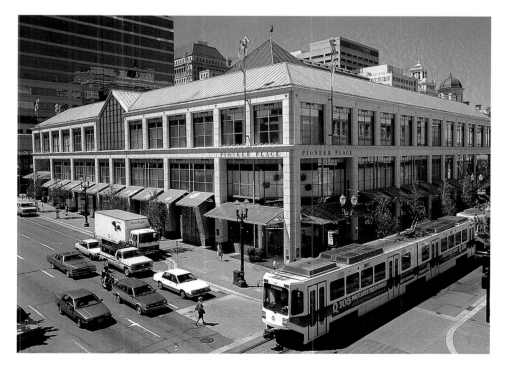

U . S . B A N K

During the winter of 1891, the city of Portland was experiencing urban growth. Over 45,000 persons lived in the city, when only a generation earlier the town was part of the Oregon territory.

Located in the U.S. Bancorp Tower, an impressive landmark in downtown Portland, U.S. Bank offers the unique combination of a community-oriented bank's personal attentiveness and the resources of a national financial services leader.

U.S. Bank employees (right) volunteer for various community programs including SMART (Start Making a Reader Today).

The Grand Central Hotel had steam heat and electric lights. The opera house was becoming a popular community attraction. And there was a new bank in town.

The United States National Bank opened for business Monday morning, February 5th. At the close of the day, 15 customers had deposited nearly $22,000.

U.S. Bank has grown with Oregon and is now the largest commercial bank in the state. There are more than 180 branches and 540 automatic teller machines throughout the state providing service to customers where and when they need it. U.S. Bank also offers a 24-hour, seven-days-a-week telephone customer service center.

INNOVATIVE BANKING SERVICES

As business operations and requirements have changed, so has how U.S. Bank provides its services. U.S. Bank was the first financial institution in the West to offer customers on-line banking using off-the-shelf software. Through UBank® Online, customers can access their financial information using a personal computer. Accounts are also accessible through the Internet; customers may sign up simply by visiting the U.S. Bank web site at www.usbank.com.

As a national leader in the development of electronic payment systems, U.S. Bank has helped businesses streamline their accounts payable operations and transaction processing.

COMMITTED TO BUSINESS

Serving more businesses than any other financial institution in the state, businesses trust and depend on U.S. Bank. Over 40 percent of commercial businesses and 30 percent of small businesses in Oregon have a relationship with U.S. Bank. Building long-term relationships and providing exceptional service continue to distinguish U.S. Bank.

As regional bankers, U.S. Bank experts understand the industries that are critical to Oregon's economy: forest and wood products, commercial real estate, high technology, agriculture, food processing, and hospitality. International banking specialists speak the languages and have a network of contacts throughout the Pacific Rim, Latin America, Canada, and Europe.

U.S. Bank was one of the first banks to eliminate much of the paperwork traditionally involved in issuing small business loans. Using its U.S. Simply Business® product, the bank is able to lend up to $250,000 within 24 hours of receiving an application from businesses whose sales are $500,000 or less. The Small Business Administration classifies U.S. Bank of Oregon as a preferred lender, and its parent corporation, U.S. Bancorp, is one of the top small business lenders in the country.

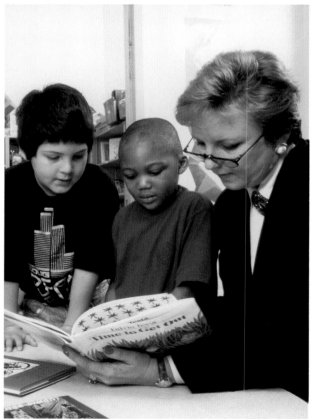

The spectrum of services provided by U.S. Bank includes one of the nation's largest bank-affiliated leasing companies. Leases are available on a wide range of equipment—from aircraft to trucks and trailers—and manufacturing machinery.

U.S. Bank's Commercial Real Estate Division is made up of experienced professionals who know the markets throughout Oregon and offer a full range of innovative and competitive lending options. Local loan experts are able to cut through red tape and provide the prompt response that is so often crucial to the success of commercial real estate projects.

Providing choice and convenience are the goals of U.S. Bank's Private Financial Services staff, who serve the bank's private banking and trust clients. Options include a variety of sophisticated products and services, such as proprietary mutual funds, stocks and bonds, government securities, annuities, and brokerage-like checking products. Highly trained specialists provide comprehensive solutions individually focused to meet each customer's unique needs. Personal service is the hallmark of their success.

DEDICATED TO THE COMMUNITY

U.S. Bank is recognized as a leader in supporting and financing the development of affordable housing. The bank has been influential in developing products, services, and programs that meet the credit needs of low- and moderate-income families and has been rated outstanding by Federal regulators for its commitment to the Community Reinvestment Act. The bank has also developed programs to assist families and first-time buyers in acquiring a home.

U.S. Bank has a long history of giving back to the communities it serves. In 1997, U.S. Bancorp contributed more than $18 million to causes throughout its 17-state market area. Organizations in Oregon receiving funding included SMART (Start Making a Reader Today), the Oregon Historical Society, the Oregon Symphony, Make A Wish, United Way, and many more. In addition, U.S. Bank employees volunteer thousands of hours each year to causes which are special to them and keep them close to their communities and to the customers they serve.

And that is the way it should be, says Oregon U.S. Bank President John Rickman: "Providing quality service is a responsibility we take very seriously. However, our commitment does not conclude with the end of the workday. We are proud to support hundreds of organizations which help to make special those places we call home."

U.S. Bank has grown up in Oregon over the last hundred years and faces the next century with dedication, enthusiasm, and confidence. ◪

U.S. Bank has built a solid reputation as a leader in high-tech and convenience banking by creating innovative products and services.

Developing and maintaining strong, long-term relationships with customers is a top priority at U.S. Bank. Local decision making enhances these relationships and provides quick responses to customer needs.

The Broadway sign of the Portland Center for the Performing Arts is a downtown icon, beckoning residents and tourists alike to the city's vibrant cultural scene.

touring Broadway shows including *Phantom of the Opera* and Disney's *Beauty and the Beast*, as well as popular hits *Chicago*, *Stomp*, and *Rent*. National concert artists, lecture series, and more fill the calendar of the Performing Arts Center throughout the year with a rich array of quality cultural attractions for the community and its visitors.

PORTLAND METROPOLITAN EXPOSITION CENTER

The Portland Metropolitan Exposition Center (Expo Center) is the region's largest consumer and trade show venue of its kind. The 60-acre site includes four interconnected buildings with total exhibit space exceeding 330,000 square feet and parking for nearly 3,000 vehicles. Expo Center hosts a multitude of public expositions, including antiques, autos, boats, collectibles, home and garden, recreation, sports and trade shows, as well as special events.

The Metropolitan Exposition-Recreation Commission (MERC) is a seven-member commission that manages, develops, and promotes the Oregon Convention Center, the Portland Center for the Performing Arts, Portland Civic Stadium, and the Portland Metropolitan Exposition Center. The Commission operates these regional facilities on behalf of Metro, the area's regional government. The MERC offices are located in the Oregon Convention Center.

PORTLAND CENTER FOR THE PERFORMING ARTS

The Portland Center for the Performing Arts (PCPA) is a landmark in the city's "Bright Lights District" on Broadway, in downtown Portland. Comprised of Portland Civic Auditorium, the Arlene Schnitzer Concert Hall, and the New Theatre Building housing the Newmark and Dolores Winningstad Theatres, the Performing Arts Center is the cultural heart of the city and region. These four venues host more than 1,000 performances annually, with attendance in excess of 1 million people—making PCPA one of the most active cultural centers in the nation. The Oregon Symphony, Portland Opera, Oregon Ballet Theatre, Portland Center Stage, and Oregon Children's Theatre are among the many resident companies producing annual performance seasons on these stages. Guest artists such as Itzhak Perlman, Kathleen Battle, Victor Borge and Yo Yo Ma add international celebrity to acclaimed performances by local professional artists.

Adjacent to the city's celebrated Forecourt Fountain, the Portland Civic Auditorium is home to

Expo Center's new 108,000-square-foot exhibit hall draws world-class exhibitions to the northwest region, such as the recent *America's Smithsonian* exhibit.

Expo Center's recent expansion added a world-class new building featuring 108,000 square feet clear-span exposition space. The inaugural event in the new building, the celebrated *America's Smithsonian* exhibit, attracted 424,000 attendees from throughout the region for this exclusive northwest showing. Expo Center is conveniently located freeway minutes north of downtown.

THE OREGON CONVENTION CENTER

The Oregon Convention Center (OCC) is a publicly owned national and international convention, trade show, and multipurpose facility. The stunning landmark with its trademark twin glass towers has won national acclaim for its beauty and superior customer service. The 500,000-square-foot facility serves as a community venue and as a magnet for convention dollars that generate economic benefits for the state and region.

The Center is located on the east bank of the Willamette River in the City Center, directly off U.S. Interstate 5. Shopping, restaurants, and entertainment in the surrounding Lloyd district and in downtown Portland are only minutes away on the MAX (light rail) line, or by foot along the scenic Tom McCall Waterfront Park.

The existing building was completed in September 1990. Construction to complete the OCC master plan and add an additional 350,000 square feet to the facility is expected to begin before the year 2000.

PORTLAND CIVIC STADIUM

Historic Portland Civic Stadium, located in the heart of downtown, serves as Portland's principal outdoor venue for professional and major college sporting events, high school football and baseball, community soccer, and large special events. Civic Stadium is home to the Portland Rockies baseball team, and recently has become an important venue for World Cup Soccer. In 1997, the Stadium hosted Men's World Cup Soccer, drawing nearly 28,000 enthusiastic soccer fans. Another Men's World Cup Soccer match (USA vs. Kuwait) was held in May 1998, and Stadium will host Women's World Cup Soccer qualifying events in 1999.

Civic Stadium is known for its heritage, its charm, its convenience (located on the region's MAX light rail line), and its unique event mix. Built in 1923 as "Multnomah Field," the facility was the area's first athletic and community facility built to seat 15,000. That first year, the stands overflowed onto the grass with upwards of 25,000 people attending events ranging from a presidential visit by Warren Harding to the community's traditional Rose Festival Rosaria Pageant. By 1926, 13,000 more seats were added to the grandstands, creating a facility of stadium proportion. The Stadium has served as a launch pad for hot air balloons, a parade ground for marching bands, and a landing site for colorful parachuters. ◪

The Oregon Convention Center has won national acclaim for its award-winning architectural design and its superior customer service.

Tab Ramos scores the historic goal on September 7, 1997, at Portland Civic Stadium. Home to baseball, college sports, concerts, and special events, Stadium has become a venue for World Cup Soccer matches. Photo J. Brett Whitesell, International Sports Images.

Nationwide is a part of this community, leading the way in highway safety, drunken driving prevention, and education.

More than 70 years of providing individuals, families, home-owners, and companies with insurance, long-term savings plans, and services to grow their business—that's the history Nationwide proudly looks back on. And it looks forward to building on that heritage of cooperation, trust, and dedication.

Nationwide has always believed in finding a better way to do things, ever since a group of Ohio farmers came together in 1926 to try to find a way to reduce the cost of auto insurance. Deciding the current offerings were overpriced, they formed a company of their own.

Today, Nationwide is one of the most respected and financially stable insurers in the world. It's the 37th largest insurance and financial services company in the world and the 15th largest in the United States.

Nationwide is really three businesses in one. The first business is personal insurance for auto and home. This includes the original flagship products the company started with in 1926. With Nationwide, you can trust you have the best possible protection for your home and possessions, whether you own or rent your home. Nationwide even has a condominium owner's policy designed exclusively for condo living. As for auto insurance, there's a reason Nationwide is the fourth largest auto insurance company in the United States. It offers quality coverage that protects policyholders from the high costs of having a car vandalized, stolen, or damaged in an accident.

Technology has changed the face of insurance service. Customer and claims service is available in person, over the phone, and through the Internet.

The second business is life insurance and financial investment products. These include a broad range of permanent and term insurance policies. Nationwide can help you determine just how much and what type of life insurance you should own. It also offers disability insurance, an often overlooked form of protection for policyholders and their families.

Nationwide's financial investment products include fixed and variable annuities, many of which are sold under *The BEST of AMERICA®* brand through banks, brokers, and private financial advisers, as well as Nationwide's own agents. Nationwide was the first insurance company to sell mutual funds, and its size is its strength. Nationwide can give competitive commissions to brokers and, at the same time, low fees to consumers. Little wonder life insurance and annuities was one of the fastest growing segments of Nationwide Insurance Enterprise, with a 21 percent increase from 1996 to 1997.

As baby boomers begin to think more about their future, they have questions about paying for college tuition and making sure they can have the kind of retirement they want. They find the answers they need from Nationwide Financial Services. They know they can have a secure tomorrow with a little planning today. Nationwide is there to help.

The third business is commercial services—protecting today's businesses for tomorrow. Businesses need to be competitive and productive. Nationwide serves the needs of large business through workers' compensation, general liability, and property insurance. There are multiple businesses within commercial services. Wausau Insurance may be the best known. No matter how large or small your company, Nationwide's business policies are tailor-made to your specific needs.

But when you come right down to it, Nationwide's real product is its people. As Senior Vice President of Property Casualty Marketing Danny Fullerton put it: "All we have to offer our customers is the promise our people will be there for them when they need us. We're not selling hard goods; what we are selling is the essence of who we are."

Intel can look at its chip. Chrysler can look at its cars. Nationwide looks at its promise to perform. Its people and how they serve their clients are always at the heart of the company's success. Nationwide's vision statement begins with the sentence, "We exist to serve our customers."

The concept of insurance is simple, but the execution of it is very complex. Understanding what it costs to repair a home or car is, in fact, quite technical. Nationwide works to constantly improve the skills of its people.

With all the advances in technology, it's an exciting time for Nationwide. Claims adjusters have laptop computer systems with automated estimating systems. They have the cost of auto replacement parts or labor costs at their fingertips wherever they are. In this way, adjusters can keep up with the rapid changes in prices and market-to-market differences to settle claims faster.

The commitment to technology extends even to Nationwide's Blue Ribbon auto repair shops. They're tied into Nationwide electronically, enabling a shop to take and transmit on line a photo of a damaged car to Nationwide for repair authorization.

Customers now can reach Nationwide through the Internet. Some can obtain quotes or purchase policies on line. Automated voice-response systems allow clients to call at any hour to change their investment options.

People want fast service when they have a claim, and Nationwide prides itself on being quick to respond to every claim, whether it be an earthquake or a mere fender bender.

Nationwide has a tremendous capacity to respond to catastrophic events. It can mobilize hundreds of claims representatives to go to the scene of a flood, earthquake, or tornado. The company gauges its performance by the cards and letters from customers thanking them after being helped through a disaster. Nationwide also gets high marks from independent rating companies for handling claims in catastrophic conditions. They don't just settle for what others think of them, however. Nationwide sends out thousands of customer-satisfaction surveys every year, and consistently gets high ratings back.

Nationwide also has a strong commitment to safety. Its involvement includes a program called Prom Promise—an education campaign in which high school students commit to not drinking and driving on prom night.

Here in Portland, Nationwide is the title sponsor of the Hood to Coast race. The longest relay in North America, the Hood to Coast travels a brutal 195 miles from 6,000 feet near the top of Mt. Hood to Seaside, Oregon. More than 12,000 runners take part on 12-person teams.

As for the future? Look to Nationwide to be one of the most successful dominant financial service companies in the business. It has the products, people, leadership, and the financial strength to sustain aggressive growth and to continue to expand its offerings to customers. Nationwide knows it will be a survivor in the acquisition and merger frenzy of today's business climate.

But as it grows into the next century, Nationwide will never forget its core objective—to help people understand what is potentially in their future, determine their objectives, and form a strategy to meet those goals. Insurance and financial planning are vital needs, and Nationwide is proud to be there to meet those needs. ◢

Since its formation as an insurer in 1926, Nationwide now provides personal insurance, life insurance and financial investment products, and commercial services.

Nationwide's product is its people. It offers customers the promise that it will be there for them when they need it.

For almost 150 years, Wells Fargo & Co. has been serving the financial needs of individuals and businesses in the western United States.

Founded in 1852 by Henry Wells and William Fargo, the company's original purpose was to provide essential banking

Wells Fargo was founded in 1852 to provide banking and express services to western pioneers during the gold rush.

services, reliable transportation of gold and goods, and dependable mail delivery to miners, merchants, loggers, and farmers.

Starting from its base in San Francisco, Wells Fargo quickly expanded into the Northwest. The company opened its first office in Portland in October of 1852, serving the pioneers who settled here after traveling the Oregon Trail. Within a year, additional offices were opened in Oregon City, Salem, and other locations to serve the burgeoning population. By 1897, Wells Fargo had 105 offices in Oregon.

FAST THEN . . .

In those early days, Wells Fargo sent gold, mail, and express shipments by the fastest transportation available, including stagecoach, steamer, railroad, and pony express. Wells Fargo agents were renowned throughout the company's nationwide network for their resourcefulness, enthusiasm, and integrity.

Wells Fargo left the express business when, as a wartime measure, the U.S. government nationalized all of the country's express services into a single, federal entity in 1918. Overnight, Wells Fargo shrank in size, with only its banking business in San Francisco remaining.

As a leader in banking technology, Wells Fargo offers customers convenient banking choices to fit their lifestyles.

FAST NOW . . .

By merging with other established banking firms, including First Interstate Bancorp in 1996, Wells Fargo has been able to

grow and return to the Northwest to provide customers with top-of-the-line products and services.

Today, Wells Fargo & Co. is one of the nation's 10 largest bank holding companies. The bank offers its customers nearly 2,000 branches and more than 4,400 ATMs throughout the western United States, including close to 160 branches in Oregon.

This network is one example of the convenience the bank provides. For customers who choose the traditional method of banking, Wells Fargo has many conveniently located branches with extended hours and friendly, knowledgeable agents. Branches placed inside grocery stores allow customers full-service banking on weekends and holidays.

Customers who can't get to a branch have the 24-hour convenience of Internet banking (wellsfargo.com), ATM banking, telephone banking, and bank-by-mail. These round-the-clock banking options are designed knowing the value of the customer's time.

The company's focus on technology and innovation allows it to deliver products and services faster than the rest of the banking industry. For example, by streamlining the approval process and accepting applications for loans under $100,000 through the fax and phone, Wells Fargo has become the leading small-business lender in the western United States.

The frontier in the 1800s was the American West, and the currency was gold dust. Today, the new frontier is the Internet, and much of our currency is digital. Wells Fargo's pioneering spirit continues to place the company at the forefront of banking technology, seeking innovative ways to meet the needs of its customers.

FERGUSON, WELLMAN, RUDD, PURDY & VAN WINKLE, INC.

Ferguson, Wellman, Rudd, Purdy & Van Winkle is one of the largest private money management firms in the Northwest, but most Portlanders don't know it. And that's fine with James H. Rudd, chief executive officer of the investment firm. "We're not offended if they've never heard of us. We're a quiet company."

A pair of stockbrokers formed the company in 1975 as one of the first fee-based investment advisory firms in Oregon. Norbert J. Wellman and H. Joseph Ferguson, native Oregonians, believed their expertise could benefit others who shared their philosophy of steadfastness and discipline. They knew something about discipline. Both had been military officers, Wellman in the Air Force, Ferguson in the Marines.

Gerald Ford was president, the Viet Nam War ended, U.S. automakers were offering rebates for the first time, "Rhinestone Cowboy" was at the top of the music lists, *Jaws* was the big movie, streaking was a fad, and Hank Aaron hit his 715th home run to claim Babe Ruth's lifetime record.

Society has changed the past quarter century, but Ferguson, Wellman's philosophy hasn't. The firm's dedication is to tailor an investment portfolio to fit the client.

Steven J. Holwerda, chief operating officer, emphasizes, "We are not going to do anything contrary to the principles on which the firm has been built. Our steady growth reflects our conservative investment philosophy, and our efforts to exceed the service and performance expectations of our clients."

The client retention rate confirms that steadiness and attention to detail. Perhaps a third of Ferguson, Wellman's clients have been with them for 15 years.

"We are most comfortable managing the money of people we know and can see and meet," says Rudd. "Trust is essential

and part of that is earned through a willingness to communicate. It makes us better managers."

To fulfill its commitment to highly personal service, Ferguson, Wellman advises only 330 clients. The minimum investment is $1 million. The list includes some of the most recognizable names in Oregon. In some families three generations are represented. Clients also include health organizations, pension funds, unions, foundations, and colleges.

Ferguson, Wellman has brought to the firm skilled counselors whose values and investment philosophy reflect those of the firm's founders. Rudd calls it a commitment to preserve the firm's culture. A vital part of the culture is commitment to the community. The firm's philanthropic efforts touch many local groups, including health care institutions, schools at all levels, anti-crime and anti-hunger foundations, trade and veterans associations, and programs in athletics and the arts.

At the end of the company's first year in business it was managing assets worth $65 million. That total now is over $1.5 billion. The achievement confirms that Ferguson, Wellman's intelligent, personal approach to risk management has enhanced the wealth, and as a result, the peace of mind of its clients. There weren't any bells and whistles to mark the accomplishment. Ferguson, Wellman is a quiet company. Its professionals and its clients like it that way. ◢

Board of Directors (left to right) Mark J. Kralj, James H. Rudd, Dean M. Dordevic, Steven J. Holwerda, and George W. Hosfield

Left to right: Kerrie D. Young, Marc F. Fovinci, and Robin L. Freeman

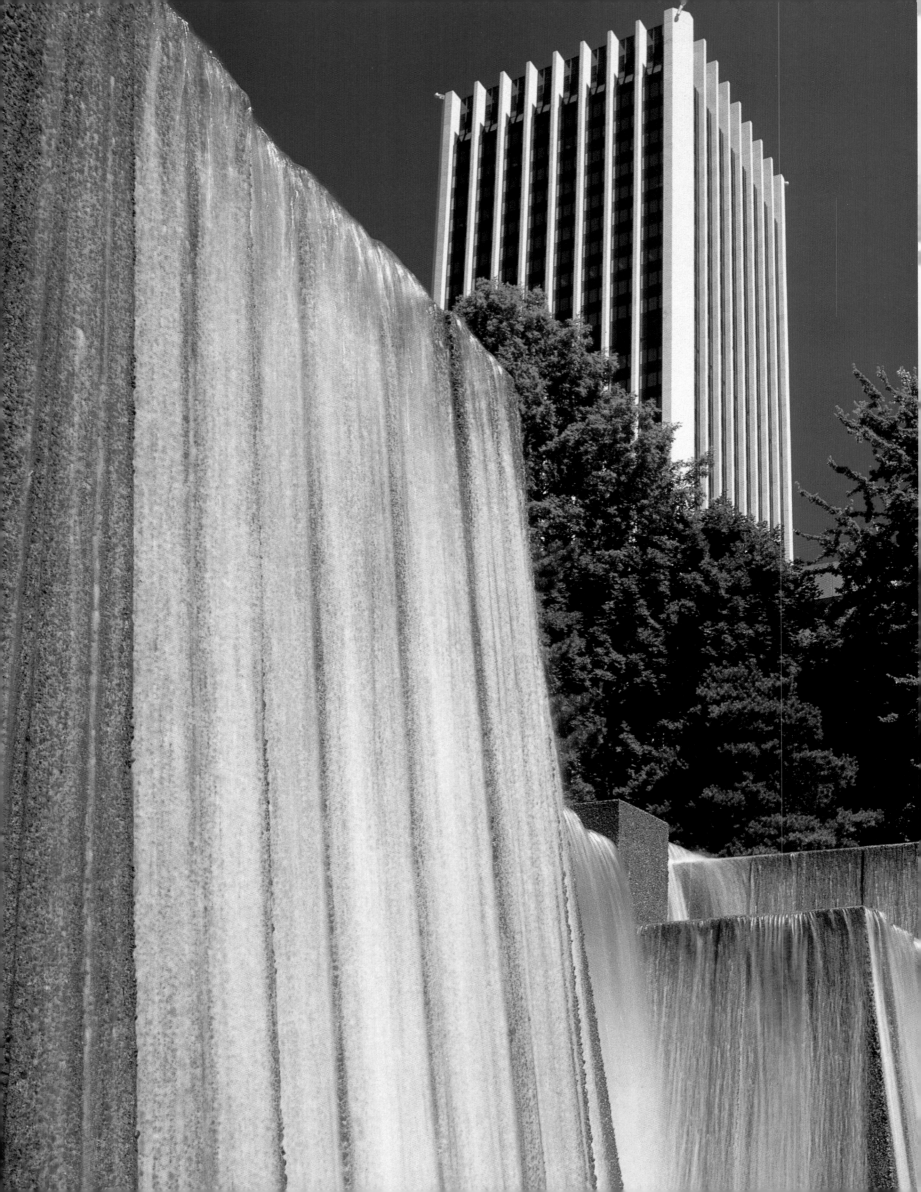

15

Professions

◗

Photo: Larry Geddis

BOGLE & GATES

In 1891, Lawrence Bogle and Cassius Gates focused their newly formed law practice on helping clients feel right at home in the Northwest. Today, that tradition of helping companies settle themselves into new territory continues at the downtown Portland office of Bogle & Gates P.L.L.C.

The Portland office of Bogle & Gates in the 200 Market Building.

A PRACTICE OF HELPING BUSINESSES GROW

Opened in 1986, the Portland office of Bogle & Gates has particular strength in litigation, labor/employment, commercial, real estate, land use, energy, environmental, and natural resource law. The latter specialties comprise what its member attorneys fondly refer to as their "dirt" practice. This strong focus on helping clients locate, buy, and develop property has enabled many companies to establish deep roots in the Northwest market.

Bogle & Gates is especially proud of its role in launching new businesses and protecting new ideas. This work has kept the firm's attorneys on the cutting edge of transactional law and especially agile in responding to ever-changing client needs.

THE BUSINESS OF LITIGATION

The firm's Portland office began primarily as a litigation practice, and this remains one of its strongest practice areas. The firm recognizes that litigation is often a necessary part of business. At Bogle & Gates, knowing the client's business— inside and out—assists in their role as advocates.

Bogle & Gates litigators are known for their thorough and tenacious work on behalf of a wide variety of regional and national business clients, along the way developing expertise in forest resources, toxic tort and hazardous waste, general business and securities, labor/employment, government contracts, and construction law. From precedent-setting telecommunications cases to securities, business liability, and timber practice litigation involving billions of dollars in claims, Bogle & Gates has established a track record as a leading litigation firm in the Northwest and Alaska.

In addition, Bogle & Gates provides the full range of legal services related to business pursuits, including finance, labor and employment law, product liability, government relations, antitrust, bankruptcy, admiralty and transportation law, and state and local taxation.

With considerable expertise in complex and highly visible cases, Bogle & Gates attorneys have successfully argued before the U.S. Supreme Court, federal and state trial courts, and various administrative tribunals throughout the West.

MAKING THE MOST OF NATURAL RESOURCES

The firm is recognized throughout the Northwest for its extensive environmental and natural resources practice, and this expertise is evident in a record of both litigation and transactional successes. The list of clients successfully represented by Bogle & Gates reads like a chapter in Northwest history—pulp and paper manufacturers, shipyards, and mining companies, among other leading resource-based companies.

This experience with the issues arising from real estate and natural resources development has enabled Bogle & Gates attorneys to develop a thorough knowledge of the special business, financial, and risk issues specific to each industry the firm represents. The firm's construction, environmental, and engineering attorneys, for example, are just as comfortable at a job site, in a stand of Douglas fir, or beside a drafting table as they are preparing a legal brief—and this versatility shows in the value-added preventive legal advice they are able to provide their clients.

The Portland office of Bogle & Gates draws upon the deep resources available from its regional Northwest offices in Seattle, Tacoma, Bellevue, Anchorage, and Vancouver, B.C. Many projects, such as the firm's recent efforts to help a Northwest-based food retailer's expansion throughout the region, involve complex real estate and financial transactions as well as permitting, land use, and environmental compliance work at many different locations. The firm takes an economical approach to problem-solving in projects of such scale, relying on an organized network of personnel—from financial advisors to information systems specialists—to produce results with grace and efficiency.

INVESTING IN THE COMMUNITY

Like other natural resources, Bogle & Gates attorneys also strive to nurture the creative human resources of the greater Portland community.

Through their participation in The Nature Conservancy, the Portland Opera, Portland Center Stage, the Northwest

The firm's list of clients—timber companies, paper manufacturers, shipyards, and mining companies—reads like a chapter in Northwest history.

Business Committee for the Arts, the Portland Arts and Lectures Series, Legacy Emanuel Hospital, the Albertina Kerr Center, and the Ronald McDonald House, the attorneys and staff of Bogle & Gates help lead the cultural, environmental, and charitable programs that make Portland such a vibrant and welcoming community. Works by local artists are featured prominently in the firm's Portland office—including a compelling painting by Portland artist Lucinda Parker that sets the tone for the office—reflecting the firm's investment in, and advocacy for, local arts and artists.

But perhaps nowhere is this dedication to community more apparent than in the significant pro bono work undertaken by the firm. Bogle & Gates actively embraces the premise of public service and takes its commitment to this legal work seriously. That commitment is fulfilled through a staff attorney whose sole practice is centered on coordinating pro bono activities firmwide. In addition, the firm's attorneys regularly exceed their individual commitment to the American Bar Association to provide 55 hours of legal services annually to those who cannot otherwise afford them.

DEEP ROOTS, A DEEPER COMMITMENT

Since 1986, the Portland office of Bogle & Gates has been proud to carry out the firm's 100-year legacy of helping its many clients—large and small—put down roots and grow in this region. The firm will continue to work for growth and prosperity in Portland and throughout the Northwest for generations to come. ◪

Works by local artists are featured in Bogle & Gates' office, a reflection of the firm's investment in the community.

Garvey, Schubert & Barer, like many law firms, lists the names of its most senior lawyers on the door. Open that door, however, and the similarity to other law firms ends. No ivory tower "legalese" is spoken here. No hierarchical mentality divides principals from associates or lawyers from staff. Instead, dynamic teamwork focuses on practical problem solving.

Nearly a decade ago, the firm initiated a practice—unusual at that time—of asking a cross-section of its clients to evaluate the performance of its lawyers and staff. In each client

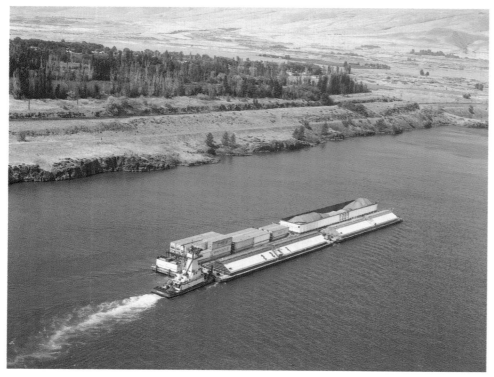

A Foss tug pushes loaded barges on the Columbia River. Garvey, Schubert & Barer provides a wide array of legal services to Foss Maritime Company and other maritime clients. Photo: Hugh Ackroyd.

audit, a lawyer who has not previously served the client visits the client's business. The issues addressed include what the client expects from its lawyers besides legal expertise, how well the firm's lawyers understand the client's business and goals, and how the firm can improve its service.

As Managing Director John Cowden, a maritime lawyer, says: "Failing to ask your clients what they think of your performance would be like navigating a ship in reduced visibility without using your radar—you can't really be sure where you are. Our firm's goal is to provide legal services of the highest quality as judged by our clients. We have to go to our clients to find out whether we're reaching our goal, what we're doing well, and, sometimes, what they think we could do better."

The firm can also point to other examples of innovation. In 1972, only its seventh year of operation, Garvey, Schubert & Barer opened a

Munson Creek cascades down a mountainside in the Coast Range, a short drive from Portland. The firm's lawyers, working on a pro bono basis, assisted River Network in purchasing Munson Creek and Munson Falls and transferring the property to public ownership to ensure enjoyment by future generations. Photo: Larry N. Olson.

Washington, D.C., office, one of the first law firms in the Pacific Northwest to do so. A year later, it was one of the first in the nation to place a lawyer in Japan. Today, more than 90 lawyers practice in the firm's Portland, Seattle, and Washington, D.C., offices.

Garvey, Schubert & Barer's Portland office has a broad practice. Its business lawyers represent emerging and established businesses in a range of commercial transactions, including acquisitions, public offerings, synthetic leases, affordable housing tax credit projects, and international distribution of products. The estate planning practice has a strong tax capability. The firm's litigation work encompasses the many types of disputes that businesses have with customers, competitors, and government agencies, among others. In addition, litigators handle other matters that require special expertise not typically found at other major law firms in town—for example, white collar criminal defense, marine oil spills, and property tax appeals.

The firm's clients are often among the leaders in their respective industries. Some examples include the following: Foss Maritime Company, the largest tug and barge company on the Columbia/Snake River System; IKON Office Solutions, one of the world's leading providers of office equipment and technology; In Focus Systems, Inc., the global leader in manufacturing and developing data/video projection products and services; King Estates Winery, one of Oregon's premier wineries and vineyards producing exceptional quality Pinot Noir, Pinot Gris, and Chardonnay; Regence BlueCross BlueShield of Oregon and its subsidiary, Regence HMO Oregon, which together are the state's largest health insurance company; Rentrak Corporation, pioneer of the Pay-Per-Transaction℠ system for distributing videocassettes on a revenue-sharing basis; Transamerica Commercial Finance Corporation, one of the largest independent

commercial lending companies in the country; and TriQuint Semiconductor, manufacturer of high-performance integrated circuits for wireless communication.

In addition to these successful businesses, Garvey, Schubert & Barer serves less fortunate clients. For example, it collaborates with Multnomah County Legal Aid Service by representing indigent victims of domestic violence in contested court hearings. The firm also donates time to such organizations as River Network, a national nonprofit organization dedicated to helping people save rivers, and Cascade AIDS Project, which provides support and services to families of people with AIDS. When River Network identifies critical lands along rivers and streams in the Pacific Northwest, the firm performs the legal work necessary to purchase the property and transfer ownership to public agencies for preservation. The firm assists Cascade AIDS Project with legal advice on providing low-income housing, ensuring client confidentiality, and responding to unlawful discrimination.

The firm believes that public service is an integral part of its practice, not merely an extracurricular activity. It has acted on that philosophy by encouraging its lawyers to devote 10 percent of their time to pro bono work and by modifying its billing software to recognize the performance of those who serve pro bono clients. In 1997, the firm's lawyers and staff combined to deliver more than 6,000 hours and one million dollars of public service legal work.

The teamwork at Garvey, Schubert & Barer extends outside the office. Lawyers and staff pound pavement together while training in downtown Portland for the 24-hour Hood to Coast road race. They face the rapids together on whitewater rafting trips. They organize outings to attend and applaud performances of the firm's musician and athlete clients. The camaraderie engendered by these activities in turn reinforces the emphasis on collaboration and personal responsibility in serving clients.

At Garvey, Schubert & Barer, providing legal services of the highest quality means actually solving clients' problems— something much more than technical excellence. The firm's collegial, egalitarian culture unites all of its members behind that goal. ◢

**Left to right:
Mike Cavanaugh, principal;
Lou Starelli, principal**

The world of employee health insurance benefit plans is a complex one, and frankly, it's one that some businesses would rather turn over to someone else. The amount of work it takes to research, develop, and then administer enrollment, premiums, and claims—all within state and federal mandates—can take valuable time away from the very business in which a company is engaged!

But whom can businesses trust to help them find and manage the right benefit plans for them?

Small and large businesses alike in Oregon, Washington, California, Hawaii, and Alaska are turning to A & I. Founded in Portland in 1954, A & I works directly with brokers, consultants, businesses, and associations to design and implement employee benefit plans. When a company or association doesn't have the time, expertise, or staff to deal with benefits plans, A & I will step in and do the job.

A & I takes care of it all—handling some $7 million a month for benefits that cover more than 30,000 lives. Plus, all of A & I's clients get a full accounting each month of their benefit programs.

A & I has built a reputation as the "one stop" full-service company. They don't pull out a "cookie cutter" approach for a prospective client, but design a custom-made benefits administration package that exactly suits a client's needs. As the middleman, A & I not only has to please the customer, but also the brokers, consultants, and carriers, and they do so with innovation that has met with great success. Their team approach of putting an account executive, account manager, benefits specialist, and accountant for each client means there's accountability all the way.

A & I also processes health care claims for self-insured plans, adjudicating and paying claims directly. And if a company has an employee stationed overseas, it can process a claim, wire the money at the current exchange rate to the employee's account, and send an E-mail to confirm that the money is there. That's just one example of how A & I uses innovation and technology to provide top service.

Another area in which A & I has made its mark is substance abuse testing. Employers can reduce their workers' compensation insurance and health care costs with drug testing programs. With over 500 employers and 10,000 workers in this program, A & I is one of the largest firms on the West Coast helping to guarantee a safe workplace for employees.

With the constant changes and increasing complexities of employee benefit plans, it makes sense to turn that part of a business over to a specialist. A & I has the resources internally and the contacts externally to make it happen so businesses get on with their real work. ◢

**Employee Benefits
Administration Team**

SIENNA ARCHITECTURE

S ienna is a Portland-based design firm specializing in architecture, interiors, urban planning, and environmental graphics for clients throughout the western United States. With a staff of approximately 60, Sienna's work includes retail, commercial, government, institutional, and urban housing projects. Projects range in size from Nike concept shops to town centers and 30-story residential towers. In business since 1951, Sienna is located in the heart of downtown, where passers-by can view design at work through the firm's two-story storefront windows.

With its long-standing business, devoted client base, and dedication to client service, Sienna is not unlike a traditional architectural firm. Yet one step inside the front door, you know this is not a typical company. Sienna CEO Gary Reddick attributes the energy and vitality to three elements: Sienna staff, style, and solutions.

Over the past decade, Sienna has been actively building a multidisciplined staff. Project teams include individuals from a variety of design disciplines, including lighting, environmental graphics, fine arts, sculpting, engineering, and industrial design. These differing viewpoints bring breadth and depth to the design process and make collaboration intrinsic to both Sienna operations and projects. Clients are an essential part of this team; they play an integral role as the team develops project design concepts.

No matter the type of work, Sienna's style is aggressive and thorough. For example, Sienna led the first project team to successfully design and build a Portland suburban office building incorporating "green" or sustainable architecture. The project integrated the client's philosophy into the building design while still addressing office building economics. As a result, the Norm Thompson Headquarters won the AIA's Architecture & Energy Award of Honor in 1996.

To Sienna, it's not always about how tall and glorious the project is, but more about how the firm approaches the project's challenges. "Our clients want creative, flexible solutions," said design principal Jeff Lamb. "Our role is to meet that challenge in a way that helps them make good economic decisions. You have to be willing to challenge traditional thinking to sometimes find the best solutions."

In its urban projects, Sienna is a champion for infill and air rights development—building on top of existing uses. One such project, Northrup Commons, located in the popular northwest Portland district, pioneered air rights development in Portland. Sienna located the property—a surface parking lot for a neighboring medical building—pursued a development concept geared towards increasing density while accommodating the existing parking, and proposed the project to

the property owner. The lot now provides upscale condominiums and townhouses for one of the hottest districts in Portland; at the same time it continues the original use in an underground parking garage and provides residential parking hidden from view behind the first floor units. The project won a 1997 AIA design award.

The six firm partners are committed to sustaining and sharing the energy and vitality found at Sienna. Says Chief Operations Officer Mike Powers, "Our goal is to be proud of what we do . . . and Portland provides the backdrop and inspiration in which to do that." ◢

Photo: Joseph Chaijoroen, Hega Bojo Visual Studio.

From outerwear to supermarkets to computer hardware and software, the Oregon practice serves a broad range of clients who have a strong presence in the Oregon economy. With more Certified Public Accountants than any other accounting

The Portland Partner Group of Deloitte & Touche.

firm in Oregon, Deloitte & Touche serves prominent clients such as Columbia Sportswear, Fred Meyer, Tektronix, Louisiana-Pacific Corporation, KinderCare Learning Centers, and PacifiCorp.

The Oregon practice of Deloitte & Touche began in the 1930s and today includes multinational, middle market, and emerging companies as part of their client base. As business needs have changed over the years, Deloitte & Touche has adapted to meet those needs. By offering professional services beyond accounting, auditing, and tax, Deloitte & Touche is able to provide the breadth of service their clients demand.

For example, the wide variety of consulting services, such as activity-based costing, financial strategy modeling, information technology, and operations management, provide midsize and emerging companies with the strategies and products they need to gain a competitive advantage or expand into new markets. Re:sources Connection, a subsidiary of Deloitte & Touche, offers high-level temporary financial support by providing temporary CFOs, controllers, and other financial professionals on a project or interim basis. The ABC Consulting

Helping all employees reach their maximum potential is the foundation for Deloitte & Touche.

practice is home to four highly integrated specialty consulting disciplines: Human Resources Strategies, Employee Benefits, Integrated Health, and Actuarial & Insurance Consulting.

Deloitte & Touche is also the leading public accounting firm in Oregon and southwestern Washington to maintain a group of professionals dedicated to serving the Japanese business community. As part of Deloitte & Touche Tohmatsu, the firm's global organization, the Oregon practice draws on an enterprise with offices in more than 130 countries. This global perspective fosters consistent high-quality service to clients wherever they operate.

Deloitte & Touche is dedicated to enriching the community, and the company encourages its professionals to give back through participation in charitable and philanthropic activities. Whether taking part in a "Fun Run," spending one-on-one time reading to a child, or holding a position on the board of directors, the employees at Deloitte & Touche maintain a well-rounded organization.

To compete in today's marketplace—and in the future—professional services firms have to attract and retain the best people. By continuously improving the work environment and creating best practices to help people develop to their fullest potential, Deloitte & Touche is building an overall high-performance organization. Those efforts helped it earn recognition in *Fortune* magazine's "100 Best Companies to Work for in America."

Deloitte & Touche LLP is proud of its strengths—an outstanding portfolio of clients, breadth of service through a strong global network, high-quality service involvement in the community, and dedicated people. ◢

NORTHWEST TEMPORARY & STAFFING SERVICES

For more than a decade, Northwest Temporary & Staffing Services has had one goal in mind: To provide its clients with the most comprehensive staffing services available as it grows throughout and beyond the Pacific Northwest. Early on, company founders identified a growing need for broad-based representation in all staffing areas. Striving to be on the cutting edge of its industry, NTSS has met and exceeded its goal.

For its clients, NTSS provides a wide and diverse range of staffing solutions in specialty areas including: administrative and medical office support, light industrial, accounting, legal, and technical.

Northwest Temporary & Staffing Services combines the talents and resources of a multidisciplined, human resource "Family of Companies." Its goal is to offer its clients the finest quality contingent labor pool available anywhere. The company's approach to recruiting, evaluating, educating, and employing this talent pool acts to fulfill its clients' need to control and manage labor costs efficiently and economically.

And it isn't only the clients who benefit. NTSS temporary employees have flexible schedules, a current week paycheck, paid vacation and holidays, access to medical benefits, networking opportunities, and a 401K plan with an employer match. NTSS emphasizes training and continuing education, and its job training program has been recognized with a Job Training Partnership Award from the Employment Training and Business Services Division of the Clackamas County Department of Human Resources.

NTSS also contributes to the strength of our economy. According to the National Association of Temporary and Staffing Services in Virginia, the U.S. temporary-help industry currently employs a record number of people. About 2.6 million Americans work as temporary employees every day.

The NTSS "Family of Companies" includes: Accountants Northwest, dedicated to placing accounting and financial professionals; Legal Northwest, specialists in providing prescreened and tested legal professionals; and Resource Technology Group (RTG), dedicated to recruiting engineering, computer, and electronics professionals.

With the strong support of a very local and constantly growing client base, NTSS has developed and implemented highly successful programs to meet the varied and specific needs of its clients. And it shows. While NTSS is Portland-based, with 26 branches throughout Oregon, Washington, California, and Idaho, the company has plans to expand outside of the region. And it continues to open more branches each year.

"The staffing industry continues to be one of the fastest growing economic segments in America, and we at NTSS are very excited to be an integral part of its growth on the West Coast. With that in mind, and the corresponding growth of our customer base on the Coast, NTSS has created a strategy which will take advantage of this industry and economic trend. With our corporate headquarters remaining in Portland, we expect this growth strategy to include branch and acquisition expansion throughout the Northwest as well as in California, Arizona, Utah, and Colorado," says Michael R. Foss, NTSS President and CEO.

NTSS is a member of the National Association of Temporary and Staffing Services and is a member of the industry associations for each of the states in which it operates. For solutions to any staffing issues, it takes just one simple call to NTSS.

LRS ARCHITECTS

D istinctive architecture, planning, and interior design can be seen in a sampling of LRS Architects' most recognizable work: Kruse Woods Corporate Campus and office buildings, Johns Landing Master Plan (including the majority of offices, condominiums, and retail facilities), Mentor Graphics World Headquarters Campus, Albany City Hall, and the new Linn County Fair and Expo Center.

exceed the client's expectations, anticipate potential challenges, and overcome obstacles, while creating stunningly on-target work.

This complete attentiveness to each client has resulted in a high percentage of repeat business and referrals.

LRS Architects' proficiency ranges from mid-rise office buildings to high-tech corporate campuses, designing efficient, cost-effective, highly marketable office structures. Because today's competitive environment demands that older buildings upgrade their image, LRS is also involved in many major renovations and public area improvements.

The four-story, 90,000-square-foot Kruse Woods IV office building is sited on a plateau in the Kruse Woods Corporate Office Park, overlooking a beautiful ravine and creek.

Rated in the top 10 architectural firms in the State of Oregon in 1997 by the *Portland Business Journal*, LRS Architects is also a leader in the specialty area of elderly housing and care facility development throughout the United States. In fact, LRS pioneered design of assisted living facilities for the elderly care market. Partner Bill Ruff helped design the landmark first assisted living project in Oregon. He was then asked by the State of Oregon to develop the architectural model for State of Oregon Assisted Living Standards. These standards were subsequently adopted nationwide.

The architects at LRS could boast of everything from new spaces and buildings to custom renovations as tangible evidence of their inspired design talent. Instead, the firm chooses to focus on its exceptional level of client satisfaction as a testament to the spirit it brings to each project.

The service the firm provides its clients—in the Pacific Northwest and throughout the nation—goes far beyond the traditional blueprint of the architect-client relationship. It emphasizes sensitivity to the individual, community, and environment. This collaborative approach is based on the belief that great design unites art, business, and technology. When LRS Architects approaches a project, the goal is to

While the design of commercial office space is certainly one of LRS Architects' areas of expertise, several other types of projects illustrate the firm's awareness of the changing world around us. These include high-end multifamily housing, education, industrial, retail, auto dealerships, and religious facilities.

Building types and markets are each supported by a team of specialists in these fields who are completely immersed in understanding and developing a sophisticated product within that market.

Founded in 1975, LRS has since grown dramatically, from 15 employees in 1993 to 45 today. Projects within the last five years have encompassed more than 8 million square feet of built facilities. Tenant development, space planning, and interior design since 1993 total over 1 million square feet.

LRS services include site planning/design, programming, master planning, feasibility studies, building design and construction documents, space planning and interior design, code conformance studies/agency approval, and building analysis/due diligence studies.

The ultimate goal at LRS is to provide clients with projects that do not just meet their needs, but go beyond requirements and make possibilities a reality. ◢

A stone and stucco arched entry with two-story window bays welcomes Hearthstone residents and visitors with a sense of elegance and spaciousness.

Photo: Steve Terrill

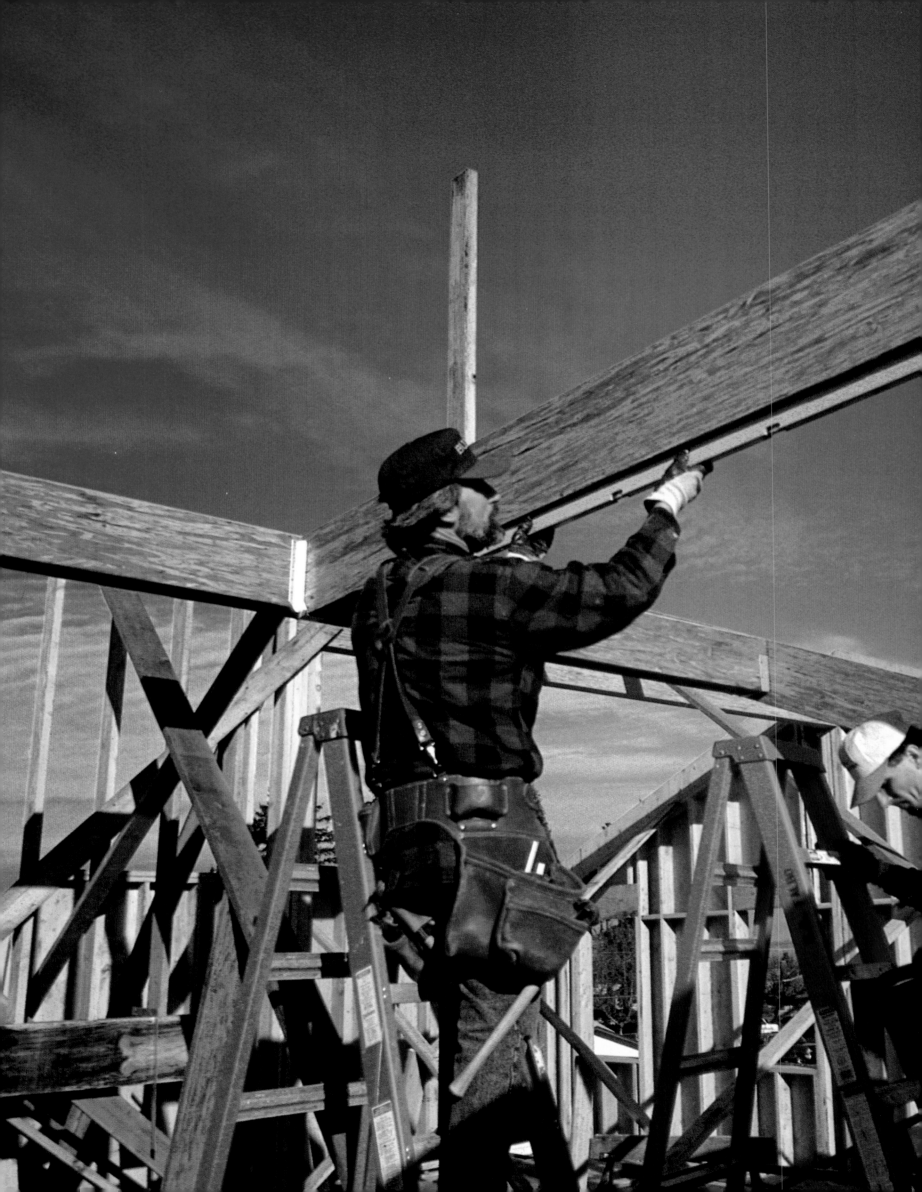

Real Estate, Development, & Construction

Businesses from across the nation and the world in search of just the right place to expand, start up, or relocate often find Portland high on the list of desirable places, and side-by-side with it, Norris, Beggs & Simpson, the Northwest's Real Estate source.

The first Norris, Beggs & Simpson office. The Wilcox Building, Southwest Sixth & Washington, Portland, Oregon - 1932.

Norris, Beggs & Simpson offers everything buyers, sellers, lessors, lessees, developers, and investors might need—brokerage services, mortgage banking, and asset/property management. Completing Norris, Beggs & Simpson's full-service offerings are market research and analysis, advertising and public relations, engineering services, human resources, payroll, benefits, and accounting services. The company has anticipated and provides everything a client might need.

And as a member of the New America International, the world's largest affiliation of major independent commercial, industrial, and investment real estate brokerage firms, NB&S can assist clients with their real estate needs anywhere in the world.

Companies as diverse as Tektronix and Wells Fargo, Nike and Eastman Kodak have been represented by Norris, Beggs & Simpson. This real estate company may have international reach, but its greatest impact has been right here at home in the Pacific Northwest.

By studying the evolution of the Pacific Northwest's real estate industry, the impact Norris, Beggs & Simpson has had in shaping the landscape here is evident.

In 1932, A.D. Norris and George J. Beggs, joined by David B. Simpson and Phillip D. Miller, opened the doors of Norris, Beggs & Simpson. First, they were merely property managers. Soon, Norris, Beggs & Simpson expanded its services into mortgage lending as loan correspondents for major life insurance companies. From there the expansion of its commercial and industrial brokerage began, broadening into today's full-service program.

NB&S helped create and develop the markets in which it conducts business today. It still serves many of those major life insurance companies, such as GNA, John Hancock Life Insurance Company, and Crown Life Insurance Company. This steady expansion of services to clients and the integrity and credibility cited by clients as the two main reasons they work with Norris, Beggs & Simpson have resulted in honest, lasting, and profitable relationships for all.

Norris, Beggs & Simpson has three offices in the Northwest: Portland, Oregon, and Vancouver and Bellevue, Washington. Today's four owners are actively involved in client work and community service. They are J. Clayton Hering, president, Joseph F. Wood, executive vice president, H. Roger Qualman, executive vice president, and L. Jan Robertson, executive vice president. Each office's key decision makers, individuals with years of knowledge and experience in a particular discipline of commercial real estate, assemble a team which, in many cases, includes a partner. This team, tailored to the client's needs, maximizes the client's opportunities.

Seeking and retaining the best and brightest individuals in the market is one secret to NB&S's success. More than 200 employees provide a depth of expertise and the long-term continuity to service client needs. The real estate industry has long been known for strong, independent personalities; at Norris, Beggs & Simpson, development of that type of character is encouraged. NB&S builds on the interdependency of employees' talents and disciplines to provide a full range of services to clients. Licensed professionals certified by real estate organizations practice within NB&S. These professionals carry designations including Certified Property Managers, Certified Shopping Center Managers, Certified Commercial Investment Member, Real Property Administrators, and Accredited Residential Managers.

A.D. Norris

George J. Beggs

David B. Simpson

Norris, Beggs & Simpson cares deeply about building a Northwest which will benefit us all. After all, the partners and employees of Norris, Beggs & Simpson live here. And work here, too. Their children go to school here. The company's community ties are strong; as such, there is a great stake in the future development of this region. The partners and, indeed, the entire staff are involved in the community by volunteering, coaching, and supporting organizations that make life better for those less fortunate.

The tenure of Norris, Beggs & Simpson in the grand Pacific Northwest makes them eyewitnesses to its cycles and trends. From this experience, the company's conservative philosophy and mission formed: Learn its clients' industries and businesses; and maintain a deep understanding of client goals. Perhaps that's why clients stay with Norris, Beggs & Simpson for the long term. And why Norris, Beggs & Simpson has prospered in a business in which many have failed.

Norris, Beggs & Simpson services are tailored to offer everything a client could want. Long ago, this company realized it was the only way to be successful—through helping its clients become successful. So its services include the following:

• Brokerage. Associates at Norris, Beggs & Simpson specialize in office, industrial, and retail sales and leasing, as well as investment, multifamily, and land sales. A team of professionals focuses on the sale of institutional-grade investment and plant-site opportunities.

• Mortgage Banking. With access to billions of dollars of lending power as mortgage loan correspondents for major life insurance companies, conduits, pension funds, and other institutional lenders, Norris, Beggs & Simpson is able to provide

the most competitive finance structures for clients. Norris, Beggs & Simpson is also a loan servicer with a mortgage portfolio, which is very impressive in terms of size and performance.

• Asset/Property Management. Norris, Beggs & Simpson is an accredited management organization, with a number of professionals certified by real estate-related organizations. These professionals take a personal interest in each property, be it office, retail, or multifamily, treating it as if it were their own property. The Accounting Department supports managers and handles all of the portfolios' financial requirements.

• Support Services. Unique to Norris, Beggs & Simpson is the exhaustive support services available to clients; these include administration, market research and analysis, advertising and public relations, engineering services, human resources, payroll, benefits, and accounting, all provided by staff specially trained to provide these services.

Norris, Beggs & Simpson sees itself as an extension of its clients; imagine, more eyes, ears, legs, and brains, all from your commercial real estate office, at a time when the world is changing far too quickly for you to keep up a business not your own.

This combination of historical knowledge, current market trends, and a perspective on the future equals Norris, Beggs & Simpson, providing clients with the technical expertise and counsel required to solve any real estate challenge. ◪

The founding partners of Norris, Beggs & Simpson - 1932

Richard Norris and Jack M. Stevens founded Norris & Stevens in Portland in 1966. In the beginning, there was just a handful of employees; the firm's initial focus was on Central Business District properties.

Today, as one of Portland's largest locally owned firms offering commercial real estate services, N&S has a staff of nearly 70 individuals. Though investment brokerage is a major element of the company's success, property manage-

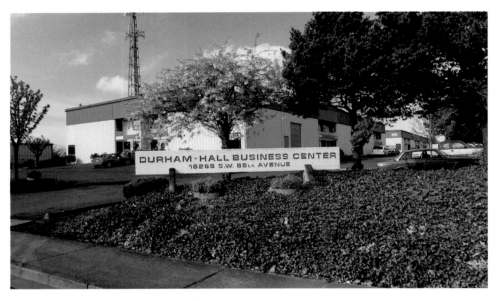

Norris & Stevens' portfolio includes warehouses, from "incubators" to "high cube."

ment is still the "bread and butter" of the firm. Approaching 180 managed properties in the Portland Metropolitan Area, its portfolio is comprised of approximately 4 million square feet of commercial space and nearly 6,000 multifamily units. In spite of the strong emphasis on property management, the business includes an intense emphasis on sales and leasing of apartments, land, industrial, investment, office, retail, and shopping centers throughout the Northwest. N&S has properties throughout Oregon and southwest Washington.

Of significant note is the track record established by the commercial brokerage division. Between 1994 and 1998, N&S sold more office buildings in the Central Business District of Portland than any other commercial real estate brokerage firm. Portlanders may recognize prominent and distinguished properties, such as the Oregon Pioneer Building, the Mayer Building, the Charles F. Berg Building, the Yeon Building, the Loyalty Building, and many more.

Another outstanding aspect of the N&S brokerage division is the care and effort put forth to manage the sale process. The firm produces entire books of detailed property information to assist and ensure the buyers get through the "due diligence" period in a timely manner with the least inconvenience. Therefore, the client is better educated as to the potential for return on his or her investment.

This classic-style Norris & Stevens property is located in Portland's central business district.

The company philosophy is "to serve the owner's interests," a focus becoming as unique as each individual client. This might include day-to-day building management, rent collection, bill payment, specialized reporting, and property maintenance. In many instances, N&S has been retained in order to reposition the property in a changing market, increasing the value in preparation to sell. Moreover, N&S prides itself on its ability to turn around an underachieving property to increase value for the owner. But the focus is established, controlled, and dictated under direction of the client. N&S is there to serve the needs of that client. N&S works toward the goal that every client will become a repeat client; this focus on long-term relationships is the key to its success, and further, its unique ability to succeed while competing with the regional and national brokerage houses.

Teamwork is a primary area of focus. Property owners can count on monthly written updates from their property managers, as well as the property leasing agent. The reports, which detail marketing efforts and strategies, the number of inquiries received, advertising, and tour summaries are a company-established priority (often other companies forget you once the contract has been signed). Property inspections are performed on a regularly scheduled basis, typically with a team of property managers, as opposed to a single individual, and cover the entire building—roof to basement. There is an ongoing effort to keep the owner advised of current and

future concerns which affect the property, such as ADA compliance, seismic upgrades, and alternative ways to deal with asbestos removal.

Further, budget estimations are done annually in order to give owners a projection of some costs they can anticipate for the upcoming year; these are prepared from a careful analysis of the expenditures from current and previous year(s), plus implementing a strategy for the future.

From Open House postcard announcements and single-page flyers, to multisection packages and exclusive listing brochures, N&S "top drawer" presentations and flyers are the result of many components coming together, another example of the overall "team" effort. The information is gathered together by the team leader, and discussed at length with all pertinent individuals.

N&S believes its affiliations help to strengthen the reputation of the firm, as well as how the employees view their employer. N&S maintains an active involvement with the following industry association leaders: the Accredited Management Organization (AMO), the Institute of Real Estate Management (IREM), The Commercial Network (TCN), and the International Council of Shopping Centers (ICSC). On a local level, N&S is an affiliate of the following prominent organizations: Portland Metropolitan Building Owners' and Managers' Association (BOMA), the Multi-Family Housing Council of Oregon (MFHCO), the Commercial Association of Realtors—Portland/Vancouver

Nearly 6,000 multifamily units comprise the Norris & Stevens list of well-maintained properties.

(CAR P/V), and the Portland Chamber of Commerce.

Portland's strong economy has helped to bring N&S the level of success it currently enjoys. At the same time, the Portland market has matured, and requires a higher level of specialization in the real estate industry. This may require an agent to have a precise focus, both geographically and type— i.e. suburban retail leasing.

Company pride is apparent when entering through the front doors of the firm, and although there have been numerous successes behind the more than 32-year history of N&S, the focus has been to service clients' needs and goals while guarding their reputation and company relationships. Robert Stutte and Brian Bjornson prefer to quietly build their list of satisfied clients and well-maintained properties, rather than spend time (and money!) boasting. Interestingly enough, they take great pride in relationships with the competition.

One of the elements of the strong benefits package offered to N&S employees is the profit sharing plan, established early in their history, to ensure everyone would benefit from the success of the company. Other annual events include a company golf tournament, annual celebration, pizza parties, monthly birthday gatherings, summertime picnic, and more. Many individuals have left N&S, only to return after a brief absence. Roughly 33 percent of N&S employees have been with the company at least five years.

Norris & Stevens will continue to provide the highest level of service for its clients, know the industry inside out, and strive to keep its employees smiling. ◢

Norris & Stevens' offerings include shopping centers from "anchored" to "strips."

JOHN L. SCOTT REAL ESTATE

ike Portland's own pioneers, John L. Scott—founder of John L. Scott Real Estate—migrated to the Pacific Northwest. He brought with him the principles that served him through world wars and the building of a business in a new country. Those are the values—established by the company's founder nearly 70 years ago—which John L. Scott Real Estate upholds today.

John L. Scott Real Estate is a family-owned business which specializes in the many growing communities of the Pacific Northwest, finding homes for people while maintaining the highest standard of professional service.

The company is recognized in its communities because of its trademark of personalized service to the many people moving in and out of the area. As our communities have grown, so has John L. Scott. John L. Scott Real Estate professionals have developed an intimate knowledge of each community's character, mood, and growth potential. Because these real estate professionals live in the communities they serve, they're ready to meet each customer's unique real estate needs. With their extensive knowledge of area schools, recreational and shopping facilities, and available transportation, these associates are able to better assist in meeting the special housing needs of their clients.

John L. Scott, a naval architect, was born near Glasgow, Scotland. In 1923, he arrived at Ellis Island. Making his way out west, he said in 1925, "I arrived in Seattle on July 12 and I liked the look of it. It looked like the City Beautiful in *Pilgrim's Progress*." He began working as a sales associate at a local real estate company. A few years later, he established his own real estate company and built a reputation based on providing quality service.

He also served his country during his business start-up time, as Lieutenant Colonel with the U.S. Air Force Intelligence Service during World War II. He received the King's Medal from King George VI. In 1955, he was honored with the Order of the British Empire by Queen Elizabeth II for his war relief efforts. Scott's son, W. Lennox Scott, served as a Major with the U.S. Marine Corps, completed his education at the Harvard School of Business, and joined the company in 1954. During the two decades of his leadership, the company expanded its influence in the growing Puget Sound region, gaining an impressive share of sales and dominating the emerging Eastside and South-end markets. He died in 1977.

J. Lennox Scott, John L. Scott's grandson, now leads the company, taking its helm on January 1, 1980, when he began the process of expansion. Heralded as one of the fastest growing real estate firms in the nation, it now serves most major cities in the Northwest. Lennox is a member of the prestigious Realty Alliance, a national real estate group which chooses its members from among the best companies in the United States. Sharing marketing resources and expertise, customers benefit from the additional knowledge acquired by members.

Today, John L. Scott Real Estate maintains the highest standard of professional service in residential home sales. Using technology to provide better service, John L. Scott offers innovative marketing, instant information, and rapid transaction processes. Services include a top-notch relocation division, marketing, builder, and land services and one of the best sales training programs in the nation.

A computer-generated Competitive Market Analysis offers fast and efficient information to assist clients in their home search. The analysis works by compiling complete and accurate market data which assists clients in making knowledge-

able decisions regarding the pricing and marketing of one of their most valuable assets—their home.

John L. Scott Real Estate plays a vital role in community support. The company and its associates founded the "John L. Scott Foundation" in honor of John L. Scott. This nonprofit organization is funded by the donations and fund-raising efforts of John L. Scott sales associates and employees, with all funds dedicated to children's health care facilities. All administrative functions support is absorbed by John L. Scott Real Estate. ◪

John L. Scott Real Estate, Portland, Oregon. Seated left: Polly Jones, senior vice president. Standing: Jerry Moon, executive vice president. Seated right: J. Lennox Scott, president.

GERDING/EDLEN DEVELOPMENT COMPANY

Gerding/Edlen Development Company is committed to developing facilities that meet its clients' needs while creating lasting value.

Robert K. Gerding and Mark C. Edlen grew up in Portland. "We like to call ourselves Portlanders," smiles Edlen. The quality of life in their town is important to them. They have personal perspective because daily they see structures they created. "The quality of what we do is important because we live and work here. We like doing projects in the central business district. It is more than just constructing a building. It adds to the livability of the city and that's important to us. We believe in the success of the city."

Gerding/Edlen's successes in the city cover a wide range. They include construction of the PG&E Gas Transmission-Northwest building, the first 100 percent commercial Energy Demonstration Project in Oregon; development and construction of Triangle Corporate Park, including three office buildings; Urban Center, renovation of a 200,000-square-foot office building for PacifiCorp and US West and a 160,000-square-foot office building for the City of Portland; construction of multiple office buildings for Sequent Computer Systems; and a 186,000-square-foot historic renovation project that includes the world headquarters of the Wieden & Kennedy Advertising Agency, as well as retail space and a penthouse. The firm has also carried out assignments for Portland State University, Oregon Health Sciences University, and the Portland Police Bureau. The variety of projects attests to Gerding/Edlen's status as the area's most active commercial developer and underscores the firm's flexibility. There is no formula, no preconceived notion of what design or financing structure is right or wrong. The first question is what does the customer need?

How to achieve that goal is concluded through a comprehensive evaluation of geographic, operational, and financial considerations. At Gerding/Edlen teamwork is not a cliché. It is an important commitment in meeting the client's short- and long-term objectives. The team includes experts in accounting, finance, engineering, planning and design, construction, law, and government affairs. The goal is to find the most creative solution to the client's needs. As the president of a Portland construction company affirms, the developers do just that: "We have worked with Gerding/Edlen on $20-million facilities and simple remodels. Each has met expectations because of their leadership, experience, and high ethical standards."

Ethics are important to the company. As Edlen puts it: "We have a pretty simple philosophy. We value our customers and believe in doing the very best job for them and treating them right. Our growth is a direct result of our determination to be responsible to our customers." The firm's convictions prompt investments in Portland Center Stage and the Portland Opera. Gerding/Edlen believe such commitments help enhance the quality of life in Portland. The firm is also a sponsor of Riverbend Youth Center and a contributor to the Juvenile Diabetes Foundation and the National Multiple Sclerosis Society.

It is probably more important today than ever that a project is finished on budget and on schedule. If a client's building is not completed on time, the ramifications can be immense. Gerding/Edlen has a reputation for performing quality work on time and within budget. The president of an architectural firm in Portland has seen these qualities first-hand: "What makes them successful is their creativity—from arranging complex financing to assisting tenants. They always follow through and they stand behind everything they do." Such consistency reflects Gerding/Edlen's commitment to the old-fashioned values of preparation, attention to detail, hard work, and constantly putting its clients first. ◢

Above: P G & E Gas Transmission Building, downtown Portland

Left: Triangle Corporate Park at I-5 & Hwy. 217

ASHFORTH PACIFIC, INC.

Liberty Centre, developed by Ashforth Pacific and Liberty Northwest, is Portland's newest 280,000-square-foot office tower.

From the northeastern United States to northeast Portland, the Ashforth Company is well-known for its century-spanning ownership and quality management of real estate. Ashforth Pacific—the Ashforth Company's Portland-based affiliate—is synonymous with Portland's Lloyd District, where it owns five percent of Portland's Central City commercial real estate market.

The Ashforth Company's firm foundation was laid in the late 1800s in Manhattan, when Albert B. Ashforth anticipated Manhattan's growth and invested in, and developed, office and residential buildings, and then managed them. A hundred years later, the Ashforth Company managed through the real estate downturn extremely well. That economic trying time raised awareness for the company to consider its next 100 years.

The family-owned company recognized it needed a deliberate direction. A strategic planning process identified the need to diversify—in business, as well as geographically.

To meet its needs for business diversification, Ashforth invested in a New York City money management firm. To meet the geographical diversification requirement, the company identified criteria for new metropolitan areas it might enter. That criteria included major universities in the area, an international airport, a growing white-collar workforce, strong population growth, solid transportation in place or planned, and a good quality of life.

Held up to that criteria, "Portland jumped off the page immediately," says Hank Ashforth, president of Ashforth Pacific. In 1995, when PacifiCorp sought to sell its real estate holdings in the Lloyd District, Ashforth responded by acquiring 600,000 square feet of office property located on some 22 acres in the Lloyd District. Today, Ashforth Pacific owns and manages over 1.5 million square feet of commercial office space in the Portland metropolitan area. The company has also established vertically integrated service businesses that improve the portfolio's performance as well as the performance of other third party accounts.

In 1997, Ashforth Pacific successfully completed the development of Liberty Centre, Portland's newest downtown high rise office building. The 280,000-square-foot building is home to the headquarters of Liberty Northwest, Ashforth Pacific's joint venture partner, KinderCare Learning Centers, and NACCO Materials Handling Group.

Mr. Ashforth attributes the company's success in Portland's commercial real estate market to Ashforth Pacific's talented team of employees, many of whom came with the culmination of the Lloyd District deal. The company plans to continue developing, owning, and managing its own buildings, in addition to expanding on its 100-plus years of real estate expertise. Ashforth Pacific's service companies, which include construction, property management, and parking services, are ready to use their expertise and their "owner's perspective" to deliver the most value for their clients.

Being a part of the community is important to Ashforth Pacific; aside from representation in industry groups like the Building Owners and Managers Association and Association for Portland Progress, leaders of Ashforth Pacific also serve in board positions with Oregon Trout, Portland, Oregon Visitors Association, and the Christie School. As a company, they volunteer together annually in the neighborhood. Ashforth employees have worked with SOLV (Stop Oregon Litter & Vandalism) on a city cleanup in northeast Portland.

Portland is a city well positioned for the future, and the Lloyd District is an important part of Portland's growth. Ashforth Pacific believes the Lloyd District is a microcosm of what every city should be; its transit, entertainment, abundant supply of hotel rooms, excellent restaurants, strong retail, and high livability are bolstered by the billion-plus dollars the community has seen in public and private development in recent years.

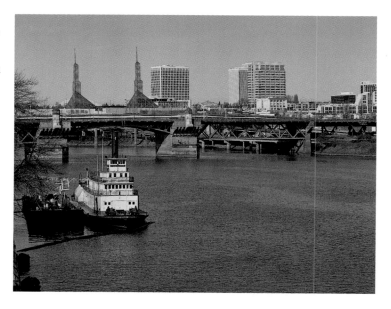

Portland's Lloyd District

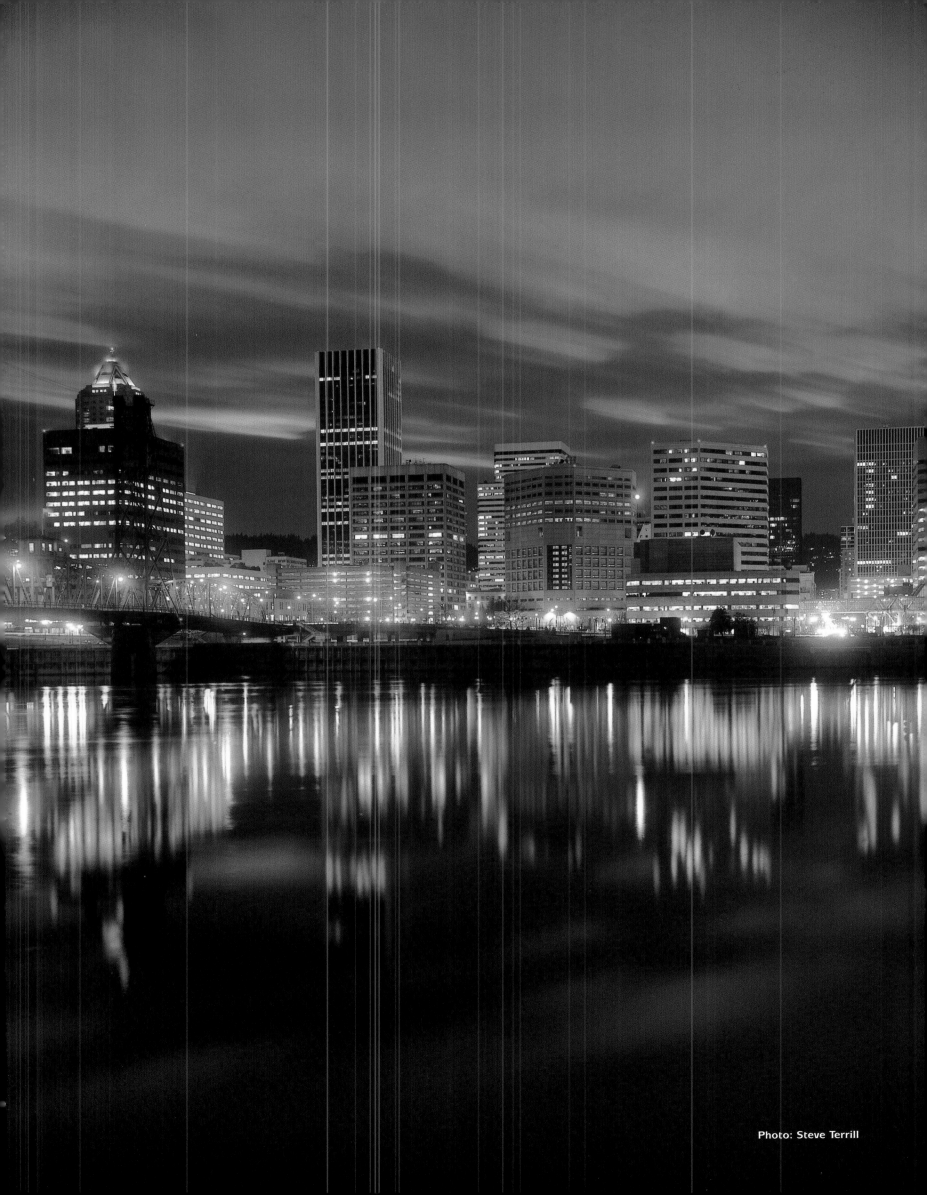

Photo: Steve Terrill

Health Care, Education, & Quality of Life

Photo: Kaiser Permanente

OREGON HEALTH SCIENCES UNIVERSITY (OHSU)

Oregon Health Sciences University's fundamental aim is to improve the health of all Oregonians. OHSU educates health professionals and biomedical researchers in a variety of fields, and it undertakes the indispensable functions of patient care, community service, and biomedical research. No other institution in the state is quite like OHSU. It touches the life of everyone in Oregon.

OHSU sits atop Marquam Hill on a 116-acre campus overlooking Portland. The institution encompasses more than 30 buildings just on its Portland campus and dozens of facilities at other sites throughout the region. Its programs and services extend across the state's entire 96,000 square miles and even reach into neighboring states.

OHSU has evolved into one of America's top academic health care and medical research centers. It has a well-earned national reputation for its expertise, leadership, and commitment to service and education. Widely recognized for its distinguished faculty and innovative research endeavors, OHSU's many top-ranking professionals have helped place the institution at the vanguard of biomedical advances for decades. The institution continues to be a magnet for attracting practitioners, faculty, and researchers who are national leaders in their fields. Top-ranking students from throughout the country vie for the opportunity to attend OHSU. The best and brightest professionals are the heart of OHSU.

HISTORY

OHSU traces its beginnings back to the 1800s. The result of the dreams of several generations of Oregonians, the medical and dental schools were born just before the turn of the century. Nursing education arrived in the early 1900s. Soon after that a hospital was built on campus, followed by the state's first full-service children's hospital. The Child Development and Rehabilitation Center emerged in the 1950s. These entities combined in 1974 to form an independent institution with the Oregon State System of Higher Education (OSSHE). OHSU is one of the few academic health centers in the United States not affiliated with a larger university.

That independence increased when the Oregon Legislature converted OHSU to a nonprofit public corporation in July 1995. While the university's academic programs still are coordinated with the state's higher education system, OHSU no longer is governed by the Oregon University System Board. Today, OHSU is governed by a single board of directors appointed by the governor and confirmed by the Oregon Senate. This governance model has replaced several layers of state government oversight and regulation.

Although no longer a state agency, OHSU retains its public obligations to heal, to teach, and to discover. The new, simpler structure merely allows OHSU to make changes appropriate to today's market with greater speed, agility, and efficiency.

HOW OHSU OPERATES

The State of Oregon and OHSU initiated a new and innovative partnership in 1995 when the institution became an independent, nonprofit public corporation. Their hope was that OHSU would have a better chance to succeed in the competitive marketplace with a streamlined governance structure.

OHSU today is structured like a private sector corporation except that it is not owned by stockholders. Its land and buildings are owned by the citizens of Oregon. The physical facilities are operated through an agreement similar to a long-term lease.

OHSU is Portland's largest employer, and the seventh largest statewide. It provides jobs for more than 8,600 people. This means it employs more people than the City of Portland, Multnomah County, or the Portland Public Schools—more

Doernbecher Children's Hospital is recognized nationally for its treatment of children with cancer, endocrine disorders, heart and kidney diseases, genetic abnormalities, serious injuries, and complications from premature birth. A variety of support service professionals, including child life therapists, social workers, and schoolteachers work closely with staff members to provide comprehensive care to patients and their families.

More than 30,000 children from every county in Oregon and five surrounding states seek Doernbecher's services each year. The new facility, built through donations and bond revenue, was open for business July of 1998.

than any other hospital, health care system, or university in Oregon. In fact, the number of employees, students, and patients on Marquam Hill creates a bustling community larger than 200 Oregon cities.

OHSU employs more than just clinicians, teachers, and researchers. Today, you'll find systems analysts, information specialists, accountants, architects, engineers, electricians, plumbers, and many others working as part of the institution to respond to the needs of the region.

With an annual budget of approximately $600 million, OHSU's impact is felt well beyond its ability to teach, heal, and discover. Economists conservatively estimate that its activities generate approximately 33,000 jobs in Oregon communities. OHSU, its students, and employees spend millions of dollars each year buying goods and services, fueling $2 billion in regional economic activity.

TEACHING

Although the institution benefits Oregonians in many ways, OHSU's principal mission is education. It is dedicated to educating the next generation of dentists, nurses, physicians, allied health professionals, and biomedical scientists.

While OHSU's primary education units are the Schools of Dentistry, Medicine, and Nursing, its training center extends to every corner of the campus and the state. Classrooms range from the traditional schoolroom to a patient's bedside, from a primary care clinic to a practitioner's office in rural Oregon or in the inner city, and from a biomedical research laboratory to a shelter for the poor or a home for the elderly.

The university's patient care units provide a rich environment for clinical experiences for students, residents, and fellows. Students who will become the biomedical researchers of tomorrow expand their classroom knowledge as they work side-by-side with scientists.

Regardless of the setting, OHSU challenges its students to strive for excellence as well as compassion and to stretch beyond the limits of current knowledge.

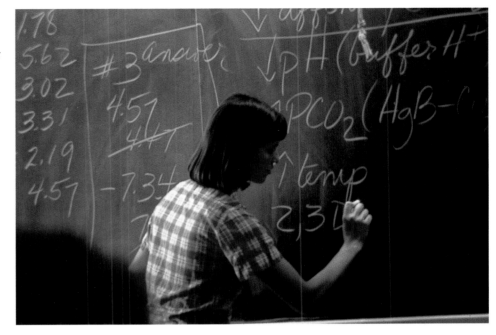

The university's three schools grant the state's only doctoral degrees in dentistry, medicine, and nursing. In addition to receiving the highest accreditation granted, each school has been recognized by peers as being among the nation's best.

The School of Dentistry has been selected by the PEW Foundation as a prime example of innovation in dental education for the school's fifth-year preceptorship program. OHSU's dental program consistently attracts applicants whose college grade point averages are the highest among all 51 U.S. dental schools. When these students graduate, 95 percent pass their exams on the first try, while nationally only 70 percent pass on the first try.

The School of Medicine attracts students who rank in the top 10 percent based on their Medical College Admissions Test scores. When these students graduate, 99 percent pass their licensure examinations on the first attempt. American medical school deans and faculty rank the Oregon school one of the top primary care medical schools in the nation.

Bringing medical students closer to patients earlier than before and preparing them to be lifelong learners is the goal of an innovative curriculum revision. Students now receive a valuable part of their education, as well as an increase in their perspectives, by working and learning in a variety of underserved areas.

The School of Nursing ranks sixth among more than 200 schools by the nation's nursing school deans and administrators. OHSU has had administrative responsibility (since 1993) for all nursing education offered by the Oregon State System of Higher Education.

In addition to the Portland campus, undergraduate and selected graduate nursing programs are offered at Eastern Oregon State College, La Grande; Oregon Institute of

The School of Nursing's graduate curricula include several nurse practitioner programs and a midwifery program. The former enables nurses to provide primary health care. The latter is one of only 24 in the nation.

As Oregon's only health sciences university, OHSU takes a leadership role in ensuring that Oregonians, regardless of where they live, have access to quality health care and education. It does this through programs that address provider make-up and distribution imbalances, combine training and care with service to the underserved, and encourage young people to consider careers in health care and biomedical research.

also works for policy changes and compassionate health care, collaborates on conferences, provides ethics networking, and serves as a regional resource.

With OHSU's education mission comes the task of helping practitioners and educators keep abreast of the latest procedures and treatments. The Continuing Education Program meets the bill by sponsoring hundreds of courses and seminars at sites throughout the state, offered in person and by satellite transmission to nearly 20,000 health care professionals.

The University Affiliated Program at the Child Development and Rehabilitation Center offers training in disabilities and ongoing health conditions. The program, recognized nationally for its success in bringing multiple disciplines together, trains students from OHSU and other universities across the country. The university is also a partner in the Oregon Health Policy Institute, administered by OHSU and Portland State University in collaboration with Oregon State University. Its purpose is to analyze, develop, and propose health policy and to conduct research on the delivery of health services. In addition, it trains others to effectively formulate health policies through professional development and education services, with the goal to provide a scientific basis that will help evaluate how best to deliver quality health care without driving up costs.

Top-ranking students vie for the opportunity to attend OHSU. Each year, 2,200 applications are received for about 90 medical student openings. More than 1,000 applicants compete for 70 spots annually in the dental programs. The School of Nursing's Portland baccalaureate program receives about 228 applications for 90 openings, and about 160 applicants for 91 spots in its outreach programs.

OHSU has 24,000 alumni. More than 2,700 students are trained through the School of Dentistry, School of Medicine, School of Nursing, and Allied Health each year. A majority of those accepted into each program are residents of the state of Oregon.

COMMUNITY SERVICE

As Oregon's only health sciences university, OHSU takes a leadership role in ensuring that Oregonians have access to quality health care and education—regardless of where they live. To do this, the organization focuses on programs that address provider makeup and distribution imbalances; combine training and care with service to the underserved; and encourage young people to consider careers in health care and biomedical research.

OHSU provides a greater portion of care for the poor than any other health system in the state—believing it is an integral part of its responsibilities as a public institution.

The Vollum Institute is a special research unit of OHSU devoted to the study of brain function at the molecular and cellular levels. The institute's award-winning building opened in 1987; since then it has grown from a handful of scientists to nearly 200 scientists, trainees, and staff members. Over the past 10 years, the institute has earned an international reputation for leading neuroscience research.

Technology, Klamath Falls; and Southern Oregon State College, Ashland. The school also uses interactive video to deliver many of its education programs, including the RN/BS Outreach Program, the Rural Frontier Delivery Program, and the Outreach Graduate Education Program. The graduate curricula include several nurse practitioner programs and a midwifery program.

OHSU's interdisciplinary education programs include the Center for Ethics in Health Care, which addresses ethical questions raised by modern technology and other health-related issues. The center's goals are to ensure patients' rights and educate students and residents about today's changing medical ethics. It examines issues such as patient-provider communications and care of the terminally ill. The center

The most immediate effects of OHSU's community outreach efforts include the following:

- Improving the number of primary care practitioners trained in Oregon, including physicians, physician assistants, and nurse practitioners;
- Giving practitioners, patients, and students improved access to university faculty, health care, education, and information resources;
- Increasing the number of practitioners offering care in less-populated communities; and
- Expanding OHSU's services throughout Oregon into metropolitan neighborhoods, the inner city, and rural communities. In addition, faculty, residents, and students also offer their services in schools, low-cost clinics, community centers, nursing homes, and other health care settings throughout the state. Examples include:
- Nurse midwives deliver babies for migrant workers;
- Dentists care for low-income populations with mental and physical disabilities;
- Physicians host health care clinics for the poor;
- Scientists conduct workshops for high school students in innovative biotechnology magnet programs;
- Dental hygienists provide oral education and screenings to the elderly, schoolchildren, and the disabled;
- Faculty and students teach Oregon school children about the prevention of head and spinal cord injuries through the Think First programs;

- Nurses and students provide health services in nursing homes and in schools; and
- Respiratory therapists, pharmacists, nurses, and physicians volunteer in camps for children with challenging medical conditions.

Cities tend to end up with the greatest numbers of medical practitioners. OHSU has taken a hard look at this and addresses imbalances in provider distribution and makeup by teaming with communities, foundations, and federal and state lawmakers. Through its Area Health Education Centers Program, which improves the education, training, and distribution of heath care professionals in Oregon, and its office of Rural Health, which helps rural communities recruit and retain practitioners, the state already is beginning to see an increase in physicians offering care in these communities.

The School of Medicine has revised its curricula to improve the state's distribution of physicians and to meet the growing need for primary care practitioners. Within this program, several residency programs offer firsthand experience in Oregon's less populated communities. The Cascades East Family Practice Residency in Klamath Falls allows residents to complete their entire three-year program in a rural area. This is the

The Center for Research on Occupational and Environmental Toxicology is one of the West Coast's newest and largest centers for research and training in the toxicological sciences. More than 40 CROET scientists work at all levels, ranging from basic molecular and cellular studies to population research. Their aim is to uncover information leading to the prevention and treatment of disease, especially among working people.

To recognize Sen. Mark O. Hatfield's extensive contributions to improving the quality of human life, OHSU opened a new center in his honor. The new facility houses the Clinical Research Center, the Oregon Hearing Research Center, Doernbecher Children's Hospital pediatric research laboratories, the Oregon Stroke Center, Emergency Department and pharmacy services, and the Oregon Cancer Center.

The world's first successful ocular microsurgery was performed in OHSU's Department of Ophthalmology, and the Northwest's first ophthalmic laser, ultrasound, and cryosurgery also were pioneered at OHSU. The search for more advanced treatments continues as the underlying causes of eye disease are investigated in the extensive research laboratories of the Casey Eye Institute.

(right, top) In addition to clinical activities on campus, OHSU has developed eight new satellite clinics, which are distributed throughout the Portland area to provide primary care services. OHSU's clinics handle more than 374,000 outpatient visits each year.

(right, bottom) The National Institutes of Health—the single largest supporter of medical research in the nation—ranks OHSU among the top three percent of about 2,000 institutions competing for research dollars. The various research units of OHSU receive over $124 million annually in grants.

first residency program in Oregon to be based outside the Portland metropolitan area.

HEALING

OHSU offers a unique patient-care environment that provides many services offered nowhere else in Oregon. OHSU clinicians also are teachers and scientists who provide a vast interdisciplinary network of expertise backed by the modern technologies and research available in an academic environment. This access makes it possible for OHSU to provide the highest quality care to its patients.

Doernbecher Children's Hospital, Oregon's first full-service pediatric facility, has been in existence since 1926. While pediatric services now are offered at other hospitals in Oregon, Doernbecher continues to provide the widest range of health care services for children in the region. A new Doernbecher Children's Hospital opened this year to replace the aging and overcrowded facility. It was built through donations and bond revenues, and houses all pediatric services in one place.

OHSU Hospital provides services ranging from primary care medicine to highly sophisticated care for patients with complicated illnesses or injuries. It has earned a national reputation for many of its programs, including primary care and specialties in neuroscience, infertility, otolaryngology, cardiology, gastroenterology, endocrinology, ophthalmology, oncology, psychiatric crisis intervention, high-risk pregnancy, emergency medicine, trauma, and genetics.

Besides the dozens of general and specialty outpatient clinics on the main campus, the university operates eight primary care community health centers in Portland-area neighborhoods. These centers allow families convenient access to the expertise of an academic health center near where they live and work.

OHSU has multiple health care programs tailored to a wide range of specialized patient needs. A few of these centers, which serve people from throughout Oregon and neighboring states, are highlighted below.

The Child Development and Rehabilitation Center provides interdisciplinary diagnosis, treatment, and rehabilitation services for children with chronic and disabling conditions, and their families. The center serves thousands of children through its clinics in Portland, Eugene, and Medford, and

through regular travel to 11 Oregon communities. Staff members provide continuing education programs for community health professionals to promote expertise in caring for children with special needs.

The Casey Eye Institute, nationally recognized for its research and treatment of eye disorders, offers the region's most comprehensive eye care, including clinical consultations and treatment in all subspecialty areas, and access to the latest technological advances and equipment. The institute includes the Elks Children's Eye Clinic, which serves thousands of children each year.

The Oregon Cancer Center serves Oregonians by providing enhanced access to the latest research and advanced therapies. More than 180 professionals in the cancer field from OHSU and other local health care facilities collaborate to design and share innovative clinical trials that draw on basic science discoveries. Their emphasis is bench-to-bedside linkage. The center recently was designated as a National Cancer Institute center. The designation marks the center as the only NCI-designated center between Seattle and Los Angeles.

The Center for Women's Health, OHSU's newest unit, represents its ongoing commitment to women's health. The center responds to both today's dynamic health care environment and the dramatic changes that have occurred in so many areas of women's lives during the last decade.

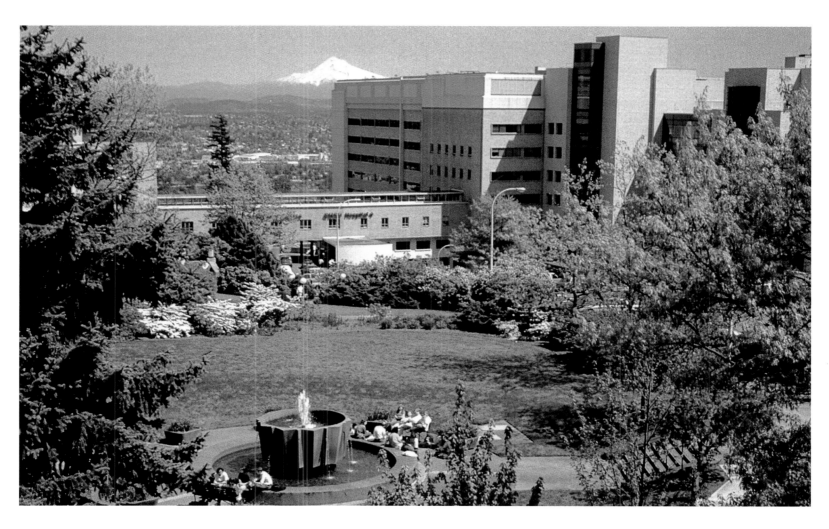

RESEARCH & DEVELOPMENT

OHSU is one of the premier biomedical research institutions in America. Some of the nation's most accomplished scientists are working right here. Many have left research centers like Harvard, Yale, and Stanford to join investigators at OHSU.

The university's ability to garner competitive funding is one demonstration of the worth of its research endeavors. The National Institutes of Health—the single largest supporter of

medical research in the nation—ranks OHSU among the top three percent of about 2,000 institutions competing for research dollars. The various research units of OHSU receive over $124 million annually in grants.

Approximately 650 scientists at OHSU are working on 1,665 basic and applied research studies. These research activities infuse faculty and students with curiosity, originality, and the tools to be continual learners and discoverers.

Research is inseparable from OHSU's teaching and patient care programs. It creates new knowledge about prevention, detection, and treatment of disease. It adds to the understanding of both positive and negative effects of treatments and interventions. It arms us with the information to combat excessive reliance or under reliance on technology. In short: It saves lives.

The excellence of OHSU helps Oregon to ensure its citizens have access to the finest health care services and attracts national talents, grants, gifts, and financial investments to Oregon. It boosts the state's economy and improves health care for all Oregonians. ◼

OHSU has evolved into one of America's top academic health care and medical research centers. It has a well-earned national reputation for its expertise, leadership, and commitment to public service and education.

OHSU is the only hospital in Oregon that provides a comprehensive solid organ transplant program. Outcomes in OHSU's transplant programs continue to exceed national averages. Kidney transplants rank in the top 5 percent and liver transplants in the top 15 percent, nationally.

More than 1 million Oregonians have medical coverage through Regence BlueCross BlueShield of Oregon. It is far and away the preferred health plan in Oregon.

The beginnings of such a system were born in the Oregon logging camps of the late 19th century. Local doctors cared for workers under a contract with the camp and sawmill owners. The operators deducted 50 cents a month from the loggers' pay to cover the "insurance."

In World War II more than 60,000 workers were building ships in Portland. Several local physician-sponsored benefit plans joined to form Oregon Physicians Service (OPS). Blue Cross of Oregon was created at the same time to provide hospital benefits for these workers.

After the war OPS became the first agency in the country to provide individual coverage. In 1946, OPS and five similar physician-sponsored plans joined to form what would become the Blue Shield Association. In 1983 Blue Cross of Oregon and OPS Blue Shield merged to form what has become Regence BlueCross BlueShield of Oregon (BCBSO).

The company has an enviable reputation among those it serves. According to recent research, subscribers see Regence BCBSO first of all as having "the best doctors and hospitals." Beyond that they described the firm as "dependable," "family-oriented," and "progressive."

Regence BCBSO takes all those adjectives seriously. It recognizes that its operations are focused on people, and that means its first priority must be to serve those subscribers well. Its nearly 2,200 employees have the capabilities to serve medium to large employers with products that fit the special needs of their workers.

As part of The Regence Group, BlueCross and BlueShield of Oregon provides unique convenience and flexibility to its clients.

The Group's primary goal is to offer consistent, seamless group health and life benefits to employers and employees across state lines in Washington, Idaho, and Utah.

Recognizing that today customers seek selection, value, and service, Regence BCBSO offers a variety of health plans that encourage wellness and disease prevention for every age group. Its HMO plan is popular with many customers and employers because it helps keep costs in check. Basic to the system is the primary care provider who directs the patient's care and, when necessary, makes referrals to a specialist.

BCBSO offers a preferred provider policy which gives the subscriber the choice of self-referral and the use of nonnetwork providers. Oregon's preferred health provider also offers life insurance plans, wellness programs, employee and third party administrator services, and flexible spending accounts.

The state's largest customer service division is available not only in Portland but also in Salem, Eugene, Roseburg, Medford, Bend, Pendleton, and Vancouver, Washington. This statewide network means more than convenience. It ensures lower costs.

BCBSO works constantly to keep health care affordable through cost containment programs. Review for medical necessity and case management are among programs which annually save millions of dollars. The company processes an average of 30,000 claims every day. About half arrive electronically.

This paperless system saves providers substantial time and money. A new HMO membership system is another innovative and cost-efficient service for BCBSO's customers. It consolidates all of the enrollment and eligibility information from each of the company's services, providing a base from which to manage future growth.

Medicare coverage is an increasingly important company service. Through Medicare Northwest, a division of BCBSO, more than 13 million Medicare Part A claims are processed annually. That makes the firm the second largest processor of claims in the country. The division also oversees the payment of Medicare Part A and B by contractors in 13 western states. And it operates the data center for claims processing by five other Blue Cross and Blue Shield Plans.

Donald P. Sacco, President and CEO of Regence BlueCross BlueShield of Oregon/Regence HMO Oregon.

In conjunction with the Lions Clubs of Oregon, Regence BlueCross BlueShield of Oregon/Regence HMO Oregon sponsors this Mobile Health Screening Unit which travels to large and small communities across the state providing free medical screening services.

BCBSO helped the state establish the Oregon Health Plan, which provides an affordable health care plan for uninsured and low-income Oregonians. The company administers a similar program for the state of Washington.

BCBSO's service to the community includes a partnership with Oregon Health Sciences University and Legacy Visiting Nurses Association on a research project to reduce smoking among expectant mothers. Researchers hope to find ways of decreasing the relapse rate among women who resume smoking after delivery.

The company is helping children survive cancer through its Pediatric Cancer Network. Young patients are referred to the network's comprehensive care facilities in Portland at the Doernbecher Children's Hospital of Oregon Health Sciences University and Legacy Emanuel Children's Hospital.

BCBSO regularly provides health education materials to schools and other community groups, and participates in many annual health fairs.

The firm's World Wide Web home page (bcbso.com) is the newest source of product, provider, health, and employment information, along with general news about the company.

The health and well-being of BCBSO employees are a priority. There is a fitness center with state-of-the-art equipment and a schedule of aerobics classes in the workplace. A registered nurse is available at the Occupational Health Office to answer questions, provide health information and education, administer blood pressure checks, and annual flu shots.

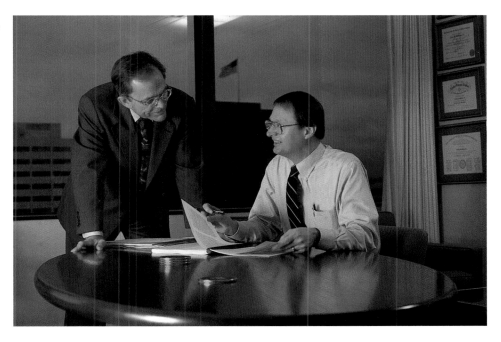

BCBSO is proud of its employees and their involvement in the community. A corporate program recognizes employee contributions and achievements.

Recognition of the company's leadership and commitment to service has come from the Blue Cross and Blue Shield Association. BCBSO received the Association's first Brand Excellence Award in 1995.

President and Chief Operating Officer Donald P. Sacco defined BCBSO's mission when he declared, "We have a social responsibility to listen carefully to our customers and to exceed their expectations in improving their health and their lives." ◪

Medical policy decisions are made by qualified, leading medical authorities, including J. Allen Johnson, M.D. (left), Medical Director for Quality Management, and J. Bart McMullan, M.D. (right), Executive Vice President, Health Care Services.

Advancements in technology keep Regence BlueCross BlueShield of Oregon/Regence HMO Oregon a leader in receiving and processing medical claims. If the claims processed electronically were to come in on paper, the daily stack would be more than nine feet tall.

A cardiac surgeon who created the first artificial heart valve restores vital blood flow to yet another patient at Providence St. Vincent Medical Center. Across the river, a researcher in a Providence Portland Medical Center laboratory explores triggering the body's immune system to produce cancer-fighting cells. Several miles to the south, a nurse cradles a baby newly born at Providence Milwaukie Hospital.

The three Portland-area hospitals are all part of Providence Health System in Oregon, a not-for-profit network of hospitals, health plans, physicians, clinics, and affiliated health services. Serving people in Oregon for more than 140 years, Providence has become the state's largest health system and its third-largest private employer.

Providence grew from the deeds of five Sisters of Providence from Montreal, Quebec, who arrived by steamship in 1856 at Fort Vancouver just north of Portland. They were bringing westward their mission of caring for the sick and helping the poor. Enduring frontier hardships, the sisters went on to open Oregon's first hospital, St. Vincent, in 1875.

Primary care physicians of Providence Health System serve as caregivers, guides, and partners to their patients.

Today, the people of Providence Health System carry forward the founding values of compassion and excellence.

"We know we're operating on people, and we know that these people are frightened and need to feel confidence and trust. We try to establish that," reflects surgeon Dr. Albert Starr, director of The Providence Heart Institute in Portland. "But when we get into the operating room, we have a technical job to do, and at that point we strive for a very high degree of technical excellence."

Providence's Heart Institute ranks as an international leader in cardiac care, research, and education. To continually enhance patient care, physicians perform groundbreaking research into such advances as heart valve repair and clot-dissolving laser techniques. Providence cardiac specialists share their knowledge throughout the United States and around the globe. The Institute also emphasizes preventive services such as classes in smoking cessation and exercise.

For those whose lives may be touched by cancer, Providence Health System provides a full range of ser-

vices, including advanced diagnostic and treatment services, pain management, counseling, and education about prevention and early detection. A world-class team of physicians and scientists conducts innovative research at the Robert W. Franz Cancer Research Center at Providence Portland Medical Center.

New life abounds at Providence hospitals as they welcome more babies each year than any other health system in Oregon. Homelike maternity suites, neonatal intensive care, and breastfeeding support all are available. A program called Providence Beginnings provides care and support for women who face special needs during pregnancy.

Serving businesses throughout the Portland area, Providence works to boost employees' health, productivity, and morale while lowering workers' compensation costs and absenteeism rates. Specialty physicians staff several conveniently located occupational medicine clinics. Health education at the worksite and employee assistance are among the array of business services offered.

Providence Health Plan, an HMO, provides health benefits packages tailored to businesses of all sizes. Offering convenient access to quality care, primary care physicians in the many clinics of Providence Medical Group and Providence Family Medicine are among more than 1,500 active medical staff members.

Providence Health System services extend beyond Portland into wide-reaching regions around the state. More than half of Oregon's residents live in areas served by Providence. "Working with others in a spirit of loving service," notes the Providence mission statement, "we strive to meet the health needs of people as they journey through life." ◪

Researchers at Providence's Robert W. Franz Cancer Research Center are taking the latest laboratory discoveries and translating them into innovative treatments for cancer patients.

THE PORTLAND CLINIC LLP

Physicians & Surgeons

Over the years, Northwest families have come to expect special care from The Portland Clinic, and for good reason. Everyday, the physicians and staff of Oregon's oldest, full-service, multispecialty medical group support a tradition of caring that has continued since 1921. While there is a large variety of medical and surgical specialties represented on its physician staff, the doctors at The Portland Clinic like to think of themselves as Family Health Care specialists. It has been that way since the Clinic's four founding physicians brought their vision of comprehensive family health care to Portland. And they knew how to make it work!

One of the Clinic's founders, Dr. Tom Joyce, was personally trained by Drs. William and Charles Mayo, creators of the world-famous Mayo Clinic. Another founder, Dr. Noble Wiley Jones, was the first recognized specialist in Internal Medicine in Portland. He built the Portland Medical Hospital on NW 19th and Lovejoy in 1916, where he introduced the Northwest to the electrocardiograph machine, used for diagnosing heart ailments, which he brought with him from his training in London.

In the early years of the University of Oregon Medical School, another of The Clinic's founders, Dr. Laurence Selling, was head of the Department of Medicine. For many years The Clinic's physicians held professorship and department head positions at the Medical School, guiding the school's growth until it could afford its own full-time medical teaching staff.

Today, the original spirit, dedication, and quality of The Clinic's founders are alive and well. And that's why over 75,000 people every year, from families throughout the Northwest, place their health care needs in the trustworthy and capable hands of The Portland Clinic.

As the Portland area has grown in size and population, so has The Portland Clinic. To better serve its patients, it now has four offices in the area. The main office in Downtown Portland is complemented by offices at the Sylvan exit on Highway 26 (west of town), at the Carman exit (south of the 217 exit) on I-5 South, and at the intersection of Tualatin Valley Highway and 160th in Beaverton.

In addition to a large selection of primary care physicians and specialists, The Portland Clinic has its own State-licensed and Medicare-approved Day Surgery, staffed by qualified operating room nurses and M.D. anesthesiologists who assist the surgeons and other physician specialists with their cases. Far less expensive and intimidating than a hospital environment, the Day Surgery cares for approximately 1,500 patients per year, who, through surveys, consistently give the highest ratings for this service.

A history of caring for four generations

The Portland Clinic also provides its patients with a full range of ancillary services, including laboratory, x-ray, mammography, hearing testing, heart and lung testing, physical therapy, and dietitian services. When faced with urgent health concerns, patients may access The Clinic's walk-in "convenient care" services at most of its offices, and Saturday and extended weeknight hours are also available for the patients' convenience.

In recent years, The Clinic added what is now an award-winning patient education department. Regularly scheduled classes are available for patients. The Portland Clinic also cooperates with pharmaceutical companies to provide patients and physicians the opportunity to participate in medical drug trials—at stages safely beyond the experimental and under highly regulated FDA protocols, giving both physicians and patients exposure to cutting-edge technology.

The Portland Clinic was first in the greater Portland area to receive accreditation from The Medical Quality Commission with the top score in TMQC's six-year history. In 1997, the Clinic received its three-year reaccreditation with praise from this same national organization. ◢

Beaverton office with 15 physicians specializing in Family Practice, Internal Medicine, and Pediatrics

Kaiser Permanente is the nation's largest and most experienced health care delivery program of its kind. Kaiser Permanente's not-for-profit, federally qualified health maintenance organization (HMO) is offered through employers and union trusts and to individuals. Because prepaid care is offered, there is no incentive to fill hospital beds; rather, the incentive is to keep members healthy and satisfied, a logical approach, yet one Kaiser Permanente literally developed from the ground up.

In 1938, in eastern Washington State, the prototype for today's Kaiser Permanente took shape at Grand Coulee Dam. There, industrialist Henry J. Kaiser and his son Edgar teamed up with Dr. Sidney Garfield to create a prepaid health care plan for the dam's builders. For the first time, the plan included workers' families. The Kaisers were building on the experience Dr. Garfield had gained several years earlier, when he set up a hospital to care for workers building the Los Angeles Aqueduct.

When World War II began, Henry Kaiser again called on Dr. Garfield to arrange the same type of health care plan for the thousands of workers flocking to Kaiser shipyards on the West Coast, including those in the Portland-Vancouver area.

From an initial membership of 6,000, the program grew to include 30,000 people at the height of the war effort.

When the war ended, and former shipyard workers found other employment, many asked to continue their membership in the health plan. Henry Kaiser and Dr. Garfield agreed to continue the plan and open membership to community enrollment. Growth accelerated in 1950 and 1951, when the first major group—the International Longshoremen's and Warehousemen's Union Health and Welfare Trust Fund—began offering the health plan to its members and their families.

A prepaid dental program was started here in 1974; like the medical care program, people responded enthusiastically and the program continues to expand.

Kaiser Permanente has influenced health care delivery and financing throughout America. It is a nationally recognized leader in using computer systems to support physicians and others who care for patients. Other examples of innovative approaches to providing high-quality, affordable health care include:

- offering an award-winning, comprehensive program to keep people with diabetes healthy. This includes such things as having diabetes education classes and contacting patients who have missed key lab tests, appointments, or special eye exams;
- reducing the chance of women giving birth prematurely by enrolling at-risk women in a special program run by nurse case managers;
- creating scientifically based, effective weight management and smoking cessation programs;
- sharing the results of studies from its Center for Health Research and working to improve the health of people throughout the community.

Kaiser Permanente was the first health plan in Oregon and southwest Washington to achieve full three-year accreditation from The National Committee for Quality Assurance (NCQA), which evaluates how well a health plan manages all parts of its delivery system—physicians, hospitals, other providers, and administrative services.

While NCQA may set the quality standards in the health care industry, Kaiser Permanente has also received national recognition from *U.S. News & World Report*, *Newsweek*, and other consumer publications.

Kaiser Permanente is committed to giving back to its community, through grants to community-based nonprofit agencies providing direct services, through human and in-kind resources, through the donations of office furniture and medical equipment, and through community programs. ◢

Kaiser Permanente's focus on preventing childhood injuries includes a bicycle safety program that has distributed more than 4,500 free bicycle helmets to low-income children. Medical Director Al Weiland, MD, and Sharon Kitzhaber, Oregon's First Lady and honorary chair of Oregon Safe Kids Coalition, brought free bike helmets to all 446 students of Marcus Whitman Elementary School in southeast Portland.

The dental program's Children's Health Awareness Program introduces young children to oral health and dental visits using a woodchuck named Chap, a storyboard, and other visuals. Here, Janet Hankins, RDH, talks with children at the Virginia Garcia Memorial Health Center.

LEGACY HEALTH SYSTEM

The Oregon Quality Award was given for the first time to a health care organization in 1996; as unusual as that was, Legacy Health System took it home again in 1997. Legacy is the sixth largest private sector employer in the Portland metropolitan area, and the largest employer ever to receive the Oregon Quality Award.

Formed in 1989 by the merger of several of the region's major hospitals and health care organizations, Legacy Health System is the only Oregon-based, not-for-profit health care system in the state. The Legacy system provides an integrated network of health care services, including acute and critical care, inpatient and outpatient treatment, community health education, and specialty services.

Legacy works in partnership with local health plans and physician groups to develop innovative ways to provide cost-effective care and improve the health status of the community. Using continuous quality improvement, reengineering, and cross-trained teams, Legacy has reduced duplication and gained the ability to effectively manage clinical programs across multiple locations. In addition, *Oregon Business* magazine has ranked Legacy among the 10 best companies to work for in Oregon several years in a row.

Legacy's cost per adjusted admission (an industry benchmark in cost containment and service delivery) has dropped every year since 1992. Because of its success in containing costs, Legacy has increased its rates for hospital services only once since 1994.

Legacy offers a full range of tertiary care services at sites throughout the Portland metropolitan area. Clinical programs and services include Cancer Services, Heart Services, Laboratory Services, Rehabilitation Services, Senior Services, Women's Services, and Pediatric Services. Legacy's facilities, which follow, host a broad range of other services:

• Legacy Emanuel Hospital & Health Center. Established in 1912, Legacy Emanuel Hospital is a tertiary care center located in north Portland. It is a Level 1 Trauma Center and the base for Life Flight Network, the region's critical care transport service, and the Oregon Burn Center. Legacy Emanuel houses Legacy Emanuel Children's Hospital, with its

neonatal intensive care unit, providing care in an environment sensitive to the special needs of children and their families.

• Legacy Good Samaritan Hospital & Medical Center. Founded in 1875, Legacy Good Samaritan is one of the oldest hospitals in the Pacific Northwest. Located in northwest Portland, it offers the state-of-the-art Kern Critical Care Unit, Rehabilitation Institute of Oregon, Devers Eye Institute, the Legacy Comprehensive Cancer Center, and the Legacy Heart Institute.

• Legacy Meridian Park Hospital. Located in Tualatin, Legacy Meridian Park was established in 1973 as a community hospital to serve what is still one of the fastest growing areas of the state. Legacy Meridian Park offers a wide range of services, including cancer treatment, diagnostics, and a Family Birth Center. A significant hospital expansion is underway which includes new wings for critical care, women's services, and outpatient services.

• Legacy Mount Hood Medical Center. Legacy Mount Hood's history can be traced back to 1922. Located east of Portland in Gresham, the hospital today continues to grow with the surrounding community. Legacy Mount Hood built a Family Birth Center in 1995 and opened a radiation oncology treatment center in 1996. Chemical dependency treatment is provided through CareMark Behavioral Health Services (a joint venture corporation of Legacy Health System and Adventist Health System/West).

• Legacy Visiting Nurse Association. Legacy Visiting Nurse Association since 1902 has provided home health care, health education, and community wellness programs. Skilled nursing, rehabilitation, hospice, obstetrics, pediatrics, psychiatric, and cancer care services are provided in the eight-county Portland metropolitan area. Its Regional Network offers infusion services and products throughout Oregon, Washington, and Idaho. ◪

Adventist Health has deep roots in the Portland area. For more than 100 years, Adventist Medical Center has served the Portland community, providing the latest medical services while focusing on its mission of delivering quality health care in a spirit of Christian compassion.

The hospital was founded in 1894 by Dr. Lewis Belknap,

who trained at the famous Battle Creek sanitarium in Michigan under Dr. John Harvey Kellogg. Arriving in Portland penniless, Belknap was taken in by Adventist church members and soon began his first sanitarium, a tiny eight-room house dedicated to preventive health measures. His practice quickly outgrew the facility. In 1895, Belknap was able to rent the Reed Mansion (which once belonged to the family who founded Reed College) for the Portland Sanitarium, or "The San," as it was called. It offered an emphasis on treating the whole person—body, mind, and spirit—a concept that was truly ahead of its time. This focus on wellness and preventive medicine has continued to be a mainstay of Adventist Health.

From such humble beginnings, Adventist Health/*Northwest* has evolved to include Adventist Medical Center, a 302-bed hospital located near Interstate 205 with special emphases in the areas of obstetrics, surgery, rehabilitation, mental health, medical imaging, and wellness services; a full-service home care agency that provides home health, hospice, personal care, and respiratory care services; and 17 primary care clinics located throughout the east side of the Portland/Vancouver area. The clinics are purposely designed in a way that makes them feel comfortable for patients—more like a neighborhood clinic than a corporate health center. The hospital has also taken an innovative approach to rehabilitation services, setting up satellite facilities in area health clubs.

Adventist Health/*Northwest* is part of a regional system known as Adventist Health, with corporate headquarters in Roseville, Calif. In a recent ranking of America's top 100 integrated health care systems, Adventist Health was ranked number three in the nation. The study, which ranked health systems on their commitment to pioneering change in the health industry, gave Adventist Health a score of 78.65 out of a possible 100 points. Everything from utilization and physicians, to services and access were considered. The study also ranked Adventist Health in the top 10 in two key categories: networks with the most outpatient sites (74 in California, Hawaii, Oregon, and Washington), and networks with the most hospitals (20).

Adventist Medical Center in Portland is known for its excellent maternity services, delivering 1,600 to 1,800 babies each year. Its Family Birth Place is the newest OB center in the city, with luxury birthing suites complete with Jacuzzi™ bath, CD and VCR players, and furniture that looks more like it belongs in a lovely hotel room than a hospital. A complete offering of childbirth preparation and newborn care classes are available for new parents.

A commitment to wellness is at the forefront of Adventist Health's services. The Healthvan, a mobile health resource, frequents the Portland community offering free and low-cost health screenings like blood pressure, cholesterol, and diabetes checks. The Healthvan travels each month to community events, schools, senior centers, and social service agencies to bring health education to people in places they can easily access. WorkWell, an employee wellness program that offers incentives, education, and support, is offered free to all Adventist Health/*Northwest* employees and their spouses. Adventist Health also works with many employers in the Portland area, helping develop customized employee wellness programs and offering corporate health services like executive physicals and on-site health screenings.

The hospital has sponsored many community events, like Race for the Cure® and the American Heart Association's Gresham Heart Walk. Employees often join in through donations and participation. The organization's leadership has been involved in the United Way Day of Caring, and held such positions as president of the Gresham Area Chamber of Commerce and chairman of the board of the Oregon Association of Hospitals and Health Systems. Several employees serve on the boards of numerous community organizations.

It all adds up to an organization dedicated to meeting the challenges of a changing health care industry: maintaining an exceptional medical staff with a higher percentage of board certified physicians than the national average, offering maximum efficiency and patient outcomes with an integrated provider system, outstanding clinical medical care with state-of-the-art facilities, a continuing dedication to improving patient care, and a commitment to giving back to the community it serves. ◢

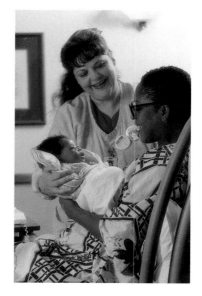

MULTNOMAH ATHLETIC CLUB

The Multnomah Athletic Club is as well-known to Portlanders as Pioneer Courthouse Square, Portland's living room. Portland's business and civic events and meetings are often held "at the MAC." So are other types of meets, like those held by the swim teams and gymnastic teams. And yet another group meets regularly at the MAC, the multigenerations of families that are the members of the Multnomah Athletic Club.

Formed in 1891 by 26 football players seeking to expand their athletic horizons, the MAC did more than that: it set the standards for amateur athletics in the Pacific Northwest. The MAC brought the first track meet here. It hosted the first state tennis championships. And it introduced hockey to Portland.

Along the way, it helped create sports legends, like Dan Kelly, who set world records in the 100-yard dash and the 220. Like Nancy Merki, who set a 1500-meter freestyle record. And Jim Grelle's sub-four-minute miles. In total, more than 40 MAC athletes and coaches have participated in Olympic Games, taking 28 medals. The MAC offers elite caliber coaching for the weekend warrior to the elite athlete.

The Multnomah Athletic Club is proud of its sports history and the sports history that remains to be made. Yet it defies branding as simply a "sports club." A magnet for city leaders from its earliest days, its responsibility to the community today is still strongly felt.

Acting on that responsibility, the MAC in 1989 formed the Multnomah Athletic Foundation to support youth athletics in the greater Portland area. The Foundation focuses on disadvantaged youth providing athletic opportunities for deserving youngsters. Independent of the Foundation, the club for over 25 years has sponsored a significant Scholar-Athlete program that reaches 27 area high schools. Students who meet the criteria receive courtesy membership privileges at the end of their sophomore year in high school. Upon high school gradu-

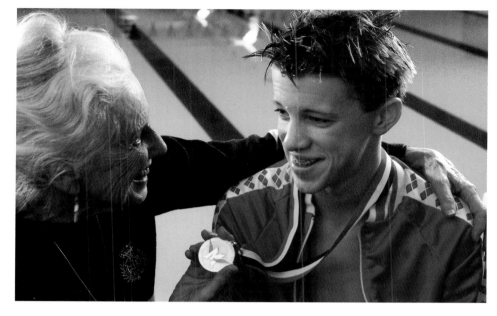

ation MAC Scholar-Athletes receive a one-time college scholarship award along with opportunity to continue their membership as a regular club member.

The MAC is a private, member-owned club with a focus on family. In fact, multigenerations of family belong to the club. Its 19,500 members can choose among athletic entertainment and workouts, including basketball, volleyball, gymnastics, running, swimming in a choice of three pools, handball/racquetball, tennis, and weight conditioning. A child-care center eliminates one excuse for not working out. A snack bar, four restaurants, a beauty salon, and retail clothing store plus easily accessible parking make the Multnomah Athletic Club a "one-stop" powerhouse. Members can also take classes in art, computers, self-improvement, and even auto mechanics.

These amenities, its serious athletic training facilities, and its commitment to the community make the Multnomah Athletic Club a desirable membership to have. However, for nearly two decades, the MAC has had very limited membership opportunities. To maintain its long-standing connection with the greater Portland community, the club in 1996 enacted a Civic Membership program which provides limited membership application opportunities for key business, community, and minority leaders as defined by the club. ◪

Junior- and senior-age athletes relish the thrill of sports competition at MAC.

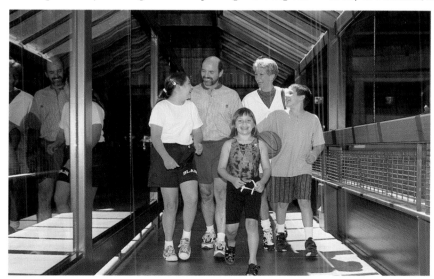

MAC supports family-friendly activities and services.

Marketplace & Attractions

Photo: Steve Terrill

From cantaloupe to Levis to comforters, if you're shopping for one or all three, you'll "Find it at Freddy's," the affectionate nickname and well-known tag line for the locally grown retail powerhouse Fred Meyer, Inc.

Fred G. Meyer's vision brought him from Brooklyn, New York, to Portland, where he sold tea and coffee door-to-door, recognized the potential in the grocery business, and then turned the grocery business upside-down when he initiated self-service and replaced traditional credit-and-delivery with convenient cash-and-carry.

Customers at the time walked from shop to shop to buy their food, waiting their turn at the butcher shop for meat, at the baker for bread, and the produce stand for fruit. Mr. Meyer broke that tradition with a new store in 1922, gathering a number of those food shops under one roof and prepackaging such products as flour, sugar, and beans which normally would have been sold in bulk from barrels or large bags. Customers could choose the groceries, pay for them, and carry them out of the store—rather than waiting for home delivery. This "marketplace" store—bakery, butcher shop, grocery store, dry goods store, and other specialty shops all under one roof—meant customers no longer had to go from store-to-store for the freshest bread, the best meats, the finest produce. And Fred Meyer's "one-stop-shopping" concept was born.

Mr. Meyer's innovations continued in 1928 when he opened the first self-service drug store in downtown Portland. He saw the impact the automobile would have on people, so he began providing free off-street parking at his first suburban store in 1931 and focused store growth in the emerging suburbs at major intersections. In the 1930s he also started adding more general merchandise and apparel in his stores, becoming the nation's leading pioneer of one-stop shopping.

Fred G. Meyer directed the company until he died in 1978 at the age of 92. Still unmatched today, his stores continue to evolve and grow, operating as the Fred Meyer Stores subsidiary of Fred Meyer, Inc.

FRED MEYER STORES—SERVING THE COMMUNITY

An inspired businessperson, Mr. Meyer also felt from the beginning that giving back to the communities where his stores operated was extremely important. Fred Meyer's commitment to the community began when he opened his first store—and continues today. The Fred Meyer Challenge, for example, a golf tournament featuring PGA professionals eagerly anticipated annually in Portland, has raised more than $6 million for children's charities since its beginning in 1986.

Mr. Meyer's commitment stemmed from both an economic and an altruistic sense. Fred Meyer recognized his company's success depended in large part on the health of the communities it served, so he worked to strengthen them. He was famous for helping local businesses get started, and his preference for buying local continues to be a strong tradition at Fred Meyer Stores.

His philanthropic side shone through as well. He not only committed his company to helping those in need, but he also personally delivered baskets of food to the poor and helped serve dinners at homeless shelters on holidays. The example Mr. Meyer set with his emphasis on volunteering in the community and corporate giving remains a vital part of the company today.

A well-defined community relations program at Fred Meyer focuses on the following main areas:

- Youth development programs that focus on health, including nutrition, motivation, and self-esteem;
- Environmental programs that foster awareness, education, and action; and
- Cultural programs to improve the livability of communities served by the company.

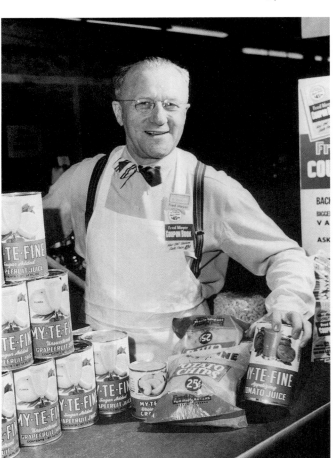

Fred G. Meyer started the company that bears his name in 1922 with a unique food store in downtown Portland.

A full-size Fred Meyer store offers more than 225,000 food, apparel, and home products under one roof for true one-stop convenience.

Fred Meyer employees volunteer thousands of hours each year through the company's employee volunteer programs.

When tragedy strikes, Fred Meyer is often right there to help the relief effort. When record floods turned western Oregon and much of Washington into a national disaster area, the company responded immediately with trailer after trailer of food, water, and emergency supplies. When the Salvation Army in Seattle faced a food collection crisis that shut down its year-end holiday donations center in 1993, Fred Meyer supplemented its annual holiday truckloads of food and gifts with a special food drive at area stores. When storms knock out power, Fred Meyer fires up generators and keeps its stores operating so residents can find the food and emergency supplies they need.

FRED MEYER STORES—A PACIFIC NORTHWEST-GROWN SUCCESS STORY

Fred Meyer Stores has more than 120 multidepartment stores and 30,000 employees in six Northwest and Intermountain states. Each Fred Meyer store is a "local" business, built close to neighborhoods, serving customers where they prefer to shop, and staffed by their neighbors. Customers' needs and preferences are closely considered when stocking a store. Sales are closely monitored and selections adjusted so that the product mix most closely matches the local customers' needs.

Fred Meyer Stores shares the corporate headquarters of Fred Meyer, Inc. in Portland. The company also operates a dairy and commercial bakery in the Portland area, maintains a large fleet of trucks and trailers, and has three major distribution facilities in Puyallup and Chehalis, Washington, and Clackamas, Oregon.

Fred Meyer Stores maintains an energetic new store and remodel program to keep the company growing and its stores fresh for its customers. Nearly all its stores are either new or have received major remodels in the past 10 years.

From the beginning, great food at low prices has been an integral part of the Fred Meyer one-stop-shopping experience. Consumers shop food retailers more frequently than any other retail category. This frequency helps Fred Meyer build customer loyalty and creates many opportunities for customers to visit other parts of the store. An aggressive, three-tier private-label program in food helps build sales while saving customers money.

The food department uses an everyday low-pricing approach. Its goal is to keep the overall food pricing at each store competitive with the lowest-priced full-service supermarkets serving the surrounding neighborhoods.

New stores feature a farmer's market approach for produce, with the fruits and vegetables displayed around a service island. The service deli offers ready-to-eat hot and cold foods for customers seeking fast and easy meal solutions. The in-store bakery, fish market, and meat market all provide fresh foods every day. The nutrition center rivals the best specialty stores and makes Fred Meyer the third largest natural foods retailer in the country. The pharmacy is located near the front of the store so that folks who are not feeling well can get in and out quickly. Fred Meyer's selection of health and beauty products is comparable to the best full-line drug stores.

On the nonfood side of the business, a full-size Fred Meyer store has more than two dozen specialty sections that primarily use a promotional pricing strategy. Fred Meyer sells national brand products typically found in department and specialty stores. Top names include Levis,

The apparel department combines impressive selections of national brand names with the decor and merchandising of specialty shops and department stores.

You'll find great food at lower prices at Fred Meyer, which has been a pioneer and leader in the grocery business since opening its first store in 1922.

Fred Meyer offers plants and flowers of all kinds to decorate the home, landscape a yard, or plant a garden.

Lee, Wrangler, Jockey, Nike, Sony, and Pioneer.

Fred Meyer also was one of the first mass retailers to shift the focus of its electronics departments from personal computers to faster-selling, higher-margin items like compact discs, videos, computer accessories, and software—a change that has paid off well.

Fred Meyer Stores was built on the vision of a man who anticipated people's shrinking time and capitalized on it by combining multiple shopping areas under one roof, providing high-quality products with exceptional service and low prices, and getting involved in the communities where the stores do business.

FRED MEYER, INC.—THE FIFTH LARGEST FOOD RETAILER IN THE COUNTRY

To meet its goal of increasing shareholder value, in 1997 Fred Meyer sought to position itself as a bigger player in supermarket retailing. In an industry undergoing rapid consolidation, Fred Meyer made the decision to acquire. To that end, the company completed mergers with Smith's Food & Drug Centers, Inc. in 1997 and with Quality Foods Centers and Ralph's Grocery Company in early 1998.

It found the right companies. They expanded Fred Meyer's current territory while simultaneously broadening its grocery business and complementing its quality standards, values, and markets. Combined with Fred Meyers Stores, the four subsidiaries of Fred Meyer, Inc. are terrific food and drug retail chains generating $15 billion in sales. They employ more than 85,000 people and include over 800 stores in a dozen western states, making Fred Meyer, Inc. the fifth largest food retailer in the country. The company boasts a vast distribution network, plus modern manufacturing facilities and management information systems. It also includes Fred Meyer Jewelers, the fourth largest fine jewelry chain in the country.

Fred Meyer customers are greeted inside the food entrance by the finest produce displayed around island service counters.

And Fred Meyer, Inc.'s common stock is traded on the New York Stock Exchange.

The Smith's stores operate under three banners—Smith's Food & Drug Centers, Smitty's Marketplace, and PriceRite Grocery Warehouse. Together, they give Smith's the top food market shares in Salt Lake City, Las Vegas, and Albuquerque. The Ralph's stores, combined with Food 4 Less warehouse stores, maintain the top food market share in Southern California. In Seattle, the QFC stores hold the number one market share.

Fred Meyer enjoys a strong commitment to similar core values across all its stores. Superior customer service, for example, distinguishes Fred Meyer companies from their competitors. While each company has its own name for it, the bottom line is that all stores operate on the belief that customer loyalty is built on quality, courtesy, and integrity.

Regardless of region, each store also seeks quality in what it sells. Freshness and quality selection define the supermarket as well as nonfood businesses of Fred Meyer companies.

The company's commitment to people begins with those on the front line—the employees. Training and education show employees that their professionalism is appreciated. Support for the communities where the Fred Meyer family of stores does business continues the tradition of caring that Fred G. Meyer began in 1922. Every day in Fred Meyer territory, employees are reaching out to help the communities they serve.

Geographically diverse, Fred Meyer no longer depends on one region for its success. With billions of dollars in combined

buying power, all four chains are able to merchandise more effectively. With many modern manufacturing and distribution facilities between them, products get into all the stores faster. By sharing management information systems, the companies are improving technologies to communicate and operate more efficiently.

The Fred Meyer family of companies includes thousands of employees and reaches millions of people. But in the final analysis, their combined strength lies in the thoughtful vision provided by Fred G. Meyer when he said, "We're not just serving our communities; we also call them home." ◢

Top national brands like Sony, Pioneer, and JVC are among the many home electronics, music, and video products you'll find at Fred Meyer.

For the bedroom, bath, kitchen, or family room, Fred Meyer has the home fashion products you need to decorate a new home or rejuvenate an old one.

Traveling executives longing for the feel of home look forward to landing in Portland. Here, they can call on Corporate Executive Housing, a company which takes care of providing just the right touch in accomodations so executives can focus on the work at hand.

Well-traveled businesspeople laugh when desk-bound peers

envy their city-hopping, thinking it glamorous and exciting. Too many veteran travelers can tell stories of waking up at night, watching the rotating ceiling fan as they try to remember what hotel in what city they're in, before they realize they're in their own bed in their own home.

Corporate Executive Housing is a lifetime away from identical bedspreads and ice machines down the hall. The company provides a home-like atmosphere with the service of a luxury hotel—without the waiting in line and impersonal service.

Corporate Executive Housing was founded in 1988 by Oregon native Gayle Renne, who knew first-hand the frustration of travel, the coldness of landing in one cookie-cutter room after the next. She created Corporate Executive Housing for executives who are on the road frequently and often in another city for long periods of time.

CEH leases and furnishes more than 100 apartments and townhouses in the Portland-metro area. In Denver, the company has more than 60 living spaces. These distinctive suites are located in traditional and surprising locations—from the heart of the city to quiet, residential areas. Locations are selected for easy access to business centers, cultural facilities, and shopping.

Each CEH residence is professionally decorated, with an eye towards elements that make guests feel at home. Dried flowers in vases, photos on the wall, tasteful artwork, comfortable lounge chairs, plus extras of everything . . . towels, blankets, and pillows. The standard tiny hotel coffeemaker that makes travelers feel like Goliath is a thing of the past; in a CEH apartment, guests can make a regular size pot of coffee, a real plus when business is conducted in the suite. The kitchen also boasts a microwave, blender, refrigerator, dishwasher, and toaster, and, of course, dishes and flatware.

Full-size bedrooms are separate from the living and entertaining areas, and come with your choice of bedroom suites, from twins to kings. Weekly housekeeping keeps disruptions to a minimum, and can easily be arranged to fit the traveler's schedule.

Relaxation is a critical part of a successful business trip, yet it's often the most elusive when confined to a typical hotel room. Tripping over the papers from the bedside table means work seemingly never stops, contributing to quick burnout and unending stress. At Corporate Executive Housing, relaxation is taken seriously. Visitors can enjoy a variety of home entertainment features, including stereos and video players. CEH will even send in the popcorn.

And act as your concierge. Guests who wish to explore the city can receive CEH recommendations for outstanding local restaurants and night spots, and schedule the transportation to get you there—either by cab or limo.

Selected apartment complexes have large, well-equipped health clubs, many with swimming pools and tennis courts, to help burn away the day's stress and keep in shape.

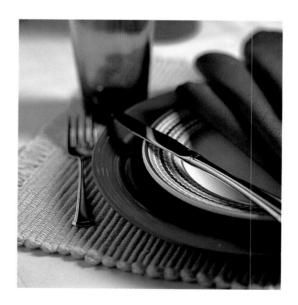

Today's travelers might be taking advantage of an opportunity to bring along their children. Corporate Executive Housing takes this lifestyle change in stride, providing cribs, car seats and high chairs as needed and helping with arrangements for quality child care. In addition, CEH keeps abreast of the latest entertainment facilities for youngsters, to direct guests to experiences that make this trip with their child so much more than a business trip.

Can't leave Fido at home? At Corporate Executive Housing, that's no problem, and that's the only time you'll be required to pay a deposit.

How affordable can a "home away from home" be? Very affordable, when it's Corporate Executive Housing. In fact, staying at a CEH apartment runs 25 to 50 percent less than hotels.

Special requests are the norm for CEH; traveling alone and planning to do lots of work in your apartment, including hosting meetings? A couple of hours after your request, the second bedroom in your apartment will be transformed into an office, with desk, meeting table and chairs, and coat rack.

"We're a small, people-oriented company," Renne says. "We're more flexible, respond to our guests' needs more quickly, and work hard to make doing business with us easy for our guests."

That attitude has created long-term clients of the likes of Nike, adidas America, Hewlett Packard, and local high-technology businesses. CEH once provided a movie producer his fondest dream—privacy—by lining up a luxury house-boat for his stay.

In Portland, Oregon, Vancouver, Washington, and Denver, Colorado, this small company's personalized service and attention to detail make business travelers much more productive. And it's not just for business travel. CEH can make your family vacation more enjoyable by providing a home-front for your stay. CEH locations have easy access to some of nature's most beautiful locations—from the quaint Oregon coast to the rugged Rocky Mountains. ◪

When it comes time for an oil change, consumers today can choose from a dizzying array of options. In Portland, however, the quick lube of choice is clear: Oil Can Henry's, the hometown favorite known as "The One You Can Trust."

With nearly 20 service centers throughout Portland, Salem, and Vancouver, Oil Can Henry's has earned a reputation for providing quick and convenient service at a fair price. Regardless of the service selected—from Oil Can Henry's trademark Famous 20-Point Full-Service Oil Change to Cooling System Flush, from Differential Service to Fuel and Emission System Cleaner—the consumer knows he is receiving a quality vehicle maintenance service from trained technicians.

The Oil Can Henry's difference—the Oil Can Henry's advantage, many would say—is readily apparent from the start.

From the distinctive salt-box design of its service centers to the warm, welcoming nature of its knowledgeable employees, Oil Can Henry's is a standard bearer for personalized service. That commitment to quality is personified by Henry, the friendly gentleman who graces the company's logo.

At Oil Can Henry's, it's a team effort to earn—and keep—the customer's trust.

When a customer drives up for service, he is quickly welcomed by a friendly greeter and given a free *USA Today*

newspaper and menu of available services to choose from. The customer can then enjoy the newspaper as Oil Can Henry's employees begin the vehicle safety checks that are part of each and every service. The windshield is washed and tire pressure checked and filled, too.

Unlike other quick lubes, Oil Can Henry's allows the customer to remain in the vehicle where she can see and hear the service as it is completed. Unique video monitors provide live views of the work as it occurs under the hood and under the vehicle.

Oil Can Henry's employees communicate using a "command/echo" system that keeps customers apprised of the work as it progresses; one employee calls out each step of the service to be completed and, when the step is completed, is answered (or echoed) by the other employee.

Each Famous 20-Point Full-Service Oil Change includes the Henry's Top-Up Guarantee, which enables the customer to have his vehicle's fluids "topped-up" to the proper level between services at no charge.

Customers clearly appreciate their Oil Can Henry's experience. Instead of being sent to a cramped waiting room, they're free to relax in their vehicle and enjoy the free newspaper. Instead of gathering up their children and herding them to the waiting room, they can rest assured that everyone is safely inside the vehicle. And instead of wondering what they'll be billed for, they participate in the service process and select what services they want completed.

So, it's not surprising to learn that Oil Can Henry's has succeeded in earning the trust and loyalty of thousands upon

Attention to detail. The distinctive, inviting design of its centers is just one of the many details that set Oil Can Henry's apart from the competition.

Come as you are. Oil Can Henry's is unique in the quick lube industry, allowing customers to remain in their vehicles and watch the service on convenient video monitors.

thousands of people throughout Portland. (While the quick lube industry battles a lack of customer loyalty, Oil Can Henry's can proudly point out that 75 percent of its customers are repeat customers.)

It's also easy to understand why the company continues its remarkable success in the increasingly competitive quick lube industry.

Since acquiring Portland-based OCH International (the franchisor of Oil Can Henry's) in 1988, John E. Shepanek has led Oil Can Henry's on a path of carefully planned growth and expansion throughout the United States. In addition to its centers throughout Oregon, Oil Can Henry's is active in Washington, California, Utah, and Arizona. A review of the company's Web site (www.oilcanhenry.com) enables customers to locate service centers along their travel routes and learn more about the variety of valuable services offered by Oil Can Henry's.

Old-fashioned personal service at a fair price. Service that exceeds the customer's expectations. And an overwhelming commitment to quality. It's all part of making Oil Can Henry's "The One You Can Trust." ◪

Stay in your car. You don't have to sit in a waiting room wondering what's being done to your vehicle. At Oil Can Henry's, you can see and hear all the work from the comfort of your own vehicle.

The One You Can Trust. From friendly, trained service technicians to a clear accounting of all services completed, Oil Can Henry's strives to earn the customer's trust.

THOMASON AUTO GROUP

Puts Portland on Wheels

If you walk into a crowd and say, "If you don't come see me today,..." whoever replies, "I can't save you any money," has lived in Oregon sometime in the past 15 years and watched Scott Thomason deliver the line on television

By pouring money back into the community, Thomason makes sure that his success becomes Portland's success.

against a backdrop of cars.

From the early '80s, when Scott Thomason coined his slogan, to today, Thomason has starred in and used the familiar tagline in his high frequency advertising campaign.

Oregon was suffering a recession just as Thomason purchased his first car dealership from his father. The slogan resulted from Thomason's asking himself what would differentiate his company in the consumer's mind from the hundred or so others in the Portland area.

The goal, of course, was to get people to think of Thomason when it was time to buy a car. To think of him, they had to remember him. A savvy marketer, Thomason developed a long-term marketing strategy—to be a consistent advertiser and to establish Thomason Auto Group as a brand and develop a strong image and identity.

With their quirky and unorthodox approaches, Thomason's television commercials stand out from the rest.

The plan worked. Thomason's marketing has long been lauded, and he's been a featured speaker at dozens of organizations on that topic. His campaign continues to feature unique humor.

"It is a very different organization than any other car company in the city," says Thomason. And it shows. Thomason Auto Group is now the largest volume auto dealership in the Northwest. Nationally, Thomason is consistently rated in the top 50 car dealerships, out of about 22,000.

From that one dealership, Thomason now has nine new car franchises and counting. "Along the way we've been fortunate enough to pick up the three major import franchises with Toyota, Honda, and Nissan," said Thomason. "Ford," he adds, "is the strongest domestic brand franchise in Portland," and another in the Thomason Auto Group stable, which also includes Subaru, Suzuki, Hyundai, Isuzu, and Mazda franchises, as well as 12 used car locations.

One dealership to nine in just 15 years. How did he do it? He attributes the success in great part to his talented team of employees. "We have the best people in the industry," Thomason said, citing their loyalty and experience. Thomason recognizes their value and rewards them with benefits beyond industry standards. "We're very focused on attracting the best people," he says.

Thomason's dealerships are closely situated to one another in the heart of Gladstone's retail shopping district. The strategy in placing all his dealerships together is solely for customer convenience. He figures that if the customers can come to one—albeit one *huge*—location, they can concentrate on finding the right car for them and not worry about selection or having to drive all over town to compare prices.

Customers—and how they feel—come first to Thomason. It's why he has always been the centerpiece of his advertising campaign. Thomason says, "I think a consumer wants to know they're buying a car from a person."

Personal interaction is another Thomason trademark. He runs every aspect of Thomason Auto Group. While understanding the importance of voice mail, E-mail, and all the high-technology tools, he believes in face-to-face communication.

"I think personal interaction in business is the key to success," he says.

Thomason is excited about Portland's current and projected growth and attributes much of Thomason Auto Group's growth to the influx of people to Oregon, especially with the impact of high technology in the state.

Yet, he says, it's important to be aware of what growth brings. "I tell our staff," Thomason says, "with growth comes more responsibility, whether it's in business or in the community."

Thomason may heavily invest in his brand image advertising campaign, sending his face into a million households nearly every day and smiling from the sides of buses traveling the metropolitan area, but he also steers his profits back into the community.

Thomason quietly supports education, giving to schools in support of various programs. He also gives thousands of dollars annually to charitable organizations, changing the focus of that giving from year to year. Most often the focus is on issues affecting women and children. He serves on the boards of the Oregon Ballet Theater and Doernbecher Children's Hospital and as a trustee at the University of Oregon, his alma mater.

What is the future of the volatile automobile industry in Portland? "The single dealer is an endangered species," says Thomason.

Thomason's visibility around town keeps him in car buyers' minds.

And the future for Thomason Auto Group? "Our type of car company is one that will survive the tumultuous times now and ahead in the automobile industry," relates Thomason. "We're going to continue to change and grow and ensure that the customer is the focus, now and in the future."

In mid-1998, Thomason merged with Philadelphia-based Asbury Automotive Group which has holdings in four other states and is one of the largest automobile companies in the nation. The company will continue to be managed by Thomason and will continue to expand in the Portland area.

Thomason sees a bright future for Portland and cites the economy, rosy and growing, as the right reason to be in Oregon today. ⌐

Thomason's bright yellow banners mark his many McLoughlin Boulevard dealerships.

When discussing the history behind the city of Portland, two words usually enter the conversation: Meier & Frank. The history of Meier & Frank is nearly as old as the City of Roses itself.

It was two years prior to Oregon's statehood, 1857, when

Ralph Lauren designer linen boutique in Meier & Frank's extensive home store

the first store was opened by a German immigrant named Aaron Meier on Yamhill and First, in Portland, Oregon. The store was a small general store that carried everything from miners' tools to canned fruit. Merchandise was brought by steamer from San Francisco and by covered wagon over the Oregon Trail. Aaron Meier founded his business on principles of customer satisfaction, service, and liberal credit and return policies. While visiting family in Germany, Meier entrusted the company to his partner at the time, Mr. Mariholtz. In 1864, upon his return, he found his company bankrupt. Leaving the previous partner behind, he and another partner started a new company in 1872 and, consequently, Meier & Frank was born.

The growth of Meier & Frank has been phenomenal. In 1885, faced with Portland's mushrooming population, the store moved to larger quarters. The new building was con-

structed on Taylor, between First and Second Avenues, in downtown Portland. Customers flocked to the store, and in 1891 Meier & Frank again expanded by adding space on Yamhill and Second.

In 1898, the Meier & Frank families built a 5-story building on Fifth Avenue, between Morrison and Alder, featuring two elevators and many mechanical innovations never before seen on the Pacific Coast. Plans were already underway for increased facilities. Eleven years later, an annex was constructed with 10 stories above the street and two basements. It was the tallest store in the Northwest and Portland's only skyscraper. The 5-story building was demolished to make way for the present modern 16-story Meier & Frank department store, which opened in 1915. In 1966, Meier & Frank was acquired by the May Department Store Company.

Meier & Frank is typically the store that people think of when considering a purchase. Customers know that they will undoubtedly get the best possible price and the best selection in their home furnishings, fashion, housewares, gift, and cosmetic departments. In addition to the variety of fine merchandise at a good price, you can expect gift wrapping, delivery, and personal service.

Service is substantial at Meier & Frank. Associates are required to go through an intensive training program in which friendliness and customer service are stressed. Aaron Meier founded this company on customer satisfaction, and that is a quality that has been maintained and continues to be taken very seriously.

Meier & Frank is a favorite of brides across the country with its nationwide Bridal Registry program. After registering, customers are able to personally print out a list of what the bride and groom have registered for from the user-friendly kiosks located throughout the stores. Once they have purchased an item off the list, the item is deleted to avoid duplicate gifts. This program is unique because out-of-town guests get the wish lists of brides at any one of the May Co. Department Stores across the nation. This wonderful service is also available with the Baby Registry program.

Meier & Frank not only satisfies people through its fine

service and products, but as a firm believer in reciprocity, the company has always been a direct contributor to the community, as well. With a focus on children and families, the store supports education through programs that help to raise money for organizations such as the YWCA Transitional School or the Bridge Builders program for African-American young men. Meier & Frank prefers to use alternative ways to support community organizations by partnering with their volunteer base for fund-raising. The downtown store's 10th floor auditorium is a highly sought-after location for such events. Meier & Frank also supports major arts organizations, such as the Kids' Concert series at the Oregon Symphony.

Also on the 10th floor, senior citizens gather for the OASIS program. The program offers classes in everything from the arts to wellness, and a resource library of books and periodicals. OASIS provides a safe, friendly place to visit with friends and also arranges opportunities for seniors to volunteer in the community.

Meier & Frank is not a newcomer to the parade circuit either. As a regular sponsor of a float in Portland's annual Rose Festival parade, award-winning entries are a common occurrence. The Governor's Award, Sweepstakes, and Best Theme are just a few of the many awards that have adorned the beautiful 100-percent flower-covered floats. Meier & Frank also sponsors and produces the Holiday Parade, held the day after Thanksgiving each year. It features more than 60 entries of marching bands, floats, equestrian units, and community groups who brave the inclement weather to entertain the hundreds of people lining the streets of downtown to cheer them on.

No holiday season would be complete without a visit to Meier & Frank's famous animated Christmas window displays and Santa Land. Santa makes a special trip here to visit

Cosmetics at Washington Square store, Portland

youngsters and hear what they'd like for Christmas. Afterwards, they can "catch" the monorail to ride above Santa Land for a bird's-eye view. Each Christmas, hundreds of children also take part in the annual Breakfast with Santa. Held both in the downtown store and in the Salem store, these pancake breakfasts include a musical performance by local high school groups and, of course, a visit from St. Nick. This tradition is so popular that families start calling in September to reserve their spots.

Meier & Frank's commitment to the community is also seen through ongoing support of organizations such as the Portland Oregon Visitors Association, Association for Portland Progress, the Rose Festival, and the Oregon Business Council, to name a few. Meier & Frank has been an indispensable part of the Portland community for more than a century. Founded over 100 years ago with a dedication to customer satisfaction, the company continues to satisfy the community by remaining a strong civic and community partner with Oregon and southwest Washington.

Meier & Frank is a division of the May Department Stores Company. There are eight stores in the Portland/Vancouver area: Downtown Portland, Washington Square, Lloyd Center, Clackamas Town Center, Vancouver Mall, Rogue Valley, Eugene, and Salem. ◢

Men's designer boutique at Meier & Frank

Corporate offices reception area

When Robert Pamplin Jr. and Gary Randall became friends in 1978, the two men—both ordained ministers—were drawn together by shared values, a common desire to impact the world, and a mutual love for God. Neither could have anticipated that their budding friendship would one day lead to a full-fledged business relationship, or that this partnership would cause them to establish one of the most influential and diverse companies in the multimedia entertainment business: Pamplin Communications.

Such an outcome, the pair agree, is something that could have been orchestrated only by God.

The two come from vastly different professional backgrounds—Pamplin is a member of the *Forbes* 400 and one of the most highly respected entrepreneurs and philanthropists in the nation, while for 27 years Randall served faithfully as a pastor to adults and youth, and for 12 years was a national

Branch location in Washington Square Mall, Tigard, Oregon

Christian television personality. But the men share a common vision.

"Bob [Pamplin] and I have agreed that our goal is to impact at least 25 percent of America with a positive, 'good news' message," explains Randall, now president and vice chairman of Pamplin Communications. "That will happen through videos, movies, Christian music, retailing, and Christian broadcasting." Pamplin, chairman of the board and CEO of Pamplin Communications, asserts that he wants the corporation "to be identified with basic decency and family values." With this goal in mind, Pamplin and Randall set out to thoughtfully and purposefully develop an entertainment network that today

includes Pamplin Entertainment, Pamplin Music, Christian Supply Centers, Inc., and Pamplin Broadcasting.

Born of a desire to provide products that nurture families and promote godly values, Pamplin Communications began in 1993 with the purchase from Multnomah Bible College of six struggling Christian bookstores. Under the leadership of Rick Wilson, the new president of Christian Supply, the troubled retail stores established within months, then quickly flourished. In one of Christian retailing's most inspiring success stories, the flagship outlet was named 1995 Regional Store of the Year by the Christian Booksellers Association, and financial records show an impressive 400 percent increase in sales in the company's first 36 months.

By mid-1998, Christian Supply Centers, Inc. had blossomed into 24 powerhouse locations, scattered throughout Oregon, Washington, and Idaho, and the company continues to move ahead with plans for future expansion and growth.

Today, customers can find expanded inventory and a wide range of products at Christian Supply—from $2,000 Thomas Kinkade art prints to inexpensive gift items, leather-bound Bibles to best-selling paperback fiction, heart-stirring Southern gospel music to alternative rock, and much more. But perhaps even more important than the diversity of product is the renewed emphasis on old-fashioned customer service. With a constant emphasis on the mission of serving others and impacting 25 percent of the nation, Christian Supply trains its employees to help people find what they need to live fuller, happier lives. Not only is such an approach more honest and honoring to God, Pamplin's leadership maintains, but it also makes good business sense. Satisfied customers will come back time and time again.

The next phase of Pamplin Communications' growth came with the development of Pamplin Entertainment in 1994. From its impressive debut to the influential position it now holds in the entertainment industry (Pamplin Entertainment leadership meets regularly with DreamWorks, Paramount, and Disney, as reported in the May 27, 1998, issue of the *Oregonian*), the company has faithfully provided families with quality programs that are entertaining, as well as purposeful and passionate in their presentation of God's truths. Groundbreaking projects include television programs, feature films, music videos, and home videos, including "The Bibleman Show," now also a popular live-action stage show boasting in excess of 100 dates per year and audiences averaging 1,200-1,500 per date.

It was within this environment, following the early success of Christian Supply Centers and Pamplin Entertainment, that Pamplin Music was born. Starting out with a refreshing, West

Coast perspective; a creative approach; and a modest roster of four talented artists, Pamplin Music established itself almost immediately as a powerful and vibrant music label. Within a brief period of time, the company became known as one of the primary "movers and shakers" in the continually changing—and rapidly growing—Christian music industry, and soon was recognized as *Billboard* magazine's number two Top Contemporary Christian and Gospel Independent Label for April 26, 1997, through April 18, 1998.

The company's areas of outreach include multiple music genres. Its first, groundbreaking label, Pamplin Music, focuses on four styles of popular Christian music: adult contemporary, Christian Hit Radio, inspirational, and pop. Organic Records, the company's second, more eclectic label, showcases unique artists with a modern rock and alternative vibe. Serving both labels, as well as select groups of independent music companies who share a passion for taking the gospel to the world, is Pamplin Music's state-of-the-art national distribution company.

"We've been given this platform, this opportunity, to build a company that's fresh and different," says Michael Schatz, executive vice president of Pamplin Music. "We're innovative like an `indie,' but with the financial strength of a major label," he continues, explaining in part the company's incredible early success. Today, Pamplin Music is known for discovering new talents, as well as drawing veteran artists such as John Elefante, former lead singer for the rock group Kansas. With numerous Top 20 hits already charted, it's clear that Pamplin Music has been embraced by the Christian music community. Yet the organization continually seeks to produce music that can reach not only believers, but the entire world with the message of redemption and life in Christ.

The most recent addition to Pamplin Communications, Pamplin Broadcasting owns and operates KPAM (the second most powerful station in Portland, Oregon, and the first high-power AM station to hit the city's airwaves since 1960) and KZTU 660 in Eugene (the strongest AM station in the state's second-largest city)—two of the region's strongest and most effective providers of godly family entertainment. Yet this is just the beginning for the company that began in early 1998; Pamplin Broadcasting recently signed a deal with Salem Communications to buy the 50,000 watt KTSL-FM in Spokane, Washington. Further stations will be added as Pamplin Broadcasting continues to grow.

With stories like these, it seems clear that

Division Street Store Music Department in Portland, Oregon

Pamplin Communications' early years have been more successful than even the most hopeful entrepreneur could have dreamed. Pamplin's leadership maintains that they simply have been blessed by God. At the same time, they take very seriously their responsibility to the one who has blessed them. The partners remain committed to their work, confident in their ability to succeed. . .and forthright about their motivation for doing so. "This is not about self-gratification," says Pamplin. "It's about providing products and services that can influence a cross section of the American population."

"We won't necessarily lead 25 percent of the population in America to the Lord," Randall admits, "although that would be great. But we will impact them. Then maybe someone else will lead them to the Lord or lead them to faith."

Despite the tremendous commercial success enjoyed by the corporation, all the work boils down to one key truth. "We believe that everything we do has the potential to change somebody's life," says Randall. "And that's not just a PR statement. . . . It's our passion." ⊿

Division Street Store Book Department in Portland, Oregon

TIMBERLINE

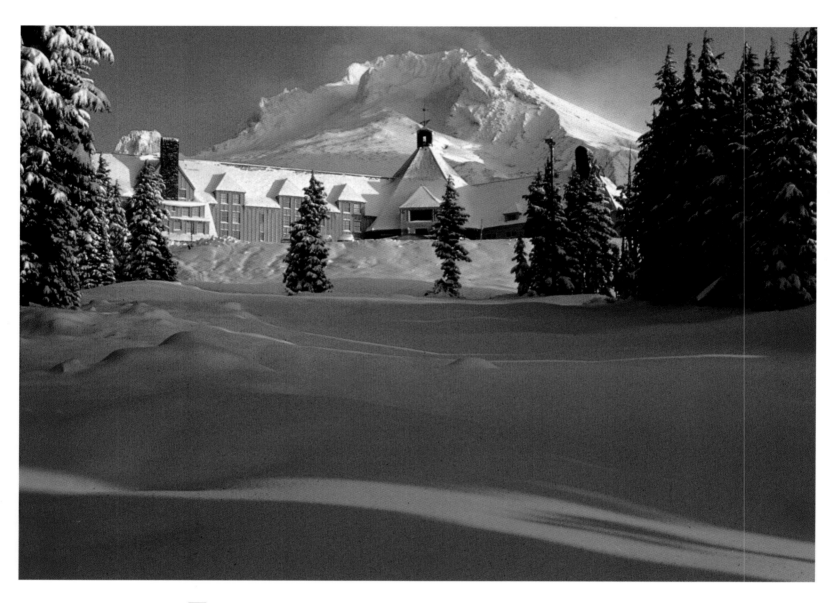

When Portland executives raise their eyes from the bottom line, they rest them on Portland's skyline and its towering glory—snow-laden Mt. Hood, home to the masterpiece of mountain lodges: Timberline.

Timberline Lodge is a National Historic Landmark and a full-service, year-round ski resort located on the south side of Mt. Hood at the 6,000-foot level. Hosting more than a million-and-a-half visitors each year, it is one of the most highly visited attractions in Oregon.

Timberline is the quintessential ski lodge. Designed in the classic architecture of the Northwest, its Cascadian style reflects the shoulders and summit of the mountain looming beyond; its materials are native—large stones and timber— and its sloping roofs remind skiers of the breathtaking downhill trip. Inside, guest rooms accommodate up to 150, conference rooms up to 250, reception areas for up to 400. Fine dining in the award-winning Cascade Dining Room, two cozy pubs, sauna, hydro-spa and seasonal pool, and an interpretive program of the Lodge keep visitors busy.

Owned by the United States Forest Service and operated since 1955 by R.L.K. & Company, Timberline was built in 1937 as a Works Progress Administration (WPA) project. Timberline became Oregon's WPA crowning jewel, with craftspeople and artists producing paintings, textiles, iron work, and handmade furniture, which still exist today—a snapshot of an era explained in art.

Timberline's ski area is one of Oregon's most popular, boasting the longest ski season in North America and the only lift-operated summer skiing in the country. Serviced by an express quad lift, Timberline's Palmer Snowfield draws the world's best skiers and snowboarders to its slopes each summer. Timberline is a classic in every sense of the word. ◾

AZUMANO TRAVEL

The result of 50 years of dedicated service in the Pacific Northwest region for Azumano Travel Service is far more than just satisfied customers. It is 50 years of Oregonians reaping the public service benefits provided by Azumano founder George Azumano and Azumano president Sho Dozono.

Azumano Travel Service is Oregon's oldest and largest locally owned travel services provider, employing more than 200, with nearly $125 million in gross sales. The company's ability to service its clients has grown through its affiliation with the worldwide travel organization Carlson Wagonlit Travel.

Azumano Travel Service is a successful business by any definition, yet the company's success is nearly overshadowed by Azumano and Dozono's commitment to keeping Portland's economy strong and its communities thriving, through the application of their brains to economic solutions and their hearts to community ones.

Azumano Travel Service's leaders were at the forefront of positioning Oregon as a tourist destination. As Americans of Japanese descent in a city poised as a gateway to the Pacific Rim, Azumano and Dozono knew that Japanese tourists were a natural audience. One big step in growing Oregon's relationship with the Japanese was Azumano's success in convincing Japanese television moguls to produce *From Oregon with Love*, a television series about a Japanese boy living on a Madras, Oregon, farm. More documentaries and television shows followed. And so did the Japanese tourists, eager to view firsthand what they had seen on their televisions: the wide-open spaces, green, tall trees, and raging rivers.

Dozono served on the board of the Port of Portland, recognizing the port as an economic engine for the city. When Dozono became a port commissioner, there were only 7 flights to Japan a week. Now there are at least 28.

Dozono and Azumano continue to seek ways in which to position Portland as an attractive place to visit and as an international city with developing trade and business commerce.

"People spend time and money when they can afford to," says Dozono, citing one important reason to maintain Portland's strong economy. Obviously, a strong economy has a direct impact on Azumano Travel's business.

Of equal importance to Dozono is time he spends on issues without the same direct payback to the company. His current passion is school funding, which he feels is a quality-of-life issue for Portlanders. He serves as president of the Portland Public Schools Foundation, a group taking very seriously the issue of funding schools at the right level to provide quality education. He's also currently a trustee with the Portland Art Museum and the Spirit Mountain Foundation.

Azumano President and CEO Sho Dozono (left) and Chairman George I. Azumano (right) continue to seek ways in which to position Portland as an attractive place to visit and as an international city. Shown here, the Japanese American Historical Plaza, located on Portland's waterfront.

Dozono's roots run deep in Oregon soil. His Japanese grandfather came to the United States, as did Azumano's parents, settled in Portland and raised families. Dozono's cultural experiences, unique to his heritage, are ones which he feels a responsibility to share with the community. Lessons from which others might learn include his experience as a member of a pioneering family, the treatment his family and other Japanese received during WW II, and others' lack of understanding and knowledge, which he believes can plague an ethnic businessperson even today. His goal is to help the ethnically diverse next generation know they can be successful in this community and that with success comes a responsibility to give back. ◪

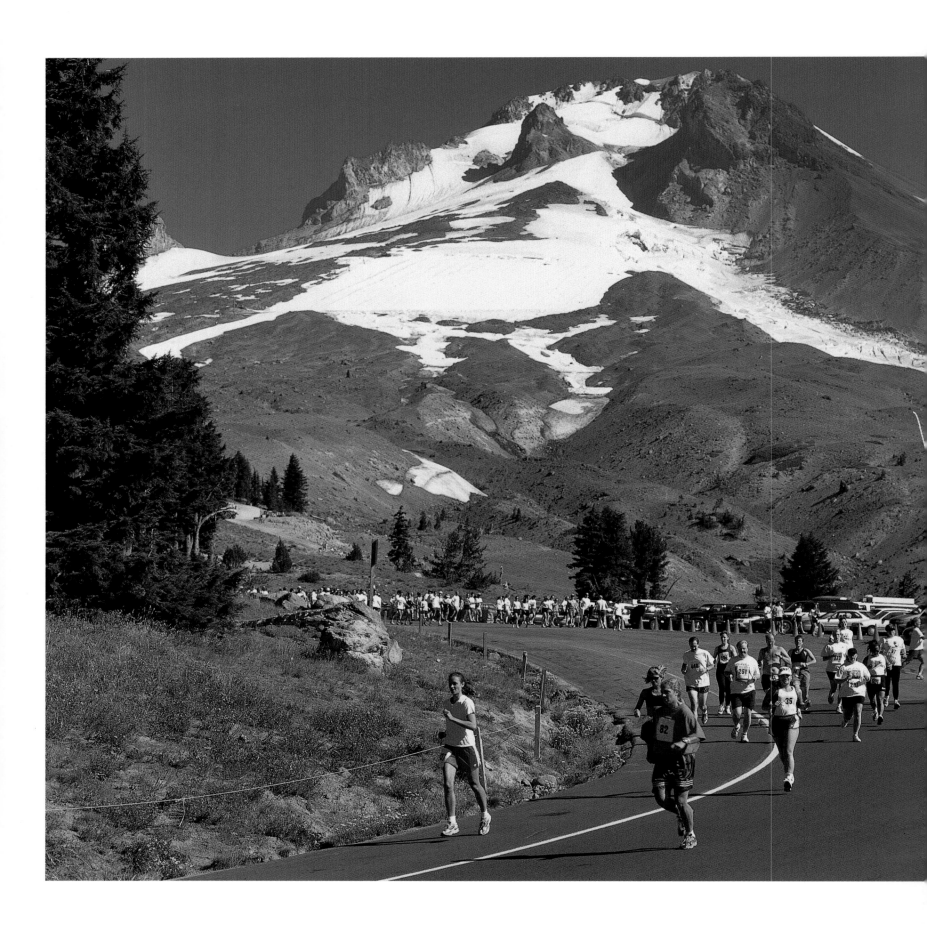

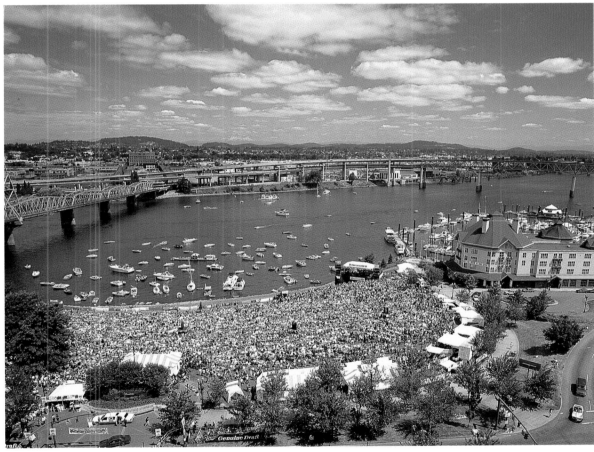

Photos: Larry Geddis

Bibliography

Christensen, Mark. *Life, Unusual Oregon*, Seattle: Sasquatch Books, 1997.

DeMarco, Gordon. *A Short History of Portland*, San Francisco: Lexikos, 1990.

Irving, Stephanie, ed., *Portland Best Places*, Seattle: Sasquatch Books, 1990.

Neiworth, Trish. *Portland's Promise: Shaping the River City*, video recording produced by KPTV in association with the Oregon Historical Society and Neiworth Media Group, Portland, 1995.

O'Donnell, Terence and Vaughan, Thomas. *Portland: A Historical Sketch and Guide*, Portland, Oregon Historical Society, 1976.

Oregon Secretary of State's Office, *The 1997-98 Oregon Blue Book*, Salem, Oregon: 1997

Snyder, Eugene. *Portland Names and Neighborhoods: Their Historic Origins*, Portland: Binford & Mort, 1979.

The author also wishes to acknowledge information gleaned from the *Oregonian*, *Monk* magazine, the Portland Metropolitan Chamber of Commerce, the Office of Neighborhood Involvement, and the Portland Oregon Visitors Association.

Patrons

ALCATEL Submarine Networks, Inc.
Nordstrom

Enterprise Index

Index